Warwickshire County Council

New 11/10	LEA		

This item is to be returned or renewed before the latest date above. It may be borrowed for a further period if not in demand. **To renew your books:**

- **Phone the 24/7 Renewal Line 01926 499273 or**
- **Visit www.warwickshire.gov.uk/libraries**

Discover • Imagine • Learn • *with libraries*

Warwickshire
County Council

Working for Warwickshire

013495077 3

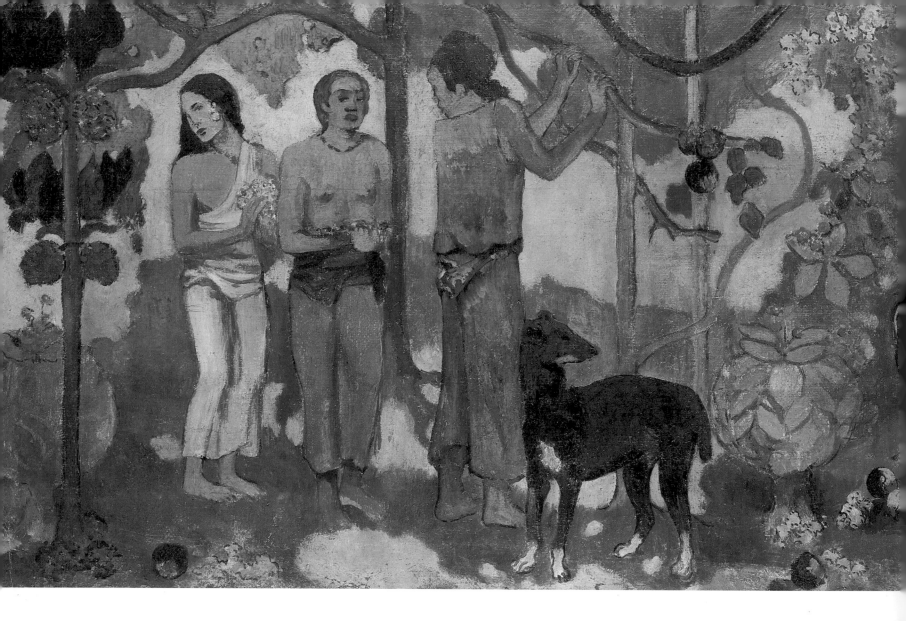

Edited by
Belinda Thomson

Consultant Editor
Tamar Garb

With contributions by
Philippe Dagen
Amy Dickson
Charles Forsdick
Tamar Garb
Vincent Gille
Linda Goddard
Belinda Thomson

Tate Publishing

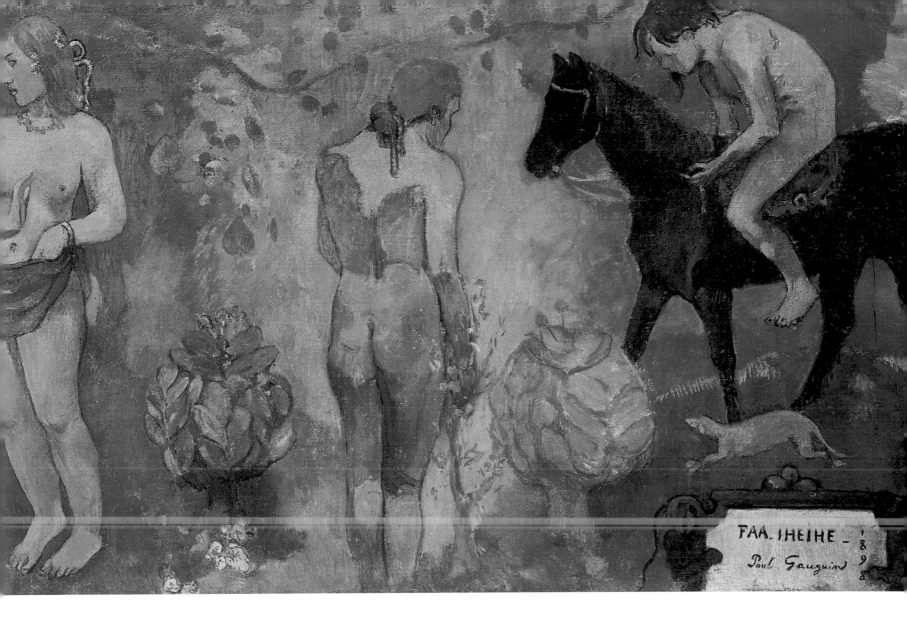

GAUGUIN

MAKER OF MYTH

KT-381-535

Global exhibition sponsor

Bank of America
Merrill Lynch

With additional support from The Gauguin Exhibition Supporters Group
The Annenberg Foundation
John and Susan Burns
Eykyn Maclean
Fares and Tania Fares
Patrick and Sophie Fauchier
Mark and Sophie Lewisohn
Catherine and Franck Petitgas
The Search Foundation
and those donors who wish to remain anonymous

First published 2010 by order of the Tate Trustees
by Tate Publishing, a division of Tate Enterprises Ltd,
Millbank, London SW1P 4RG
www.tate.org.uk/publishing

on the occasion of the exhibition
Gauguin: Maker of Myth
organised by Tate Modern, London, in association
with the National Gallery of Art, Washington

Tate Modern, London
30 September 2010 – 16 January 2011

National Gallery of Art, Washington
27 February – 5 June 2011

© Tate 2010

All rights reserved. No part of this book may be reprinted or reproduced or utilised
in any form or by any electronic, mechanical or other means, now known or
hereafter invented, including photocopying and recording, or in any information
storage or retrieval system, without permission in writing from the publishers

British Library Cataloguing in Publication Data
A catalogue record for this book is available from the British Library

ISBN
978 1 85437 902 3 (paperback)
978 1 85437 871 2 (hardback)

Design concept by Why Not Associates
Layout by Miguel Rodrigues
Printed in Great Britain by St Ives Westerham Press
Cover: Paul Gauguin, *Nevermore O Tahiti* 1897 (detail, no.118)
Measurements of artworks are given in centimetres, height before width and depth

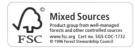

FSC Mixed Sources
Product group from well-managed
forests and other controlled sources
www.fsc.org Cert no. SGS-COC-1732
© 1996 Forest Stewardship Council

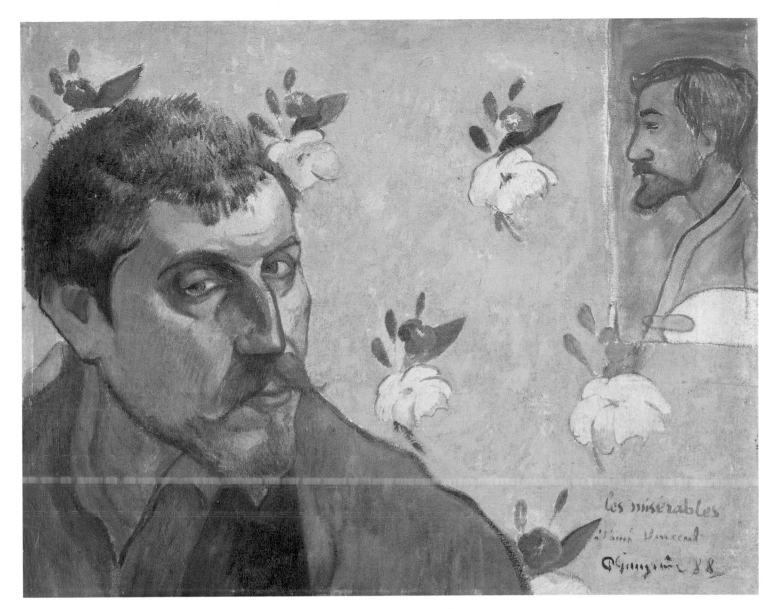

Fig.1 *Self-Portrait, Les Misérables* 1888
Oil on canvas
45 x 55
Van Gogh Museum, Amsterdam
(Vincent van Gogh Foundation)

The Artist's Persona

*'Mon terrible moi que je porte lourdement'*³

Central to Gauguin's narrative strategies was self-presentation, and the legend-building uses to which he put his colourful life. For a number of years Gauguin tried to lead parallel existences, as a dutiful family man and breadwinner on the one hand, and an artist on the other, affiliated to a group with a revolutionary, innovative agenda. In this endeavour, which lasted from the late 1870s to 1885, he failed. From the point of deciding, in Copenhagen, that he was no longer prepared to compromise with his artistic calling, until his death in 1903 on the Marquesan island of Atuona in relative penury, Gauguin convinced himself that his life – and he seems to have had a sense of the preordained here – was telling a different story. The truth was he had to reframe the narrative of himself (no.1). Instead of the opportunistic, business-like investor and collector his Impressionist peers had come to know, and grown wary of, he needed to project a different persona. In his mode of dress and behaviour, he progressively began to flout bourgeois society's duties and expectations along with its narrow aesthetic rules, justifying the change by reference to innate compulsions, to blood and racial incompatibilities, to his 'savage' nature. Creating the myth of his savage nature helped explain the changes in his art, but it also had the effect of distancing Gauguin from his mentors and, eventually, of alienating most of his friends. Those who knew him most intimately – his wife Mette-Sophie (née Gad, 1850–1920), his teacher Camille Pissarro –

11

were never quite convinced by this reinvented symbolist/savage Gauguin who emerged after 1887. The process was a gradual one, but it was accelerated by certain events, notably the increasing public interest and attention his work started to command. Vincent van Gogh (1853–1890), who famously shared his Arles studio with Gauguin for two months in late 1888, was puzzled by his personality, feeling it would benefit just as much as his own from being subjected to psychological scrutiny.[4]

The gradual focusing of Gauguin's artistic goals toward exotic otherness was enhanced by his period working in Martinique in 1887. It was also the experience of exchanging aesthetic ideas with other artists that confirmed Gauguin's shift in priorities, his very public rejection of urban life and its sophisticated 'Parisianiste' styles in favour of primitive values (no.7). Gauguin's symbolic flight from Paris, 'a desert for the poor man', was gradually hardened into an article of faith in which the city became a corrupt Babylon.[5] But in this projection of his uncompromising 'outsider' artistic persona, the one who ultimately rejected Europe for ever more distant shores, Gauguin would never fully shrug off his old persona as sophisticated 'man of the world'.[6] Moreover, getting on required making periodic assaults on the metropolis he professed to abhor but whose careerist networks he well understood. It meant finding influential backers, targeting well-placed critics.

Questions of identity, racial and cultural, were integral to Gauguin's sense of self, and he explored them both in written and visual form. When seeking to justify to his wife, three years after their first separation, his renewed resolve to pursue his artistic career singlemindedly, impervious to family ties and emotions, he produced a graphic image of his two conflicting natures, the 'sensitive self and the Indian who walks straight ahead unhesitatingly'.[7] If, here, he used this hybrid, civilised/savage image as an explanation for the acerbity and new coldness of character he was cultivating in the domestic sphere, atavistic romanticism also became part of the rhetoric surrounding his artistic output. His dealer, Theo van Gogh, was clearly prepared to give him special dispensation as a result: 'it's evident that Gauguin, who is half Inca, half European, superstitious like the former and advanced in ideas like certain of the latter, can't work every day in the same way.'[8]

Saying Gauguin made use of his own life as a narrative strategy – something we all do to different degrees – is emphatically not to imply that he went in for soul-baring revelations or penning a misery memoir. The fragmented nature of his upbringing and the extent of his travels sound almost modern. He circumnavigated the globe several times and sampled, or experienced more fully, life in the Americas (Peru, Panama, Martinique), Europe – from its cultural heart (Paris) to the far polar north (Tromsø) and extreme west (Finistère) – and Oceania (Tahiti and the Marquesas). But he used the data he gathered highly selectively. All his travelling involved long months at sea, but rarely does Gauguin allow one to glimpse the impact of such ocean-going, which he never recorded directly in his artistic work. Nevertheless, that hardening, seafaring life in the merchant marine was a factor in his personality to which many of his contemporaries drew attention, noticing how it affected his speech, bearing, demeanour and mode of dress. One can well imagine that the experience of meeting Gauguin was powerful – many contemporaries testified to that – and that, interwoven into his sardonic anecdotes and giving authority to his pronouncements, there were snippets of personal history that contributed to that larger-than-life impression. It is from their witness accounts and from the profiles drawn by such writers as Octave Mirbeau (1850–1917), that the highly coloured image has been handed down, with Gauguin's complicity: the fine figure of a man, the acerbic wit, the cruel prankster, the athlete, fencing, boxing, throwing spears like Buffalo Bill on the beach in Brittany, womanising and drinking others under the table. The artist reinforced these different aspects to his character through a steady output of self-portraits, differently loaded visual icons addressing posterity that have more to do with role-playing than with engaging in introspective self-analysis. His written autobiographical leanings took different forms. In *Noa Noa* (1893–7) he assumed the pose, carefully crafted, of the Frenchman progressively going native. *Racontars de rapin* of 1902, his score-settling text laying out his artistic position, only allows the writer's personality to emerge by default, in the interstices of his pugnacious opinions.[9] The

text of *Avant et après*, 1903, a lively, sometimes scabrous assemblage of memories and observations, withholds all intimacies, tender feelings, signs of human frailty, admissions of failure.[10] Gauguin was a lover and reteller of tall stories who ended up believing, and finding creative nourishment, in his own narrative. A more rounded picture of the human being has only become available in recent years, as more letters have come to light.

The publication of Gauguin's correspondence revealed the artist's life in reverse order. First appeared the letters from Polynesia to his loyal friend and de facto agent, Daniel (also known as George-Daniel) de Monfreid (1856–1929), many querulous and mercenary in tone, and morbidly preoccupied by his infirmities. Published in 1918, these letters, even with Victor Segalen's sensitive *hommage*, presented him as an extremely egotistical figure, one verging on the monstrous – the one who fascinated Somerset Maugham and informed his literary embodiment.[11] Gauguin's earlier letters to his wife, family and other friends, first published in 1946, tempered this image and revealed a more complex, paradoxical and humane individual, whose tender, conjugal and paternal feelings alternated with his more bullying tendencies. The letters to the van Gogh brothers, first published in 1983, and the ongoing editions of his complete correspondence, including much previously unpublished material, revealed Gauguin's humour, cool-headed strategic professionalism and the depths of his intellectual life at the crucial juncture of the late 1880s.[12]

Gauguin's late-starting career was propelled by an extraordinary level of self-belief, evident in such statements as: 'I am a great artist and I know it. It is because I am that I have endured so much suffering. To follow this path otherwise I would consider myself a brigand. Which is what I am, moreover, in the eyes of many people.'[13] If Gauguin began playing the part of legendary genius around 1886, others, it must be admitted, were willing to lay that mantle on his shoulders. In the process of stressing his otherness and outsider status and denouncing the bourgeois values of which, only recently, he had been an exemplar, Gauguin gathered disciples, consisting of other, mostly younger, discontents looking for leadership: Émile Schuffenecker (1851–1934), who formerly worked with him at the Bourse and frequently lodged him in Paris, Charles Laval (1862–94), who accompanied him to Martinique, Vincent van Gogh and Émile Bernard (1868–1941), with both of whom he had electric, creative relationships, which ended badly. Even before the formation of the so-called Pont-Aven group, these different artists were speaking of Gauguin's extraordinary talent, his Herculean strength, his poetic genius.

It is worth remembering that Gauguin was striving for recognition at a time when parading one's individualism had become a form of artistic currency. Apart from Impressionists who actively cultivated their 'temperament' (Claude Monet and Paul Cézanne for instance), there was James Abbott McNeill Whistler (1834–1903) whose robust aesthetic ideas, expressed in the *Ten O'Clock* lecture, were a talking point in 1885. That summer Gauguin and he were both in Dieppe; did something of the American's cosmopolitan flamboyance and willingness to make enemies rub off? One thinks also of the shameless publicity-seeker Pierre Loti (1850–1923), naval officer and author of popular exotic novels and travelogues, with his narcissistic love of having himself photographed in different guises, seeking and winning election to the Académie française at a preposterously young age. The advantages of publicity were appreciated to the same degree by Gauguin, and manipulated ruthlessly to similar effect. His dandyism took the form of an embroidered Breton waistcoat, personalised canes and clogs, a Magyar-style cloak, large-brimmed Bolivar hat, astrakan fez; as well as creating multiple self-portraits, like Loti, Gauguin made a point of distributing photographs of himself among his would-be admirers.

But in Gauguin's case there was also a familial precedent for this self-aggrandisement: his grandmother Flora Tristan (1803–1844), whom he never met, had become a legend in her own lifetime; a monument to her memory was unveiled in Bordeaux by her admirers a few months after his birth. What Gauguin actually says about Tristan is relatively sparse and equivocal – in *Avant et après* he mentions that she was a feminist bluestocking who probably didn't know how to cook. Certainly his own mother had suffered a lonely childhood as a result of Tristan's absences and negligent parenting style. But her dramatic, courageous, peripatetic life, which she exploited to the

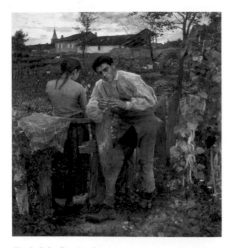

Fig.2 Jules Bastien-Lepage
Love in the Village 1883
Oil on canvas
194 x 180
The State Pushkin Museum of
Fine Arts, Moscow

full in travelogues, her indomitable pride, her ability to assume different identities as occasion demanded, all bear remarkable similarities to his own.[14] That Gauguin knew and valued his grandmother's writings is clear.[15] He surely identified with her sense of grievance and empathised with the disempowerment and *misère* her illegitimacy entailed; as a struggling artist he claimed a similar pariah status to the one she assumed in narrating her *Pérégrinations d'une paria*, 1838. In reality, the journey to Peru that Tristan's book described – leaving behind husband and two children – was largely motivated by money, as she had gone there to reclaim her inheritance from a wealthy uncle (the same Don Pio Tristan Moscoso in whose Lima home Gauguin spent his early years, and in whose name he offered *Vision of the Sermon* 1888 to a Breton church). Back in France, after narrowly escaping death at her husband's hand, she took to the road again as one of the era's most ardent Saint-Simonien socialists, championing the rights of women to divorce and property, rallying workers to the cause. In 1840 she published *Promenades dans Londres,* a trenchant report on the city that she had visited several times, most recently in the spirit of a critical journalist wishing to get under the skin of the country then conspicuously enjoying industrial and global dominance.

So within his heredity Gauguin could find precedents for many of his more extravagant stances, or surprising detours – the late involvement in satirical, campaigning journalism, for instance. It was maternal genealogy that led him to claim his hybrid, mixed-blood identity, for as well as French ancestry he claimed descent from the Spanish nobility and even, so he fondly believed, from the Incas. The fact that such an identity was a tenuous thread only encouraged his tendency to romanticise it in a classic myth-making way.

Tale-telling came naturally to Gauguin. An important instance of this propensity is the episode of the *Livre des métiers* by Wehli-Zunbul-Zadé. This didactic text – which opened with the august words, 'Thus spake Mani, painter and giver of precepts' – purported to have been handed down by a revered Hindu sage to his pupils. It circulated among the Parisian avant-garde of Gauguin's acquaintance in 1886 before reaching the critic Félix Fénéon who organised its publication the following year in the Belgian periodical *L'Art moderne,* with an editorial note remarking on the curious aptness of Mani's words to the colour theories of the Impressionists and the compositional preferences of 'M. Georges Seurat'.[16] Years later Fénéon reprinted the text and revisited the question of its authorship, noting that Jean de Rotonchamp, Gauguin's first biographer, had found a manuscript version, slightly differently worded, among Gauguin's papers, and clearly believed he was its author.[17] That Gauguin invented this set of rules for picture-making seems entirely plausible. It was no coincidence that it surfaced just when his ambitions had been knocked sideways by the success of Georges Seurat (1859–1891) and the neo-Impressionist group at the eighth Impressionist exhibition of 1886, and when, after studying the latter's works in Paul Signac's (1863–1935) studio, he declared war on everything connected with 'the little dot'. Among Mani's precepts are recommendations that sound remarkably similar to Gauguin's own future pictorial preferences: in colour terms, the avoidance of stark oppositions, the cultivation of harmonies; in compositional terms, the avoidance of the 'pose involving movement. Each of your figures must be shown in the static state.' Its pervasive tone of lofty injunction, coupled with deliberate mystification, also smacks of Gauguin. Just the same tone can be found in some of his more portentous titles: '*Soyez amoureuses, vous serez heureuses*'; '*Soyez mystérieuses*'. One of the final precepts uses an idiosyncratic image – that of creativity being a boiling of the blood, a volcanic eruption – which became an oft-repeated mantra in Gauguin's writings: 'Do not finish [your work] too much; an impression is so fugitive any subsequent attempt to render it in infinite detail will spoil the first freshness. You let the lava grow cool and turn boiling blood into a stone: though it were a ruby, fling this far from you!'[18] Mani was one of Gauguin's first alter egos and there were many more instances of such role-playing to come.[19] Unreliability and playfulness, that propensity to absorb and project different identities, these traits were sticking points for a number of Gauguin's early commentators and continue to divide critical opinion to this day. Yet it was through such paradoxical and provocative manoeuvres that Gauguin communicated the serious, radical tenets that would shape his art.

Fig.3 Georges Seurat
A Sunday on the Grand Jatte (1884)
1884–6
Oil on canvas
207.5 x 308.1
The Art Institute of Chicago.
Helen Birch Bartlett Memorial
Collection

Gauguin's Rupture with Impressionism

When Gauguin emerged as a new player on the French art scene in the early 1880s, the place of narrative in figurative painting was a contentious issue, affecting artists across a wide spectrum of practice, from the academic to the modern. For successful academic history painters such as Jean-Léon Gérôme (1824–1904) and Jean-Paul Laurens (1838–1921), and naturalist genre painters such as Jules Bastien-Lepage (1848–1884) and Émile Friant (1863–1932), underpinning the compositional structures of their carefully contrived tableaux were certain well-understood conventions they had been taught at the École des Beaux-Arts. Irrespective of whether the subject featured a scene from the *Odyssey* or Roman history, a north African slave market or a gathering of labourers in rural France, there would typically be centralised focus on a pregnant moment in the narrative, the key protagonists indicated by appropriate lighting and colour, telling interchanges conveyed through plausible, sometimes histrionic gesture and facial expression. If the resulting images, even when brought to a fastidious, quasi-photographic level of finish, suffered from a degree of staginess, the advantage was that the public instantly knew how to read the artist's meaning, especially when helped along by a title. That might be prosaically descriptive, teasingly piquant, or allusively poetic (fig. 2).

With Édouard Manet (1832–1883) in the 1860s and the advent of 'la nouvelle peinture', as Impressionism was dubbed in 1876 by Edmond Duranty, new narrative conventions came into play together with new subjects. In the hands of skilled figure painters – Edgar Degas (1834–1917) or Berthe Morisot (1841–1895) for instance – narrative did not disappear but took on more subtle guises. Particularly in genre (everyday life) painting, theatricality and rhetorical gestures were abandoned in favour of discreet low-key ways of infiltrating meaning, devices appropriate to the informality and intimacy of the chosen subject and the faster pace of modern life: typically, figures seen from awkward angles rather than head-on, placed off-centre or cut by the frame, their individuality characterised by telling details of costume or body language. In 1886 Seurat presented his major challenge to these narrative conventions of informality and naturalness when he deployed his static, ordered, frieze-like composition in *A Sunday on the Grande Jatte (1884)* (fig.3), in the process hinting at the artifice and formal posturing he saw in modern urban life. But resorting to extra-pictorial literary devices, requiring pictures to be read, was increasingly anathematised. Gustave Moreau (1826–1898), committed though he was to the traditional themes of history painting, roundly castigated artists who had recourse to literary tags and anecdotage instead of attending to the material business of painting.[20] The long-standing tradition of *ut pictura poesis* – wherein

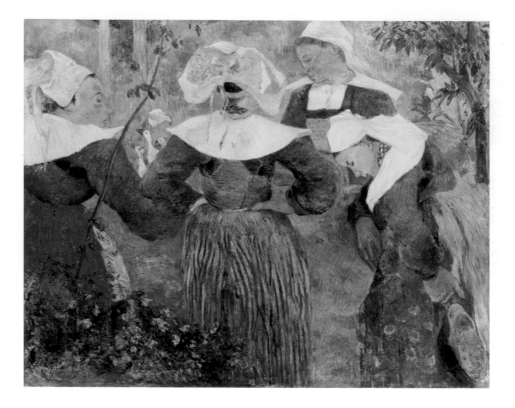

the sister arts of poetry and painting, although constantly vying for dominance, were held to be interdependent – looked set to be toppled.

In his first efforts at composing modern landscapes and figure subjects, Gauguin was not tempted down the route of mainstream naturalism; he abhorred slick painting that had adopted a veneer of modernity but not fundamentally altered its mode of addressing the viewer, like the *plein-air* views of his own brother-in-law, Frits Thaulow (1847–1906).[21] If he went to the Salon and paid attention to its star turns, which he did, it was an incitement to do differently.[22] Claude Monet (1840–1926) and Paul Cézanne (1839–1906) were his heroes and Camille Pissarro (1830–1903) and Degas his chosen mentors: he imbibed their values along with their technical know-how. Like them, he was deeply suspicious of the 'literature of painting'.[23] Nevertheless, even during his years of exhibiting with the Impressionists from 1879 to 1886, Gauguin stood apart. For one thing he demonstrated from the outset that he would be exploring his artistic ideas in three dimensions: he worked as a sculptor, first in marble then carving directly in wood; from 1886 on, having been initiated by Ernest Chaplet, who gave him access to a kiln, he modelled pots and sculptures in clay which he regularly put on show.[24] Working in these three-dimensional media encouraged an alternative conceptualisation of the role of subject matter. The realism still evident in the first statuettes and portrait busts gave way to decorative, playful or symbolic combinations of motifs – figural types and animals – which he used to animate the surfaces of increasingly irregular-shaped pots (no.30). Furthermore, Gauguin's take on the genres of still life, portraiture, interiors and landscape was highly personal. Painting his children, as he frequently did, he betrayed a desire to enter into their imaginative worlds (*Clovis Asleep* 1884, *The Little One is Dreaming* 1881, nos.24, 25); and his still lifes regularly disrupt the expectations of the viewer, making the familiar feel strange.

The chaos caused to Gauguin's personal life by the abandonment of his financial career, his self-imposed exile from Paris, first in Rouen, then in Copenhagen, and the painful separation from his wife and children that ensued, only exacerbated a period of great uncertainty in his art. The new direction-seeking found expression in theoretical ideas about colour and line, nature and exaggeration, ideas that engaged with Impressionism but were also prescient of new directions. In his *Notes synthétiques*, drafted in a sketchbook used in Copenhagen, he explored the correspondences and differences between painting, literature and music, concluding – as Leonardo da Vinci had done – that painting was the pre-eminent art because the viewer was not expected

Fig.5 Camille Pissarro
<u>*Apple Picking*</u> *1886*
Oil on canvas
124.5 x 124.5
Ohara Museum of Art, Kurashiki

to perform a feat of memory but could embrace the painter's meaning at a single glance: 'Like literature, the art of painting tells whatever story it wants but with the advantage that the reader experiences simultaneously the prelude, the mise en scène and the dénouement.'[25] But there was little sign at first of Gauguin putting such ideas into practice. In 1886 he turned his attention to rural peasant and landscape subjects in southern Brittany, a region to which he was drawn first and foremost for reasons of economy. Although he succeeded in contradicting the practice of the painstaking 'earthbound' naturalists by whom he found himself surrounded, initially he struggled to be other than derivative of Pissarro (fig.5).

It was in 1888, working alongside Émile Bernard and Vincent van Gogh, that Gauguin dramatically distanced himself from Impressionism and his art became distinctive and simplified in style, clearcut and powerful. He was bringing new stylistic sources into play – Japanese prints, children's book illustrations, *images d'Épinal* – and these served to unlock the promptings of his imagination. With the distinctive 'synthetist' style that resulted from this year of collaborative experimentation, in 1889 he went after public attention, seizing the opportunity to exhibit in Brussels and in M. Volpini's café at the Paris Universal Exhibition. Part of his challenge lay in presenting a new range of subjects. Indeed, the paintings, sculptures and ceramics of 1888–9 evoked Breton folk traditions, sinister undercurrents of rural sexuality. The Martinique subjects also, crucially, hinted at exotic worlds beyond France's borders.

In his writings, especially in his letters of the same period, Gauguin confidently and vociferously championed an art that went beyond material appearances, reclaiming those complexities of poetic meaning that had been lost in the great drive towards naturalism. The problem with Impressionism too, or so Gauguin believed, was that it was insufficiently intellectual. His old Impressionist comrade Armand Guillaumin (1841–1927), for instance, was incapable of responding to anything but ocular sensations, forgetting the part played in art by the brain; this was the reason he shrugged his shoulders at Gauguin's latest, more pondered, work.[26] What Gauguin was striving for – and admired in the work of others – was art that suggested something unseen, unknown. And he felt, in key works such as *Vision of the Sermon*, that he had achieved his aim. Paradoxically, he still craved the Impressionists' esteem. In 1891, on the verge of leaving France for Tahiti, he was desperate to know whether Monet approved of his 'evolution towards a complication of the idea through simplification of the form'. But could Gauguin really have expected Monet, whose principles he was now so openly flouting, to give his blessing to this blatant undermining of Impressionism? Monet was not to be so drawn.[27]

When Gauguin embarked upon the second half of his career, painting in the tropics thousands of miles from Paris, he had wrested from his Impressionist beginnings a mature, idiosyncratic approach to subject and style. Approaching the new Polynesian subject matter, he clearly felt his own master and able to control his responses to nature, free to heighten or simply reinvent where reality failed to match his dream. That alertness to the strange, the unexplained, the mysterious and symbolic – narratives that pervade his later work – had been a constant feature of his art, salient in the less familiar areas of his production, his ceramics and his carvings, but there too in the paintings that refused to be contained within the familiar appearances of reality.

Gauguin's Individual Use of Narrative
By his own admission the technical and aesthetic tendency of Gauguin's drawing and painting was to simplify form and colour – to seek out essential synthetic lines and shapes from the superfluity of detail in nature – in order to 'complicate the idea'. Thus, his art runs counter to the modernist tendency to evacuate meaning from painting, to tend toward flatness and non-representation. Looking closely at Gauguin's work and writings together reveals an artistic imagination of subtlety and complexity. In a plethora of ways he succeeded in insinuating into his work ideas that have an implicit or explicit narrative dimension, drawn from a wide variety of sources. For alongside the savage artist who wanted to go back to the beginnings of art was the artist who was attuned to the wit and fast-paced media of the boulevard and financial world,

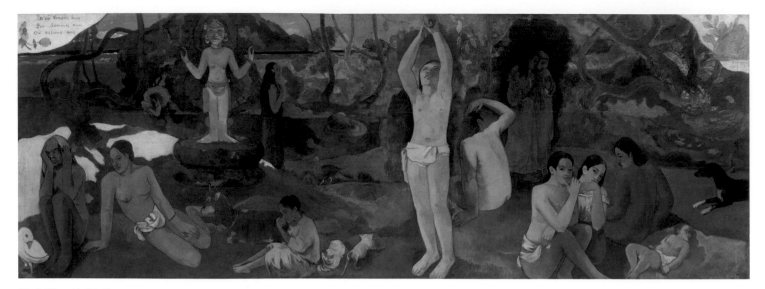

Fig.6 *Where Do We Come From? What Are We? Where Are We Going? (D'où Venons Nous / Que Sommes Nous / Où Allons Nous)* 1897
Oil on canvas
139.1 x 374.6
Museum of Fine Arts, Boston

who both admired the pathos in Rembrandt van Rijn's etchings *and* delighted in the succinct visual narratives and sardonic captions of Honoré Daumier (1808–1879) and Jean-Louis Forain (1852–1931).

Gauguin's own deployment of narrative was anything but straightforward. Sometimes it amounted to what one might call anti-narrative. Favourite ploys include hinting at half-understood goings-on through pregnant choices of motif or pose; having figures within the composition make eye contact and seemingly interrogate the spectator in portentous ways; imposing on the composition a suggestively loaded title, often framed as a question, yet leaving the interrelationships of the protagonists unclear. In *Aha oe feii (Eh quoi! Tu es jalouse / What! Are you Jealous)?* of 1892 (no.116), for instance, the figures' gestures are deliberate and pondered, but we do not know who is addressing whom. The regular inclusion in his compositions of Tahitian words was a way of simultaneously suggesting meaning but placing a barrier to its comprehension. Even when seeming to offer a verbal exegesis of a complex work, as Gauguin did on various occasions in letters sent to those likely to have to speak on his behalf, he often proffered an incoherent narrative, or promptly retracted what he had just said. He began to do this with the first difficult works of 1888 – *Self-Portrait, Les Misérables,* for instance, *Vision of the Sermon* and *Misères humaines* – and the practice continued to the end of his career when he engaged in a dialogue with André Fontainas over the meaning of *Where Do We Come From?* (fig.6). This teasing, provocative, take-it-or-leave-it attitude to meaning carried over into Gauguin's writing. Imposing such blocks to the viewer's fuller understanding was part of his renegotiation of a space in art for suggestive, but not explicit, narrative meaning. Operating within an avant-garde that disdained 'literary painting', Gauguin had to position himself with great care. In 1901 he told de Monfreid: 'I have always said, (or if not said) thought that the literary poetry of the painter was special and not the illustration or translation into forms of written texts.'[28] Quite possibly he had not said this, but Whistler had, in 1885 in the *Ten O'Clock* lecture.

Although inspired by nature, Gauguin defended his right to exaggerate his observations for artistic effect. His melancholic scenes of Breton rural life corresponded, he made clear, not to how Pont-Aven or Le Pouldu actually looked but to his own subjective vision. He wanted 'to suggest suffering without specifying what kind of suffering'.[29] This sometimes meant fusing experienced reality with pre-existing, cultural stereotypes: presenting Brittany as the land of superstitions and sad desolation. In 1893 Charles Morice felt the need to put viewers of Gauguin's first exhibition of images from Tahiti on their guard: 'to find your way around the *island* his work would make a bad guide, if your soul is not akin to his'.[30] If Gauguin's individual representations defied truth to appearances, within the work as a whole there was an overarching logic at work. Certainly, one quickly becomes aware of reprises, repetitions of an almost musical kind, recognisable poses that recur in different contexts. These sometimes take on the appearance of hauntings, personal obsessions, or leitmotifs, as in the case of the hooded

figure seen in still lifes and Polynesian religious scenes (nos.23, 99, 101). With its revival of the great stories of Christianity, its appropriation and exploration of Polynesian – or what he called 'Maori' – legends, Gauguin's art regularly forged links with specific literary and cultural ideas. We see this in the self-portraits where his own features became those of Victor Hugo's hounded criminal Jean Valjean from *Les Misérables* (fig.1), the martyred John the Baptist (no.5), Christ in the Garden of Olives (no.9), or a satanic seducer (no.93). His nudes became Ondines, Eves, Hinas or Vairaumatis, his mothers became Madonnas, thereby evoking, consciously or not, that persistent Romantic myth of the Eternal Feminine. These works served as preludes to Gauguin's more ambitious engagement with the grand narrative topoi that characterise his later work – creation myths, subjects evoking fear, death and the supernatural, the myth of the Earthly Paradise. When the artist's career is viewed as a whole in this way, rather than in the discreet chronological or geographical segments that are often used to shape it, it can be seen as coherent and logical, as he maintained it was.[31]

The Pitfalls of Historiography

How, then, did Gauguin's art become coupled with the notion that to be modern, art had to set aside issues of subject matter? To understand this conundrum it is necessary to go back to the reactions of the young artists and critics he most profoundly affected. To them, Gauguin's synthetism seemed to imply nothing short of a redefinition of painting. In 1890 the twenty-year-old Maurice Denis published a theoretical manifesto entitled 'Definition of Neo-traditionism' in which Gauguin's recent art played a central role. Denis began with the arresting injunction: 'Remember that a painting, before it is a warhorse, a nude woman or some anecdote or other, is essentially a flat surface covered with colours arranged in a certain order.'[32] The phrase was intended to shock out of their complacency those who saw and judged art exclusively in terms of subject matter. Its uncompromising force led even Denis's closest peers to agonise about their painting, no longer sure what role the study of nature should be allowed to play, anxious about any temptation toward sentiment or story, anything that seemed to get in the way of purely formal concerns. Denis's motivation was a wish to persuade his readers of the plastic component of art's emotional expressiveness; he placed works such as Gauguin's *Breton Calvary* (no.67), for instance, and the contemporary murals of Puvis de Chavannes, greatly admired by Gauguin too, within a decorative tradition going back to the Italian primitives and the Egyptians. Yet though Denis's own commitment to an art that expressed his profound Catholicism was never in doubt and the extremism of his famous phrase was certainly never intended to open the door to abstraction, formalism took on a life of its own. Even as Gauguin was developing his complicated and allusive art in the South Seas in the later 1890s, the artist himself was anxious about being overtaken by history, feeling that his successful young supporters had in a sense moved the story on without him.

The formalist ideas of the 1890s gained a new international currency when the art critic Roger Fry organised an exhibition in London in late 1910 with the aim of introducing British audiences to the previously little-seen work of Gauguin, Cézanne and van Gogh.[33] Now rather too firmly defined as 'Post-Impressionists', they soon came to be seen as the cornerstones of modern art. At the inaugural exhibition of the Museum of Modern Art in New York in 1929, Gauguin was presented as an exemplar of High Modernism, side by side with Cézanne, van Gogh and Seurat. Hence the initial tendency to downplay the tale-telling aspect of Gauguin's art as a slight embarrassment, certainly an irrelevance. What mattered above all else was the freedom Gauguin claimed for artists to depart from the limitations of seen reality, to exaggerate the colour contrasts in nature, to simplify its forms, to produce a synthesis that stood as an equivalence for the artist's intense sensation. Fry's famous catch-all term, Post-Impressionism, legitimised in the 1940s and 1950s by John Rewald's documentary work, tended to put all the emphasis on formal shifts, rather than seeing content and form as of a piece. It is a style label, no more.

As with all radical shake-ups in art history, provoking such a reaction depended upon presenting a stark, caricatural case. But Fry subsequently showed himself to be

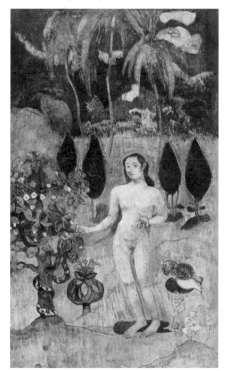

Fig.7 Exotic Eve 1890
Oil, gouache and mixed media on
paperboard mounted on canvas
43 x 25
Pola Museum of Art, Japan

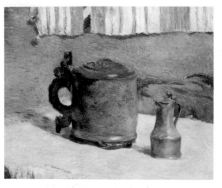

Fig. 8 Wood Tankard and Metal Pitcher 1880
Oil on canvas
62.9 x 52.1
The Art Institute of Chicago.
A Millenium gift of Sara Lee Corporation

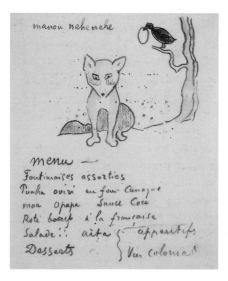

Fig. 9 Menu illustrating the Fable, Le Corbeau et le Renard 1900
Watercolour, ink, charcoal and crayon on paper
21 x 17.2
Private Collection

aware, albeit uncomfortably, that there was a narrative dimension to Gauguin's paintings, that in his great masterpiece, *Where Do We Come From?*, the ambitious philosophical theme was necessary to the form and that Gauguin's success lay in balancing the two:

> The extraordinary thing is that this intensely self-conscious and intellectual Frenchman did manage to create an art which fused perfectly the naïveté of savage art with the most accomplished European tradition. Gauguin was never naïve; the wonder is that an artist so sophisticated, so nearly an academic (in the best sense of the word) did manage this feat without becoming affected or acquiring a false naïveté . . . Gauguin's Noa Noa proves how readily a literary form of expression came to him, how much of a poet he was as well as a painter, so that one need not wonder at finding him towards the end of his life trying also to make his extraordinary powers of design serve the same ends. Fortunately he never forgot the limitations of pictorial art, so that in the great composition here in question we are really not in the least concerned with the meaning of the symbolism.[34]

Gauguin's Literary and Artistic Sources

'I notice that the poets still show, with rare exceptions, a spontaneous and profound deference to Gauguin, both to the man and his art. This is logically explained by the predilection the artist showed in his work for poetic thought, or should I say, "literary" thought.' So wrote Charles Morice, poet and collaborator with Gauguin on *Noa Noa,* in his biographical memoir of the artist published in 1919, adding later: 'His reading wasn't very wide-ranging; but it went very deep.'[35]

In *Racontars de rapin* Gauguin hinted at the importance he attached to literature when he listed the essential qualities of the artist: 'The plastic arts are not easily fathomed, to get them to speak one has to interrogate them constantly whilst interrogating oneself. Complex arts if ever there were any – A bit of everything goes into them, literature, observation, virtuosity (I am not talking about skill), gifts of the eye, music.'[36] Yet he was highly ambivalent about being regarded as a literary painter, and if his writings are infused with the spirit of fable, parable, or demonstrate poetic aspirations pointing to the importance of his reading, one is just as likely to find him making disclaimers on this score. He was willing to accept for himself the epithet 'lettré', but he had a horror of the concept of the 'man of letters'. How can one make sense of these paradoxes?

The extent to which Gauguin read has long divided opinion. Although he did not, like van Gogh, ever equate his need for books to his need for daily bread, he took a pride in his French cultural heritage and referenced his reading in a variety of ways. A respect for the classics was doubtless instilled in him, along with the Bible, at his Catholic seminary in Orléans, and he was clearly conversant with the great writers of French literature.[37] As a father of small children he would have wished to share that heritage, and it pained him in the later 1880s to read his own children's increasingly stumbling efforts in the French tongue as they became progressively more Danish. Among the artist's effects inventoried in Atuona in 1903 there was a significant library, including a four-volume Bescherelle dictionary, a dictionary of science, seventy volumes of the wide-ranging Symbolist periodical the *Mercure de France* to which he subscribed, twenty-five miscellaneous volumes (presumably including some favourites among the classics) and five books with personal dedications (we know he received authors' copies from Stéphane Mallarmé and André Fontainas, and it is likely that Paul Verlaine and Morice would also have offered him their works).[38]

Favourite authors were Jean de La Fontaine (1621–95), whose *Fables* Gauguin cited readily in his letters and interpreted in pictorial form, and Honoré de Balzac (1799–1850), another touchstone, although his preference was for the author's curious Swedenborg-inspired mystic work *Séraphîta* (1835) and his semi-autobiographical *Louis Lambert*, books little read for pleasure nowadays, over the better-known realist novels. More striking are Gauguin's visual citations of classics of English literature. In his *Portrait of Meijer de Haan* two volumes figure prominently: John Milton's *Paradise Lost*

Fig.10 *Studies for Ceramics* c.1887
From the *Album Briant*
Charcoal, pen and ink on paper
35.1 x 23
Musée du Louvre, Département des
arts graphiques, Fonds Orsay

is there in a French translation, alongside Thomas Carlyle's *Sartor Resartus* (nos.10, 13).[39] The attraction for Gauguin of Milton's poetic reinterpretation of the story of the Creation and the Fall in Genesis is unsurprising. The pictures Milton paints of Satan, the charming fallen angel, and of the temptation of Eve, certainly entered into Gauguin's own pictorial repertoire, in the caricatural *Self-portrait* for instance (no.11), and various images evoking the Garden of Eden. But did he in fact read *Sartor Resartus,* a philosophical treatise on the meaning of clothes, a text not then available in French, or has its presence more to do with the portrayal of his Dutch friend? Another favourite foreign author was Edgar Allan Poe (1809–1849). Poe's aesthetic theories and methods of composition were of particular importance to Gauguin, and his tales of mystery and psychic phenomena haunted his imagery. Gauguin's etched portrait of Mallarmé and his late Tahitian nude painting *Nevermore* referenced Poe's famous poem *The Raven*.[40] The same taste for the darkly macabre accounts for the painter's fondness for *Le Bonheur dans le crime* by Jules Barbey d'Aurevilly (1808–1889).

Finding inspiration in La Fontaine was not in itself unusual for artists at this period: examples possibly known to Gauguin include artists as diverse as Charles-François Daubigny, Gustave Moreau and Louis-Maurice Boutet de Monvel.[41] But Gauguin was characteristically oblique in his way of doing so. Is there or is there not a reference to the fable of the *Pot de terre et le pot de fer* in his still life of 1880 (fig.8)? Although the jug was in fact a wooden Norwegian tankard, and the smaller jug was made of pewter, the opposition Gauguin sets up between these two domestic receptacles seems to evoke the La Fontaine fable. The most plausible explanation for his strange ceramic pot featuring horned rats, to which Gauguin was singularly attached, including it in two paintings, seems to be the relatively unfamiliar fable of the *Combat des Rats et des Belettes* (fig.10, nos.35, 36).[42] In one of the Volpini prints Gauguin directly cited La Fontaine but reversed the anthropomorphism, recasting the feckless grasshopper and hard-working ant as Martiniquaises (no.125). And late into his career La Fontaine was still fresh in his mind, readily supplying the witty decorative motif for a diverting colonial menu (fig.9). Whether or not he was aware of La Fontaine's Indian sources, cross-cultural fabulist narration went to the heart of what Gauguin was trying to do in his art: condensing stories into their most elegant and economical forms, keeping moralising intentions well disguised behind outward playfulness, handing over the action to animals – these were narrative manoeuvres from which Gauguin derived valuable pictorial lessons.[43] The foxes, geese, dogs, pigs, snakes and lizards that begin to assert their presence in his work from 1886 on were rarely gratuitous and frequently became charged with meaning. His own preferred self-image, first used of him in 1893 by Degas, was that of the collarless wolf from La Fontaine's fable *Le Chien et le Loup*.

When Gauguin needed public backing for his audacious plan to travel to the other side of the world in order to further his artistic project – an idée fixe after 1889 – he deliberately courted up-and-coming Symbolist writers and critics who seemed liable to support him: Charles Morice, for instance, and Albert Aurier, who published two articles by Gauguin in his jaunty 1889 periodical, *Le Moderniste illustré*, and wrote a high-flown article hailing Gauguin as the long-awaited master of Symbolism.[44] Gauguin's attempts to interest the aristocracy and political classes in his work were ostensibly ineffective.[45] But with Morice's help, he succeeded in winning over to his cause prominent public figures: Stéphane Mallarmé, and the critics Octave Mirbeau and Jean Dolent, Antonin Proust (principal arts administrator of the 1889 Universal Exhibition) and Georges Clemenceau (then member of the Chambre des Députés, future prime minister).

As is well known, Gauguin's artistic inspirations ranged wide chronologically, culturally and geographically. Prior to 1891 he owned a collection of Japanese prints and French caricatures. He also assembled an assortment of visual prompts that he could transport overseas: prints, drawings, ethnographic photographs and art reproductions featuring oriental miniatures, Buddhist carvings from Borobudur, fragments of Egyptian wall painting, Trajan's column and the Parthenon frieze. His portable *musée imaginaire* has been well researched, the task made easier by his willingness to 'import' – in effect, plagiarise – his sources wholesale.[46] One of his most exhaustively mined

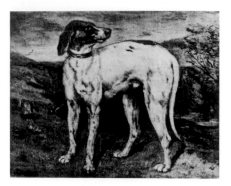

Fig. 11 Gustave Courbet
Chien de chasse aux écoutes
Photographed by 'G. Arosa, St Cloud'
Illustration from Auction Catalogue
of Modern Pictures belonging to M.
Gustave Arosa, Hôtel Drouot, Paris,
25 February 1878
National Gallery of Art, Washington

resources was an illustrated auction catalogue recording the sale, in 1878, of the picture collection of Gustave Arosa, his guardian and sponsor who found him his first job and stood witness at his marriage. This document presumably spoke to Gauguin of his first artistic awakenings: it reveals his early exposure to Camille Corot (1796–1875), particularly the portraits; Gustave Courbet (1819–1877), whose hound (fig.11) he slotted into Breton and Tahitian works (fig.59, nos.54, 143); and less obvious models such as Octave Tassaert (1800–1874), whose oxen Gauguin quoted in a late Tahitian nativity scene, and Ignacio Merino (1818–1876), whose view of Mexican horsemen on a beach inspired two late Marquesan compositions. It was Arosa's collection, too, that fostered possibly his greatest artistic admiration – for Eugène Delacroix (1798–1863) (fig.12). Although Gauguin enjoyed none of the same public patronage, his career was in some ways consciously modelled on Delacroix's: the range of literary and exotic subjects, the ambitions as a decorative painter, the skill as a writer, even, ultimately, the desire for solitude.

As Delacroix's journal makes clear, reading was the constant wellspring of his pictorial imagination; but Gauguin, like Delacroix before him, disavowed all taint of the literary in his approach to picture-making, insisting that the artist's emotional and plastic inspiration was of a wholly different order from that of the writer. These disavowals can sound hollow, or paradoxical. In a letter to van Gogh written shortly before joining him in Arles, he implicitly dampened the Dutchman's enthusiasm for literature, claiming not to know what he meant by 'poetic ideas, it's probably a sense that I lack' – the coming intellectual tussle that would characterise their relationship already evident. Yet in the next breath he asserted that he found poetry everywhere, in the mysterious corners of his heart, 'in forms and colours brought into harmonies'. Further on in the same letter he confessed to being enlivened by, and finding a savage poetry in, a very specific poetic idea, that of Christ's Passion: 'The artist's life is one long Calvary.'[47] The story that lay at the heart of Christianity was indeed, for Gauguin, a poetic idea. Whereas for the protestant Dutchman, painting the things of Christ proved a tempting but ultimately impossible challenge, for Gauguin it was one that bore fruit not only in self-portraits but in a whole range of religious compositions to come (nos.67, 68).

It was perhaps Gauguin's admirer, the painter Armand Seguin (1869–1903), who in a rarely cited and extraordinarily prescient article, published in 1891 in a rural Breton newspaper, best identified the non-illustrative literary qualities that, for him, made Gauguin special:

> Gauguin is in essence a painter of sensations which all emanate from memories and literary assimilations or rather, which all correspond in our mind to certain literary reminiscences. He is almost – and I can find no other word to express my thinking – a painter philosopher, a sadly ironic one, whose every canvas synthesises a character but in so cruel a fashion that – when it doesn't raise our thoughts to distant horizons – this character surprises us as true, even though up to then it had not been understood in this way. In his decorative arabesques, in his rare understanding of composition, he alone has understood Brittany, not as it really is, certainly not; and yet it corresponds more closely, the way he sees it, to our preconception than to the way it really looks, and with such truth that it seems the reality has become a dream to suit our illusions. The Brittany of our desires, as once we hoped to find it – remote moors, sad houses, solitude, melancholy.[48]

Seguin hints here at the spirit in which, even then, Gauguin was beginning to paint the Tahiti of his – and our – desires.

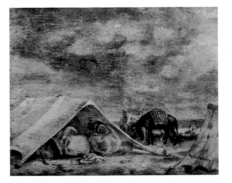

Fig. 12 Eugène Delacroix
Campement arabe
Photographed by 'G. Arosa, St Cloud'
Illustration from Auction Catalogue
of Modern Paintings belonging to M.
Gustave Arosa, Hôtel Drouot, Paris,
25 February 1878
National Gallery of Art, Washington

Gauguin's Legacy

The aspects of Gauguin's practice that proved most influential for formalist modernism in the early twentieth century – the powerful synthetic line, the flat non-naturalistic zones of decorative colour – are not necessarily those that have the strongest appeal in the twenty-first. Many artists in recent times have had recourse to techniques, word and image combinations and narrative manoeuvres that can be traced back to Gauguin. Doubtless each viewer will find different points of convergence between Gauguin and more recent art, perhaps in the overt plagiarism and recycling of ideas; the willingness to work across the media; the making of the artist into the subject; the voluntary displacements and restless migrations; the immersion in, and appropriation of, other cultures, merging others' stories with his own.

In October 1897, discouraged by the desultory sales of his work in Paris, Gauguin looked ahead to a 'time when people will believe I am a myth, or rather an invention of the press'.[49] In 1902, nearing the end of his life, he paid a high price for his Faustian pact with fame – forced to live out the remainder of his days in isolation. Nostalgic for home, feeling an atavistic desire to return to the country of his birth, Gauguin dreamed of settling in the Pyrenees, near Daniel de Monfreid. But he was dissuaded from taking such a disastrous step. Those who had his best interests at heart were concerned for his health, already undermined by syphilis; de Monfreid did not mince his words, warning that to come back to Paris would spell death. But more important at this juncture was the damage it would do to his myth: 'You are at the moment that extraordinary, legendary artist who sends from the depths of Oceania his disconcerting, inimitable works, the definitive works of a great man who has disappeared, as it were, off the face of the earth.' Coming back would merely stir up his enemies and destroy the slow but steady rise in his status. 'In short, you enjoy the immunity of the great dead, you belong now to the *history of art*. – And in the meantime, the public is learning; people are building up your reputation, unwittingly or deliberately. Even Vollard is working at it bit by bit. He can already perhaps scent how your celebrity will become uncontested and universal.'[50]

GAUGUIN AND THE OPACITY OF THE OTHER: THE CASE OF MARTINIQUE

Tamar Garb

Martinique Landscape is the name given to the only purely landscape painting that Gauguin produced during his four-month stay on the island of Martinique in mid-1887 (fig.13). In it are the expected ingredients of a Caribbean paradise as conceived in the French imagination: impressive foliage, opulent fruit, mountain slopes, sea and terracotta earth, all made visible in a sun-drenched landscape.[1] Empty of all inhabitants – only a stray cockerel and a camouflaged hut provide evidence of a domesticated or lived-in location – the painting's powerful colouration, textured brushwork, flattened accretion of shapes and serpentine delineations of plant-life, construct a dream-space of such intensity that the work seemed, for some of its first viewers, to depict a mythic imaginary setting, beyond the time and place of modern experience. Even when populated with figures, Gauguin's evocation of this place retains the distilled, defamiliarised intensity of the pure landscape, providing the textured and heightened colour field for half-glimpsed figures and statuesque groups who seem embedded, almost fused, into the lush vegetation that embraces them. No wonder that Octave Mirbeau, writing in 1891, saw in the Martinique works 'monstrous flora', 'formidable sunsets', an 'almost religious mystery' and a feeling of 'sacred abundance' evoking the 'Garden of Eden'.[2] Nothing as yet exhibited in Paris had prepared viewers for the combination of strangeness, saturated experience, excess and otherworldliness that characterised these paintings. But Gauguin's Martinique was not only the product of fantasy and latent assumptions. Born undoubtedly out of an accretion of cultural expectations – the 'tropics' after all was a well-worn literary and visual topos by the time Gauguin made his journey to the sun – what he 'saw' in Martinique nevertheless registered the specificity of a visceral encounter with a climate, a culture and a location that he struggled to know and represent. Gauguin had brought with him to the 'tropics' many assumptions and skills (including the newly learned lesson of Paul Cézanne's signatory brushmark, freed from the objects it described). Nevertheless, as he now faced an unfamiliar environment and society, he learned to marshal his painterly touch and preconceived ideas to a new-found sense of design and an inventive but simplified palette so that the filter of felt experience joined the repository of cultural (and psychic) projection to produce something different from anything that had preceded it.[3]

Gauguin is alternately lambasted and lionised for the manner in which his pictorial invocation of the faraway and the unfamiliar stages the encounter between a French subject and its colonial Other.[4] Martinique was only the first of his painterly incursions into the far reaches of the French Empire, but it provided a decisive hinge for his complex self-construction as both 'savage' and 'European' and his ambivalent identification with and distancing from the 'native' peoples and foreign places he set out to paint.[5] Although Gauguin's disavowal of the modern and the metropolitan had begun closer to home, in Brittany, it was, by his own admission, only in the 'tropics' that he had discovered 'himself'.[6] This is a curious and complex assertion. For Gauguin, and his commentators, it was the experience of Martinique – far from France but inextricably linked to its circuits of exchange – that catalysed a change in his working methods as well as fuelled his sense of himself as an isolated outsider. Here, the story goes, he was able to discover the potential of decorative distortion and invent a pictorial

Fig.13 *Martinique Landscape
(Végétation Tropicale)* 1887
*Oil on canvas
116 x 89
The National Gallery of Scotland,
Edinburgh*

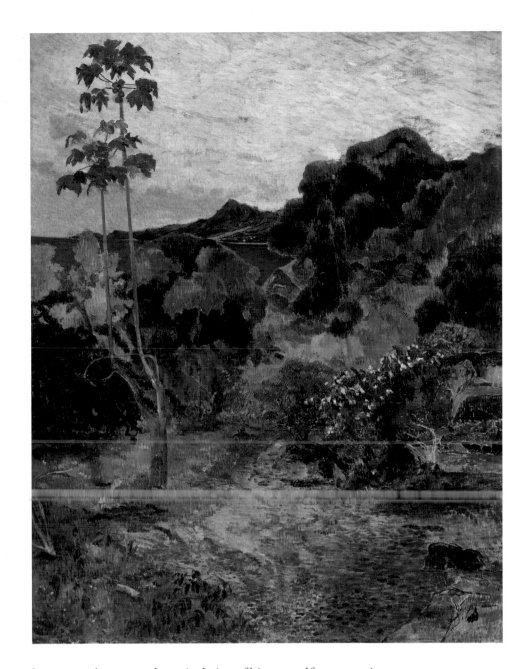

language adequate to the articulation of his own self-construction as part-savage, part-primitive pariah with Peruvian origins and a rootless itinerant past.[7] Impecunious, and disillusioned with life in Paris where his work had not met with much commercial or critical success, Gauguin had sailed forth in March 1887, his itinerary determined by established colonial shipping routes, to journey in the Caribbean and the Antilles, even flirting at the time with the idea of visiting the Indian Ocean island of Madagascar.[8] He was not bothered as to where he would land up, provided that life was cheap and conditions conducive to support a man who had packed 'his colours and his brushes' in pursuit of new subjects and scenery.[9] That Gauguin was, on the eve of his departure from Marseille, already predisposed to finding 'himself' in the refracted face of the foreign is clear from his own narration of events. Intending to 'live as a savage' on scarcely populated, fertile land, far from the company of 'men' and nourished by freely available fish and fruit, he travelled, a third-class passenger from France, with a whole set of assumptions in place. Amongst these was the belief that free from financial care and the drain of family responsibilities, he would be able to be true to himself. Life in Martinique 'delicious in its ease and amenities', he believed, would provide the respite necessary for the integration of a fractured and unsettled self. In the beautiful and cheap environs of the island there was much for an artist to do.[10] In the words of the Martinican thinker and writer Édouard Glissant, Gauguin and his contemporary the American writer Lafcadio Hearn (whose 'Martinique Sketches' provide an invaluable

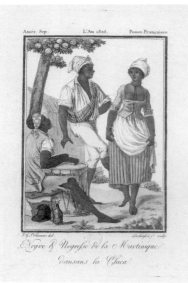

Fig. 14 *Jacques Grasset de Saint-Sauveur*
Martinique Negro and Negress Dancing
the Chica 1805
From 'Voyages Pittoresques dans les
Quatre Parties du Monde'
Bibliothèque Nationale de France, Paris

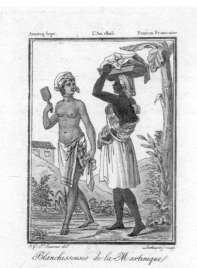

Fig. 15 *Jacques Grasset de Saint-Sauveur*
Martinique Laundresses 1805
From 'Voyages Pittoresques dans les
Quatre Parties du Monde'
Bibliothèque Nationale de France, Paris

resource for understanding a nineteenth-century visitor's view of the island) were, in their travels abroad, 'slumming at the limits of an alterity they hoped to influence (to accommodate, to appropriate for themselves)', even if the complex reality of the Creole culture they confronted remained incomprehensible to them and they found themselves searching, in time, for more 'authentic', 'pure' and ancient civilisations with which to merge.[11] In fact, it was, according to Glissant, the unintelligibility of the island that led Gauguin and Hearn to move on from the Creole reality – Hearn to Japan, Gauguin to Tahiti – in search of the purported authenticity and homogeneity that was not to be found in the shifting, intermixing and intermingling of Martinique's own hybrid population.[12] But Gauguin's incomprehension of the island was to prove fruitful. Out of his own self-delusion as well as the opacity and obdurate resistance of the culture he encountered, Gauguin constructed a painted world: not one that was purely descriptive or necessarily accurate, nor only mythic and imagined, but one that registers both his doomed desire for fusion and his tragic recourse to objectification, made manifest in a tangible profusion of pigment (the blur of benighted vision), recycled figural types and over-determined vignettes.

For the nineteenth-century French public, the 'tropics' functioned as a generic, distant locus, infused with warmth and peopled by colourful (if at times hostile) natives and strange, impressive vegetation. Audiences in France made little distinction between the specific localities of the colonised world despite the interest of ethnographers and geographers in tabulating, describing and delimiting the findings gleaned on expeditions abroad. When, in 1888, Vincent van Gogh recounted in a letter to his sister that their brother Theo had bought a large painting from Gauguin produced while 'he lived and worked in tropical nature, notably in Martinique', and which represented *négresses* dressed in 'red, blue, orange and yellow cotton, under tamarind, coconut and banana trees, the sea in the distance', he likened the scene to Otahiti in the novel *The Marriage of Loti*, an available cultural reference point for the invocation of a sultry paradise conceived as the setting for a sexual fantasy.[13] That Gauguin had not yet set foot on the Pacific island of Tahiti made little difference. Nor did the fact that the racial category identified in the work was specific to the African-derived populations of the Americas and Antilles, rather than the Pacific peoples of whom Pierre Loti was enamoured. It was the mythic tropical paradise that Van Gogh 'recognised' in these pictures.

The vocabulary for such a scene had already been set earlier by prints and poetry. Already in 1805 Jacques Grasset de Saint-Sauveur had published plates depicting the 'Nègre et Négresse de la Martinique' in which 'happy negroes' (dressed like French peasants) dance barefoot amongst fruit-laden trees and luscious plants (fig.14). And idyllic scenes of laundresses, load-bearing carriers and semi-dressed, dark-skinned bathing nymphs were widely known (fig.15). It is not surprising, therefore, that Félix Fénéon, writing in 1888, likened Gauguin's Martinique paintings to 'old engravings of the islands' familiar to nineteenth-century print collectors.[14] It was just such a print that had prompted Charles Baudelaire's (1821–1867) 'hero' in 'Les Projets' or 'Plans', one of the prose poems of *Paris Spleen* and written in the mid-century, to dream of a typical 'tropical landscape' saturated with sensual and olfactory associations as a suitable setting for his beloved: 'By the seashore, a fine wood cabin, surrounded by all those bizarre, gleaming trees whose names I've forgotten . . . in the air, that intoxicating, indefinable scent . . . within the cabin, a powerful perfume of rose, of musk . . . farther off, behind our little domain, the tops of masts rocking on the ocean swells'.[15] For the poet, precision of place and nomenclature were unimportant. The dreamt-up landscape, props and people – Baudelaire invoked the 'chattering of little Negresses', 'birds drunk with light', 'cool braided mats and sensual flowers' as part of the 'décor' – provided him with a powerful imaginary spur through which to think competing definitions of 'home'. For Baudelaire the cabin of the tropics competes with two other possibilities – the palace and the inn – but in the end it is the power of the imagination to plan that triumphs over all three. 'Home', ultimately, is where the poet dreams. But the components of the Baudelairean fantasy of the faraway were not unique and can even be recognised in the banal studio props and painted backdrops of contemporary photographic studios where Creoles and Colonials had their pictures taken and entrepreneurial image-producers

Fig.16 *Nègreries Martinique* 1890
*Gouache, watercolour, ink, gold paint
and collage on paper
33.2 x 24.8
Galerie Krugier & Cie*

posed local women who performed their roles as 'mulâtresses', 'négresses' or 'les belles Martiniquaises' against the familiar settings of palm leaves, cacti and fruit-filled baskets.[16]

For Vincent van Gogh it was the sensual overload of the landscape as the location for an unfamiliar and exotic cast of characters that was memorable in the two paintings of Martinique that he saw at his brother Theo's in 1888. Recalling a river-bed, purple mud, pools reflecting the 'pure cobalt blue of the sky, green grass', van Gogh described 'a negro boy with a red and white cow, a negress in blue, and some green forest'.[17] Intense colour and a specific figural type is what had stuck in the mind of this observer. In fact, the idea of the 'negro' as a signifier of this series is repeatedly invoked by successive commentators. And when Gauguin himself chose, two years after his visit, to invoke the island in a flattened synthetic design, he accompanied his easily identifiable figures – the women clad in characteristic colourful scarves and knotted headdresses – with the inscription '*Nègreries Martinique*', as if his new-found linearity, flattened style and arbitrary colouration could sit under the banner of this racially inflected inscription (fig.16). By 1889, when the experience of Martinique had already become a *souvenir*, Gauguin translated it into paintings, prints and figurines which encapsulate the racialised myth that was at the heart of his encounter with this place. The terracotta *Statuette of a Martinique Woman* (c.1889) has flesh painted a sonorous black. And amongst the prints of the Volpini suite are two images depicting a place peopled by 'négresses' arranged in statuesque poses and distilled into flattened, pictorial emblems nestling against the backdrop of an imaginary landscape (no.125).

Gauguin's almost exclusive concentration on African peasants and rural workers in his Martinique paintings is extraordinary, given the fact that the island was known to host one of the most diverse and mixed populations imaginable in the nineteenth century. In fact, it was the *créolité* of the island that Gauguin had already repressed, even before he went searching, as Glissant was to claim, for 'authenticity' elsewhere.[18] Lafcadio Hearn, on the other hand, took prurient pleasure in chronicling the permutations of identity produced by Martinican *métissage* at a time when theories of pure blood and untainted racial lineage were pervasive in Europe and the colonies. He described the island as having 'a population of the Arabian Nights', invoking the exoticising narratives of the orientalist and filtering his experience through an acculturated colour-coded lens: 'It is many-colored (*sic*); but the general dominant tint is yellow – yellow in the interblending of all the hues characterizing *mulâtresse, capresse, griffe, quarteronne, métisse, chabine*, – a general effect of rich brownish yellow'.[19] In a veritable inventory of the hybridised products of miscegenation, Hearn invokes the categories invented in francophone culture to accommodate and contain human variety. For Gauguin, such figures were of limited interest. It was not this melding of peoples and progeny, produced, for the most part, through the history of sexual congress between male slave owners and female slaves, that Gauguin pictured in oils. Nor was he much interested in depicting the large immigrant communities of Indians and Chinese who had been brought as indentured labourers to the island in the wake of the abolition of slavery in 1848, or the white colonials, the *békes*, from whom he kept his distance. Instead, Gauguin's paintings construct a coherent and mythic world – little found on the island at the time – a rural paradise, or 'Pastorales Martinique'[20] as he himself was to label it, comprised predominantly of African women accompanied by domestic animals and the occasional child or youth.

Soon after arriving with the painter Charles Laval at the bustling port of Saint Pierre on the west coast of Martinique, after a miserable sojourn in Panama, Gauguin wrote in a letter to his wife Mette: 'Right now we are living in a Negro hut (une case à nègres) and it's a paradise compared to the isthmus. Below us is the sea, bordered by cocoanut palms, above us, all kinds of fruit trees . . . Negroes and Negresses go about all day with their creole songs and their endless chatter; don't think its monotonous, on the contrary it is very varied . . . I can't tell you how enthusiastic I am for the life in the French colonies . . . Nature is at its richest, the climate is warm but with intermittent coolness'.[21] The echoes with Baudelaire are clear. Chattering locals, abundant nature, gentle weather conditions: these are the familiar fantasies that informed Gauguin's quest and which he was predisposed to paint. That Gauguin and Laval were 'slumming

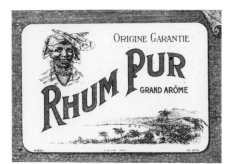

Fig. 17 *Rum Label*
Print on paper
Musée Régional d'Histoire et
d'Ethnographie, Fort de France

it', to use Glissant's phrase, is clear. Choosing, in this highly segregated society, still structured around the production of sugar cane, to live in a simple cabin situated in a compound of impoverished black workers, the two painters were making an emphatic statement about where they placed themselves in the social structure of their temporary home. The *cases à nègres* were habitually two-roomed, wooden structures that had housed slaves on the smaller plantations, or *habitations*, which characterised the Lesser Antilles; and though slavery had been abolished in 1848, the social position and living conditions of workers had shifted little by the time Gauguin and Laval took up residence in their ramshackle quarters, set two kilometres from the town, near to the ocean and surrounded by fruit trees and plants. Presumably the only two Europeans to take advantage of the cheapness and availability of such accommodation, the painters must have seemed oddly misplaced to their bemused and inquisitive neighbours.

But the *case* did not only provide convenient and cheap accommodation for Gauguin. It also appeared as a structure in numerous works from paintings to fans and inscribed something of the specificity of this place (nos.42, 45). Crucially, its associations and location fed a number of fantasies that were generative for the work he would produce. Lafcadio Hearn, in his novel *Youma: The Story of a West Indian Slave*, set in Martinique and written during exactly the same period that Gauguin and Laval settled into their temporary home, describes the importance of these dwellings in Antillean folk tale and myth: 'The European cottage of folk-tale becomes', he declared, 'the tropical *case* or *ajoupa*'.[22] These structures, according to Hearn, provided the rich setting for Creole fairy tales of 'beautiful half-breed girls' who replace the familiar 'Cinderellas' and pale 'Princesses' of the European imagination with sultry Venuses and duplicitous devils, strikingly reminiscent of the 'half-nude *travailleurs*' with whom they are easily confused. The *case*, therefore, provided a locus of phantasmatic immersion: not only did it appear to be embedded, by its very material structure and situation, within the lush vegetation and sensual richness of the island, it also functioned as the perceived setting for the legends, folk tales and myths of its intriguing and mysterious inhabitants. That Gauguin's situation was fuelled by an unresolved desire for fusion or identification with the 'savage' sensibilities of his neighbours is encapsulated in a figurine he produced soon after his return to France. Revisiting the erotic and aesthetic orthodoxies of the classical tradition, Gauguin reworked the figure of Venus/Salomé in the form of a black woman, adorning her with headdress and earrings as well as the serpentine plant-life associated with this island paradise, but placing his own severed head, like a supplicant to some foreign deity, precariously in her lap (no.97).

Like Baudelaire who had invoked 'the chattering of little Negresses', Gauguin was, as we have seen, struck by the sounds and the speech of his adopted neighbours, which like the warmth of the Antillean breeze or the humidity of the air, appeared to suffuse and surround him. It was in the environs of his hut, near the paths through the mountain and along the beach where the famous *porteuses* (female carriers) promenaded and on the banks of the river where the *blanchisseuses* (laundresses) beat their washing against the stones, that Gauguin recognised his subjects. In this he was not alone. Countless photographs of the period capture just such figures who, as we have seen, had provided the favoured subjects of lithographs and prints for some hundred years. It was also these very types whom Lafcadio Hearn so graphically invoked, devoting lengthy chapters of his 'Martinique Sketches' to each and wondering at their deportment, movement and 'half-savage beauty'. Gauguin, too, expressed his fascination with the 'comings and goings of the *négresses* rigged out in colourful rags with their gracious and infinitely varied movements'.[23] Identified with the stock theme of the 'happy negress', Martinique had, by the mid-century, come to be viewed by the French as the home of a wholesome, natural femininity which was as much a product of the island as the sugar and rum that it exported. Indeed, it was this very image that was used to market its products. Before he had even left Paris, Gauguin would have seen images on trademarks, labels and advertisements for the famous island rum in which the familiar coast of St Pierre is accompanied by the costumed bust of this emblematic figure (fig.17). So when he emerged from his hut, sketchbook in hand, to draw the folk that he saw, Gauguin

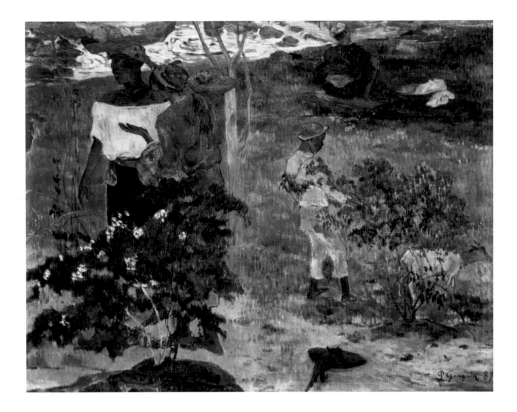

was already furnished with a set of internalised images and stereotypes that would delimit his choices and predispose him to certain figural constructions.

And it was to these that Gauguin turned, channelling his preconceptions into visceral encounters with models and sitters who would pose for the European stranger now residing amongst them. In pencil, pastel and crayon he drew his neighbours, picking fruit, doing laundry, sorting washing or sifting coal, seated thighs apart or walking with their loads held high on their turbaned heads (fig.18). Intrigued by their gestures and gait, he pictured the expressive hand-movements and characteristic stance of individual figures, sometimes isolating fragments, like the bare feet, outstretched limbs or spread-legged postures which were so foreign and fascinating to him. Only on one occasion did the sketch reach the status of a portrait, with the animated frontal address of the model and the unique gesture of the hand coexisting on the page with the coordinates of generalised typology (no.46). Mostly the faces are turned, screened or distanced, so that it is the costume and characteristics that define the figures as types. Gauguin's Martinican corpus revels in bodies saturated with difference. Though originating here, they would feed into a lexicon of poses recycled throughout his life. Uncorsetted, squatting or crouching close to the earth on which they sat or stood on their hardened soles, these bodies seemed, to the foreigner, unburdened by civilisation and the suffocating strictures of the society from which he had so recently fled.[24]

But Gauguin made decisive choices as to viewpoint and scene, models and motifs. Most noticeably, he created a world populated almost entirely by female figures, censoring out the labourers and fishermen who cohabited in his immediate surroundings. Not for him the 'half nude *gabarriers,* wont to wield oars twenty-five feet long; – the herculean *nèguegouôs-bois*, brutalised by the labor of paddling their massive and awkward craft; – tough *canotiers*, . . . the men of the cooperies, and the cask rollers, . . . the stowers; and the fishers of *tonne*, – and the fishers of sharks'.[25] Not for him the bustling activity of the port and the labour of the men who sustained it. Instead, Gauguin constructed an effortless, accommodating world in a nature so abundant and plentiful that it appeared to nourish rather than enslave its docile inhabitants, content like their farmyard animals to live out their simple existence. But in it, Gauguin felt his difference – without it how could he have painted? For all his desire to 'live as a savage', he remained profoundly aware of his identity as 'un blanc' ('a white man') and a 'European' amongst women of colour, and wrote to his wife of the need to defend himself against the flirtatious and predatory behaviour of the locals whom he described as 'les dames Putiphar' (invoking

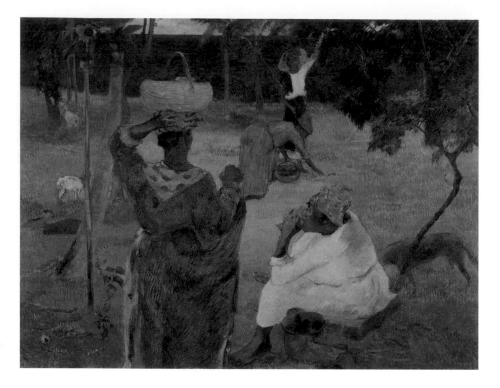

Fig. 19 *Among the Mangoes,
Martinique* 1887
Oil on canvas
86 x 116
Van Gogh Museum, Amsterdam

the archetypal figure of the shameless seductress from the Hebrew Bible).[26] Nothing of the febrile flirtatiousness and coded seductiveness of which he boasted in his oddly inappropriate correspondence emerges in Gauguin's paintings. Instead, the world he adumbrates is oddly chaste: feminine, yes, but without the coquettishness or skittishness he puts in writing. The pastoral fantasy of a faraway world, peopled by dark-skinned female figures, loosely garbed, provides a glimpse into a highly selective sensorium, saturated with sexual difference but without the erotic address of which he so evidently dreamed.

Comings and Goings, Martinique 1887 provides a classic example (no.45). Seated and standing along a flaming orange path in a rich green field, women wearing tunics – the garb derived from the curious sumptuary laws for slaves that prohibited certain shapes but not colours and textures – depicted in the barefoot manner deemed natural and appropriate to them, seem to go about their leisurely business.[27] In the landscape palm trees and straw huts, cane fields and fruit trees coexist with goats and sheep, chickens and hens, contributing to the sense of a rural idyll in which nature provides and nurtures. Recycled from painting to painting, the figures recur. Economical with his labour, Gauguin reused his studies over and over again, changing scale and setting while replaying the essential ingredients of his island pastoral. The crouching figure at the centre of *Comings and Goings*, for example, is seen again in *Tropical Conversation (Negresses Chatting)*, a scene of intimate engagement between two foreground figures – staging the European's fascination with the speech of local women – while in the background the river and baskets of washing lend new meaning to the pose's characteristic spread-legged position (fig.18). In *Among the Mangoes, Martinique* 1887 two elaborate figure studies made in chalk, pastel and wash over a traditional graphite grid, are inverted, enlarged and transposed into a flattened horizontal plane in which hieratic figures and fluid individual brushmarks combine to construct a world that appears both observed and dreamed (fig.19).

Surrounding and enfolding the figures is a beneficent Nature – not the ongoing murmuring violence of the volcanic Mount Pelée, which was to erupt and destroy almost all the inhabitants of Saint Pierre just over ten years after Gauguin's short-lived stay. He was not interested in the mountain's impressive height and awe-inspiring impenetrability, but preferred to picture its lower slopes and distant silhouette or to avoid it altogether in his gentle views of undergrowth, pastures and bay.[28] Fresh from France with the landscapes of Normandy still present in his mind and the pictorial precedents of Pissarro and Cézanne furnishing his imagination, Gauguin, during his short sojourn, remade the island according to the rules he had learned and the images

he had imbibed. Cézanne's brushstroke, Japanese prints, popular engravings: all these must have informed his vision.[29] And yet, as we have seen, the island and its inhabitants were also catalysts for a shift in Gauguin's practice and perhaps in his mode of viewing. And this is as clear in the unpeopled landscape of *Martinique Landscape* as it is in the carefully composed contours of the racialised barnyard and primitivised pastorale that he invented elsewhere. Here the ocean is rendered as a brilliant cobalt sheet advancing between the vibrating warmth of foliage and fruit, while the middle ground and foreground are composed of intense chromatic clusters and visible, pulsating brushmarks. Certainly Gauguin simplified the shape of the coastline and subsumed the setting into new-found spatial distillations, but at the same time as the signs of specificity were banished, something about the singularity of this place – its light, its flora, its humid, intense physicality – catalysed the shift in his practice and allowed him to marry the sensation-filled pulse of the brush to the schematic rendition of the land.

Impenetrable, opaque, daunting: the known had to be marshalled by Gauguin in order to manage the unknown. Only the screen of selection could render this place intelligible, could mask his incomprehension, even his fear. And so, anxiety as well as anticipation must have gripped him as he surveyed the unfamiliar scene before him. For a short while he managed. But already ill on arrival and desperately short of money, Gauguin was soon to beg to be delivered from his island paradise.[30] And even in the early days in which he staved off the disease that was to turn him into a desperate skeleton, the landscape, for all its beauty, must have been filled with intense foreboding and dread. For the open air in Martinique was known for its hidden dangers. Writers from Hearn to Glissant have dwelled on the density of the forest, the harshness of the heat, and more specifically the threat posed by the poisonous snakes for which the island was widely known. It was, in particular, the dreaded *fer-de-lance,* the deadly Martinican pit viper, that was an object of universal terror – famous in local folklore – and known to be able to strike at any time.[31] Glissant recounts the euphemisms used traditionally by locals to invoke the creature without naming it for fear of reprisal.[32] For Hearn, the snake is at the heart of his narrative construction of the slave girl Youma, who protects her white ward from the creature by placing her own life at risk. In the end Youma cannot save her charge from the rising tide of black insurrection, but the equivalence that the novel constructs between the dangers of a hostile nature (figured in the phallic form of the intrusive serpent) and those of a politicised and emancipated masculinity are clear.

Far from being a benevolent and beneficent landscape, the terrain in which Gauguin situated himself was both treacherous and threatening. Much admired amongst local workers were the specialist snake-killers whose weathered faces and tattered clothing, captured in a contemporary photograph, speak to the actual poverty and dangerous labour of the men Gauguin must have encountered but whom he refrained from picturing. Seated with his sketchbook on the open paths or near the rivers and streams in the furious heat of the summer, he must have been aware of the threat that lurked around him. Even as he produced his painted paradise, the unfamiliarity and dangers must have haunted him. So, while nature could be tamed through composition and people could be packaged in stereotypes, the anxiety of the white-skinned foreigner, out of his depth in alterity, must have seeped into the fabric of his pictures, despite their exotic charm. Perhaps its trace can be found, inadvertently, in the wriggling serpentine brushstrokes through which Gauguin's Martinican world is filtered. *Martinique Landscape* is, after all, a writhing mass of sinuous, snakelike movements even if the creature itself is not made manifestly present. Snakes themselves would only appear in Gauguin's work two years later, when he was safely back in Paris and his sojourn on the island was repackaged as memory. But if, as Mirbeau alleged, Gauguin's Martinique suggested a 'Garden of Eden', it is worth remembering that the retrospective fantasy of a prelapsarian or otherworldly paradise is always haunted by the Fall, located as much in the anxiety of the dreamer as in the hidden dangers of the world.

'FOLLOWING THE MOON': GAUGUIN'S WRITING AND THE MYTH OF THE 'PRIMITIVE'

Linda Goddard

'This is not a book', declared Gauguin in his loosely autobiographical text *Avant et après* (1903), and 'I am not a writer. I should like to write as I paint my pictures – that is to say, following my fancy, following the moon, and finding the title long afterwards.'[1] Such denials appear to cast doubt on the literary status of the substantial body of critical, confessional, journalistic and satirical writing that he had produced during his career. But should we take Gauguin at his word? After all, the phrase 'This is not a book' is itself modelled on a literary precedent, *This is not a Story* (1798), by the Enlightenment philosopher Denis Diderot, whose writings Gauguin admired (see no.135).[2] Structured in the form of a dialogue, Diderot's text drew attention to the conventions of storytelling by incorporating a 'reader' who mocked the predictability of every twist in the narrator's tale of love affairs gone wrong. In *Avant et après* Gauguin likewise interrupted his collection of anecdotes and reminiscences with the repeated reminder that 'This is not a book'. By mimicking Diderot's title, he lent authority to his rejection of conventional narrative devices such as plot and chronology. At the same time, however, he undercut his claims of authorial naivety by paying homage to a classic text. An anti-literary statement that betrayed his intellectual credentials, Gauguin's refrain sums up the blend of learned allusion and apparent artlessness that is the essence of his writing.

The need to defend visual art from the interpretations of art critics was a constant theme of Gauguin's writings. In a letter to his friend, the artist Daniel de Monfreid, he confessed that he had written *Racontars de rapin* (1902), a late diatribe against art criticism, expressly to prove that 'under no circumstances do painters need the support or instruction of literary men'.[3] In his early *Notes synthétiques* (1885), he had criticised writers for their reliance on self-justification: 'their preface always acts as a defence of their work, as though a truly good work could not defend itself'.[4] Yet during the seventeen years that separated these declarations of self-sufficiency, Gauguin picked up the pen almost as often as the brush to express his ideas on aesthetics, religion and colonial politics, and to offer accounts of Tahitian life and legend. As a critic and journalist, he contributed to French periodicals including *Le Moderniste illustré*, *Le Soir* and *Essais d'art libre*, and in Tahiti he founded his own satirical broadsheet *Le Sourire* (1899) and edited the newspaper *Les Guêpes* (1899–1900).[5] In addition to his best-known literary work, *Noa Noa* (1893–7), an Orientalist travel narrative written in collaboration with the Symbolist poet Charles Morice, he produced a series of hybrid texts combining fiction, autobiography and a collage of theoretical statements borrowed and invented: *Cahier pour Aline* (1893), *Diverses choses* (1896–8), the aforementioned *Racontars de rapin* and *Avant et après*, and *L'Esprit moderne et le catholicisme* (1902). Numerous other manuscripts were recorded among Gauguin's effects at his death, but have never been found. Although the only work published during his lifetime was a later version of *Noa Noa*, rewritten by Morice (1901), Gauguin himself had carefully revised his initial draft of this text and made sustained efforts to publish it.[6] He also worked hard to publish both *Racontars de rapin* and *Avant et après*, sending them to the art critic André Fontainas in Paris, and confessing his 'personal and malicious interest in publishing' the latter manuscript.[7]

Fig.20 *Diverses choses* 1896–8
pp.228–9, folios 117 verso, 118 recto
Manuscript notes and sketch,
pasted-in photographs and press
cuttings
Each page 31.5 x 23.2
Musée du Louvre, Département des
arts graphiques, Fonds Orsay

Despite Gauguin's prodigious output, most scholars have avoided these writings, viewing them as merely self-serving or confessional and accepting at face value Gauguin's denials of literary expertise.[8] Even those who have published editions or anthologies insist on the crudeness and simplicity of his prose, claiming that Gauguin 'was not a writer'[9] and 'lacked the essential strategies of rhetoric'.[10] In relation to *Noa Noa*, Jean Loize argued that 'As soon as he takes up a pen, Gauguin is entirely spontaneous, with no literary tricks: he knows that he is barbarous and shocking.'[11] In a recent monograph on Gauguin, Henri Dorra similarly described his writings as 'spontaneous and untidy' and 'hopelessly wordy and repetitious', while Richard Brettell concurred in his foreword that the painter 'fortunately, operated more fully in the realm of the visual than the verbal'.[12] This essay challenges these assumptions of naivety, arguing that Gauguin's writing is more sophisticated than has generally been supposed, and central to his artistic identity. In particular, it explores Gauguin's claim to 'write as I paint my pictures'. This is not to lend credence to his own suggestion that he wrote and painted with equal spontaneity – 'following my fancy' – but to argue that the apparent naivety of his writing was as deliberately constructed as that of his paintings and 'savage' persona.

'I am going to try to talk about painting, not as a literary man, but as a painter', Gauguin declared in *Racontars de rapin*. He went on to contrast the sterile erudition of the 'so-called learned critic', whose expertise amounts to the recollection of 'names in catalogues', with the unassuming knowledge of the artist, who, even with his 'special gifts', barely succeeds in 'penetrating the secrets of the masters'.[13] Gauguin's contrast between the critic as arrogant fact-gatherer and the artist as naive mystic parallels the confrontation that he staged between the corruption of European society and the purity of Polynesian culture. In his texts and paintings Gauguin constructed a mythical vision of Tahiti as a tropical paradise – at once unspoiled and possessing an undercurrent of savagery and sexual adventure – that was being destroyed by contact with civilisation. In a similar way he presented artists as the innocent victims of literary critics, those 'corrupt judges' whose preconceived ideas prevented them from understanding

alternative forms of expression.[14] Far from being 'natural', Gauguin's apparently uncalculated prose was designed to echo the 'primitive' qualities that he attributed to Tahiti, in contrast to the more polished techniques of professional writers. For to prove his point that artists were better equipped than writers to analyse works of visual art, in his own writing he needed both to display evidence of his superior insight and to emphasise at all costs its non-literary character.

In order to achieve this, Gauguin adopted a deliberately fragmentary style of writing that was intended to contrast with the 'erudite', 'logical' prose of the critic.[15] Using exactly the same words, he defined both *Avant et après* and *Diverses choses* – a still-unpublished appendix to *Noa Noa* – as consisting of 'childish things': 'scattered notes, without sequence like dreams, like life made up of fragments, and because others have collaborated in it'.[16] On the title page of *Diverses choses*, Van Gogh's sketch of his 1888 painting *La Mousmé* – a provençale girl cast as a 'Japanese' adolescent – accompanies this disclaimer, confirming Gauguin's emphasis on collaboration, naivety and primitivism.[17] Gauguin's suggestion that episodes in his texts are randomly grouped 'partly for personal relaxation, partly to assemble certain favourite ideas' is found in both *Avant et après* and in the preface to the first edition of his broadsheet *Le Sourire*.[18] If offered only once, this confession of literary inadequacy might be convincing as a genuine apology, but when repeated insistently from text to text, it evolves into a statement of intent. Indeed, at one point in *Avant et après* Gauguin developed the formula into a striking visual metaphor, evoking a prismatic harmony of fragments: 'Different episodes, numerous reflections, a few jests, appear in this volume, from who knows where, come together and retreat; a child's game, images in a kaleidoscope.'[19]

These qualities of fragmentation, collaboration and childlike spontaneity can be seen in one of several double-page spreads of collaged images and text in *Diverses choses* (fig.20). In an imaginary 'letter to the editor' at the bottom of the right-hand page, to which he has added his signature, Gauguin continued his attack on art criticism, mocking critics who seek to categorise and label artistic styles and movements. Yet on the same page he pasted several cuttings from a review by Roger Marx of his 1893 Durand-Ruel exhibition, which include photographs of himself and his artistic creations, undermining his claim that artists should defend their own work 'without the intervention of an interpreter'.[20] Gauguin succeeded in minimising this contradiction, however, by using a careful arrangement of text and image to shift the focus away from the context of European art criticism, and toward his affiliations with poetry and the 'primitive'. At the top of the left-hand page, a simplified, stylised self-portrait, falsely attributed to 'my vahine [mistress] Pahura', confirms his savage credentials. He has placed it above a transcription of the Symbolist poet Paul Verlaine's confessional poem from *Sagesse* (1881), 'Le ciel est, par-dessus le toit' ('The sky is, above the roof') – a poem celebrating freedom and the beauty of nature, written while Verlaine was in prison for shooting his lover and fellow poet Arthur Rimbaud.

When copying Verlaine's poem, Gauguin reversed the order of the last two stanzas, shifting the focus from the theme of wasted youth in the poet's closing lines to the 'simple and peaceful' life evoked in his penultimate verse. He had already made this link between Verlaine's poem and his own idyllic vision of the Tahitian landscape when he transcribed it above an 1893–5 watercolour (fig.21) depicting a figure crouching by a large tree at the seashore (recalling the tree that dominates Verlaine's first two verses). In *Diverses choses* the poem is followed by a reference to the twelfth-century Cistercian monk Saint Bernard of Clairvaux, quoting his paean to solitude: 'Beata solitudo, sola beatitudo' ('Blessed solitude, only blessing'). By placing his self-portrait at the head of the page, above these borrowed texts, Gauguin suggestively linked his own exile from 'civilisation' to the virtuous isolation of the pious monk or the incarcerated poet.

On the right-hand page, the pasted-in section of Marx's review juxtaposes one of Gauguin's cylindrical sculptures showing the Polynesian moon goddess Hina with a passage from Charles Baudelaire's prose poem 'Les Projets' (1857), evoking a tropical landscape, and directly compares painter and poet in terms of their rejection of materialism and experience of exotic travel.[21] In the cluster of photographs at the top Gauguin has placed an 1894 studio portrait of himself in profile – which closely mirrors

the profile of his 'savage' likeness on the opposite page – alongside his representations of Tahitian women. In this photograph he stands in front of the seated figure from *Te Faaturuma (Boudeuse / Brooding Woman)*, whose pose reflects that of the female Buddha in the reproduction of his *Idol with a Pearl* carving to the right; directly below, a cropped photograph of *Vahine no te Tiare (Woman with a Flower)* focuses attention on the androgynous face of the woman, whose contemplative demeanour echoes Gauguin's own static pose. Again, this arrangement visually cements his identification with the Tahitian figures. Together, these various textual and visual associations build up a multifaceted portrait of the artist as a 'poetic savage'. Using a variety of media, authorial voices and literary registers – aphorism, criticism, poetry, polemic – Gauguin avoided the linear logic and labelling of the critical writing that he despised, in favour of the suggestive and synthetic approach that he associated with visual art.

Although not all the pages of *Diverses choses* include this combination of text and image, it could be argued that Gauguin based the structure of his entire manuscript on the principle of collage. Lacking narrative development and coherence, it consists of a patchwork of borrowed texts (often adapted, misattributed, or unaccredited), juxtaposed with passages of his own writing – frequently repeated from earlier texts, and sometimes attributed to a fictional author. Across one double-page spread, for example, a pasted-in quotation from Baudelaire, advocating exaggeration and excess in art, is surrounded by a crude anecdote about mating birds, followed by a fake Oriental treatise in which Gauguin disguised his own thoughts on the importance of simplicity in art as the advice of the 'ancient Turkish painter Mani-Vehbi Zumbul Zadi'.[22] As the voices of his alter egos combine with the borrowed words of his heroes and contemporaries, snatches of verse or light-hearted sound bites are attributed to 'a woman', 'a saint', an 'inmate from Charenton [an asylum]', or introduced with the words 'which English author was it who said that . . .', as if to highlight the shared ownership and mutability of ideas.[23] Moreover, Gauguin's claim that 'the thought which guides my work . . . is mysteriously linked to thousands of others, whether my own, or heard from other people' is expressed thematically in the content of his borrowed material, including, for example, the writer Edgar Allan Poe's theory of the imagination as 'infinite, encompassing the whole universe',[24] or the composer Richard Wagner's celebration of the 'total art work' ('*Gesamtkunstwerk*'). Wagner's belief that the idea of a 'fecund union of all the Arts' corresponds to a nation's desire to recall 'the noble mystery of its origins' and be 'restored to its purest essence' chimes with the connection

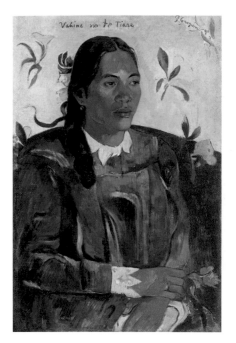

*Fig. 22 Vahine no te Tiare
(Woman with a Flower) 1891*
Oil on canvas
71 x 46
Ny Carlsberg Glyptotek,
Copenhagen

that Gauguin made between memory and a 'primitive' state of youthful purity: 'sometimes I travel right back, way beyond the horses of the Parthenon, to the hobby horse of my childhood, the good old wooden horse'.[25]

This principle of interrelatedness – the collective nature of memory and the unifying power of art – shifts the focus of creativity from the expression of personal ideas to the inventive recombination of existing fragments. For Gauguin, this transformative process was specifically painterly. Using the traditional distinction between the spatial art of painting and the temporal art of poetry, he followed artists including Leonardo da Vinci and Eugène Delacroix in promoting painting as the most universal of all the arts, the only one capable of evoking the senses simultaneously, through the medium of colour. Leonardo's *Treatise on Painting* (compiled posthumously, c.1550) celebrated visual art as the highest form of expression for its ability to compress simultaneous actions into a single image: 'The poet, in describing the beauty or ugliness of a body will describe it to you part by part and at different times, but the painter will make you see it all at the same time.'[26] In some notes that Gauguin copied into *Diverses choses*, Delacroix attributed this quality of immediacy to painting's key component: colour. Unlike literature, he explained, which relied on telling stories, painting could create a 'poetic' effect through 'musical' arrangements of colour, so that 'before even knowing what a painting represents . . . you are struck by that magical harmony . . . this is the true superiority of painting over that other art'.[27] On several occasions Gauguin constructed a similar hierarchy of image over text, arguing, for example, in *Notes synthétiques*, that 'painting achieves a unity impossible in music, where the chords follow one after another . . . sight embraces everything, and at the same time simplifies'.[28]

In *Diverses choses* Gauguin stressed the importance of using colour as an imaginative equivalent rather than as a literal imitation of nature, explaining that 'pure' colour can 'facilitate the flight of the imagination, decorating our dreams, opening a new door onto the infinite and the mysterious'.[29] He described colour in synaesthetic terms as the 'language of the eye which listens' and located its highest expression in the art of the 'Orientals' and Persians, who had 'bestowed on their carpets a marvelous eloquence'.[30] Likewise, in *Cahier pour Aline* he urged artists to find their 'maternal milk in the primitive arts', in opposition to the arts of 'high civilisation'. He contrasted the writer's constant struggle between the desire for 'beautiful language, beautiful forms' and the need to 'tell stories', with the autonomy of painting, which as 'sister to music, lives off forms and colours', just as music is based on 'sounds and harmonies alone'.[31] Gauguin therefore consistently linked painting, by virtue of its reliance on colour, with the qualities of mystery, abstraction and universality that he valued in the 'primitive'. With its synthesis of sources the collage technique of *Diverses choses* functions – like colour – to create a holistic vision based on imaginative associations. It replaces the successive, temporal logic of the professional critic with the synthetic, intuitive vision of the 'primitive' painter.

In *Noa Noa* Gauguin transformed these theoretical associations between colour and the 'primitive' into a fictional description of his attempt to understand and represent Tahiti. Scholars have treated *Noa Noa* primarily as an autobiographical document or as a 'literal narrative explanation' of his paintings.[32] However, as in *Diverses choses*, the text establishes themes and patterns that are less an accurate record of his life than a means of enhancing the mystery of his art. Recounting his early efforts at painting his new surroundings, Gauguin wrote:

> Everything in the landscape blinded me, dazzled me. Coming from Europe I was constantly uncertain of some colour [and kept] beating about the bush: and yet it was so simple to put naturally on to my canvas a red and a blue. In the brooks, forms of gold enchanted me – Why did I hesitate to pour that gold and all that rejoicing of the sunshine on to my canvas? Old habits from Europe, probably, – all this timidity of expression of our bastardised races.[33]

Like other European artists who were inspired by the 'exotic', Gauguin promoted the idea that non-Western societies represented an idyllic golden age uncorrupted by European civilisation. In this passage the purity of the primary colours – red, blue and yellow (i.e. 'gold') – symbolises the supposedly untainted character of a 'primitive' race. In fact, Gauguin had already advocated the use of 'pure' colour before his departure from France.[34] His suggestion that he could cultivate a more authentically 'savage' technique by embracing the brighter shades of Tahiti is therefore rhetorical. Tellingly, his opposition between 'savage' and 'civilised' colours immediately precedes his description of how he came to paint a portrait of his Tahitian neighbour, represented in the painting *Vahine no te Tiare* (fig.22). In this bold and simplified 'portrait' we find precisely the 'Tahitian' colours that Gauguin admired, in the blue of the sitter's dress, the undefined expanse of red that echoes the curve of her shoulders, and the gold background behind her head. Her enigmatic expression, and the flowers that unite the surface of the canvas, contribute to a sense of decorative mystery that Gauguin valued in the 'primitive'. His description of how she wore 'a flower behind her ear, which was listening for her fragrance' recalls Baudelaire's mingling of the senses in a line from his influential 1857 poem 'Correspondances' – 'perfumes, sounds and colours correspond' – as well as Gauguin's own multisensory definition of colour in *Diverses choses*.[35] It also heightens the sense of painting as a 'total art, which absorbs all the others and completes them'.[36]

This fusion of the senses lifts the image beyond literal visual likeness into the realm of the imagination, in accordance with Gauguin's aim to create 'a portrait resembling what my eyes veiled by my heart perceived'.[37] Acting as both 'real' plants and wallpaper motifs, the flowers on the right of *Vahine no te Tiare* become increasingly ethereal and stylised as they ascend from the dropping bloom in the woman's right hand to the schematically brushed-in leaves that surround the artist's name at the top of the canvas. It is appropriate that Gauguin's signature takes the place of the petals: in *Diverses choses* he directly compared artists to flowers, entreating 'learned men' to 'forgive these poor artists who have never grown up; if not out of pity, then at least for the love of flowers and heady scents, for they often resemble them'. He implicitly likened the artist's condition to that of a 'primitive' culture coming into contact with civilisation: 'Like flowers, they bloom at the slightest ray of sun, releasing their perfume, but they wither at the impure contact of the hand that tarnishes them.'[38] As a frequent attribute of the Tahitian women in *Noa Noa*, flowers also evoke their natural beauty and aesthetic sensibility. In an early scene describing the funeral of King Pomare V of Tahiti, Gauguin admired the floral arrangements of Queen Marau, who 'with the fine instinct of the Maoris . . . turned everything she touched into a work of art'. In contrast to the 'great mass of black' that enveloped the official mourners, he observed in her eyes 'plants beginning to burgeon in the first sunshine'.[39]

The flowers in *Vahine no te Tiare* therefore symbolise the intuitive creativity of the artist and his affinity with the 'primitive' aesthetic, as embodied in the decorative sense of the Tahitian women. In the text, the refrain 'noa noa' (which means 'fragrant') acts as a literary equivalent of this floral motif: scattered at intervals throughout the narrative, it links the themes of sensuality, 'primitive' enlightenment and artistic inspiration, as when Gauguin describes his companion Tehamana – 'clothed in the orange-yellow garment of purity' – as 'a beautiful golden flower, whose Tahitian noa noa filled all with fragrance, and which I worshipped as an artist, as a man'.[40] However, if Gauguin's literary techniques echo his visual strategies of repetition and suggestion, individual episodes in the text frequently contradict aspects of the paintings that they appear to describe, creating a disjunction between text and image. Thus, in *Vahine no te Tiare* we see the 'enigmatic smile' that Gauguin records, but not the 'nasty grimace' or 'impulse of coquetry' that are also supposed to have marked his neighbour's features.[41] In keeping with Gauguin's description of painting as an art that 'embraces everything and at the same time simplifies', the temporal flow of the narrative – which describes Gauguin's rush to finish the portrait and his model's resistance and eventual surrender – is distilled into a vision of solidity and calm.

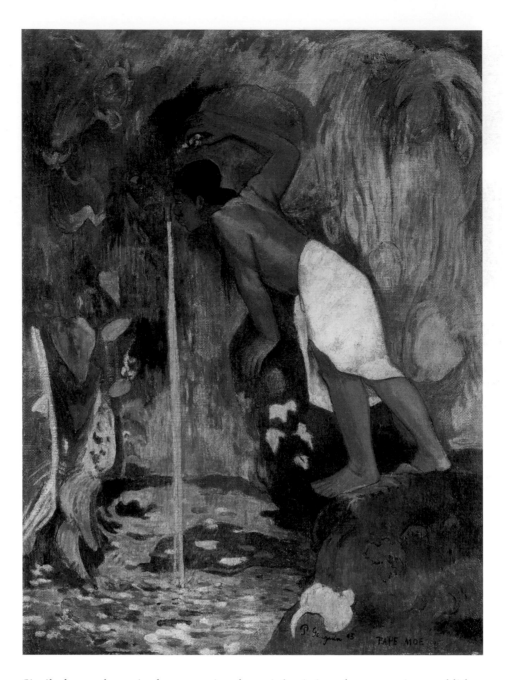

Similarly, another episode, recounting the artist's trip into the mountains, establishes a context for the painting *Pape Moe (Mysterious Water)* (fig.23), but the details of the narrative fail to correspond to the visual image. In the written account Gauguin discovers a naked girl by a waterfall erotically pouring water over her breasts. As he approaches she is startled like 'an uneasy antelope', and suddenly disappears in fright, only to be replaced by an enormous eel writhing amongst the pebbles on the riverbed.[42] The sensuality and violence of the written account contradict the calm, strength and androgyny of the figure in the painting, whose sturdy calves do not suggest a frightened animal in flight, whose breasts are concealed by her muscular arm, and whose sexual identity remains hidden beneath the white cloth.

The contrast between the strong woman in the painting and the frightened, bestial creature in the account tells us more about Gauguin's troubled attitudes to Tahitian women than it does about the source of the painting, which has been traced to a photograph of a 'Samoan' figure drinking from a waterfall (fig.24).[43] The passage from *Noa Noa*, meanwhile, was partly inspired by similarly voyeuristic waterfall scenes in Pierre Loti's hugely successful romance *Le Mariage de Loti* (1880).[44] As for the girl's transformation into an eel, it bears a strong resemblance to a Polynesian legend in which a young princess encounters the severed head of an eel sprouting from the bushes

Fig.24 Charles Georges Spitz
Tahitian drinking at a waterfall
c.1888
Coloured gillotage reproduction of an
albumen print
22 x 17
Serge Kakou, Paris

The title 'Fontaine dans la roche aux
Samoa' was given to this photograph
(of which Gauguin owned a copy) by
the botanist Édouard Raoul.

by a spring, just like the fish's head that confronts the woman in the painting.[45] Both image and text are therefore based on a collage of representations – whether oral legend, colonialist fiction, or photography – not on autobiographical fact. Far from providing a 'literal narrative explanation', the text in fact deviates from the painting, allowing the image to function independently.

Although Gauguin himself encouraged the view that *Noa Noa* 'would facilitate the understanding of my painting', his elliptical accounts do not so much explain his work as seek to prove its resistance to interpretation.[46] Artists' writings are traditionally understood as predominantly expository or biographical, rather than as literary works in their own right.[47] Gauguin's colourful life story, and the way in which his art offers symbolic clues but frustrates straightforward readings, heightens the urge to turn to his writings for explanations. However, although he certainly hoped that his writing would help to publicise his work, for Gauguin to have offered literal interpretations would have thwarted his desire to emulate the 'mystery' of Polynesian culture, and risked reverting to the rational explanation of the civilised art critic. At the end of *Diverses choses* he confessed that 're-reading this, I should be embarrassed by the naivety of these daily scribblings, had I not set out my childish inclinations from the start'.[48] Gauguin adopted a structured simplicity in his writing, not because he lacked professional expertise or rhetorical flourish, but in order to evoke the qualities of spontaneity and synthesis that he associated with visual art, and so to protect painting from literary interference.

GAUGUIN'S POLITICS

Philippe Dagen

Why 'Gauguin's Politics'? Until recently, most French art historians have barely concerned themselves with what might be considered political within the artist's work – the term 'political' understood in the sense of an observation and a critique of living conditions, and embracing economics, society, sexuality and religion as much as the exercise of power itself. (That said, Gauguin's art has of course attracted recent critiques of a broadly political kind in so far as it relates to sensitive sexual and post-colonial issues.) At first glance this lack of interest seems reasonable: what do the pictures of Brittany or Polynesian myths have to do with such issues? It would seem more important to study Gauguin's drawing and painting techniques, his chromatic harmonies and the various origins of his allusions to non-Western cultures. It would seem logical enough to suppose that his revolutionary art would be complemented by equally revolutionary political opinions, or at least ones marked by the spirit of change and revolt.

The few sentences that indicate the artist's political ideas confirm this theory and the concept of avant-gardism it underpins. This is clearly true of the letter Gauguin addressed to the Danish Symbolist painter Jens Ferdinand Willumsen (1863–1958) at the end of 1890, in which he justifies his departure for Polynesia. After writing that he is leaving for Tahiti because 'I want to forget the bad things about the past and die over there, unknown here, free to paint without any glory whatsoever for others', he continues with an often quoted prophecy: 'A terrible age is being prepared in Europe for the next generation: the kingdom of gold. Everything is rotten, both men and art. We must continuously tear ourselves apart . . . Whilst in Europe men and women satisfy their needs only after relentless labour, whilst they struggle in convulsions of cold and hunger, tormented by poverty, Tahitians, on the contrary, as happy inhabitants of the unknown paradise of Oceania, are familiar only with the sweetness of life.'[1] One only has to read *Noa Noa* to confirm that this latter hope was utopian, that for a long time these unknown paradises had in fact been enslaved colonies, that Gauguin's disillusionment was proportionate to his desire. One also has only to look at the canvases from Gauguin's first trip to Tahiti, in which he shows the enforced Westernisation of dress and manners, the banning of nudity and the dejection of the resigned colonised natives. But this is not for the time being our intention. In the first instance Gauguin's description of Europe in 1890 deserves to be examined.

The first point to be made is that Gauguin mentions an age of labour and poverty, the enslavement to gold, and alludes to cold and hunger. A few biographical facts should be mentioned here: Gauguin's years at the Paris stock exchange (1872–83) and his subsequent familiarity with the world of stockbrokers, in other words Parisian financial capitalism; and, a bit later, the years of financial difficulty, the commercial endeavours in Denmark and their failure (late November 1884–June 1885), the period of poverty in which Gauguin was obliged to accept the job of sticking up posters, which amounted to the loss of his social position and proletarianisation. Gauguin's remarks in his letter to Willumsen can be compared to those of others: the bourgeoisie 'has resolved personal worth into exchange value' and 'for exploitation, veiled by religious and political illusions, it has substituted naked, shameless, direct, brutal exploitation'. These quotations are taken from *The Communist Manifesto* published by Karl Marx in

Fig.25 Jean-François Millet
L'Angelus 1857–9
Oil on canvas
55 x 66
Musée d'Orsay, Paris. Aquisition:
Legs Chauchard, 1910

1848. Gauguin's description of industrial capitalism can be found here in all its detail down to the mention of women, because as Marx writes, 'differences of age and sex have no longer any distinctive social validity for the working class'. His observation that the lower strata of the middle class 'sink gradually *into the proletariat*' for lack of capital or during a crisis applies exactly to Gauguin, who descended from living comfortably into penury. The artist does not seem to have read *The Communist Manifesto* even though it was translated into French as early as 1848, and then a second time in 1886. Our intention is not to claim that Gauguin would have been a Marxist or a Communist in the strict sense but rather to establish that his critique of industrial society was, at the date he made it, almost banal, being a viewpoint that others had held ever since the theories within *Das Kapital* had become widely known. Gauguin adds nothing to the subject: he simply shoulders with conviction a condemnation of society that, in 1890, was that of all revolutionaries, at a time when social battles were particularly intense. Furthermore, the year 1890 saw the establishment of 1 May as a symbolic date representing the workers' struggle; it also witnessed the creation of the first labour exchanges, the demand for an eight-hour working day, and the foundation of the Parti Ouvrier Socialiste Révolutionnaire (POSR) with anarchistic leanings. It is difficult to imagine Gauguin being unaware of this political climate.

The second point is that Gauguin alludes to art being made rotten, just as men are, by money. Again, this opinion was shared by a good many of his acquaintances. On the occasion of the sale of Jean-François Millet's (1814–1875) *L'Angelus* (fig.25) on 1 July 1889, the writer Octave Mirbeau (1848–1917) described the auction room at the opening of the bids in the following terms: '*L'Angelus* no longer existed. It had disappeared beneath the gold with which its ransom had just been paid . . . There was no longer any art, there was no longer any France, or even America. There were only piles of gold and around these piles of gold, eyes gleaming covetously and spines bent in respect.'[2] He continues: 'to pay five hundred thousand francs for a painting, whatever the work may be, is monstrous . . . a barbaric insult to the [picture's] resignation to labour and poverty, an outrage against the beauty of the artist's mission . . .'[3] His denunciation was backed up by a vindication of those artists whose canvases were worth very little money in 1889: Monet, Pissarro, Rodin, Degas. On the day the article was published, Mirbeau's attack prompted a short letter from Stéphane Mallarmé: 'You are the only one to have understood that to assign an actual monetary value to a work of art, even half a million,

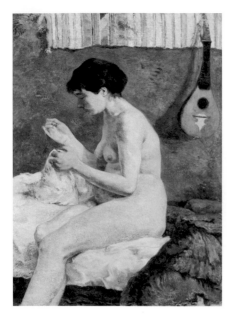

Fig.26 *Study of a Nude* 1880
Oil on canvas
114.5 x 79.5
Ny Carlsberg Glyptotek,
Copenhagen

is to insult it.[4] Three months later Gauguin published in *Le Moderniste illustré* his polemical text 'Qui trompe-t-on ici?', using as a pretext the sale of Millet's painting for 'the very modest price of five hundred and some thousand francs'.[5] The agreement between the three men is obvious. Moreover, Mirbeau and Mallarmé were also two of the rare writers to show any interest in Gauguin at this time. Gauguin etched a portrait of Mallarmé before leaving for Tahiti as a sign of their poetical understanding (no.138). As for Mirbeau, a year and a half after his article on Millet, he published 'Paul Gauguin' in the same daily newspaper, an article in which he praised the artist and, unlike most other commentators, mentioned Gauguin's time spent at the stock exchange. Bending reality, he writes: 'We cannot follow, at one and the same time, a dream and interest rates, marvel at ideal visions only to fall immediately from the heights of heaven to the hell of liquidations and reports. M. Gauguin hesitates no more. He abandons the stock exchange, which eased his material life and gives himself over entirely to painting, despite the threat of difficult times ahead . . .'.[6] The painter's life becomes a parable, with Gauguin at the crucial moment choosing art rather than gold, at the risk of poverty. The announcement of a Gauguin sale on the following 23 February occasioned a second, shorter article. It continues along the same lines: 'we live in times where pure art brings only suffering and disappointment to those who cultivate it; and life is full of immediate, relentless demands'.[7] This is to say that Mirbeau makes of Gauguin an emblem of 'pure' art as opposed to what the artist calls art made 'rotten' by gold. Their agreement is clear on this point and Mirbeau's articles, if they contribute to Gauguin's notoriety, also aim to set him up as a hero of the highest aesthetic invention as opposed to one who practises commercial or industrial art. In the first lines of the article in *L'Echo de Paris*, the link is established between the man's greatness and his solemn resolve to leave European civilisation where his work can only ever be greeted with hostility and consequently doom him to material suffering.

The two main arguments described in Gauguin's letter to Willumsen can be summarised thus: the critique of society fits into a protest defended strongly by Marxist philosophy, workers' movements and revolutionary political parties in the last third of the nineteenth century in France. Similarly, the critique of the artist's situation appears as a common conviction held by people close to Gauguin such as Mallarmé and Mirbeau. If Gauguin has political convictions they are shared by many and, in 1890, are virulent in a way that can be considered almost natural.

Fig.27 *The Swineherd* 1888
Oil on canvas
73 x 93
Los Angeles County Museum of Art.
Gift of Lucille Ellis Simon and
family in honor of the museum's
twenty-fifth anniversary

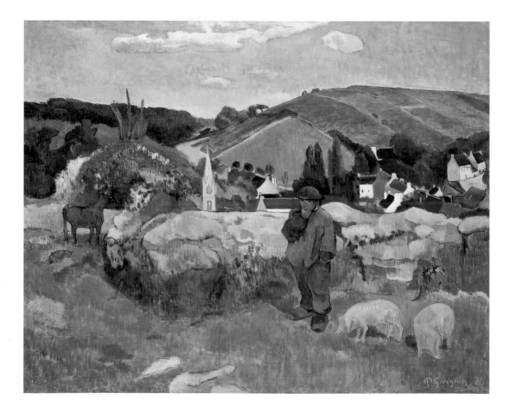

Fig.28 *Seaweed Gatherers* 1889
Oil on canvas
87 x 123.1
Folkwang Museum, Essen

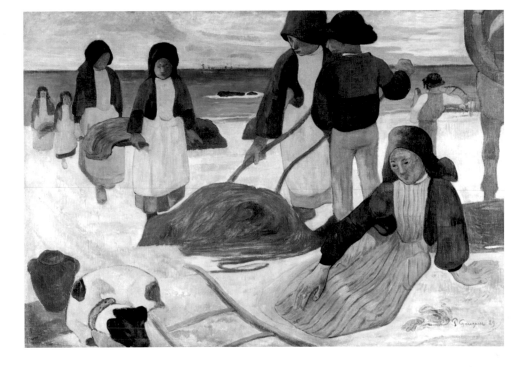

Fig.29 *Little Breton Girls by*
the Sea 1889
Oil on canvas
92.5 x 73.6
National Museum of
Western Art, Tokyo.
Matsukata Collection

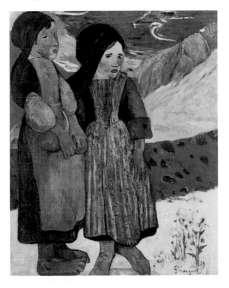

We would expect, then, at least a few of Gauguin's works to show a noticeable denunciation of the state of the world. Yet, as anyone interested in Gauguin's works will know, no such works exist. There is nothing of this kind in the landscapes and still lifes of his Impressionist years: the landscapes are mainly of the area around Vaugirard and the countryside and woods outside Paris without any reference to industry, unlike what can occasionally be seen in works by Monet, Guillaumin or Pissarro;[8] no greater engagement is offered by the still lifes, bourgeois interiors decorated with bouquets and comfortably furnished. The *Study of a Nude* exhibited at the Salon des Indépendants in 1881 was so highly praised by Joris Karl Huysmans not because it depicted the working woman's condition but because 'It is a girl of our times, and a girl who is not posing for the gallery, who is neither lewd nor simpering, but is simply busy darning her clothes'[9] (fig. 26). Huysmans does not even allude to what is humble about this act, what it indicates about the model's modest living conditions. His only concern is with the rejection of academic idealism and the treatment of flesh and anatomy: 'what truth in all these parts of the body'. We would have expected the novelist of Parisian misfortune, of solitude and embitterment, to comment on the canvas's naturalist implications – but he does not and the occasion for establishing Gauguin as the painter of working people is missed.

The situation is scarcely different in Brittany. Although accounts of impoverished peasant life, the harshness of the times for fishermen and farm labourers are far from rare,[10] and although the themes of poverty and hard labour can be seen everywhere at the Salon thanks to the paintings of Jules Bastien-Lepage and Jules Breton, only a few of Gauguin's canvases painted in Pont Aven and Le Pouldu can be interpreted in this way. If the adolescents are naked, it is because they are bathing or wrestling in the grass. The women's dress does not indicate anything either, and if we put the religious question to one side – we shall come back to it later – Gauguin does not seem to be overly sensitive to the everyday life of those he frequented from 1886 to 1890. The shepherdess in *Breton Shepherdess* dreams, and the figure of the pig keeper in *The Swineherd* is less important than the landscape in which he is set (fig.27). The *Seaweed Gatherers* could be seen as a counter example were it not for Gauguin's letter to Van Gogh in which he talks about the painting only in terms of composition and colour (fig.28). We look in vain for the trace of any protest against the hard labour of these women, as much in the letter as in the canvas. Only one work, *Little Breton Girls by the Sea*, shows ragged, barefoot children with sad eyes – 'two poor girls', as Gauguin described them (fig.29).[11] It remains to be determined whether the essential element in the artist's view is their *misère* or their youth, already desperate, already deprived of its innocence. And, whatever the case may be, one canvas would still be insufficient to

Fig. 30 I Raro te Oviri (Under the Pandanus)
Watercolour monotype pasted onto inside cover of album Noa-Noa / Voyage de Tahiti 23.2 x 31.5
Musée du Louvre, Département des arts graphiques, Fonds Orsay

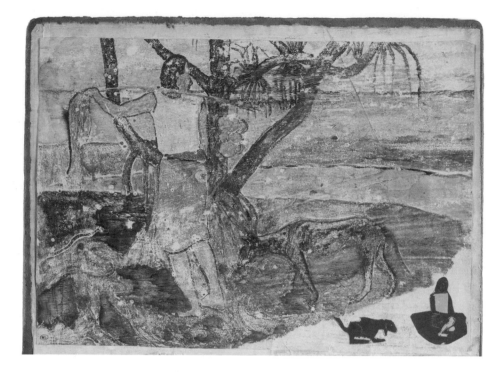

establish a strong relationship between what Gauguin thought of contemporary Brittany and the way he painted it.

What is interesting here is not so much the nature of the artist's political thoughts as the fact that they seem to be confined to his correspondence and his statements: their transferral into the painting does not seem to take place. At least it does not take place in the expected way: through description and, possibly, satire.

Would it be any different in Oceania? The stances taken by Gauguin are as vigorous – and public – when printed in *Le Sourire* or *Les Guêpes*. He quickly understood that the rules were the same in the colonies as they were in the capital: the rule of 'How much'. 'At the colonial prison, at the colonial hospital there are always these same words "How much?" You are labelled soldier, sergeant, officer according to the weight of your purse ... Then death takes you by surprise, carries you off: and you are given a beautiful white shroud, a piece of grey fabric, a filthy rag according to the weight of your purse ...'[12] The terrible age that, in 1890, he announced would come to Europe had spread to Oceania: 'Civilised hordes arrive and plant their flag: the fertile soil becomes sterile, the rivers dry up; it is no longer a continual party, but a continual struggle for life, and unceasing toil.'[13] Ten years on, Gauguin was still writing along the same lines, adding simply that contrary to what he thought before his arrival, Polynesia had not escaped from the triumph of gold that 'rots' everything and from 'sweet progress' – sweet is undoubtedly used here to mean its opposite. It would be easy to add other quotations all confirming the artist's judgement upon Western capitalism in its colonial variant.

It would also be just as easy once more to object that the canvases, drawings, engravings – not to mention the wooden sculptures – bear no confirmation of this point. They contain no allusions to social and economic differences. Not that Gauguin doesn't depict the Tahitian population he frequented and with whom he lived. But what he paints is its acculturation, the invasion of Christian manners and morals imposed by missionaries – most of reformed faith – and colonial civil servants: long dresses, Tahitian women condemned to modesty and remorse, their sadness, their apathy, the deceitful ways of behaving they have developed from their contact with the white man.[14] The portraits of women and the 'genre scenes' that often allude to jealousy and deception in matters of love bear witness to the introduction of notions such as sin and contrition unfamiliar to the Tahitians until the arrival of the French. On the other hand, themes of labour or poverty do not appear either in the works or in *Noa Noa*. Rather it is the opulence of nature, the abundance of fruit and animals, the fabulous tuna fishing and the generosity of the artist's neighbours that are the themes painted or written about again and again (fig 30).

However detailed it may be, the study of Gauguin's production during his periods of residence in Tahiti and the Marquesas Islands reveals nothing new on this matter, with the result that analysis is caught in a contradiction: the repeated and vehement political and social critique of capitalism and its colonial development on the one hand; and on the other the extreme rareness, if not absence, of works that correspond to this critique. This contradiction means we are obliged to examine the artist's political thought more closely, as it may be more complex than at first sight.

One text reveals itself to be decisive, the *Cahier pour Aline*, written in 1892, and reduced too often to only one of its fragments, the genesis of *Manao tupapau* 1892. It contains remarks on poverty: 'I have known extreme poverty that is to say to be hungry, cold and all that follows . . . But what is terrible about poverty, is the impossibility of working, of developing one's intellectual faculties. In Paris especially, as in big cities, the race for money takes up three quarters of your time, half of your energy.'[15] It includes heavy references to the Panama scandal – which concerned Gauguin all the more in that he was briefly employed on the digging of the canal. He first condemns the immorality and the indifference of corrupt speculators, investors and politicians. He concludes by agreeing with the opinion of all those who see proof in the scandal of a conspiracy between parliamentary democracy and financial speculation: 'The stock exchange, all speculation, should be abolished, on these moral grounds.' But the following sentence reads: 'And yet this same stock exchange and speculation are the pivots of our financial existence. Without them, modern society wouldn't be able to function.'[16] Thesis and antithesis come one after another without resulting in a third sentence, or synthesis, to resolve the contradiction.

This is not the only such case mentioned in the *Cahier pour Aline*. In the same passage Gauguin states first that he is a Republican. 'Long live democracy! It's all there is.' However 'philosophically', the Republic is a 'trompe l'oeil' and artistically a disaster: 'The democrats, bankers, ministers and art critics strike protective postures and yet they do not protect, haggling like fishmongers at the market. And you want an artist to be Republican! . . . If the artist cannot live, then society is criminal and badly organised.'[17] That an artist cannot live, the Impressionists – and Gauguin with them – are the proof: the Third Republic despises them, its institutions keep them in the background. Gauguin cannot consider democracy, which is in reality a plutocracy, as the best form of government.

What would be the best form? Communism, Anarchism? The hypothesis is not even considered. The answer is the opposite. It is contained in two arguments: 'Intuitively,' writes Gauguin, 'instinctively, without thinking, I love nobility, beauty, elegant taste and the old saying "Noblesse oblige." I like good manners, even the politeness of Louis XIV. I am then instinctively, without knowing why, an ARISTO.' Intuition is followed by historical reasoning: 'As an artist. Art is only for the minority, it must itself be noble. Only great lords have protected art out of instinct, duty, and pride maybe. Anyhow they have made great and beautiful things happen. The artist was treated as an equal, so to speak, by kings and popes.'[18] Surprising sentences and a clear regret: he gives himself free rein as much on an autobiographical level, 'by instinct', as on a historical and artistic one – by citing Louis XIV, Michelangelo and Julius II, Titian and Philip II. Modern society is reprehensible, therefore, because it enslaves people to the humiliating power of money, replacing all previous relationships by the law of 'how much'. The purpose of this critique is not, however, to prepare the advent of a new, egalitarian and more democratic world. On the contrary, it is based on the admiration of, and regret for, a past era of aristocrats who knew how to treat artists and who did not haggle over their works like 'fishmongers at the market'. It is in no way a question of decadence but of the disappearance of one social and political system and of the dominance of another. It would be right to use the term 'reactionary' rather than conservative to define these reflections, to the extent that they are a reaction to the actual state of things in order to promote a vision – certainly idealised – of a previous lost state. The following somewhat undemocratic maxim can be found once again in the *Cahier pour Aline*: 'Great monuments have been built under the reign of potentates. I believe that great things too will be done only with potentates.'[19]

A previous lost state: it is easy to recognise one of the artist's essential themes in these words, so essential that his love for 'primitives' of whatever kind cannot be separated from it. This is obvious in Oceania. In *Noa Noa*, concerning the death of King Pomare V on Tahiti, Gauguin writes: 'There was one king less, and with him disappeared the last remains of Maori customs. It was well and truly over, nothing left but civilised people. I was sad: to have come so far for . . .'[20] He makes the same remark concerning the Marquesas Islands: 'And so we witness this sad spectacle which is the extinction of a race for the most part consumptive, with infertile loins and ovaries devoured by mercury. In seeing this, I am led to think, or rather dream, of that moment when everything was absorbed, dormant, annihilated in the sleep of the first age, its infancy budding.'[21] In this way Gauguin condemns colonialism less for the oppression and injustice of which it is guilty,[22] than for its destruction of traditions and even the genetic patrimony of the native populations. Artistic primitivism, even though it appeared to be a revolutionary avant-garde aesthetic, was a response to this regret and to the destruction of bygone societies. This process was taking place as much in Europe, where the bourgeoisie had defeated the aristocracy, as in the tropics where the colonial regime had destroyed the old world and the 'old Maori cult'. Although the situations were very different in Paris and in Papeete, what the artist was witnessing were the consequences of a general change, the destruction of previous structures and social habits and the constitution of a new order based on money.

Feeling himself 'by instinct' to be an 'ARISTO', Gauguin can only be infuriated by this change which is so global that it affects even the Pacific Islands, just as he can only witness the loss of the Marquesan 'race' with sorrow, because to be Marquesan, as with being 'ARISTO', is a question of birth – a question of 'nobility'. Naturally, his socialist grandmother Flora Tristan was a 'noble lady'[23] and his mother herself a 'very noble Spanish lady'.[24] It is not for nothing that Gauguin depicts in such terms his childhood in Lima and his family tree in *Avant et après*. These tales explicitly place him within the old social system, and the ruin of his Peruvian family was a question of money and the stock exchange,[25] and as such it was a bourgeois drama typical of the bleak nineteenth century. In these autobiographical texts Gauguin rewrites his destiny in such a way that it coincides with his general political and historical theory.

The paintings and sculptures from these two sojourns in Oceania fit logically into this system. If, as already mentioned, a few allude to the acculturation of the Tahitians, to the change in manners and dress, the wooden sculptures, the mythological canvases and *Ancien culte mahorie* are attempts to recognise, restore and repair the irreparable damage of modernity. 'Would I succeed in finding a trace of that so distant and so mysterious past? And the present had nothing worthwhile to say to me. Finding the old hearth, reviving the fire in the midst of all these ashes. And doing this all alone,

Fig.31 Ancien culte mahorie 1892–3
pp.12–13, folios 6 verso, 7 recto
Watercolour, pen and ink
21.5x 17 (book)
Musée du Louvre, Département des
arts graphiques, Fonds Orsay

without any support.'[26] These sentences from *Noa Noa* clearly state the archaeological aspect of primitivism: the 'arrangements' of Tahitian, Marquesan, Kanak, Buddhist or Japanese references are an attempt to evoke a bygone age, lost cultures. Primitivism is an aesthetics of looking back. It must be accepted that it owes its aesthetic modernity to this desire for the past, and that it is deeply hostile to the Western world's material and social modernity, to its technical progress and to the advent of a new social order. We must admit that it embodies this paradox: an anti-progressive avant-garde that is simultaneously and dialectically revolutionary and counter-revolutionary.

The term 'lost cultures' has just been mentioned: the adjective brings to mind the 'lost paradise' of the biblical tales, the more so in that Gauguin deals with this explicitly in his painting *Te Nave Nave Fenua* and the variations on paper associated with it (nos.105, 103). There are other Christian motifs in the Oceanic style to add to this, which brings our analysis back to Gauguin's position on religion. The author of *L'Église catholique et les temps modernes* and *L'Esprit moderne et le catholicisme* is reputed to have been the bitter enemy of missionaries, clerical authorities and the enforced evangelisation of the natives. Seen from this angle, religion is only one of the instruments of acculturation, that is, the establishment of a new order. Religion or the Church? Gauguin does not confuse the two. His critique is addressed to the Church, its hierarchy and its priests as the abettors of the new social order, of 'modern society: . . . people who from earliest childhood suffer from *misère*, the contempt of others and to whom the priest offers, as sole compensation and consolation, absolution, happiness in paradise, all of which is guaranteed by the State.'[27] We can easily find hundreds of similar quotations denouncing the Church as tyrannical, deceitful and extremely rich. This modern Church goes 'against the grain of true biblical doctrine and Christ'.[28] So we must not confuse 'in our repugnance, Christianity with (the Church) which claims to be identical to it, its traditional, privileged and infallible interpreter, whereas it was only ever its doctrinal misinterpreter and was practised in the wrong way'.[29]

On several occasions Gauguin the anticlerical, the scourge of corrupt and corrupting bishops, evokes the early years of Christianity and the archaic Church in contrast to modern clergy. It is not surprising therefore that, just as he tried to breathe new life into Polynesian myths, he also attempted to rediscover the way to a Christian art worthy of early Christianity's fervour. In 1888 he wrote to Van Gogh about the *Vision of the Sermon*: 'I think I have reached a great rustic and superstitious simplicity in my figures.'[30] The painting was rejected by the priest of the church to which Gauguin wanted to give it – 'naturally'[31] rejected, he writes to Émile Schuffenecker. Why naturally? Because this 'superstitious' conception of religion already belonged to the past, just as firmly as European aristocratic society and 'Maori' culture did. Running so counter to modern society, all efforts to revive the emotions and customs of past centuries and the old aristocratic world could only ever be doomed to misunderstanding or hatred.

Translated by Anna Hiddleston

THE LAST ORIENTALIST: PORTRAIT OF THE ARTIST AS MOHICAN

Vincent Gille

Fig. 32 Self-portrait as an Indian
Detail from a sheet of sketches
1889
Charcoal on paper
19 x 30
Current whereabouts unknown

We have a large orchestra, a rich palette, a variety of resources. We know many more tricks and dodges, probably, than were ever known before. No, what we lack is the intrinsic principle, the soul of the thing, the very idea of the subject. We take notes, we make journeys: emptiness, emptiness! We become scholars, archaeologists, historians, doctors, cobblers, people of taste. What is the good of all that? Where is the heart, the verve, the sap? Where to start out from? Where to go? We're good at sucking, we play a lot of tongue games, we pet for hours: but – the real thing! To ejaculate, beget the child! [1]

At the dawn of the twentieth century, in a place far from Europe, Gauguin's light went out. At the same moment, many nineteenth-century constructions of the 'Orient' also passed away: constructions created and made manifest, most notably, by the poet's pen, the painter's brush, explorers' tales and (more sinisterly) the military might of colonial expansion. To understand Gauguin as an Orientalist, here, is not to force him into a category to which he clearly does not belong – a school of painters that he himself called 'ethnographers'. It is to suggest that the impulse that drove him to travel for his art – whether it be to Pont-Aven, to Martinique or to Oceania – makes most sense in relation to the ways in which, from the 1820s to the last decades of the century, painters and poets left their homes to seek the colours, sounds and syntax of a real or imaginary 'Orient'. Perhaps we can best understand this desire to escape, to go to the ends of the earth, in the light of the ways in which the 1880s and 1890s set up a paradoxical dichotomy between the 'near' and the 'far': between Paris and the 'exotic', 'untamed' places that the city dreamt up and dramatised in its spectacular exhibitions. The here and there, the real and the imaginary, the mundane and the mythical, the civilised and the savage … (fig.32) permeable and changeable, the categories through which Gauguin weaved his

Fig. 33 Young Women in Traditional Costume in Pont-Aven
Musée des Civilisations de l'Europe et de la Méditerranée, Marseille

Fig. 34 Société d'Excursion des amateurs de photographie 'Brittany diorama' from the French room in the Paris Ethnographic Museum c.1895 Musée du Quai Branly, Paris

way were more present than ever in the spirit of the times. Between the far-off fantasies in which he got lost, seeking his way, and the countries whose characters and contours he tried to grasp, there is a middle ground where imaginary and real journeys, paradise and disenchantment come together. My text aims to follow him to the heart of that territory, tracing the steps of early nineteenth-century poets and travellers, ones who kept pace with their painterly and literary companions.

A Detour

In Paris, in January 1829, the young Victor Hugo published his second volume of poetry: *Les Orientales*. If its offerings were in keeping with the 'spirit of the times',[2] as their author himself observed, for their first readers, they had a poetic tone and brilliancy that were entirely new. Therein Hugo introduced a palette of novel sonorities, with an original vocabulary, handling unusual rhythms with distinctive brilliance. But the metaphors he used and the images he brought into play – from the predictably cruel Turkish warrior, to the ravished woman and the lascivious odalisque – were conventional nonetheless. This dabbling with the 'Orient' was an excuse to play with words, sounds and lights, to reveal great violence and diffuse eroticism. The 'Orient', in this scenario, was merely incidental: an ornament, a box of tricks containing all manner of sensations and landscapes. What mattered, then, was a question of aesthetics. The words were more important than the setting in 'This useless book of pure poetry',[3] as Hugo apologised in his preface.

Beyond the dazzling colours, sounds and rhythms, Hugo's poems introduced unusual narrative modes that disrupted traditional prosody: a succession of hypothetical questions in 'La Douleur du pacha', the repetition of one or several lines, like a refrain at the end of stanzas in 'Chanson de pirates' and 'Marche turque', a counting rhyme in the form of a wish in 'Voeu', or a curse as in his 'Malédiction'. The origin of these new ideas lay in popular Greek songs or Persian poems, medieval fables, oriental tales and Spanish romances. Hugo's recourse to these 'exotic' and popular sources, rich in 'naïve' imagery, unusual rhythms and original narrative modes, enabled him to break with the traditional forms and rhythms of epic poetry. This is characteristic not only of the *Orientales* but of romantic poetry in general: 'In the narrative poem, Romanticism, because it challenges old models, because it discovers new ones in what it naively calls "popular tradition", undertook research which was inconceivable up until then, into the construction of both the story and the narrative.'[4]

Gauguin and some of his circle at Pont-Aven had a similar approach when, in an attempt to break free from naturalism and Impressionism, they looked to the formal inventions of Japanese prints or *images d'Épinal* (popular nineteenth-century prints showing idealised scenes of French life); likewise when they attempted to absorb the

Fig. 35 *Noa Noa / Eve* 1893–7
pp.4–5, folios 3 verso, 4 recto
Woodcut on fine Japan paper pasted
on folio 3 verso
31.4 x 24
Musée du Louvre, Département des
arts graphiques, Fonds Orsay

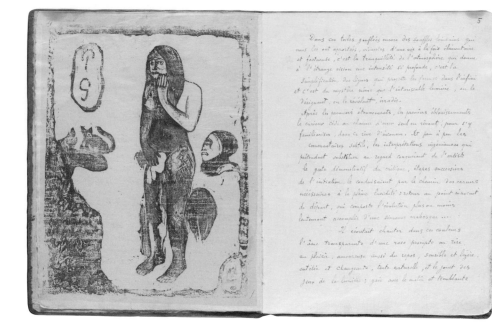

'character of the people and the country'.[5] 'I love Brittany', wrote Gauguin, 'I find the wild and the primitive here. When my clogs resonate on this granite ground, I hear the muffled, powerful thud that I'm looking for in painting.'[6] Brittany was perceived at the time as the place in France where popular traditions were still at their most vital, even if they were heading towards extinction (fig. 33). The room dedicated to Europe at the heart of the Ethnographic Museum that opened in Paris in 1884 presented, in particular, a reconstructed Breton house (fig. 34): 'The models of men and women that animate this interior are dressed in full contemporary costumes, several of which, though commonplace formerly, are dying out. Next to this group, [Breton] ethnography is represented with other costumes, including an intricate bride's gown decorated with sequins, some very curious christening bonnets, headdresses, etc.'[7] So Gauguin's approach can be understood as a comparable desire to enrich painting through 'naivety', straightforwardness, the direct transcription of immediate sensations and the appeal to the supernatural: the characteristics of popular tradition. And just as the aim of Hugo's volume of poetry was perhaps neither Orientalism nor exoticism, Gauguin's overriding priority – beyond his Breton, Martinican or even his Tahitian settings – seems to have been to bring about a fundamental formal and poetic shift. He did so by finding, via popular tradition, 'a lost paradise of poetry, which is a place of total light and total simplicity'.[8] Or, as he put it: 'I think I have attained a great rustic and *superstitious* simplicity in my figures.'[9]

Fables and Fantasies

Unlike Hugo, who dreamt of an 'Orient' he never visited, Gauguin travelled constantly. Back in France, he made his first journey the subject of a narrative of sorts; the subtitle of his *Noa Noa* is *Voyage à Tahiti*, which aligns its author with the great literary tradition of *Voyages* typified by, amongst others, François-René de Chateaubriand, Alphonse de Lamartine and Gustave Flaubert. Here I would like to pause for a moment to consider the extraordinary *Voyage en Orient* that Gérard de Nerval published in a series of articles between 1844 and 1850, and which he then brought together in a volume in 1851, several years after the journey itself of 1843.[10] Though it conveys a magical sense of homogeneity to the reader, in effect, Nerval's *Voyage en Orient* is a collection of fragments: a collage of what he had seen and what he had read. '[Nerval] saw less than he read. Often he saw thanks to books alone. Sometimes he makes us see what he had not seen, without making the difference between what he had read and what he had actually seen apparent.'[11] And just as, for example, the Cairo wedding procession that Nerval described was in fact based on information he gleaned in libraries,[12] the mythological tale Gauguin presented as having been told to him by his mistress – *Ainsi parlait Tehamana* – has its roots in the 1837 *Voyage aux îles du grand océan* by Jacques-

Pagode d'Angkor

Antoine Moerenhout. The *Noa Noa* manuscript is a yet more varied collage of things seen, read, borrowed and – in Gauguin's case – drawn. In the manuscript, to the text that constitutes the narrative, he added photographs, reproductions of artworks from all sources, drawings, woodcuts – these combined with biographical fragments, souvenirs, sketches and mythological tales. Nerval and Gauguin wished to recreate, each in his own way, the full sensory and intellectual experience of a *journey* that plunges the traveller into other landscapes, languages, customs and belief systems. Their texts were designed to 'speak' in the first person; therein the authors presented their own memories or transformed them through the inclusion of imported material. Gauguin interspersed his narrative with descriptions of paintings; but these appear seamlessly, as if the depicted scene had really taken place.[13] The addition of numerous woodcuts or drawings links the artwork to the journey inextricably (fig.35). Travel and the creative process are intermeshed; as if what was painted had really been *seen* and experienced. If Nerval, travelling as a poet, created a poetic work, Gauguin – the painter – created one that was essentially painterly.

Correlations can also be drawn between the references to what he called 'Maori' mythology that Gauguin integrated into his story and the legends and mythical tales that (on three occasions) punctuated Nerval's traveller's tale. This provokes a dualistic reading, which on the one hand links the journey to the narrator's contemporary life, and on the other connects it to an Arcadian past, to some kind of Eden before the fall. Thus the journey becomes an initiation. In the words of Nerval: 'Truly, I had already felt that in setting foot upon this mother earth, in re-immersing myself in the revered sources of our history and our beliefs, I would stop the passing of my years, that I would be a child once again in the earth's cradle, still young at the heart of this eternal youth.'[14] As for Gauguin, he seemed to find a piece of this far-off paradise in Tahiti: 'Everyday life – Tehamana opens up more and more. Docile, loving; the Tahitian noa noa perfumes everything. I am no longer aware of days and hours, of Good and Evil.'[15] Likewise he talked of *rejuvenation* as he left the island: 'Adieu, hospitable soil. I leave with two additional years – feeling twenty years younger, more barbaric and yet more learned.'[16] But this 'barbarism' must be understood as something rather different: as a search for material and spiritual harmony. 'There, in Tahiti, in the silence of beautiful tropical nights, I shall be able to listen to the sweet murmuring music of my heart's movements in loving harmony with the beings around me. Free at last with no money troubles and able to love, sing and die.'[17] Hence Gauguin's journey acquires one of the characteristics of voyages to the 'Orient' that, since the beginning of the nineteenth century, were always a return to origins, a nostalgic dream of a paradise lost, 'a flight back to the country of the

sun, to the cradle of humanity, that is to say towards the Orient, to bathe in the very source of the mystery of creation and eternity, to be reborn under the sign of the sun'.[18]

Journeys and Disenchantment

After Nerval, but in his shadow nonetheless, Charles Baudelaire and Gustave Flaubert introduced the idea that the journeys we undertake can never live up to our dreams. This gap was to grow as the century advanced as, increasingly, the imagined heavenly 'elsewhere' was found to be almost identical to one's place of origin. And when presented there, in Paris, this mythical destination transpired to be full of mirages. Pierre Loti's novels, the articles and illustrations of the *Tour du monde* and the *Journal des voyages*, the huge success of exhibitions and the extraordinary displays of the International Exhibitions, contributed to the belief that the world was within easy reach, that the most distant place could be brought quite literally to the pavements of Paris.[19] 'It is a fairy-tale. But a fairy-tale without parallel. All colours, all forms of monuments are there to charm you . . . As far as one can see are domes, bell-turrets, minarets, towers. A kind of unparalleled joy reigns over the ensemble. The eyes know not where to settle, since there are solicited from all angles, and we are tempted to run after the brightest [things], no longer knowing where they are. We walk in a dream', wrote Camille Debans in *Les Coulisses de l'exposition*.[20] Thus an all-encompassing syncretism was added to the now-familiar exoticism: all the world's eras, styles and forms were condensed into a few square kilometres (fig.36).[21] 'You were wrong not to come', wrote Gauguin to Émile Bernard of the 1889 International Exhibition. 'In the Javanese village, there are Hindus. All the art of India can be found there and the photographs I have of Cambodia can be found there replicated perfectly.'[22]

So Gauguin found in the literature of his time (travel journals, exotic novels and official propaganda), and in the colonial section of the 1889 International Exhibition, the images of his desire for elsewhere if not the source. ' . . . Under a winterless sky, on marvellously fertile soil, the Tahitian only has to reach up his arms to gather his food – and so he never works', wrote Gauguin to the Danish painter Jens-Ferdinand Willumsen. 'While in Europe men and women satisfy their needs only after relentless labour, whilst they struggle in convulsions of cold and hunger, tormented by poverty, Tahitians, on the contrary, as happy inhabitants of the unknown paradise of Oceania, are familiar only with the sweetness of life. For them, living consists of singing and loving (conference on Tahiti by Van der Veene)' (fig.37).[23] This completely idyllic description is copied almost verbatim from the 1889 Colonial Exhibition's official handbook, which offered an enchanting description of Tahitian women taken from the same conference speaker. The text continued in the same tones: 'Born under a winterless sky, on marvellously fertile soil, the Tahitian only has to reach up his arms to receive the bread tree fruit and the féhi which constitute the basis of his food.'[24]

Gauguin's 'Orient', if enlarged to include the French Colonial Empire,[25] functioned as an antidote to his hatred of European civilisation. His desire to get away smacks of escapism: 'May the day come (and maybe soon)', he wrote to his wife Mette, 'when I can run and escape into the woods of an Oceanic island, living there on rapture, calm and art. Surrounded by a new family, far from this European struggle for money.'[26] And so he left, and he left on exactly the same terms as would an Orientalist painter: supported by an official mission,[27] and with the idea that he would for a certain time garner 'documents' to feed his work. 'When I come back I will have enough to satisfy customers . . . I feel I am beginning to grasp the Oceanic character and I can assure you that what I am doing here has never been done by anyone else and is unheard of in France.'[28] Furthermore, at first, his journey appeared to live up to the expected enchantment: 'I am writing to you this evening. The silence of the night in Tahiti is even stranger than the rest. It exists only here, without a bird cry to disturb the peace . . . The natives often move around at night, but barefoot and silently. Always this silence. I understand why these people can stay sitting for hours, for days, without speaking a word and looking melancholically at the sky. I feel that all of this will take me over . . .'[29] These words are reminiscent of the Baudelaire of *Les Projets*, where a character describes an engraving: 'By the seashore, a fine wood cabin, surrounded by all those bizarre, gleaming trees whose names I've forgotten . . . in the air, that intoxicating,

Fig. 37 Charles Georges Spitz
Fishing Scene near Afaahiti,
Tahiti c.1889
Photograph
Serge Kakou Collection, Paris

Fig. 38 Jules Agostini
Gauguin's house in Tahiti
Photograph
Musée du Quai Branly, Paris

indefinable scent . . . around us, beyond the room lit by the pink light filtering through the blinds, cool braided mats and sensual flowers . . .'[30]

But it was only a dream. Quite clearly, the liberating journey – the one to resolve all problems, widen horizons, the one that would reveal and satisfy the 'savage' self did not unfold as planned. It is possible that this 'savage' heart, like the 'savage' people exhibited on the outskirts of Paris and at the Esplanade des Invalides, was itself an illusion: a decoy, a perverse invention that might serve to justify the process and progress of colonisation.[31] The 'elsewhere' that Gauguin hoped for so desperately did not exist, could not exist; contained by colonisation, it had disappeared entirely. 'The Tahitian soil is becoming entirely French', he wrote to Mette upon arrival, 'and little by little the way things used to be will disappear entirely.'[32] So disenchantment overtook Gauguin fairly quickly, a disenchantment common to a good many writers in the second half of the nineteenth century, as they too awakened to the realisation that the 'Orient' was but an illusion. To quote Nerval, for example: 'In sum, the Orient does not come close to that waking dream I had of it two years ago, or rather, that Orient is even more distant and unattainable. I have had enough of running around after poetry; I think it is on your doorstep, or perhaps in your bed. I am still a man who runs around, but I am going to try to stop and wait.'[33]

Painting, Exile

Perhaps after all, painting, like poetry, is not to be found at the ends of the earth. To his wife who reproached him for distancing himself from Paris, the supposedly real artistic centre, Gauguin replied: 'My artistic centre is in my mind'.[34] He already said of his stay in Martinique (my emphasis): 'The experience I had in Martinique was crucial. I only really felt *myself* there and it is in what I brought back from there that you should look for me, if you want to know who I am, even more than in my Brittany works.'[35] Beyond its location, painting is therefore *also* the result of an inner desire – 'what I desire is a corner of myself that is still unknown', he explained to Émile Bernard.[36] Gauguin, who never stopped describing himself as a savage, an Indian, a primitive, perhaps discovered, in an 'Orient' that was not so much exotic as created in direct opposition to the hated West, an understanding, a mysterious harmony, comprised of light and spirit, colours and perfumes, 'one of the greatest spiritual riches that I came to look for in Tahiti'.[37] Just as in *Les Orientales* Hugo created a work of poetry above all else, and just as Nerval, when writing his *Voyage en Orient* sought, beyond anecdote and simple narrative, truly mythical material within which to inscribe and understand his own life, it may be that Gauguin, by and in his work as a painter, thought to capture an authentic Orient which dwelt within himself, one that he could bring to light because he recognised what he saw. For the Oriental dream is, indeed, a dream, that is to say an inner journey. 'Man cannot change the depths of his heart. Exterior objects can distract him for a moment, but what will occupy him continuously and present itself to him continuously is his inner self, the

Fig. 39 Henri Lemasson
Atiheu Bay (Nuku Hiva), Marquesas
Islands
Photograph
Serge Kakou Collection, Paris

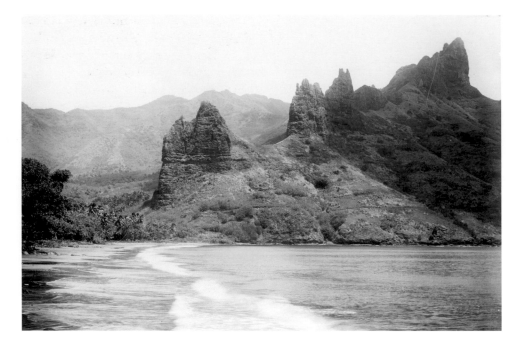

familiar dreams of his soul. After wandering around outside of himself for a while, he will, so to speak, go back into his heart.'[38]

Gauguin returned to Paris. The topic of his travelling, exile and exotic works had been effective forms of promotion, and they were used as such by his fawning admirers and preface-writers. At the time of the painter's first departure in 1891, Octave Mirbeau had written: 'I hear that M. Paul Gauguin is leaving for Tahiti. He intends to live there alone for some years, to build his hut and work anew on the things that haunt him. I found the idea of a man voluntarily fleeing civilisation in search of oblivion and silence in order to feel better, to hear better the inner voices that suffocate in the hubbub of our passions and arguments, both curious and disturbing . . .' (fig.38).[39] Gauguin's insistence on giving his works Tahitian titles, his extravagant costumes, his relationship with Annah la Javanaise, his studio in rue Vercingetorix decorated with Tahitian objects and accessories, all of this combined during his last stay in Paris to highlight his exiled, barbarous, wild character. However, between Gauguin's first and second trips to Tahiti there was a marked difference. The first, which can still be seen as the typical Orientalist undertaking, was only a *journey*. The second resembled an exile – due to continual financial problems and a feeling of failure: '. . . the difficulty in earning my living in a regular fashion despite my reputation, and my taste for the exotic into the bargain made me take an irrevocable decision . . . I am going back to Oceania . . . Nothing will stop me from leaving and it will be forever. What a stupid existence is European life.'[40] This time he intended never to return, 'since my project to bury myself in the Pacific Islands', as he wrote to Maurice Denis.[41] This exile, coupled with his virulent hand in Tahitian political controversy between 1898 and 1899, and the disenchantment born from his work's lack of success, seemed at first to drive him to the role of a simple colonist. 'I am currently organising my life in such a way as to dissociate myself more and more from painting, to withdraw as they say from the art scene by undertaking written work in Tahiti or with a bit of agricultural work on my land.'[42] At this stage, clearly, the dream seemed broken, the man resigned.

Yet there would be a last burst of energy. 'I am grounded today, overwhelmed by misery and especially by the sickness of an altogether premature old age. Will I have some respite so that I can finish my work, I hardly dare to hope: in any case I shall make a last effort next month by moving to live on the still almost cannibalistic Marquesas Island of Fatu Hiva. I believe that there, the entirely savage element, the complete solitude will give me a last fire of enthusiasm before dying which will rejuvenate my imagination and be the conclusion of my talent'[43] (fig.39). In Nerval's words, this really was a yearning for 'a more distant, unattainable Orient'; and an 'Orient' of cannibals, no less, the most savage of 'savages'. Since Tahiti had become a country of colonists, it was necessary to journey

further still. To follow this logic – ultimately, the logic of an Orientalist – would be to disappear definitively, to merge with this communion of an 'Orient' at once real and chimerical, visionary and inaccessible. This required a sensitive harmony between the painter and this land of origins, a harmony produced by a certain degree of openness. Such a conclusion was no longer a question of understanding, characterising or clarifying,[44] but of becoming one with the dream, of allowing the landscape and the myth to crystallise in his work. Here the search for a mythical Orient, where man's natural, immemorial links with the world could be restored, finds its terrain. 'The path of the stars and the Desire for the Orient – Europe . . . – the dream becomes real – The seas – memories unravelling through – Men have made me suffer – Climate where my head rests – Loves left in a tomb – She, whom I had lost – . . . – Vessel of the Orient', notes Nerval in his *Carnet du Caire*.[45] On the subject of *Where Do We Come From? What Are We? Where Are We Going?*, Gauguin noted: 'The idol is there not as a literary explanation, but as a statue, less statue perhaps than the animal figures; less animal too, becoming one in my dream, in front of my hut, with the whole of nature, dominating *our primitive soul*, the imaginary consolation of our sufferings and what they contain of the vague and the uncomprehending before the mystery of our origins and our future.'[46] And so that we might bear witness to this dream, so that in Paris his works could be understood as a *veritable* Orient[47] – that is to say, one born of an immaterial, heavenly dream – the painter had to fade, dissolve completely into this timeless – and non-existent – Orient. In some sense, it is as Daniel de Monfreid addressed Gauguin: 'You are currently this extraordinary, legendary artist, who from the depths of Oceania sends disturbing, inimitable works, definitive works of a great man who has in a way disappeared from the world . . . In short, you enjoy the immunity of great dead men, you have passed into the History of Art.'[48] As for Gauguin, he echoed this with a last dream: 'No later than last night I dreamt I was dead and, strangely enough, it was the true instant when I lived happily.'[49]

Translated by Anna Hiddleston and Nancy Ireson

GAUGUIN AND SEGALEN: EXOTICISM, MYTH AND THE 'AESTHETICS OF DIVERSITY'

Charles Forsdick

The 'Significant Missed Rendez-Vous'

When, in January 1903, Paul Gauguin's life was drawing to a close, a young French naval doctor thirty years his junior, with literary aspirations and emerging ethnographic interests, arrived in Polynesia. Having recently completed his medical training, Victor Segalen (1878–1919) was entering the first stage of his own short yet intense, diverse and extremely productive career. Segalen's posting as medical officer on the vessel *Durance*, stationed in Papeete but with various duties throughout the French possessions in the Pacific, would be followed throughout the final decade of his life by a number of periods in China. It was such contact with radically different, 'exotic' cultures that would subsequently allow Segalen to become the French author and thinker who most consistently explored questions of cross-cultural encounter, and who also addressed, in the opening decades of the twentieth century, closely associated issues of cultural diversity and its decline.[1]

The anthropologist James Clifford describes the arrival of Segalen on Hiva-Oa in August 1903, three months after Gauguin's death, as a 'significant missed rendez-vous'.[2] Had Segalen, en route for Papeete, not been delayed in San Francisco by the typhoid he contracted whilst crossing the United States, and had his arrival in the Pacific not coincided with a devastating cyclone in the Tuamotu archipelago (to which his ship was called to give emergency aid, and to transport the surviving inhabitants to neighbouring islands), then the two might actually have met. It remains of course a subject of speculation as to how Gauguin would have reacted to the visit of the young naval officer, although Segalen's Breton origins and his association with literary and artistic figures with whom the painter was familiar would undoubtedly have stood him in good stead. In Clifford's view, however, this failure to meet did not serve as an obstacle to Segalen's engagement with Gauguin; it might even be suggested that the lack of direct contact permitted instead a more openly creative, even mythologising interpretation of the artist and of his particular perception of the Pacific.

This interpretation would, in many ways, serve as the foundation of Segalen's struggle during the final fifteen years of his life to articulate what he called an 'Aesthetics of Diversity'. Segalen's exoticism, grounded very clearly in the initial experience of the Pacific, prefigures contemporary, postcolonial debates regarding the globalisation of cultures (and the possibility of resistance to such processes), and has as a result contributed to his growing status as an influential thinker in this field. For Clifford, Segalen serves – along with his near contemporaries Blaise Cendrars (1887–1961) and Antonin Artaud (1896–1948) – as a direct inheritor of Gauguin and Arthur Rimbaud (1854–1891). He is one of a group of writers and artists who challenged the colonial exoticism of the fin-de-siècle as it persisted into the early decades of the twentieth century, and who sought to develop a 'postsymbolist poetics of displacement' dependent on 'more troubling, less stable encounters with the exotic'.[3]

Segalen's contribution to such a poetics is concentrated in a diverse and extensive corpus of works, most of which remained unpublished at his premature death at the age of forty-one. These works reflect his polymathic interests (ranging from ethnography to archaeology, from art history to musicology) as well as his ability

Fig. 40 Daniel de Monfreid
Portrait of Victor Segalen 1909
Oil on canvas
65 x 51
Private Collection

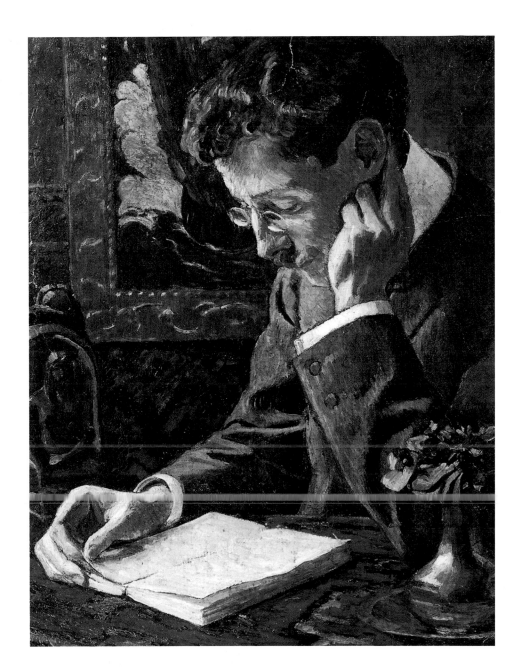

to engage with and often re-engineer a range of literary genres. His oeuvre is customarily divided into a series of 'cycles', reflecting his evolving interests and the changing geo-cultural contexts of his writing.[4] The first of these cycles, after the medico-literary criticism of his very early career, is 'Polynesian' ('le cycle polynésien'), and it is here that Segalen's principal writings on Gauguin are to be found: passages in his travel diary; an early article in the *Mercure de France*; the multiple drafts of an unpublished, semi-biographical novel inspired by the life of the artist; the long introduction to the first edition of Gauguin's letters to Daniel de Monfreid. The apparent neatness of these groupings, however, disguises the fact that Gauguin remained an object of fascination for Segalen throughout his literary career to such an extent that the artist was the subject of both his earliest and his final writings.[5] Gauguin's persistently catalytic role in the evolution of Segalen's thought is equally apparent in his correspondence, in which there are regular references to the artist. His influence is also present in Segalen's Chinese travel journals, where attempts to capture the colour and texture of place rely in a number of cases on references to Gauguin's distinctive gaze and palette.

David Sweetman's characterisation of Segalen as 'the first of many who would build a career out of Gauguin's memory' thus only tells part of the story.[6] Exploring the relationship between Gauguin and Segalen is in fact doubly illuminating: not only does it allow us to understand Segalen's progressive emergence, in this initial Polynesian context, as an artist and thinker, and to explore the ways in which that first contact, in

*Fig.41 Seated Tahitian 1896–9
Noa Noa, opening page of Chapter
XII, folio 89 recto, p.171
Watercolour monotype on wove paper
covered with thin tissue, pasted onto
the manuscript page
Musée du Louvre, Département des
arts graphiques, Fonds Orsay*

*Fig.42 Max Anély [Victor Segalen]
Les Immémoriaux
Paris, Mercure de France, 1907
Limited edition with leather binding
designed by Segalen and executed by
his wife Yvonne
Private Collection*

the work of Gauguin, with a radically different culture (and a radically different way of looking at that culture) constantly shaped his subsequent reflection on exoticism, most notably in China; but it also permits us to track key stages in the rapid emergence of Gauguin's own afterlife as an increasingly fictionalised and mythologised figure of more generally symbolic proportions.

'He was called Paul Gauguin'

In a letter to his parents from the Marquesas Islands, dated 5 August 1903, Segalen recounts his medical duties among the indigenous population: 'seventy-five children vaccinated, sixty-five teeth extracted'. He goes on to outline the way he was spending his free time: 'On a neighbouring island, a painter who had escaped from the Symbolist school has just died . . . I have enjoyed piously going through his manuscripts, collecting impressions of his final days that I am going to send to his friends in Paris who will be grateful to me for having defended, from so far away, a group to which I am increasingly attracted. He was called Paul Gauguin.'[7] Despite the nonchalant tone of the correspondence and the implication that his family were unfamiliar with the painter, Segalen himself was certainly aware of Gauguin's work before his departure for the Pacific, not least because of his contact with figures in the Symbolist and post-Symbolist milieu of the *Mercure de France*, including Remy de Gourmont (1858–1915) and Saint-Pol-Roux (1861–1940). He was also acquainted with Dr Gouzer, a naval doctor like himself, who had been one of Segalen's supervisors at the hospital in Brest during his studies there in 1898. Gouzer had met Gauguin in 1897, during his own tour of duty in the Pacific, and appears to have bought a canvas from the painter (possibly it was a gift, according to de Monfreid), which it is likely that Segalen had seen before his departure from France in 1902.[8]

As Segalen's later 'Hommage à Gauguin' (1918) makes clear, the preliminary information he received in the field was less sympathetic, with one interlocutor responding to enquiries in a particularly dismissive manner: 'Gauguin? A mad man. He painted pink horses.'[9] Segalen remained curious, however, about this compatriot living remotely on Hiva-Oa, around nine hundred miles from Tahiti and about a week away from the Polynesian capital by sea. There is no evidence that he was at this time aware either of Gauguin's legal difficulties or of the trial he underwent shortly before his death for defamation of a government official (he was fined 500 francs and sentenced to three months' imprisonment), and when the painter died on 8 May 1903 Segalen was in New Caledonia, only receiving the news of his death on his return to Tahiti in early June. By a happy coincidence, however, it was the *Durance* that was sent to the Marquesas Islands to collect Gauguin's remaining possessions. Segalen's ship arrived at Nuku-Hiva, the archipelago's administrative capital, on 3 August, and it was there that the young medical officer had his initial contact with what he dubbed in his diary 'traces' of the painter. In the local administrator's house, Segalen was able to sift through a case of manuscripts, letters and other papers taken from the dwelling on Hiva-Oa. As the remainder of Gauguin's possessions not already sold at auction in the artist's 'House of Pleasure' on 20 July were transported to Papeete for a second sale, it was these 'relics' that he consulted on board ship, transcribing several passages into his *Journal des îles*.

Segalen compensated for the absence left by Gauguin's death by attempting to recover whatever traces of him were left. He talked to the artist's friends, spoke to those such as Tioka and Ky Dong who had been with him in his final months, and met local figures including the gendarme Jean-Pierre Claverie and the Protestant missionary Paul Vernier, both of whom had played key roles in the circumstances surrounding Gauguin's death. Segalen also visited the 'House of Pleasure' itself while on Hiva-Oa, using his observations and interviews to reconstruct – in a way that David Sweetman accurately sees as 'more fanciful that factual' – an account of the artist's final days.[10] Unusually, Segalen's initial direct contact with Gauguin's life and work was therefore not so much through his painting as through his writing and thought. Thirteen manuscripts were included in the chests transported on the *Durance*,[11] and Segalen's

Fig.43 *Breton Village in the Snow* 1894
Oil on canvas
62 x 87
Musée d'Orsay, Paris

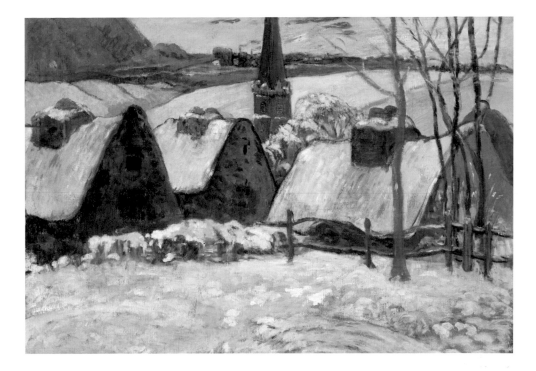

diary contains transcribed passages from the artist's expanded and annotated edition of *Noa-Noa* (fig.41) as well as from the then unpublished *Cahier pour Aline*, of which he was almost certainly the first reader (no.126).[12] These texts by Gauguin clearly had a direct influence on Segalen's own Polynesian writings (and on the substantial correspondence he wrote while in the region), in which there are very clear traces of the artist's reflections on the devastating effects of colonial contact, on the aesthetics of representing the Pacific and its peoples, and on the affective dimensions of his personal contact with Polynesian culture. Gauguin's manuscripts can also be seen as a clear inspiration for, or at least galvanisation of, Segalen's plans for his first major work, the ethnographic novel *Les Immémoriaux*, which would appear in 1907 (fig.42).[13] The impact of this encounter with Gauguin's work would persist throughout the remainder of Segalen's life, with the artist embodying the more general intellectual, aesthetic and deeply personal impact that Segalen's stay in Polynesia itself had generated.

Papeete, 2 September 1903
On his return to Papeete on 20 August 1903, Segalen was involved in what has become one of the key scenes in modern accounts of exoticism in the French-speaking world (as well as one of the most regrettable episodes in the history of modern art): the auction of the fifteen cases of Gauguin's remaining possessions that had arrived back in Tahiti the same day. Segalen had already had the opportunity to examine closely these artefacts on board the *Durance*, and the experience had clearly strengthened his resolve to invest the equivalent of almost a month's salary in purchasing twenty-four lots in the sale on 2 September.[14] Already aware, from his observations on Hiva-Oa, of the misunderstanding to which Gauguin's work was widely subject, Segalen's reaction to the auction may be read as an act of salvage that represents at the same time a seminal moment in the construction of Gauguin's posthumous reputation. The local authorities had discarded a number of lots judged unfit for sale, and the keenest interest was in Gauguin's carriage, furniture and other household possessions. The attitude to his art was principally one of derision. As Gilles Manceron notes, this public response is reflected in the fact that the artist's sewing machine was sold for eighty francs, whereas one of his canvases went for a mere two francs.[15] Segalen records that when the canvas of *Breton Village in the Snow* (fig.43), which he subsequently purchased, was held up on its side, the auctioneer dismissed it as an image of Niagara Falls, much to the amusement of the crowd.[16]

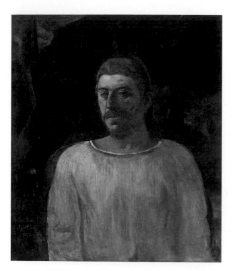

Fig. 44 <u>Self-portrait near</u>
<u>Golgotha</u> 1896
Oil on canvas
76 x 64
Museu de Arte, São Paolo

For Segalen, who by this stage had already assumed the role of the artist's 'inflexible champion', purchasing Gauguin's relics was an 'act of piety' and an element of what he saw as 'fighting the good fight' against the philistine religious and colonial authorities.[17] Of extremely limited means, Segalen nevertheless managed to secure seven of the ten canvases included in the sale, as well as a large number of prints, photographs, drawings, books, sketchbooks and carvings (including, most significantly, the panels that had surrounded the door of the 'House of Pleasure' (no.155).[18] Much of the remaining material was either scattered or discarded, but Segalen is to be credited with saving key works such as *Scene of Tahitian Life* and *Self-portrait near Golgotha* – one of Gauguin's final paintings in which he depicts himself – a canvas in such poor condition that he had it restored on his return to France (fig.44). In addition to two other unidentified paintings, he also purchased a second Breton canvas, *Christmas Night* (fig.51), described in his diary among the objects initially discovered at Nuku-Hiva. Among the lots Segalen acquired was a further key relic that he would subsequently use to suggest that *Breton Village in the Snow* had been the artist's final work, namely, Gauguin's palette, purchased for a derisory two francs.

Segalen undoubtedly saw the purchase of such a range of lots as an automatic means of gaining an entrée to those artistic circles in Paris in which, on his return to France, he aspired to move. It was certainly a crucial act of protection, in a material sense and in terms both of Gauguin's and his own reputation, that would win him favour with members of the artist's circle, such as George-Daniel de Monfreid, who he met in 1905 and with whom he indeed developed a close association. De Monfreid painted what is perhaps the best-known portrait of Segalen in 1909 (fig.40), which shows the author seated at his desk beside Gauguin's sculpture, the *Idol with a Pearl*, and painting, *La Barque* (no.85). At the same time, however, Segalen's purchases reflect the impulsive and instinctive reaction that the indirect encounter with Gauguin triggered in him, a response that he described toward the end of his life, in 'Hommage à Gauguin', in terms of a 'duty'.[19] The objects that he brought back with him to France were slowly dispersed (a process continued after his death by his family), both as gifts and, with the steady rise of Gauguin's reputation, as a source of income; and these artefacts continued to be subject to journeys of their own. The carvings from the 'House of Pleasure' were, for instance, lent to Saint-Pol-Roux in 1905 to decorate his home on the Crozon Peninsula in Brittany, until Segalen requested their return during the First World War when he sought inspiration for his text 'Hommage à Gauguin'; they remained in the family, featuring in a photograph that accompanied an article about Segalen's daughter published in *Vogue*, before being acquired – along with canvases and other items – by the Louvre in 1952.

'Gauguin in his final setting'

In his *Journal des îles* Segalen transcribed the final line of Gauguin's *Cahier pour Aline*: 'To my daughter Aline, scattered notes, discontinuous like Dreams, like Life made up entirely of different pieces.'[20] The fragmentation described here reflects equally the material – both concrete artefacts and gathered information – with which Segalen himself was left after both the visit to the Marquesas and the auction at Papeete. It was nevertheless from such sources that Segalen began to assemble the multifaceted image of Gauguin to whose construction he would continue to contribute until his own premature death in 1919. For David Sweetman, the privileged yet indirect access to the material sites and artefacts associated with the end of Gauguin's life triggered, almost immediately after the artist's death, the processes of his mythologisation: 'Segalen was a worthy disciple in the way that his account of Gauguin's life in Atuona merges truth and fiction, launching the myth of the solitary artist-hero of the Pacific, the tortured genius.'[21] Segalen was a key figure in the posthumous recognition of Gauguin, not only because of the salvage of works and other relics at the auction on 2 September 1903, but also because he would go on to publish the first detailed account of Gauguin's final weeks and of his physical surroundings at the time of his death.

Segalen wrote letters to a number of Gauguin's key friends and associates – Charles Morice, Saint-Pol-Roux, Remy de Gourmont and Daniel de Monfreid –

Fig.45 *Self-portrait drawing*
c.1902–3
Pencil on paper
15 x 10
Musée du Louvre, Département
des arts graphiques, Fonds Orsay

to inform them of the painter's death, but it was in 'Gauguin dans son dernier décor' ('Gauguin in his final setting'), which appeared in the *Mercure de France* in June 1904, that we read his first published reflections on his visit to Hiva-Oa. The article retains an immediacy and freshness that result in part from the fact that Segalen, despite his failure to meet Gauguin, was one of only a few observers sympathetic to the artist to be in the Pacific at around the time of his death. The text presents the (reconstructed) surroundings of the artist in his final days in theatrical terms, and describes the objects left in his dwelling in the terms of quasi-religious relics. Among these, he focuses in particular on works he purchased at the auction – most notably *Self-portrait near Golgotha* and sculpted panels that had been placed around the door of Gauguin's 'House of Pleasure' (four of the five of which he had purchased at auction). In a reference to *Breton Village in the Snow*, Segalen also for the first time makes the apocryphal claim – repeated elsewhere in his work – that, shortly before Gauguin's death, the artist had focused on the radically different vision of a snow-covered Brittany.[22]

 Central to the article is an attempt to encapsulate Gauguin's outsider and even 'outlaw' status, and this study is the likely foundation of Segalen's later unfinished project, entitled *Les Hors-la-Loi* (Outlaws), in which the artist was to have figured alongside other figures such as Rimbaud. The reference to *Near Golgotha* alludes also to the artist's own conscious self-fashioning, and it is significant that among the lots purchased by Segalen was an additional undated sketch, *Self-portrait drawing*, for which he paid fifteen francs (fig.45). Adopting a stance reminiscent of Auguste Rodin's (1840– 1917) *The Thinker*, Gauguin shows himself as fragile, emaciated and deep in thought. As a result of observing these works, Segalen becomes aware from an early stage of the artist's self-performative, self-mythologising tendencies, and the efforts to project a certain version of himself that this betokens. Segalen actively contributed to these efforts by laying the foundations for Gauguin's posthumous mythologisation, and 'Gauguin dans son dernier décor' ends with the particularly enigmatic phrase of the artist's companion Tioka: 'Now there are no more men.'[23] By recording this mournful observation, Segalen signals the sense that Gauguin's death constitutes the premature conclusion of an aesthetic project similar to his own, the aim of which was to capture traces of a culture in decline before its distinctiveness was lost to the entropic effects of colonialism and Westernisation.

Mythologising Gauguin: The Master-of-Pleasure

'Gauguin dans son dernier décor' was Segalen's first published literary work. With it – fifteen years before Somerset Maugham had published *The Moon and Sixpence*, his 1919 short novel inspired by Gauguin's life, and almost a century in advance of Mario Vargas Llosa's *The Way to Paradise* (2003) – he began the processes of fictionalising Gauguin's life that have played a central role in the more general mythologisation to which he has been subject. Segalen himself worked for almost a decade, between 1907 and 1916, on a fictional account of Gauguin's life entitled *Le Maître-du-Jouir* (The Master-of-Pleasure), the final manuscript of which he had hoped to complete during a six-month stay in the Pacific after the First World War. The novel constitutes a clear shift from history to myth, and Segalen outlines the project in a letter to the philosopher and essayist Jules de Gaultier, where he describes his protagonist, a semi-prophetic Western character with Nietzschean overtones, whose aim is to re-infuse Tahitian culture with what it has lost, 'joyous, naked life'. He continues: 'The painter Gauguin sketched out, with certain aspects of his life, the outline of this man. It is a matter of re-imagining his dream.'[24] The published version of the novel begins with a statement of ignorance: 'I did not know this man, or at least not his living person, and I do not claim ever to have got close to him.' But this distance permits the emergence in the text of a re-imagined, mythologised figure whom Segalen describes as feeling a growing anxiety regarding the Western presence in the Pacific and the apparent indifference of the indigenous population to the implications of that presence. The planned novel begins where Segalen's *Les Immémoriaux* concludes. It outlines the efforts of the eponymous hero to recover 'dead voices' and to counter an aesthetics of cultural decline (associated in Segalen's mind with the exoticist fictions of Pierre Loti in particular) by adopting a

Fig.46 Portrait of Victor Segalen
1904
Photograph
14 x 9.8
Private Collection

subversive, regenerative form of artistic intervention that permits a new generation of Tahitians to unlearn Western teaching and influence, to rediscover and reconnect with traditions seen as forgotten or lost.

Segalen presents the artist's project as a form of external intervention to protect Pacific cultures against not only European influence but also indigenous indifference to that influence. Recent scholars have often countered the interpretation of Gauguin represented in *Le Maître-du-Jouir*, a text that is characterised equally by a violent reaction against all manifestations of cultural and biological hybridity. Some have seen in Gauguin an attempt to capture a culture in transition, in which the indigenous and the Western are juxtaposed and seen in a process of negotiating the relationships that connect them; others have signalled the artist's denial of local agency, and his inability to imagine an indigenous response to the nefarious effects of cultural contact. In relation to the latter, Stephen F. Eisenman claims: 'For Victor Segalen, Gauguin was every bit as racially exotic a being as the Marquesans with whom he lived; his works and personal effects must therefore be gathered together before they turned to dust, before that is, they joined the forgotten memories ('les immémoriaux') of the Polynesians themselves. Like Gauguin, however, the native people of the Pacific refused to become relics and pass into the tomb of history.'[25]

Such a postcolonial interpretation may be seen to detect the ideological blind spots in both Gauguin and Segalen, but there is a risk that such retrospective interpretations ignore the divergence between the aesthetics of diversity on which their work depends and the received wisdom regarding other people and cultures evident in the cultural production of the majority of their contemporaries. Segalen, like Gauguin, was the product of a particular historical niche, and the author discovered in the work of the artist a means of critiquing the context from which he emerged. The impact of Gauguin on Segalen's work was not restricted to his Polynesian texts: it is in evidence throughout the reflection on exoticism that would dominate Segalen's career. Perhaps his key work is the unfinished, undoubtedly unfinishable *Essai sur l'exotisme* (Essay on Exoticism), an accumulation of fragments produced over fourteen years between 1904 and 1918. The role of Gauguin in this work is evident from the outset: in the opening note – drafted off Java in October 1904, as Segalen returned home to Brittany from his first tour of duty – the impact of Polynesia is underlined, and the centrality of the artist is apparent from his inclusion in a list relating to painting and exoticism.

The only other reference to Gauguin relates to Segalen's supposition – subsequently challenged by scholars, as has been discussed above – that the final work on which Gauguin had worked whilst on Hiva-Oa was *Breton Village in the Snow*, the canvas of which he claimed had been found on its easel at Gauguin's death. Segalen's own relationship to his native Brittany was a contradictory one, characterised not only by the chronic extroversion that motivated his endless travelling, but also a complementary attraction that constantly drew him back to the region where he himself would die prematurely in May 1919. The image of the dying artist ignoring his tropical Marquesan surroundings and longing for the Breton winter thus appealed doubly to Segalen, as a reflection of his own ambivalent relationship toward the region, but also as an example of the radical alternation between differences on which his concept of exoticism depends. Segalenian exoticism may be seen to evolve according to two stages. The initial phase, inspired by the author's experiences in the Pacific, suggests that exoticism is in fact bilateral and not simply ethnocentric, and permits as a result a reversal of perspective according to which the Western traveller is viewed through non-Western eyes, being subsequently exoticised. The second stage, associated with Segalen's contact with China, focuses instead on the opacity or radical alterity of cultures, and their potential resistance to an external gaze. The impact of Gauguin is apparent in each of these stages, for despite their different emphases both depend on diverse senses as a mode of mediating otherness, both imply a reciprocity as a result of which the stability of Western travellers' identities is itself challenged by the presence of those they meet. As Segalen outlines in 'Hommage à Gauguin', what he principally discovered in Gauguin was an alternative way of seeing: 'Before him . . . no convincing image of a Maori had been seen in Europe . . . From now on, no traveller can claim to have fully

seen the landscape and inhabitants of these islands if they have not been revealed and explained to him through Gauguin's canvases.'[26] The impact of Gauguin's aesthetics on his own approach to writing became apparent early, for as he wrote to de Monfreid in 1906, in relation to *Les Immémoriaux*: 'I have tried to "write" the Tahitians in a manner similar to the way in which Gauguin saw them to paint them: in themselves and from inside outwards.'[27]

The 'significant missed rendez-vous' of 1903 had such an impact on Segalen that he spent the next fifteen years of his life attempting to understand who Gauguin was and what, posthumously, he meant for Western art and its representation of other cultures. Segalen's notion of exoticism is the outcome of such a reflection, and from the artist this concept draws a number of questions that continue to influence those who explore cultural difference and the modes of its representation. To what extent does Western art attempt to tame non-Western cultures, or to what extent might those cultures generate instead a troubling inverse exoticism, destabilising accordingly established aesthetic assumptions and practices? How might the alternation or contrast of cultural extremes disrupt the emergence of an entropic middle ground associated with levelling forces such as, in a contemporary context, globalisation? And, finally, might the role of the creative artist be not the domestication of other cultures but rather the representation of their persistent opacity, their ultimate impenetrability when faced with an intrusive external gaze?

GAUGUIN: A VERY BRITISH RECEPTION

Amy Dickson

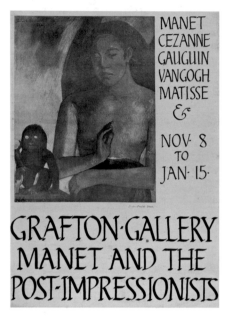

Fig.47 Poster for 'Manet and the Post-Impressionists' at the Grafton Galleries 1910

A century has passed since Roger Fry's groundbreaking exhibition *Manet and the Post-Impressionists* opened at the Grafton Galleries in London with a private view on the evening of 5 November 1910. The impact of the exhibition was immediate and explosive, with over fifty articles appearing in the press in November alone.[1] In a letter to his father, Fry described the 'wild hurricane of newspaper abuse from all quarters'.[2] Criticism ranged from the comical to the sinister: H.M. Bateman's humorous cartoon for the *Bystander*, 'Post-Impressions of the Post-Impressionists', depicts an English gentleman in top hat and tails, upright and respectable 'before' his trip to the Grafton Galleries, then bent over, swooning, mopping his brow 'after' the experience, as well as caricatures of the well-to-do clutching their sides and each other in uncontrollable mirth at the sight of this new art (fig.48). Robert Ross's wry review in the *Morning Post* was explicit in its political implication: 'A date more favourable than the Fifth of November for revealing the existence of a wide-spread plot to destroy the whole fabric of European painting could hardly have been chosen.'[3] Ross's review itself was critical dynamite when considered against the backdrop of contemporary concerns about social and political unrest, from the constant news reports about anarchist groups active in Europe to the mobilisation of the suffragette movement, which by 1910 was gaining momentum at home.

The 1910 exhibition, which was visited by around 25,000 people during its run of two months, proved a *succès de scandale*, playing a significant role in bringing 'modern art' into the British consciousness and in the development of a critical discourse around 'modernism'. Fry's selection of works for the show was decidedly influenced by Julius Meier-Graefe's seminal book, *Modern Art: Being a Contribution to a New System of Aesthetics* (1904), recently translated into English (1908).[4] Three of Meier-Graefe's modernist protagonists, Paul Cézanne, Vincent Van Gogh and Paul Gauguin, emerged through the 1910 show into the collective British mind as pioneers of modern art. With more works in the show than the other artists, and his *Poèmes Barbares* of 1896 as the poster image for the exhibition (fig.47), Gauguin's prominence was noted by the British artist Spencer Gore (1878–1914): 'Of all the painters represented here Gauguin seems to be the least disliked. He is certainly the best represented.'[5] Thirty-seven Gauguins were hung in two main groups in the Large Gallery and the Centre Gallery. Tahitian works including the controversial yet popular *Manao tupapau* (no.121) dominated the former, and Breton works including *Christ in the Garden of Olives* (no.9) dominated the latter.[6] Other smaller groups of works featured elsewhere in the exhibition.[7]

An unsigned review from the *Daily Express*, 9 November 1910, 'Paint Run Mad', demonstrates the overwhelming emphasis on 'primitivism' in the contemporary British discourse around Gauguin's work: 'In the large gallery the eye meets Gauguin's primitive, almost barbaric, studies of Tahitian women – bizarre, morbid and horrible.'[8] As scholar Bullen has commented, such responses were 'coloured by a number of contradictory prejudices, preconceptions and received ideas, many of which were socially, culturally, aesthetically and even scientifically determined'.[9] These contradictions allowed critics to pen 'lurid accounts aimed both to repel and titillate'; and framed in this way, Gauguin's works would undoubtedly have had anthropological appeal for a British public whose understanding of Polynesian culture was largely limited

Fig. 48 <u>*Cartoon from 'Bystander'*</u>
<u>*23 November 1910*</u>
Private Collection

to ethnographic displays and museum cabinets of curiosities.[10] Furthermore, 'the term [primitive] is used to evoke. It is never clearly defined. "Primitive" aspects of Gauguin's life and the "primitive" style he evolved in response to "primitive" subjects are interchangeable.' This slippage between Gauguin as 'primitive' and the 'primitivism' in his oeuvre is symptomatic of the conflation of his life and work in contemporary critical responses, which focussed on his unconventional lifestyle and intriguing biography, romanticising it as indicative of his artistic genius.[11] Indeed, C. Lewis Hind described him as 'the "great barbarian" who fled from Europe and civilisation, painted the walls of mudhuts in Tahiti, and died on one of the islands',[12] and Laurence Binyon hinted at the importance placed on biography conflated with notions of 'genius' in his statement, 'you feel the interest of a personality behind the work'.[13]

It is unsurprising that the myth of Gauguin as the artist-genius-gone-native dominated British contemporary critical discourse in the year 1910–11: Meier-Graefe's influential account of Gauguin in *Modern Art*, the first scholarly account of the new movement, is firmly rooted in a heroic reading of the artist's biography and particularly his South Sea odyssey, as recounted in *Noa Noa*. The latter had been published by

Fig.49 Spencer Gore
*Gauguins and Connoisseurs at
the Stafford Gallery* 1911–12
Oil on canvas
83.8 x 71.7
Private Collection

Charles Morice in *La Revue blanche* in 1897 and in book form in 1901. Meier-Graefe forged the link between Gauguin's life and work, 'the book [Noa Noa] is not merely a unique poem in contemporary literature, a legend of the Homeric stamp; it is also the history of Gauguin's art'.[14] Meier-Graefe had written to Gauguin early in 1898 requesting information in order to write 'a serious study'.[15] Gauguin thought it might be useful to get his name known in Holland (he incorrectly assumed that Meier-Graefe was Dutch).[16] Several years later, on 21 August 1903, Daniel de Monfreid wrote to Gauguin on the subject of Meier-Graefe: 'M. Fayet is in touch with a writer who is going to do a study on you (and on other artists, I believe, such as Degas, Renoir etc . . .) Meier-Graef [sic] if I'm not mistaken. He will publish in his book your manuscript originally destined for "Mercure de France". I will oversee that closely and keep you up to date, of course.'[17] This was after Gauguin's death, but before de Monfreid had learned of it. In considering Meier-Graefe's text as seen through the lens of, and informed by, Gauguin's writings, we are directed toward the artist's own role in the creation of a 'Gauguin myth'; for as he himself knowingly observed: 'You wish to know who I am, my works are not enough for you.'[18]

A significant change in the tone of its critical reception had occurred by the time Fry's exhibition closed on 16 January 1911. An anonymous reviewer in the *Daily Graphic* wrote: 'During the first week or two of the exhibition a considerable proportion of the spectators used to shout with laughter . . . But on Sunday the general attitude was one of admiration and regret that an exhibition which has furnished so much food for discussion must close.'[19] This paradigm shift was confirmed later that year when, in November, the exhibition *Cézanne and Gauguin* opened at the Stafford Gallery in Mayfair, London. In stark contrast to the hysteria engendered by the Gauguins at the

Fig. 50 Spencer Gore
*Preparatory drawing: Gauguins
and Connoisseurs at the Stafford
Gallery* 1911–12
Graphite and coloured chalk on
grey paper
30.3 x 27.2
The Trustees of the British
Museum, London

Fig. 51 *Christmas Night* 1902–3
Oil on canvas
71.1 x 82.5
Indianapolis Museum of Art
Samuel Josefowitz Collection of the
School of Pont-Aven, through the
generosity of Lilly Endowment Inc.,
the Josefowitz Family, Mr and Mrs
James M. Cornelius, Mr and Mrs
Leonard J. Betley, Lori and Dan
Efroymson, and other Friends of the
Museum

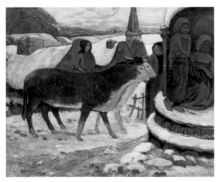

Grafton Galleries the previous year, the Stafford Gallery exhibition was described by J.B. Manson as 'a much-needed opportunity for the calmer study of the two most interesting personalities in modern art', and he went on to praise Gauguin's 'genius for decoration' and 'unusually strong and sensitive gift of drawing'.[20] Gauguin was now established in the British consciousness as a Modern Master.

Three works by Gauguin formed the central focus of the Stafford Gallery exhibition and are depicted in Spencer Gore's painting, *Gauguins and Connoisseurs at the Stafford Gallery* 1911–12, echoing Gauguin's own compositional device of rendering paintings within paintings (fig.49). They are – from left to right – *Manao tupapau*, *Christ in the Garden of Olives* and *Vision of the Sermon*. Contemporary British artistic and critical interest in Gauguin's work is implied by Gore's inclusion of his red-bearded Camden Town Group colleague Augustus John (1878–1961) in the foreground and Philip Wilson Steer (1860–1942), looking to the right, carrying grey gloves and a walking cane.[21] In his use of vibrant colour, rhythmic composition and silhouetting of form, Gore explicitly demonstrates Gauguin's influence on British contemporary practice. *Gauguins and Connoisseurs at the Stafford Gallery* may have been commissioned by Professor Michael Sadler to celebrate the exhibition, of which he had been a key instigator: his acquisition of these three important Gauguins marked him as the first significant British collector of the artist's work.[22] This theory would seem to be borne out by Gore's careful preparatory drawings for the painting, including detailed studies of the Gauguins (fig.50).[23]

Much importance has been placed on Fry's 1910 exhibition in shaping the reception of modern art, and of Gauguin, in Britain. However, it is necessary to consider the 1910 exhibition in the context of the other, smaller exhibitions that preceded it, and Gauguin's growing posthumous fame.[24] Following his death in May 1903, Gauguin's reputation grew dramatically: his work featured in a number of group and solo exhibitions held at forty-six different venues in fifteen different cities between 1903 and 1912.[25] In November 1903, soon after news reached France of Gauguin's death, Ambroise Vollard (1865–1939) arranged a small retrospective of fifty paintings and twenty-seven transfer drawings in his Paris gallery.[26] This was followed in 1906 by a large retrospective at the Salon d'Automne, which, like many of the major shows of modern art in Paris between 1905 and 1910, received significant coverage in the British press. A critic writing in *The Times* was enraged by Gauguin's 'unnatural and obstrusive colour' and 'indifferent drawing'. However, what most infuriated the critic was that 'in France, Gauguin was treated by an articulate and growing minority as a great painter and part-founder with Cézanne of a new movement in art'.[27]

The Eighth International Society exhibition at the New Gallery in London January – February 1908 included a single Gauguin, *Haere Pape, Tahiti* 1892, the first to be shown in Britain.[28] The exhibition was largely ignored by the press, though an editorial in the February *Burlington Magazine* described it rather dismissively as 'The Last Phase of Impressionism.' But it was the mayor of Brighton's radical decision in early 1910 to mount an exhibition of modern French art at the newly opened Brighton Galleries that was to be the decisive influence on Fry's decision to put on *Manet and the Post-Impressionists*. Gauguin was represented by three works, 'a pleasant little landscape', 'Fruits of Tahiti', and 'a curious picture of oxen passing through a town in the snow' (fig.51).[29] Reviews in the local Sussex press ranged from dismissive to unequivocally hostile.

Exhibitions were by no means the only way in which Gauguin and his art entered the British consciousness – both *Noa Noa* and Meier-Graefe's seminal account of the artist had provided critics and commentators with a biographical framework and language with which to discuss Gauguin's work, and this information had trickled down to the popular press. After the First World War, three key texts were published, stimulating further the fascination with Gauguin: Segalen's edition of the artist's letters to Daniel de Monfreid, Charles Morice's biography, and a novel, *The Moon and the Sixpence*, by W. Somerset Maugham. Susan Stein has made a convincing case for the importance of these texts, and in particular Maugham's novel, in widening Gauguin's appeal in the United States. As a contemporary critic observed, 'it was an entirely new section of the community that Mr Maugham awakened to an interest in art'.[30] The same

was certainly true in Britain, where the book quickly became established as a popular classic (fig.52). Maugham's novel is a thinly veiled *roman à clef*, in which Gauguin is cast as a callous Englishman, Charles Strickland, who abandons his wife, children and well-to-do life in London to pursue a career as a painter in Paris. Maugham was fascinated by the impact of the arrival of modernism from Europe on an insular British consciousness and the emergence of a cult of the modernist artist-genius – *The Moon and Sixpence* is at once a satire of Edwardian mores and a Gauguin biography.

It is likely that Maugham first heard about Gauguin around 1904 from the British artist Roderic O'Conor, who had been in Brittany with Gauguin from 1894 to 1895.[31] Maugham briefly alludes to Gauguin in his earlier autobiographical novel, *Of Human Bondage* (1915): 'In Brittany he had come across a painter whom nobody else had heard of, a queer fellow who had been a stockbroker and taken up painting at middle age, and he was greatly influenced by his work. He was turning his back on the impressionists and working out for himself painfully an individual way not only of painting but of seeing. Philip felt in him something strangely original.'[32] Mirroring the experiences of the principal 'narrator' in *The Moon and Sixpence*, who is also a writer, Maugham travelled to Tahiti in 1914 where he acquired the stained-glass painting by Gauguin, *Woman with Fruit* (1896), which he installed in his house in Cap Ferrat in 1916.[33] The poet Rupert Brooke, also lured to the island by the prospect of finding 'lost Gauguins' in 1914, complained in his memoirs that he had narrowly missed out to someone (perhaps to Maugham?) who had found 'some Gauguin paintings on glass. Damn!'[34]

The Moon and Sixpence simultaneously perpetuates and problematises certain myths about Gauguin's life, many of which were begun by the artist himself and had been written into the modernist canon by Meier-Graefe. Indeed, Maugham's elusive title indicates that he was familiar with Meier-Graefe's text on Gauguin in *Modern Art*. His explanation of the title *The Moon and Sixpence* concerned Philip Carey, the protagonist of *Of Human Bondage*, who was described by a reviewer in *The Times*, 'like so many young men he was so busy yearning for the moon that he never saw the sixpence at his feet',[35] echoing Meier-Graefe's observation that 'He [Gauguin] may be charged with having always wanted something else.'[36]

At the heart of Maugham's portrayal of Strickland is the heroic notion of the modern artist as 'genius', fostered by Meier-Graefe in his account of Gauguin, whom the art historian described variously as 'one of those rare beings who are all harmony', 'a marvellous artist' and 'an immeasurable extension of artistic boundaries in general'. It is in pursuit of this construction of 'artistic genius' that Maugham's 'narrator' crosses continents. The novelist pushes this understanding of genius to an extreme in his portrayal of the abhorrent Strickland, whom the narrator defends in the opening chapter: 'His faults are accepted as the necessary complement to his merits. It is still possible to discuss his place in art, and the adulation of his admirers is perhaps no less capricious than the disparagement of his detractors; but one thing can never be doubtful, and that is that he had genius.'[37] The narrator's justification plays off Gauguin's own apologia: 'I am an artist and you are right, you're not mad, I am a great artist and I know it. It's because I know it that I have endured such sufferings. To have done otherwise I would consider myself a brigand – which is what many people think I am . . . What do husbands generally do, especially stockbrokers? On Sundays they either go to the races, or to the café, or with whores, for men need a few distractions, otherwise they cannot work and besides it's only human nature.'[38]

In this way, Gauguin's life is a literary vehicle for Maugham's satirical exploration of contemporary notions of the modern artist as genius. With each first-person narrative shift, from the principal narrator to the various characters he encounters – Amy Strickland, Dirk Stroeve, Dr Coutras – each in turn taking on the role of narrator, the reader finds the 'truth' about Strickland and the nature of genius slipping further from reach.[39] It was this aspect of Maugham's book that was to frustrate a reviewer writing in the *Guardian* in 1919: 'Does Mr. Maugham so convince us that this Strickland is a real man and a real artist that we can absorb his traits as part of the essential human creature who lives eternally by his work? It seems to us that he does not.' The reviewer went on to conclude that 'Technically the whole thing has great

Fig. 52 *Cover of 1919 original edition of Somerset Maugham's 'The Moon and Sixpence'*
The Trustees of the British Museum, London

interest. But as an illumination of the nature of bizarre and uncompromising genius, ready to sacrifice every person and every association that stands in the way of its fulfilment, "The Moon and Sixpence" fails through its literary accomplishment and lack of true creative inspiration.'[40]

If *The Moon and Sixpence* popularised the 'Gauguin myth', Albert Lewin's 1943 film adaptation would have widened its appeal further, with George Sanders's caustic portrayal of the 'unmitigated cad' Strickland immortalising 'Gauguin' in celluloid for the first time. Lewin uses the film as an opportunity to explore Maugham's conception of artistic genius and the cinematic ways of rendering such an abstract notion. To this end, Strickland's life in Edwardian London and turn-of-the-century Paris is filmed in black and white, with Tahiti rendered in nostalgic sepia, presumably to evoke a sort of romantic primitivism. The only scene in full colour is that in which Strickland's last masterpieces are revealed – murals painted on the walls of his native dwelling, after he had lost his sight. In case the viewer misses the implication of Lewin's use of colour, on discovering the murals Dr Coutras declares 'I knew that this was genius. Nothing had prepared me for the immense surprise of these awe-inspiring pictures in a native hut far from civilisation.'[41]

The significance of *The Moon and Sixpence* in shaping subsequent representations of Gauguin and in echoing the artist's own self-mythologisation was described by the art critic Robert Hughes in an article for *Time* in 1971: 'The harpies of legend, having once gripped an artist, are slow to let go. One of their regular victims has been Paul Gauguin. The image of the painter has been yanked, tugged, tortured and distorted by a succession of novels and films starting with Somerset Maugham's *The Moon and Sixpence. Moon* provided a legend of the theatrical kind that Gauguin himself invented.'[42] 'Gauguin' has continued to be a popular character in films. From Anthony Quinn's Oscar-winning portrayal of the artist as the ruthlessly rational foil to Kirk Douglas's hysterical Van Gogh in Vicente Minelli's 1956 adaptation of Irving Stone's *Lust for Life*, to Donald Sutherland's brooding, predatory portrayal in Henning Carlsen's *Wolf at the Door* (1986) – traces of Maugham's interpretation remain. As Maugham's narrator in *The Moon and Sixpence* observes: 'The faculty of myth is innate in the human race. It seizes with avidity upon any incidents, surprising or mysterious, in the career of those who have at all distinguished themselves from their fellows, and invents a legend to which it then attaches a fanatical belief. It is the protest of romance against the commonplace of life. The incidents of the legend become the hero's surest passport to immortality.'[43]

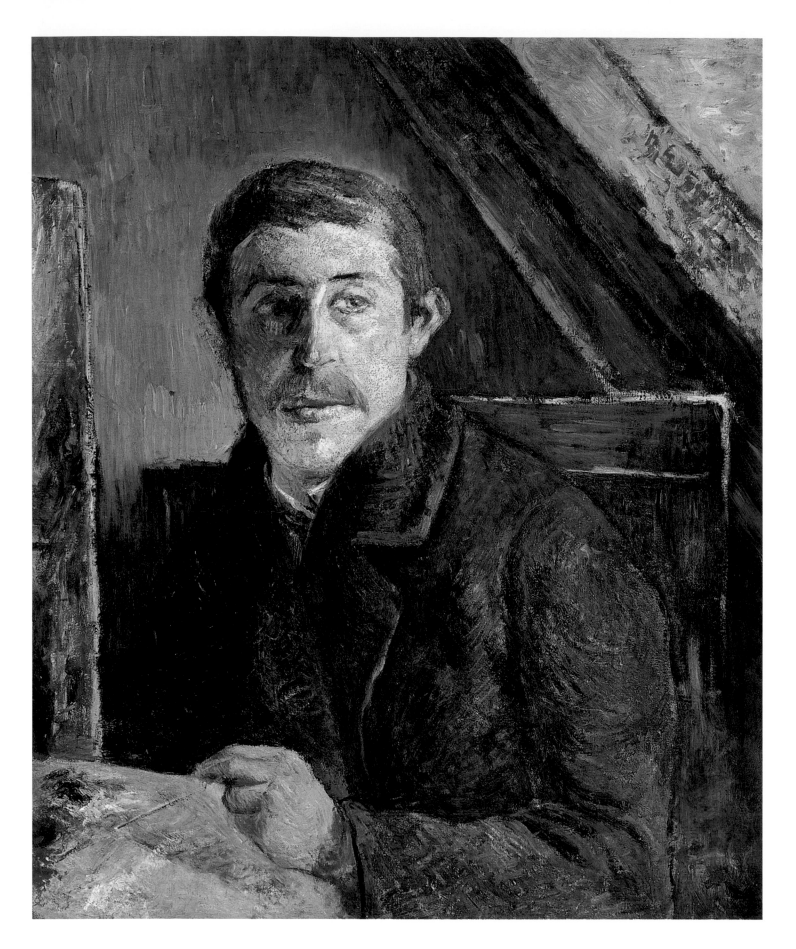

1
Self-Portrait 1885
Oil on canvas
65.2 x 54.3
Kimbell Art Museum, Fort Worth, Texas

IDENTITY AND SELF-MYTHOLOGY

Without question the subject matter that gave Gauguin the greatest scope for narrative invention was himself. He was capable of juggling diametrically opposed views about himself, views that inform his powerful sequence of self-portraits. Here he presented himself in dramatic roles, sometimes in colourful costume, sometimes assuming alter egos or animal form, sometimes embedding his features within his imagery in ways that are only gradually discernible.

Gauguin's face and features were distinctive and arresting: the low brow, the lazy, hooded eyes of an intense blue, the hooked nose and cruel, unsmiling mouth, were clearly promising raw materials on which to hang different personae and identities. His dark complexion was due, he liked to boast, to the Peruvian side of his ancestry. In word and image Gauguin presents a protean personality, by turns sardonic, cool, calculating, businesslike, reflective, melancholic, philosophical, or pugnacious, bantering, domineering, boastful. If he played up his status as outsider and his hybrid genetic origins, he also dramatised his plight as misunderstood accursed artist. Some images, like the studied portrayal of himself as an artist in a cold garret (no.1), seem like proud retaliations against withering familial remarks about the folly of his career change; others seem to rise to the epithets of Gauguin's critics, as when the critic Félix Fénéon had described him as '*grièche*', meaning something like 'stroppy', and it had rankled. The most forceful identity he sought to assert was his savage nature, but it was less of an inherent savagery than a carefully crafted one.

In an early, relatively conventional painting recently acknowledged to be a self-portrait (no.2), the artist is smartly attired in wing collar and tie, wearing the kind of soft black fez with ribbon worn by the lounging student in Édouard Manet's *Déjeuner sur l'herbe* and favoured by mid-century bohemian artists and intellectuals.[1] Gauguin's play with his identity begins in his carved ornamentations for a walnut frame containing his portrait photograph, which occasioned a rebus-like exploration of stock images from popular culture (no.4). The artist's photograph was cut down from a posed marital portrait taken in 1884–5 in Copenhagen – a difficult time in Gauguin's marriage

to Mette-Sophie Gad – and in that double portrait, tellingly, the preoccupied gazes of husband and wife veer off in opposite directions.[2] Yet the frame seems to celebrate their union. Perhaps it was carved at an earlier, happier date, its entwined Gs representing their respective surnames. The elegant female silhouette plausibly represents Mette as would-be stylish *Parisienne*, while the male figures flanking the photograph seem indicative of opposite pulls on Gauguin's career: left, toward down-and-out bohemianism, right, toward membership of the artistic bourgeoisie (the portly figure in profile is reminiscent of Jean-Pierre Dantan's caricatural statuette of Honoré de Balzac).

An extraordinary concentration of charged self-portraits dates from 1888–90, a period in Gauguin's life of self-interrogation and radical stylistic transformation. Ahead of his expected arrival in Arles, in September 1888 the artist had sent his self-portrait to Vincent van Gogh, explaining its symbolic meaning (fig.1). Gauguin's identification with the pure-hearted Jean Valjean, hero of Victor Hugo's novel *Les Misérables*, whose conviction for a minor crime had led him to be hounded from society, resulted not just from feeling personally beleaguered; Gauguin claimed the connection as a symbol of the plight of the Impressionist artist in general. The self-portrait in a gold-braided Breton waistcoat probably dates from the Arles stay. It is painted on the jute canvas first acquired there (no.6).[3] Originally, it bore a dedication to Charles Laval, Gauguin's travelling companion to Martinique; indeed it may have been a response to Laval's self-portrait in front of a window, a picture that arrived in Arles in early November. But in 1891 or thereabouts, Gauguin revised the dedication, inscribing the name 'Eugène Carrière'. He presumably offered it in exchange for the portrait the Symbolist had painted of him, in which he noted, with gratification, his own resemblance to Eugène Delacroix.

There is some ambiguity about whether Gauguin gave his own features to the figure of the sermonising priest in the lower right corner of *Vision of the Sermon* from 1888 (no.65). Such a ruse would be in character. But there is no missing Gauguin's presence in many of his 1889 works, his personae veering from the saintly to the demonic. In two stoneware pots dating from

Fig.53 *Self-Portrait in Form
of Grotesque Head* 1889
Stoneware with thick glaze
h.28
Musée d'Orsay, Paris

Fig.54 *Self-Portrait with Yellow
Christ* 1890
Oil on canvas
38 x 46
Musée d'Orsay, Paris

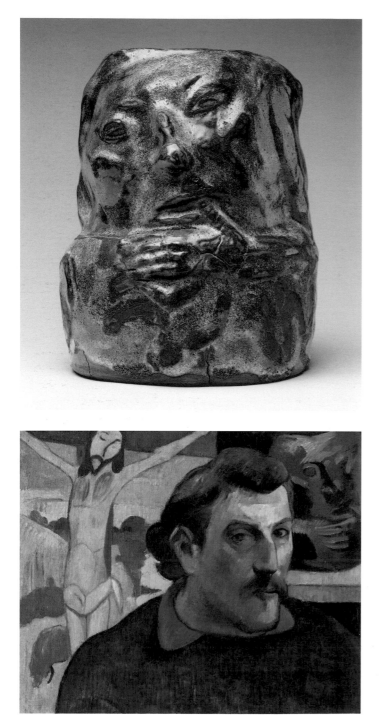

1889–90, he shows his own features mutilated or agonised. In the first, *Self-Portrait Vase in the Form of a Severed Head* (no.5), a finely wrought likeness, he probably intended to draw an analogy with Christ's forerunner, John the Baptist, and his cruel decapitation at the whim of Salome. But modelled immediately after his period of cohabitation with Van Gogh at Arles – which ended when the Dutchman threatened Gauguin with a razor, then severed his own earlobe – was it a reaction to the danger in which he later claimed to have felt himself? The image, with pools of blood around the neck and a gaping cranium, also betrays a taste for the macabre that was not untypical at the time and which Gauguin took extraordinary steps to fuel. On returning to Paris, on 29 December 1888, he attended the guillotining of a convicted murderer, Prado, whose lurid case he and Vincent had been following.[4] On the other hand, his contemporaneous tobacco jar, crudely modelled and doubling as a grotesque self portrait, sought to give concrete form to his manufactured savage identity (fig.53). Some months later, in a letter to Émile Bernard, he explained the rationale for his molten features: 'like that artist glimpsed by Dante on his visit to hell – Poor devil, hunched up in order to endure the suffering.'[5] The idea of using this rebarbative work to test the limits of Madeleine Bernard's admiration led him to offer it to her as a gift which, understandably, she turned down. These two extraordinary realisations, in which Gauguin took particular satisfaction, were then recycled and presented anew in paintings, as in *Self-Portrait with Yellow Christ* (fig.54).[6]

Two painted self-portraits of 1889 were a more obvious continuation of discussions in Arles. On visiting the Musée Fabre in Montpellier, Gauguin and Van Gogh encountered numerous likenesses of Alfred Bruyas, handsome and narcissistic patron of the arts, one in the guise of Christ in the Garden of Olives, another greeting Gustave Courbet in the latter's monumental *Bonjour Monsieur Courbet*. In *Christ in the Garden of Olives*, begun in June 1889 (no.9), the bluish landscape provides a haunting setting for what is clearly Gauguin's self-portrait. Reinvented as a redhead not unlike Bruyas, or Vincent van Gogh, this identification on Gauguin's part with Christ's imagined sense of betrayal lends the subject an extreme emotive humanity. The Montpellier visit also prompted Gauguin's full-length self-portrait, *Bonjour Monsieur Gauguin* (no.7), in which, like Courbet, he mobilises the image of the artist as wandering Jew, although his painting is slightly less

confrontational and set in a Breton rather than Mediterranean landscape. The hooded Breton peasant woman offers the artist no promise of patronage, merely wary respect. He incorporated this and a caricatural self-portrait with snake, apples and halo into the decoration for Marie Henry's inn at Le Pouldu on the Brittany coast. Confronting the image of his friend Meijer de Haan across the inn's dining room, the appropriate analogy for this paradoxical self-portrait (no.11) seems to be Lucifer, the fallen angel of Milton's *Paradise Lost*.

The wood carving *Soyez amoureuses*, dating from the autumn of 1889, had a narrative complexity that Gauguin admitted needed unpicking. Writing to Vincent van Gogh in November 1889, he explained the role he had given himself: 'A monster who looks like me is taking the hand of a naked woman – that's the main subject.'[7] (no.93) As demonic seducer, or master of ceremonies presiding over a topsy-turvy world, his attempt to lead astray a resistant mature married woman was possibly an allusion to his wife. However, the features are unlike Mette's. Significantly, the pseudo-moralistic exhortation addresses womankind in general, not an individual.[8] The provocative message possibly harks back to saucy prints of the Romantic era; it certainly subverts traditional Catholic injunctions to continence and chastity. And, as Gauguin admitted, its conclusion was blatantly false, for the multiple symbols of anguish in the interstices suggest a baleful outcome.

It was perhaps in drawings that Gauguin examined himself most candidly. In one (no.21), his synthetic manner and concentration on the setting of his eye and skull seem to explore the possibility, touched on in his writings, that he possessed 'the evil eye'. Its simplicity and power informs a number of subsequent paintings. Two other drawings relate to experiences at the 1889 Universal Exhibition in Paris. In one doodle he imagines himself as a 'Red Indian' brave from Buffalo Bill's rodeo, while in the amusing caricatural group portrait dating from 1890, he sprouts demonic horns and apes the hieratic gestures of the Javanese dancers (no.18). In a monotype of multiple faces Gauguin exaggerates the line of his already pronounced nose, claiming this is how his 'Tahitian vahine' sees him (no.19).

Although no painted self-portraits seem to have been done during Gauguin's first trip to Tahiti in 1891–3, several that he made on returning to France reflect upon his time there: in one dated 1893–4 (no.3), with palette, white glove, fez and dramatic cloak, he is the assertive man of the world; in another, also dated 1893 (no.17), he identifies himself with his most contentious recent work, *Manao tupapau*. In a third (no.16), with now longer hair and striped piratical jersey, he sets his features alongside one of his own carved 'barbarous' tikis (wooden idols), whose forms he had unashamedly plundered from Oceanic artefacts – to the sharp disapproval of some contemporary commentators.[9]

Within Gauguin's late work a more menacing image of power, a horned devil, keeps appearing and this, too, undoubtedly relates to a demonic facet of Gauguin's sense of self, or, rather, of his sense of how others perceived him. In *Noa Noa* Gauguin reintroduced this serene yet menacing head in photographic form (no.128), and he also put it into several late graphics. Its origin was a powerful carving he made from a suggestively twisted piece of tropical wood. By contrast, in the caricatural self-images associated with his satirical journal *Le Sourire*, Gauguin presents himself mischievously baiting the colonial authorities (no.20). Mocking the political machinations and war-mongering of Governor Gallet, he appears both as simian savage (in the woodblock-printed headpiece) and chief clown and pot-stirrer, wielding drumsticks with his feet to the tune of the French popular song 'Malbrough [sic] s'en va t-en guerre'.

In marked contrast with these extravagant performances, in a late, reflective pencil drawing possibly dating from 1902–3, recovered and treasured by Victor Segalen, Gauguin once again, as in the savage *Self-Portrait Vase in the Form of a Severed Head* and the *Soyez amoureuses* wood carving, has his thumb to his mouth, a gesture of dumb stupidity (fig.45). Yet this austere, fine-line drawing, and Gauguin's vulnerable semiclad state, seem devoid of theatre. And in Gauguin's last painted *Self-Portrait* of 1903 (no.22), we see him in a white shift, possibly a hospital gown, with close-shaven head, the glasses lending a studious air. This self-portrait disarms the viewer with the intensity of its gaze and its doleful image of suffering in self-imposed isolation; yet the artist was even then engaged in penning his often scabrous, score-settling memoirs destined for posthumous publication. As Gauguin said in *Racontars de rapin* of Balzac's infamous master-criminal in *La Comédie humaine*: 'Vautrin is always Vautrin in spite of his many disguises.'

Meijer de Haan

Gauguin's portrayals of his friend Meijer de Haan – unique examples in his oeuvre of such an obsessive focus on another male subject – seem to have been motivated by the desire to probe the artistic mind, to explore the nature of creativity and introspective intelligence. Meijer de Haan has often been interpreted as functioning for Gauguin as a kind of alter ego.

The Dutch painter first met Gauguin in Paris in early 1889, introduced by Theo van Gogh with whom he was then lodging. De Haan (1852–1895) was already reasonably well known as a painter in his native Holland for depicting historical themes concerning Amsterdam's Jewry. The hostile reception of the most recent, ambitious and controversial of these, on which he had laboured for years, had probably precipitated his decision to leave Holland in 1888.[10] He sought Gauguin out in Brittany the following summer, and voluntarily submitted to his tutelage. As a result his dark, meticulous, somewhat Rembrandtesque style underwent a radical 'synthetist' change: henceforth he would paint still-life and landscape themes in brighter, more Gauguinesque colours.

But far from being a one-sided relationship, Gauguin quickly recognised that he had met a match in this Jewish freemason, a man handicapped physically by a curvature of the spine but of formidable intellect. Testifying to the importance of their relationship, Gauguin made a series of images of the Dutchman. These began with a charcoal study and then a remarkable pen and ink drawing from 1889 (no.14), catching de Haan in characteristically studious pose, poring over what looks like an illustrated book.[11] This plays upon the idiosyncracies of de Haan's physiognomy – his furrowed, bulbous forehead denoting intensity of thought – and offered an intriguing template for the subsequent images Gauguin went on to make. In these Gauguin progressively loaded and complicated his initial economical and caricatural sketch, taking it beyond the realms of portraiture into myth.

Probably the first was the 1889 portrait in oil, which Gauguin painted, to match his own, on the door panel of the Le Pouldu inn on the Brittany coast where they took their meals (no.10). Both portraits demonstrate a similar spirit of sardonic, caricatural humour. De Haan's exaggerated features, the uncannily staring eyes, the horn-like tuft of blond hair escaping from the Jewish cap – this, to judge from his self-portrait of a similar date, was something he habitually wore – the hand resembling a cloven hoof, have encouraged commentators to read this as a diabolic portrayal.[12] The books and lamp underline the image of a night owl with a taste for serious literature, John Milton and Thomas Carlyle. The small watercolour from the same year is extremely close to the oil, but looks less like a study than a portable replica (no.13). Indeed, without it, Gauguin would scarcely have been able to revisit the exact configuration of de Haan's face up to a decade later. However, there are two intriguing aspects to this repetition which complicate its meaning. It is painted within a drawn rectangle but so as to mimic the appearance of a book cover, the vertical streak of blue to left giving a sense of solidity to the putative volume; secondly, on the verso, it has a page of script with truncated margins which deals with the disadvantageous position of woman in society. This turns out to come from a transcription Gauguin made from his grandmother Flora Tristan's book *Promenades dans Londres*, 1840.[13] Deliberate or haphazard, this curious conjunction of image and text foreshadows the assemblage techniques Gauguin adopted in his artist's books.

Gauguin's carved portrait bust of de Haan from 1889–90 (no.15) originally stood on the mantelpiece of the same Le Pouldu inn. Roughly carved from a block of oak and, in part, stained green, it incorporates a rooster, a pun on his name and an acknowledgement, perhaps, that where Marie Henry, the landlady, was concerned, de Haan ruled the roost (she later bore him a daughter). The traditional hardwood medium may have suggested the exaggerated representation; certainly de Haan, with his gnomic half-closed eyes, looks somewhat like a gargoyle from a medieval church. The portrayal in gouache from 1889–90 is one of the most extreme instances of Gauguin's wilful and mischievous mythification (fig.55). Here a foxy de Haan appears against a background of rocks and sea, with the contrasting nudes, Breton Eve and Ondine, behind him like figments of his imagination. To lower right Gauguin has inscribed, then partially obliterated, the word *Nirvana*, paradoxically conjuring ideas of Buddhism's higher plane of being and renunciation.[14]

The images have been seen as hostile and of dubious racist undertow, particularly in view of the financial support de Haan was bringing to the relationship. But although they

unquestionably address certain Jewish stereotypes, these images should not lightly be given such a negative interpretation. Certainly Gauguin was intrigued by de Haan's absorption with his Jewish identity – which presumably manifested itself in his conversation as well as in his dress and sombre demeanour. Allowance should also be made for de Haan's own agency. For it was only through him that Gauguin had any sort of access to Carlyle's book, *Sartor Resartus*, whose eccentric central character, Professor Teufelsdrökh, offers an obvious and humorous literary pretext for Gauguin's playing with the melancholic or devilish aspects of his friend. Interestingly, if Carlyle and Milton became an increasing preoccupation for Gauguin from this date on, so did Rembrandt. What is unclear is whether de Haan himself retained any of Gauguin's images.[15]

This sequence of images coincided with the artists' protracted period working and living together in Le Pouldu, a more successful and harmonious reprise, from Gauguin's point of view, of his cohabitation with Vincent van Gogh. Gauguin's mentoring role, his admiration for de Haan's talent and the generally bantering humour that characterised the artistic community of Brittany all played a part in the relationship. There was no open animosity between them, de Haan expressing his profound admiration for Gauguin in a letter to Theo. Just at the time of their supposed rivalry for the favours of Marie Henry, they were planning to make the trip together to Tahiti.[16] Gauguin later wrote to his wife Mette regretting de Haan's decision not to come, and complaining of the solitude that he was enduring as a result.[17]

Although he was well aware of de Haan's fragile health, it is not known whether Gauguin learned of his friend's early death in 1895. If he did know of it, it might explain de Haan's mask-like features resurfacing in a woodcut datable to 1896–7 and in two later paintings. In the woodcut, the same configuration of the earlier melancholic face-in-hand motif floats before a gaunt spectre and a dark-haired, possibly Tahitian, woman in three-quarter view (no.12). De Haan's features hover, like a memory, behind a floral still life of uncertain date.[9] Finally, his crouching persona, clad in a blue dress, the *vahine*'s voluminous missionary-style smock, but revealing devilish clawed feet, makes a last surreal appearance in the extraordinarily powerful but wilfully enigmatic composition *Contes barbares* of 1902 (no.154).

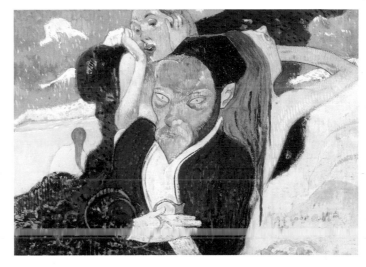

Fig.55 *Portrait of Meijer de Haan* 1889–90
Gouache on cotton
20 x 29
Wadsworth Atheneum Museum of Art,
Hartford. The Ella Gallup Sumner and
Mary Catlin Sumner Collection Fund

2
Self-Portrait c.1876
Oil on canvas
46.7 x 38.4
Harvard Art Museum / Fogg Museum,
Cambridge, MA. Gift of Helen W.
Ellsworth in memory of Duncan S.
Ellsworth '22, nephew of Archibald
A. Hutchinson, benefactor of the
Hutchinson Wing

3
Self-Portrait with Palette c.1893–4
Oil on canvas
92 x 73
Private Collection

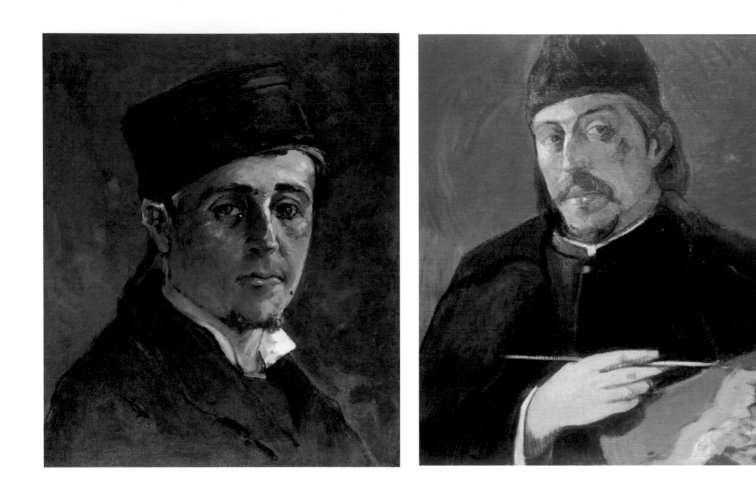

4
Embellished Frame or Frame with Two Interlaced 'G's 1881–3
Carved walnut containing a photograph of the artist (photograph c.1885)
18.9 x 33.6 x 1
Musée d'Orsay, Paris. Gift of Corinne Peterson, in memory of Fredrick Peterson and Lucy Peterson, 2003

5
Self-Portrait Vase in the Form of a Severed Head 1889
Stoneware
h.19.5
The Danish Museum of Art & Design, Copenhagen

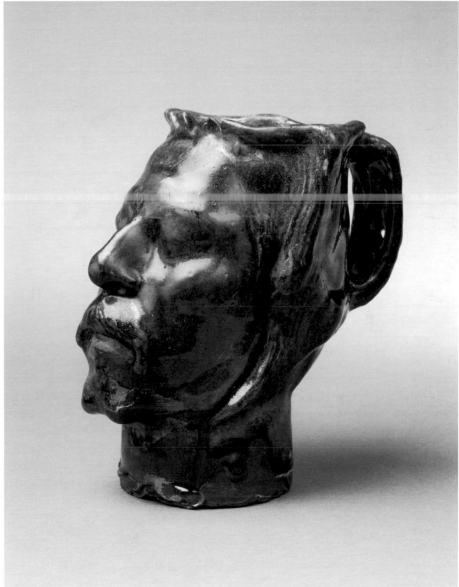

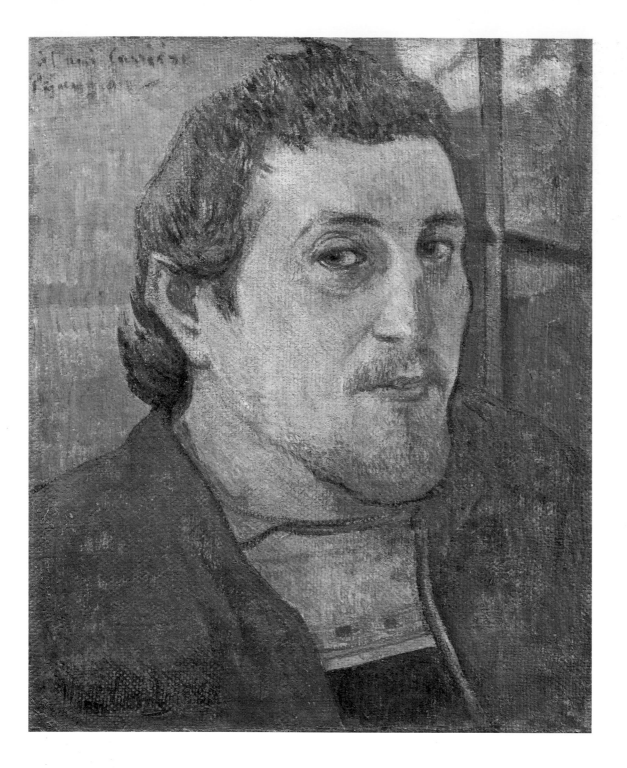

6
Self-Portrait Dedicated to Carrière
1888 or 1889
Oil on canvas
46.5 x 38.6
National Gallery of Art, Washington.
Collection of Mr and Mrs Paul Mellon

7
Bonjour Monsieur Gauguin 1889
Oil on canvas glued onto wood
74.9 x 54.8 x 1.9
Hammer Museum, Los Angeles. The
Armand Hammer Collection, Gift of
the Armand Hammer Foundation

8
*Last page of letter from Gauguin to
Vincent van Gogh with Sketches of Soyez
amoureuses, Christ in the Garden of Olives*
November 1889
Pen, ink and watercolour on paper
42 x 27
Van Gogh Museum, Amsterdam
(Vincent van Gogh Foundation)

9
Christ in the Garden of Olives 1889
Oil on canvas
72.4 x 91.4
Norton Museum of Art, West
Palm Beach, FL. Gift of Elizabeth
C. Norton, 46.5

'As for me, I own myself beaten – by events, by men, by the family, but not by public opinion. I scorn it and I can do without admirers ... But you, why do you suffer too? You are young, yet so early you begin carrying the cross. Do not rebel; one day you will feel a joy in having resisted the temptation to hate, and there is truly intoxicating poetry in the goodness of he who has suffered ...'
Letter to Émile Bernard, November 1889

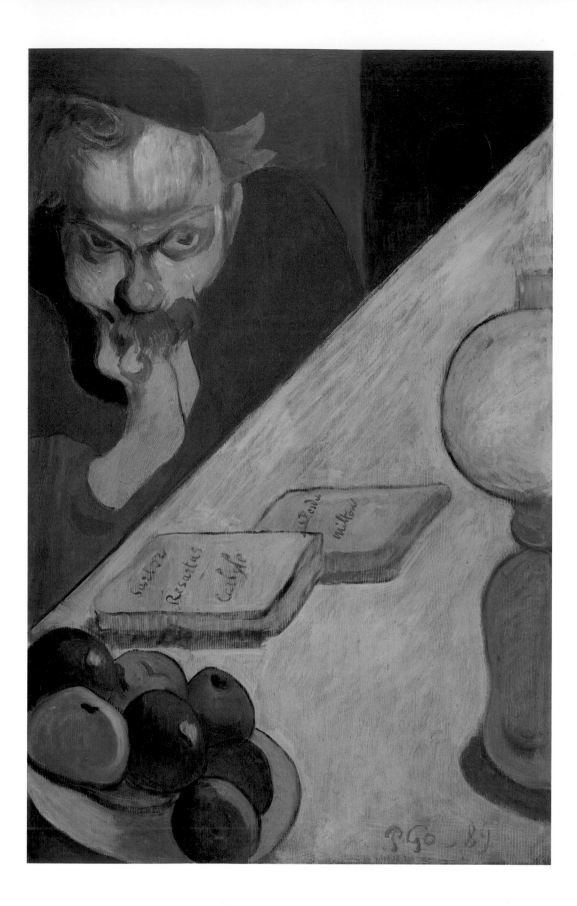

10
Portrait of Meijer de Haan by Lamplight
1889
Oil on wood
79.6 x 51.7
The Museum of Modern Art, New York.
Fractional gift from a Private Collector

11
Self-Portrait *1889*
Oil on wood
79.2 x 51.3
National Gallery of Art, Washington.
Chester Dale Collection

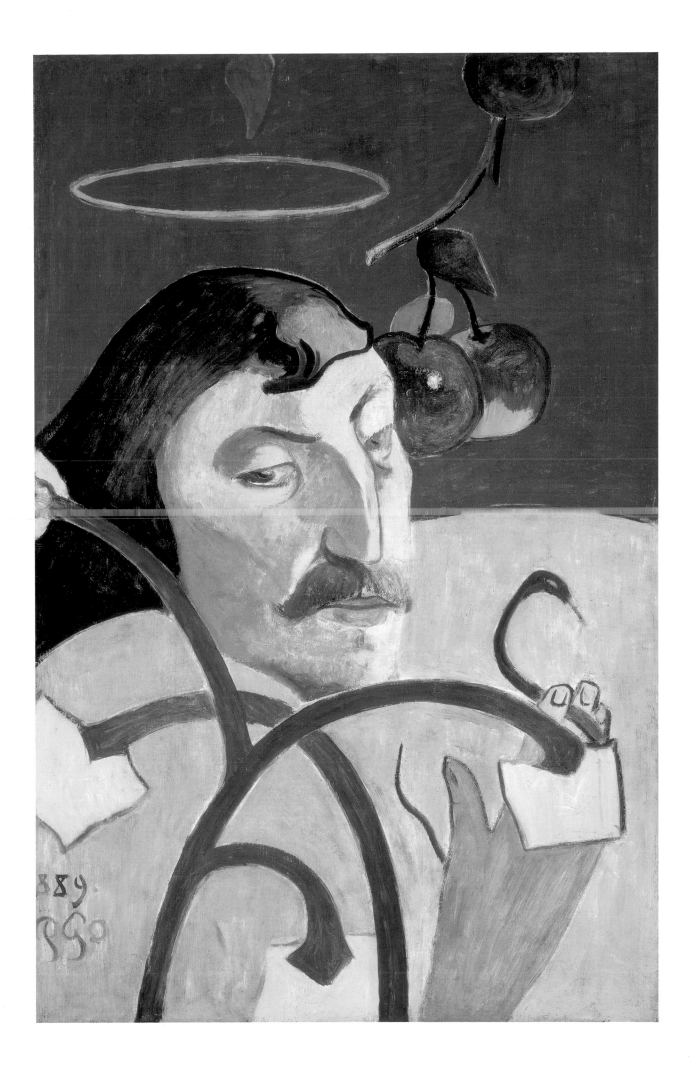

12
Memory of Meijer de Haan 1896–7
Woodcut on tissue laid down on paper
10.6 x 8.1
The Art Institute of Chicago. Gift of the
Print and Drawing Club

13
Portrait of Jacob Meijer de Haan 1889
Watercolour and pencil on paper
16.2 x 11.4
The Museum of Modern Art, New York.
Gift of Arthur G. Altschul, 1976

14
Portrait of Meijer de Haan Reading 1889
Pen and ink on paper
29.2 x 19.4
Private Collection

15
Portrait Bust of Meijer de Haan 1889–90
Carved and painted oak
58.4 x 29.8 x 22.8
National Gallery of Canada, Ottawa.
Purchased 1968

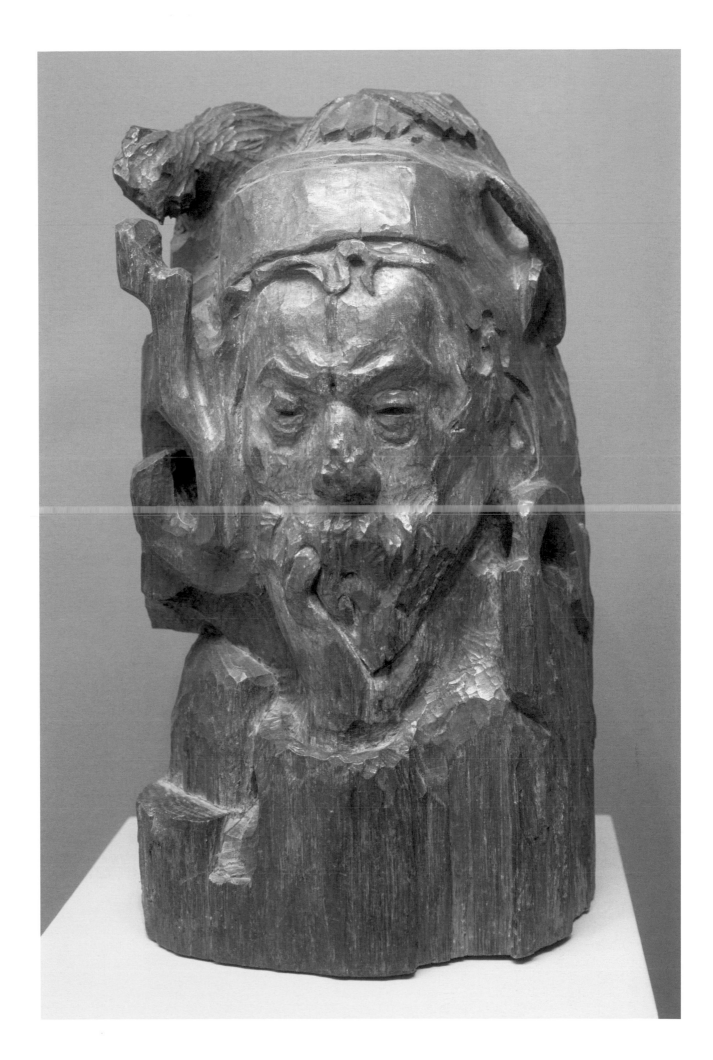

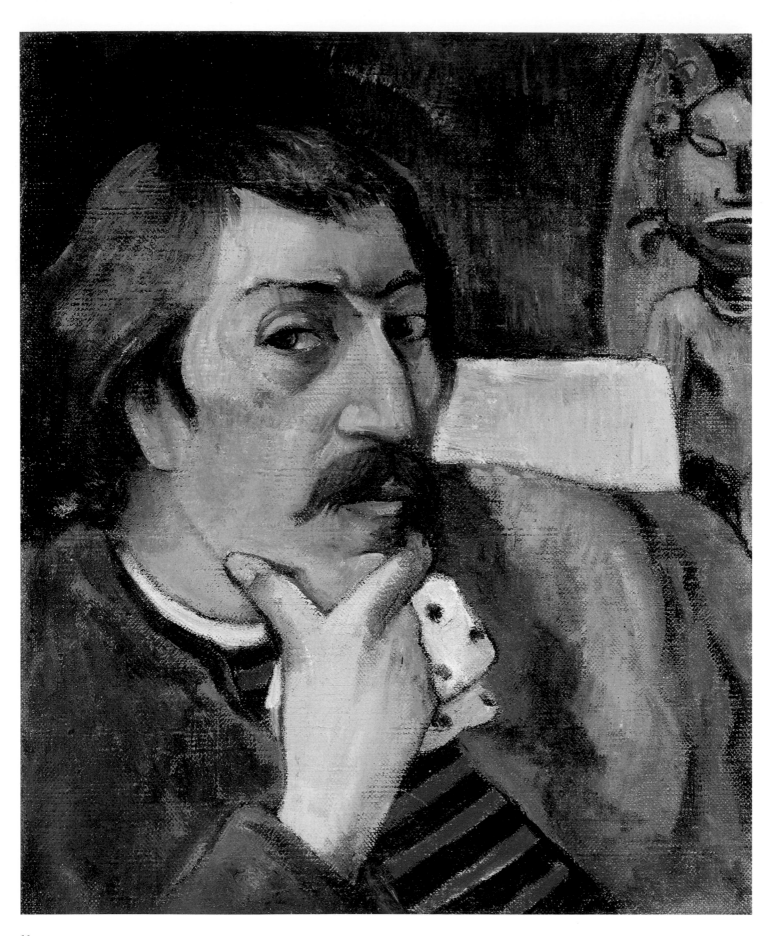

16
Portrait of the Artist with Idol c.1893
Oil on canvas
43 x 32
McNay Art Museum, San Antonio. Bequest
of Marion Koogler McNay

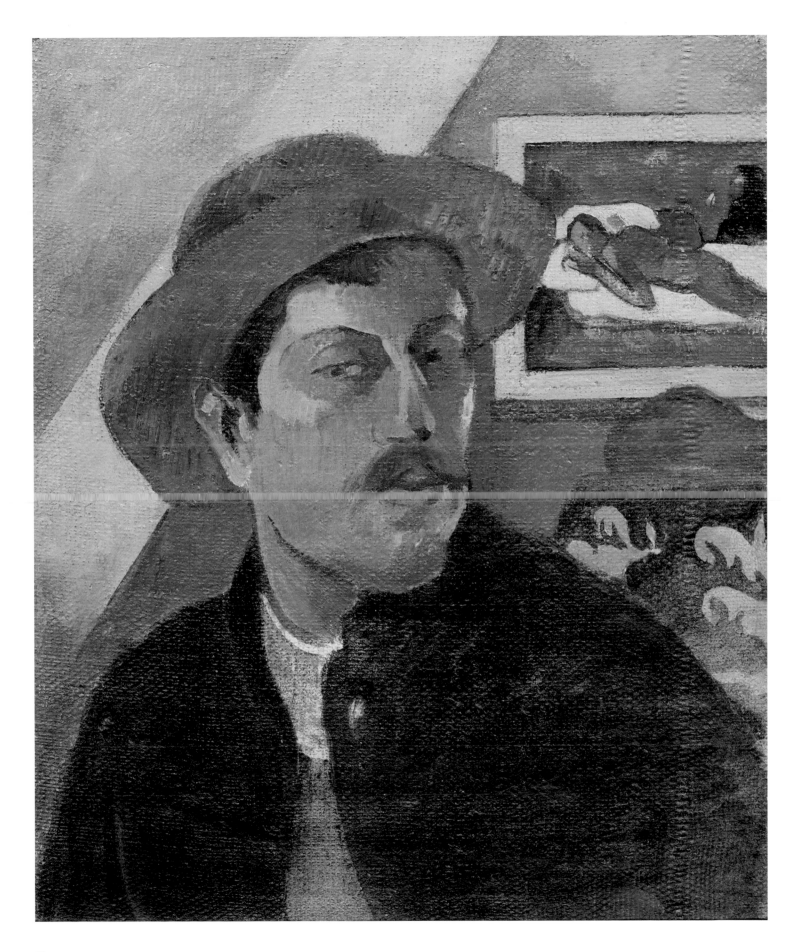

17
Self-Portrait with Manao tupapau 1893–4
Oil on canvas
46 x 38
Musée d'Orsay, Paris

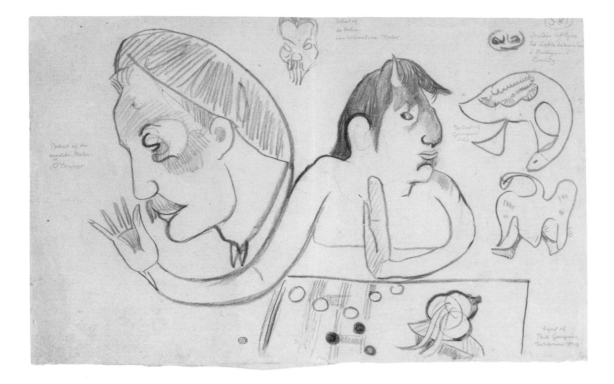

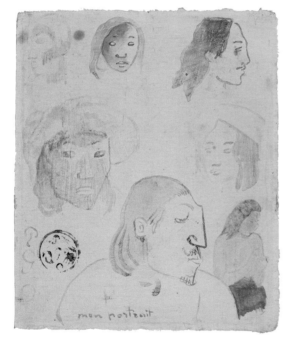

18
<u>*Self-Portrait with Portraits of Roderic*</u>
<u>*O'Conor and Jacob Meijer de Haan*</u> *1890*
Crayon on paper
28.8 x 45
The J.F. Willumsen Museum, Frederikssund
Denmark

19
<u>*Tahitians: Sheet of studies with six heads*</u> *1894*
Colour monotype printed on paper
24 x 20
The Trustees of the British Museum, London

20
<u>*Headpiece for 'Le Sourire'*</u> *1899–1900*
Woodcut printed on paper, above
drawing in watercolour, pen and ink and
crayon; sheet laid down on board
29.6 x 20.4
The Art Institute of Chicago. Gift of
Walter S. Brewster

89

21
Self-Portrait Drawing 1889
Charcoal on paper
31 x 19.9
Musée d'Art moderne et contemporain de
Strasbourg

90

22
Self-Portrait with Glasses 1903
Oil on canvas
41.5 x 24
Kunstmuseum, Basel. Gift of
Dr Karl Hoffmann

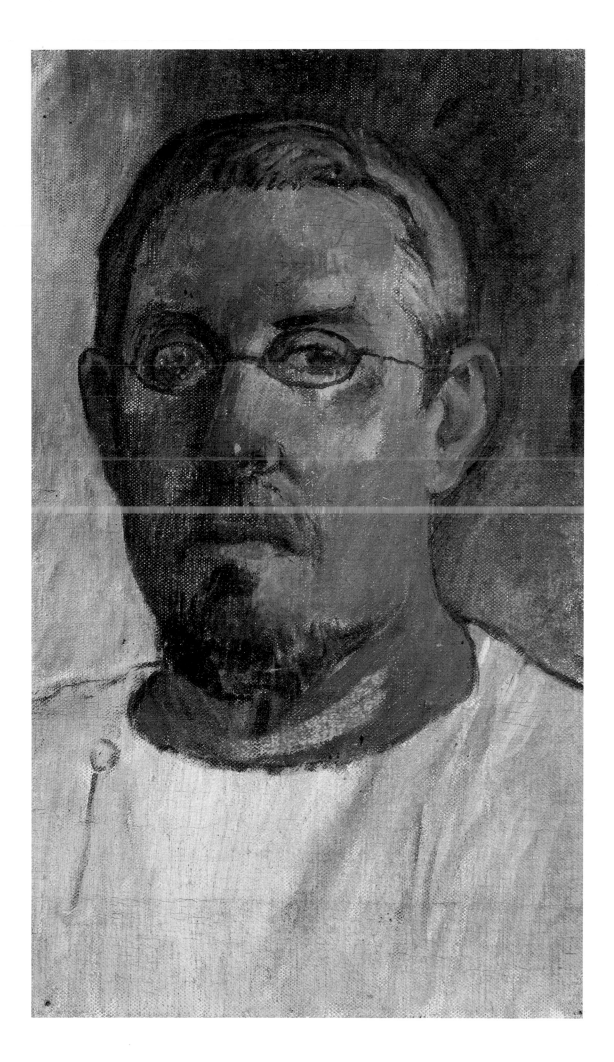

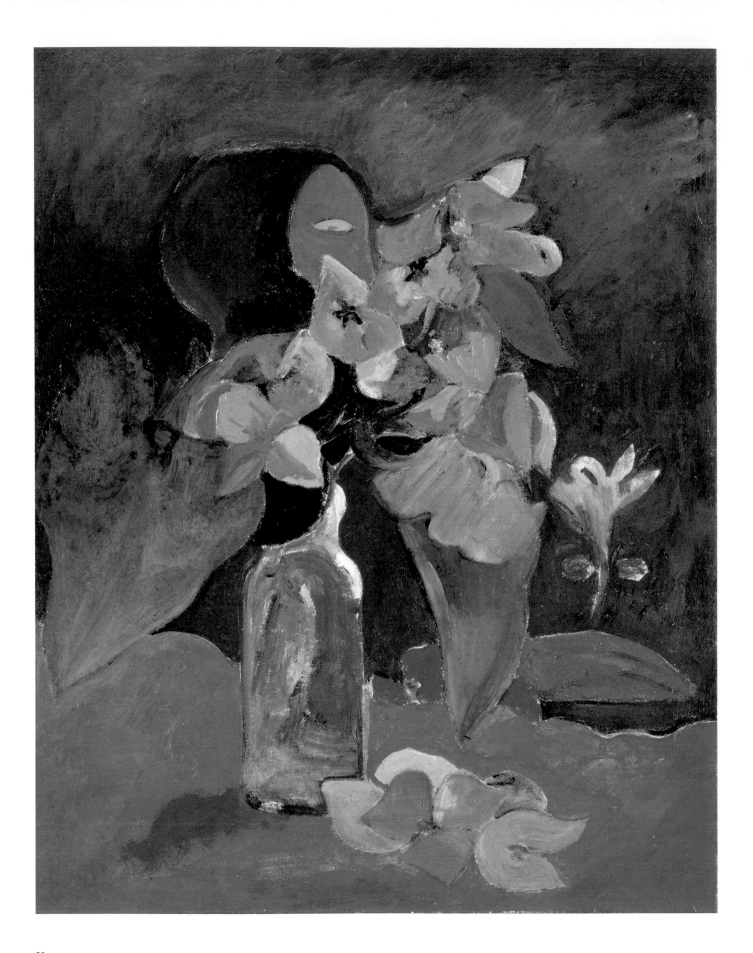

23
Still Life with Flowers and Idol 1892
Oil on canvas
40.5 x 32
Kunsthaus Zurich. Gift of
Walter Haefner

MAKING THE
FAMILIAR STRANGE

Gauguin's boast that his work hung together logically, bound by a consistency of thought, was not an idle one. If painting and drawing represented his main artistic effort, ceramics and woodcarving were in no way tangential or disconnected endeavours. Gauguin found many ways to plough his interest in tactile objects back into his two-dimensional work. Thus in still lifes, portraits and interiors he frequently insinuated pieces he had modelled or carved into ostensibly familiar contexts, using the associations and possible meanings of those insertions to carry the burden of the work's narrative implications.

The homes that Gauguin and his wife Mette created for their growing family were somewhat unconventional, a series of makeshift settings reflecting eclectic cultural allegiances. The time of greatest prosperity in their marriage, 1880–3, coincided with living at Rue Carcel, near the Rue de Vaugirard in Montparnasse, but the room featured in Gauguin's ambitiously large *Inside the Painter's House, rue Carcel* 1881 (no.26) is neither particularly homely nor French-looking, with its bare walls, heavy wooden furniture, clogs and squat china figurine. The rapport between the woman playing the piano (surely Mette) and her unidentified male listener is difficult to gauge given the awkward placement of the upright piano itself, its back separated by a screen and stove from the dining area. Moreover, the figures are screened off from the painter by an extravagant flower arrangement. More than most of his Impressionist colleagues, Gauguin used the still-life genre in ways that emphasise aspects of his identity. In view of its date, 1884, and the fact it was painted in Rouen, the presence, in *Still Life with Peonies* (no.27), of two works of art , one possibly a landscape of his own, the other a much-prized Degas pastel of a dancer, can be read as Gauguin asserting his artistic credentials and allegiances; (and despite the friendly and prominent dedication to his wife's brother Theodore, it was this new career orientation that would soon sour relations with his Danish in-laws). The same can be said of the inclusion of Delacroix's sketch, the *Expulsion of Adam and Eve from Paradise*, in a still life composed of tropical fruits, making the early date of 1887 and a Martinique setting plausible (no.29).

One prized family possession Gauguin liked to paint was a large wooden tankard, or *tine*, to use its Norwegian name, presumably brought to the marriage by Mette. It had a handle carved with lion motifs and it makes its presence felt in several familial portraits and genre scenes, including *Clovis Asleep* from 1884 (no.24) and *Still Life in an Interior* 1885 (fig.56). Unlike his daughter Aline, whom Gauguin painted asleep in bed, dreaming dreams that he could allude to but not fully share (no.25), his son Clovis has fallen asleep at the table, having sipped his father's beer perhaps – his hand still clutching the mesmerising tankard.

Woodcarving had been a pastime for Gauguin since childhood, particularly on board ship. One of the most intriguing early examples of his competence is a pearwood casket onto which he carved motifs from the ballet and theatre by Degas and the painter, printmaker and illustrator Jean-Louis Forain. He also attached Japanese netsukes to it and leather flaps to the casket's interior. But inside the coffer, instead of a gift, we find a recumbent female corpse, a shocking discovery for the uninitiated. A plausible suggestion is that this corpse alluded to Denmark's Bronze Age mummified tomb figures, several of which had been discovered in the nineteenth century and put on public display. Whatever its intended function, the casket underlines Gauguin's highly idiosyncratic approach to decorating and defamiliarising his environment.[1]

Unlike woodcarving, ceramic work was an activity that Gauguin confined to Paris. He took it up out of aesthetic curiosity and in the belief that pots would provide a steady income. His sessions working with master potter Ernest Chaplet at a kiln in Rue Blomet, Montparnasse, showed he had all the necessary manual skills, but unfortunately his timing was wrong: the following decade, when the decorative arts received renewed interest and financial investment from collectors, things might have been different, but Gauguin launched himself as a ceramist in 1886–7, returning to Rue Blomet at various subsequent dates. Moreover, he had none of the required tact or willingness to compromise in order to patiently build a clientele. Commercial aspirations aside, he soon found himself absorbed by this most

Fig.56 *Still Life in an Interior* 1885
Oil on canvas
60 x 74
Private Collection

primordial of crafts, intrigued by the technical difficulties of glazes and the haphazard drama of the firing process. As in the case of the casket, the search for motifs with which to adorn the basic shapes of his pots and vases led him to raid his personal art collection – he regularly incorporated motifs from Delacroix, Paul Cézanne or Degas. That search also led to a radical simplification of Gauguin's own drawing style.[2] The children's illustrations of Randolph Caldecott (1846–1886), or Louis-Maurice Boutet de Monvel (1851–1913) perhaps, served his decorative purposes very well, informing his own toylike reductions of Breton motifs, costumed figures and farm animals like geese and goats (no.37). A number of his pots show him investigating the more inventive animalistic forms of pre-Columbian pottery, incongruously mixing incised motifs of Arabs in the desert or dancers from the Paris Opéra borrowed from Delacroix and Degas with shapes derived from ancient Inca culture to which he felt an atavistic affinity.[3] If Gauguin had remembered pre-Columbian pottery from his Peruvian childhood, it was an interest kept alive by his mother's collection and Gustave Arosa's publications on the subject.[4] Although the artist's ceramics by his own admission took 'mad', that is, highly unconventional, directions, and consequently did not sell, they aroused the admiration of Chaplet, Félix Bracquemond, Camille Pissarro and Octave Mirbeau. Importantly, Gauguin also found a way to insert his ceramics into his pictures, reinvesting and complicating a number of still lifes and portraits with their constantly disturbing presence (nos.35, 36, 38, 39).

Certain pots became an essential part of Gauguin's dialogue with other friends and artists, asking questions and disturbing seemingly straightforward representations; an example is the pot of no obvious function that he placed at the centre of *Still Life with Profile of Laval*, a painting from 1886 which preceded his and Charles Laval's 1887 journey to Martinique (no.31). With its large central cavity and tongue-like protrusion, the pot, rather than the Cézannesque still life of fruit, captures his friend's attention. Its nearest surviving equivalent is perhaps the *Double Vessel with Mask of Woman* from 1887–8 (no.30). One of the first things Gauguin sought on returning from Martinique was this same pot, and he quizzed his wife in case she had

removed it. It seems that Gauguin required the presence of his favourite pots as touchstones of his own distinctive and different creativity. He went to considerable lengths to have one small pot with him in Arles, requesting of his friend Émile Schuffenecker that he wrap it and send it south. What made it distinctive were the three horns rising from the body of the piece on which Gauguin had modelled the heads of two or three rats. Hardly surprisingly, it has not survived, but we know what it looked like from its insistent presence in two otherwise unexceptional paintings, the *Madame Alexandre Köhler* (no.36) and the *Still Life with Fan* (no.35). If the pot was inspired by La Fontaine's *Le Combat des Rats et des Belettes*, a fable aimed at deflating the puffed-up and pretentious, this may have been an intentional jibe at the sitter, or her bourgeois home, for both paintings apparently represent the same red-walled interior. The Köhlers were Alsatian neighbours of Schuffenecker's, well enough off to commission Madame's portrait but whose patriotic politics Gauguin enjoyed mocking.[5]

There is a high likelihood that Gauguin had some jocular or symbolic meaning in mind when he staged the 1888 composition of *Still Life with Three Puppies* (no.34). Implausibly, the lapping pups seem to be standing on a tabletop behind a diagonal formed of three goblets and three apples. If the flattened perspective and simplicity of drawing evoke Japanese compositional patterning, those insistent numbers put one in mind of a child's counting rhyme. To date no literary explanation has emerged and Gauguin did not offer one. He played games of a different kind in the equally startling *Still Life – Fête Gloanec* of the same year (no.40), a painting of fruit and a Breton galette intended as his statutory birthday offering to the proprietress of the Auberge Gloanec in Pont-Aven. But lest she look askance at its flat synthetic style and non-naturalistic treatment, Gauguin signed it 'Madeleine Bernard', the name of the pretty eighteen-year-old who had recently arrived in Pont-Aven. Madeleine, like her brother Émile, was under Gauguin's thrall at that date, so presumably she went along with this charade. Compared to the way Meijer de Haan represented what must be the same piece of meat in 1889 (fig.57), Gauguin gives to his *Ham* an inexplicably ceremonial and disturbing presentation (no.41), removing it from its expected domestic context, setting the ham off on its circular

pewter platter and metal tabletop against a starkly decorative grid of yellow and black. Uncanny observers or half-hidden eyes and faces add their disconcerting note to a number of other still lifes (no.33), including a decorative and, at first sight, innocent Tahitian flower piece (*Still Life with Flowers and Idol* 1892, no.23), where the viewer is only gradually made aware in the background of a hand and a dark hooded face, its yellow eye gleaming. It was surely paintings such as this, or the equally bold and synthetic portrait of Schuffenecker's children (no.32), that earned the comment from Stéphane Mallarmé which so pleased Gauguin: 'It is extraordinary that one can put so much mystery into so much brilliance.'[6]

Fig.57 Meijer de Haan
Still Life with Ham 1889
Oil on canvas
33 x 46
Norton Simon Museum, Pasadena.
Gift of Mr Norton Simon

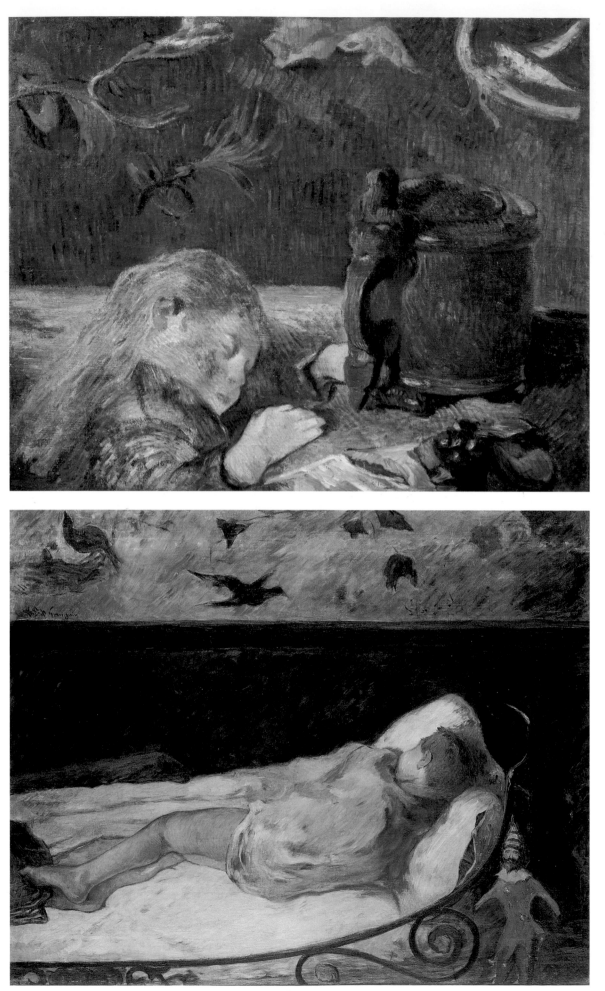

24
Clovis Asleep 1884
Oil on canvas
46 x 55.5
Private Collection

25
The Little One is Dreaming,
Study 1881
Oil on canvas
59.5 x 74.5
Ordrupgaard, Copenhagen

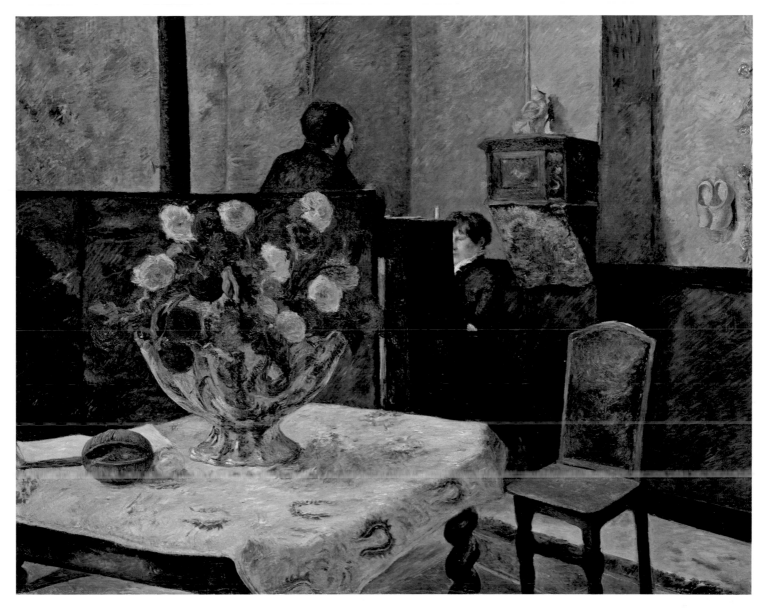

26
Inside the Painter's House, rue Carcel 1881
Oil on canvas
103.5 x 162.5
Nasjonalmuseet for kunst, arkitektur og
design, Oslo

27
Still Life with Peonies 1884
Oil on canvas
59.7 x 73
National Gallery of Art, Washington.
Collection of Mr and Mrs Paul Mellon

28
Still Life with Sunflowers on an Armchair
1901
Oil on canvas
66 x 75.5
Bührle Foundation, Zurich

29
Still Life with Sketch by Delacroix 1887
Oil on canvas
45 x 30
Musée d'Art moderne et contemporain de
Strasbourg

'I am doing some art pottery. Schuff says they are masterpieces, so does the maker, but they are probably too artistic to be sold. However given time ... perhaps ... they will be an amazing success. I hope the Devil is listening!'
Letter to Mette, 26 December 1886

'If you are curious to see all the little products of my crazy ideas (hautes folies) now that they've come out of the kiln, they're ready – 55 pieces in good condition. You are bound to cry out in horror at these monstrosities but I am convinced they will interest you.'
Letter to Félix Bracquemond, late 1886 or early 1887

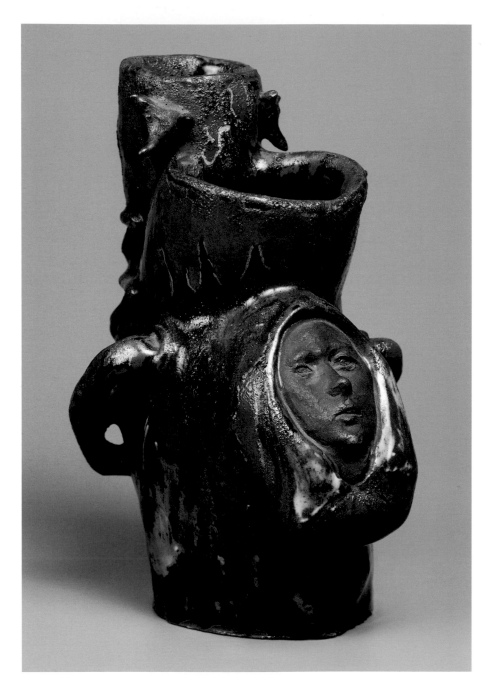

30
<u>*Double Vessel with Mask of Woman*</u>
1887–8
Glazed and unglazed stoneware with touches of gold
h.19.5
Ny Carlsberg Glyptotek, Copenhagen

31
<u>*Still Life with Profile of Laval*</u> *1886*
Oil on canvas
46 x 38.1
Indianapolis Museum of Art. Samuel Josefowitz Collection of the School of Pont-Avon, through the generosity of Lilly Endowment Inc., the Josefowitz Family, Mr and Mrs James M. Cornelius, Mr and Mrs Leonard J. Betley, Lori and Dan Efroymson, and other Friends of the Museum

P. Gauguin 85

32
Two Children c.1889
Oil on canvas
46 x 60
Ny Carlsberg Glyptotek, Copenhagen

33
Still Life with Fruit 1888
Oil on canvas
43 x 58
*The State Pushkin Museum of Fine
Arts, Moscow*

34
Still Life with Three Puppies 1888
Oil on wood
91.8 x 62.6
*The Museum of Modern Art, New York.
Mrs Simon Guggenheim Fund, 1952*

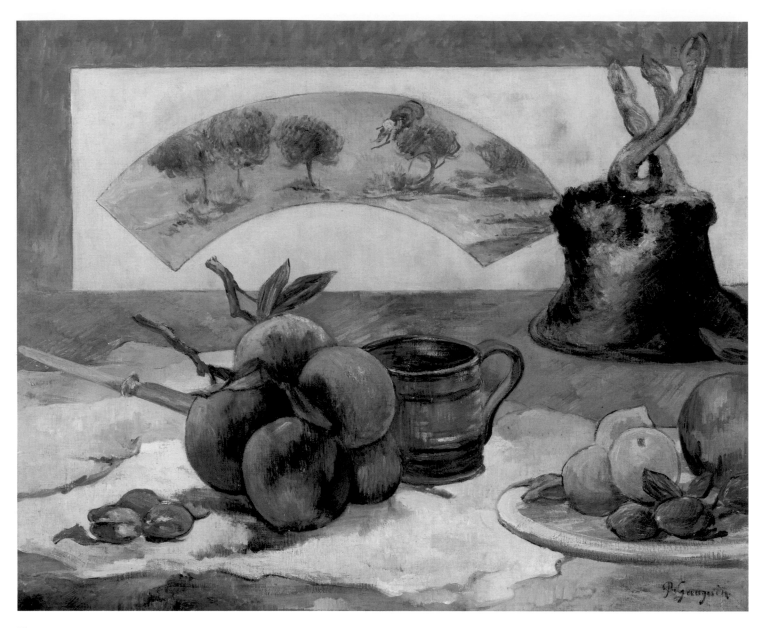

35
Still Life with Fan 1888
Oil on canvas
50 x 61
Musée d'Orsay, Paris

36
Madame Alexandre Köhler *1888*
Oil on linen
46.3 x 38
National Gallery of Art, Washington.
Chester Dale Collection

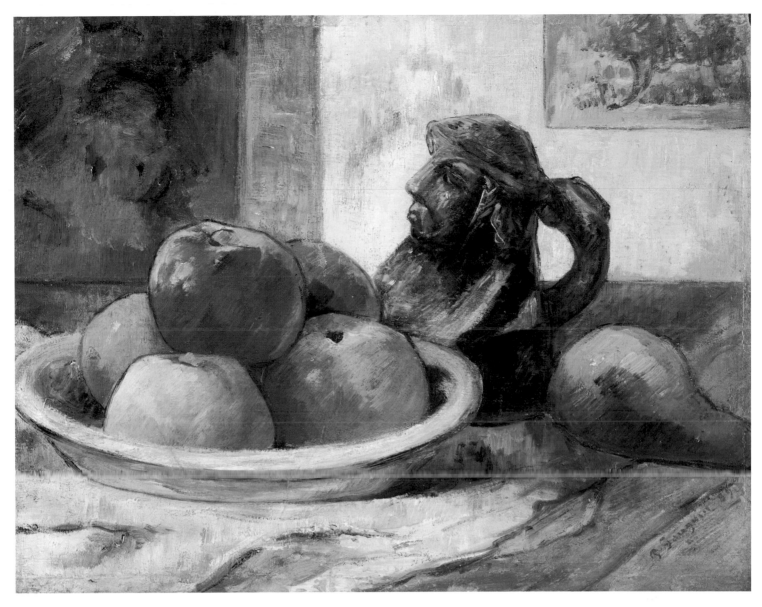

38
*Still Life with Apples, a Pear and a
Ceramic Portrait Jug* 1889
Oil on cradled panel
28.6 x 36.2
*Harvard Art Museum / Fogg Museum,
Cambridge, MA. Gift of Walter E. Sachs*

39
Study of Heads c.1886
Watercolour, red solid and pencil on paper
27.2 x 17.6
*The Trustees of the British Museum,
London*

40
Still Life – Fête Gloanec 1888
Oil on canvas
38 x 53.2
Musée des Beaux-Arts, Orléans

41
The Ham 1889
Oil on canvas
50.2 x 57.8
The Phillips Collection, Washington, DC

42
Women in a Mango Grove, Martinique
1887
Oil on canvas
92.4 x 72
Private Collection

LANDSCAPE AND RURAL NARRATIVE

You're a Parisianist. Give me the country. I love Brittany: I find the wild and the primitive here. When my clogs resonate on this granite ground I hear the muffled and powerful thud that I'm looking for in painting. All that is very sad ... but to each painter his character.[1]

I am trying to put into these desolate figures the savagery that I see in them and which is in me too ... Dammit, I want to consult nature as well but I don't want to leave out what I see there and what comes into my mind.[2]

Gauguin to Émile Schuffenecker and Vincent van Gogh

Fig.58 <u>Blue Trees</u> or '<u>Vous y passerez, la belle</u>' 1888
Oil on canvas
92 x 73
Ordrupgaard, Copenhagen

111

For all his antipathy to what he calls 'Parisianism', Gauguin was by no means a natural countryman. It took him some time to devise strategies for representing the rural life and landscape of Brittany, Martinique or Oceania in ways that captured his fascination with their difference and registered his own presence. When working in a new place, unlike other contemporary artists, Gauguin steered clear of sites of dramatic topographical or architectural interest in favour of more intimate habitats that revealed the indigenous population. Building on his apprenticeship with Camille Pissarro, which had equipped him for dealing with the characteristics of vegetation without becoming lost or unduly detained, he sought a way to unlock the essence of a place through figure drawing. In every new setting he concentrated, in sketch after sketch, on studying the typical physiognomy of the local inhabitants, how body shape and gestural language were dictated by different styles of dress, and on observing the rapport between figures and nature. Inspired by the experience of unfamiliarity that drove him to ever more extreme shores, Gauguin sought to instil an equivalence to that excitement of 'dépaysement', of his intrusiveness as an alien even, into his representations. In a sense he was performing a balancing act between trying to surrender to another set of cultural norms and asserting his own identity and cultural expectations.

Gauguin's approach has been much trumpeted as primitivising – not least by himself – in its desire to attack what he saw as the corrupt and decadent aesthetic of the West by asserting the values of strength, simplicity, crudeness and purity that he found in non-Western art forms. In this respect his work is heir to broader nostalgic and reactionary tendencies in nineteenth-century art such as one finds in Romanticism and Orientalism. But running counter to Gauguin's conscious desire for simplification – and disdain for the modern – was the narrative complication. In 1887 in his first tropical landscapes with figures, *Among the Mangos* (fig.19), *Women in a Mango Grove* (no.42) and *Comings and Goings, Martinique* (no.45), he set out to represent the gestures and activities that were assumed to embody the essential character of the Antillaise 'négresse'. Folkish superstition was enshrined in the landscape of Brittany too, where every prominent feature – especially rocks and springs thought to have spiritual or magical properties – had a local name. But Gauguin avoided the documentary recording of such features, his whole approach seeking rather to elicit the special consonance of figure and field, actor and setting. In his early paintings and ceramics

Fig.59 <u>*Among the Lilies*</u> *1889*
Oil on canvas
92.5 x 73.5
Hilti Art Foundation, Liechtenstein

Gauguin openly embraced popular clichés. He played, for example, to the humorous but patronising analogies drawn by contemporary writers and caricaturists between *Bretonne* and goose (no.50) or *Bretonne* and cow (no.57).

Another narrative strategy was to give an otherwise neutral rural scene a loaded, perplexing title, drawing attention to figural activity that might otherwise pass unnoticed. In the case of three works from Arles, which Gauguin sent in 1889 to the important independent avant-garde exhibition of 'Les XX', he substituted titles clearly meant to pique the viewer's curiosity for the more straightforward ones he had first noted in a sketchbook – *Les Cochons* becoming *En Pleine Chaleur*, *Vendanges à Arles* becoming *Misères humaines*. In the case of one landscape (previously and subsequently known as *Blue Trees*), the sexual innuendo of the title '*Vous y passerez, la belle!*' strayed so far from the ostensible motif that it has only been possible to reconnect the two from a careful reading of the critics (fig.58).[3] Elsewhere one finds instances of what one might call truncated narratives. The intrusion of the outsized hound in *Among the Lilies*, and the strangely prominent red dog in *Harvest: Le Pouldu* (no.54) – in both cases literally imported from a painting by Gustave Courbet formerly owned by Arosa (fig.11) – hints that all is not as it might seem. Furthermore, as a symbol of perversity or as an alter ego, the fox image reached a peak of potency in two overtly symbolic works, *Soyez amoureuses* (no.93) and *The Loss of Virginity* (no.55). But it is instructive to compare the success of the latter with a painting in which that poetic ambiguity tipped over, producing something more akin to melodrama, *Pont-Aven, Village Drama* (fig.60).

Animal imagery offered Gauguin a conveniently ambiguous secondary level of meaning that he would sustain in Polynesia, where he was delighted, for instance, to learn that the ubiquitous pigs had been introduced by missionaries as a substitute for human flesh (nos.58, 60). Just as Gauguin the draughtsman sought to isolate essential differences of contour, gait and body language, Gauguin the musician was alert to differences of sound and language whose understanding was initially closed to him – his clogs on granite, for instance, or a phrase like 'Haere mae', which he frequently heard called out by Tahitian women, only later discovering it meant 'Come eat'. Although the analogy he frequently made between colour harmonies and music is widely

with Breton motifs he gave the scenes a quaintly picture-book look, assigning the lead roles to children as in *The Breton Shepherdess* (no.43) and *Breton Girls Dancing, Pont-Aven* (no.48); increasingly, he lent them an inexplicably wistful demeanour, in works such as *En Bretagne* (no.52) and *Among the Lilies* (fig.59). This sadness, with which he also infused his Breton religious paintings, was characteristic, so he claimed, both of the locale and of his own personality (no.51). And in paintings and prints where he made Martiniquaises or Bretonnes the main subject (largely ignoring the male population, as has often been remarked),

acknowledged and respected, little interest has been shown in his recourse to words and language or the uses to which he put aural stimuli.[4] The fragments of overheard foreign conversation that he inscribed onto paintings were a facet, with folklore and myth, of his attempt to play on cultural difference, his search for an essential otherness, drawing attention to his own presence as the foreigner.

In Brittany, Gauguin forced a marriage between his vision of the region, whose lines and colours he deliberately exaggerated and simplified, and the local objects of religious cult, in order to produce a charged spirituality. In Tahiti, he hoped to achieve a similar conjunction of luxuriant setting and eloquent indigenous artefact. On arrival in Papeete in June 1891, however, he soon realised that the Tahitian landscape had been cleaned out of its old icons, and if he wanted it to have a mystic, spiritual dimension, he would have to supply it. The sort of thing Gauguin might have hoped to find was anticipated in a description by Pierre Loti of travelling up to a remote temple in the mountains of Japan and finding strange threatening deities set into rocks or on promontaries, granitic carvings overgrown by foliage; in his poetic evocation of this arcane world, Loti conflated the reality of the Japanese landscape with reminiscences of Tahiti, 'l'île délicieuse', and Brittany, whose familiar church spires, crosses and calvaries he sought in vain. If Gauguin read this text, it could only have fired his project of resurrecting Oceania's lost domains.[5]

After a year or so assembling 'documents', Gauguin began to confect, alongside his more straightforward depictions, Tahitian landscapes and rural scenes that satisfied his imaginings, fusing the possible with the impossible according to his 'dream'. Often he did this by introducing into his paintings a seemingly natural standing 'tiki' (no.73) or larger idol (no.76), inspired by one of his own carvings. Emboldened by his readings in Jacques-Antoine Moerenhout's ethnographic account *Voyage aux îles du grand océan* (1837), he had started the process of devising appropriate forms for the Polynesian theogony, first in rubbings and watercolour illustrations. He drew one of his first tikis in a letter to his wife Mette in the spring of 1892 (no.74). The presence of this or a similar carved idol in the background of certain key 1892 paintings, *Mata Mua* (*In Olden Times*) for instance (no.63), and *Parahi te Marae* (*There Lies the Temple*) (no.87), brings a narrative dimension to these lyrical landscapes, and such idols crop up more overtly in the background of figure compositions

with landscape settings such as *Vairaumati tei oa* (*Her Name is Vairaumati*), *Arearea no Varua ino* (*Words of the Devil*) (nos. 79, 80) or *Mahana no Atua* (*Day of God*) (no.81). As in the previous decade, this fusion of personal, charged, three-dimensional crafted 'objects' with compositions in which figures and natural forms are only mildly distorted was one of Gauguin's most effective and consistent narrative strategies.

Fig.60 <u>Pont-Aven, Village Drama</u> 1894
Oil on canvas
73 x 92
Private Collection,
whereabouts unknown

113

43
The Breton Shepherdess 1886
Oil on canvas
61 x 74
Laing Art Gallery, Newcastle
upon Tyne (Tyne & Wear
Archives and Museums)

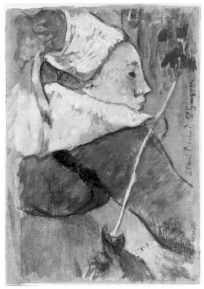

44
Breton Woman from Pont-Aven
in Profile 1886
Watercolour on paper laid down
on cardboard
20 x 14
Galerie Charles Bailly, Paris

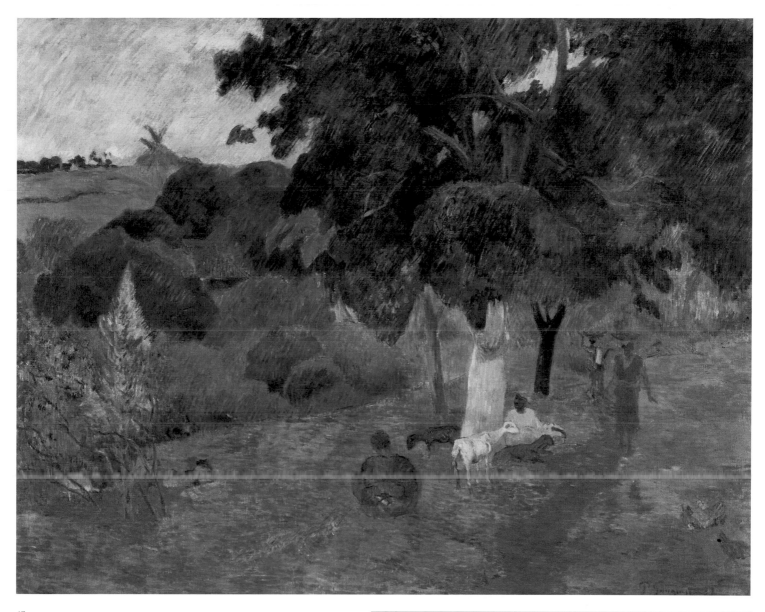

45
Comings and Goings, Martinique 1887
Oil on canvas
72.5 x 92
Carmen Thyssen-Bornemisza Collection,
on loan at the Thyssen-Bornemisza
Museum, Madrid

46
Study of Martiniquaises 1887
Pastel and charcoal on paper
41.9 x 53.6
Private Collection, Moscow

115

48
Breton Girls Dancing, Pont-Aven 1888
Oil on canvas
73 x 92.7
National Gallery of Art, Washington.
Collection of Mr and Mrs Paul Mellon

47
Breton Girls Dancing, Pont-Aven 1888
Pastel, charcoal, watercolour and gouache
on paper
58.6 x 41.9
The Morgan Library & Museum,
New York. Thaw Collection

49
Carved Cane 1888–90
Boxwood, mother-of-pearl and iron
h.93.3
The Metropolitan Museum of Art, New
York. Bequest of Adelaide Milton de Groot
(1876–1967), 1967

50
Gauguin's Wooden Shoes 1889–90
Polychromed oak, leather, and iron nails
Each 12.9 x 32.7 x 11.3
National Gallery of Art, Washington.
Chester Dale Collection, 1963

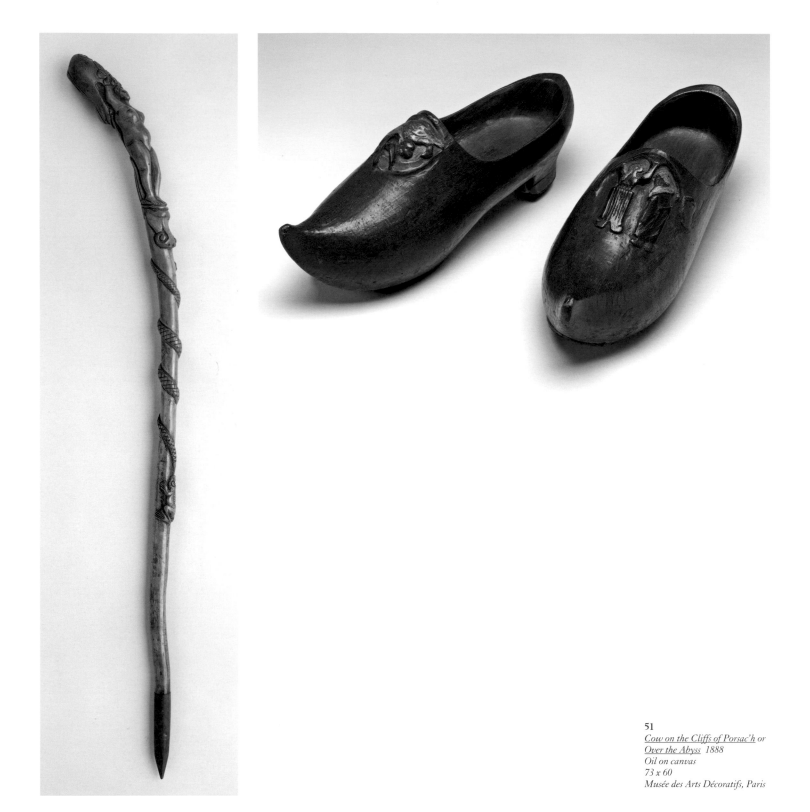

51
Cow on the Cliffs of Porsac'h or
Over the Abyss 1888
Oil on canvas
73 x 60
Musée des Arts Décoratifs, Paris

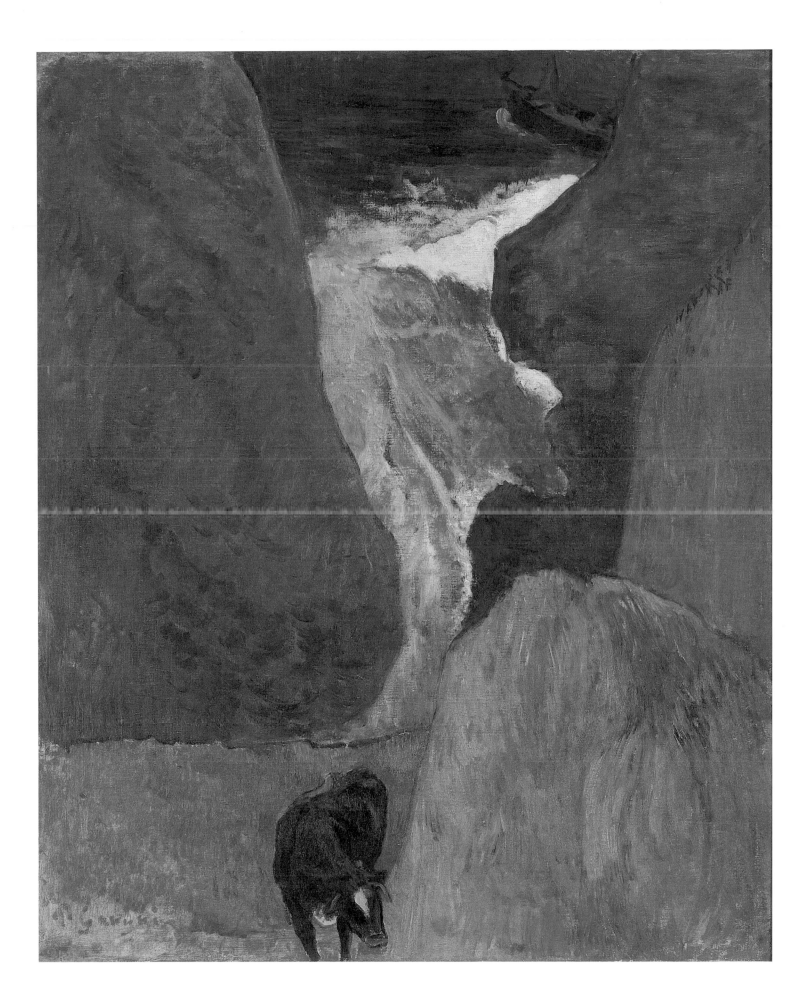

52
En Bretagne (In Brittany) 1889
Gouache and watercolour on card
37.9 x 27
The Whitworth Art Gallery,
University of Manchester

53
Breton Girl Spinning 1889
Oil on plaster
116 x 58
Van Gogh Museum, Amsterdam

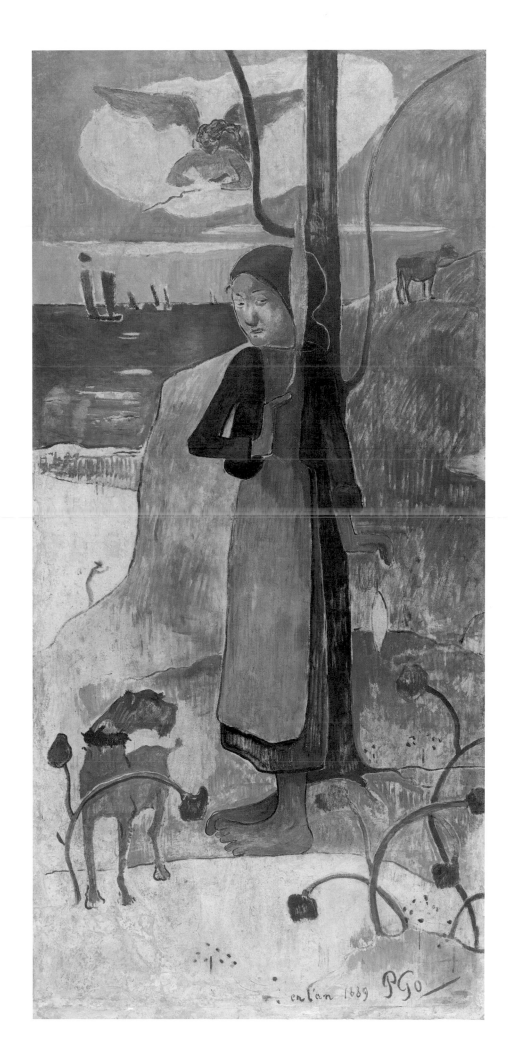

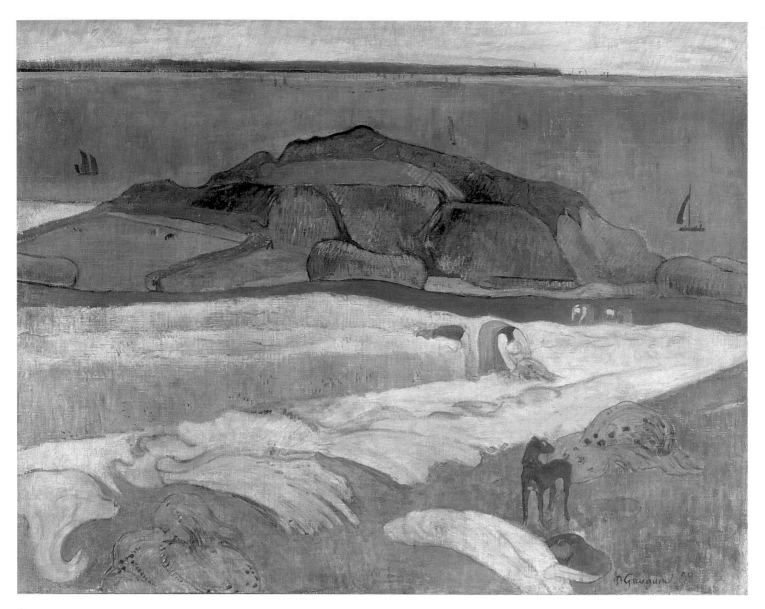

54
Harvest: Le Pouldu 1890
Oil on canvas
73 x 92.1
Tate. Accepted by HM Government
in lieu of tax and allocated to the
Tate Gallery, 1966

'What I've been doing this year is simple peasant
children, walking unconcernedly by the sea with
their cows. Only since I don't like the trompe-l'oeil
of the open air, or of anything else, I try to put into
these desolate figures the savageness I see in them
and that is also in me. Here in Brittany the peasants
have a medieval air about them and do not for a
moment look as though they think that Paris
exists and that it is 1889.'
Letter to Vincent van Gogh, c. 20 October 1889

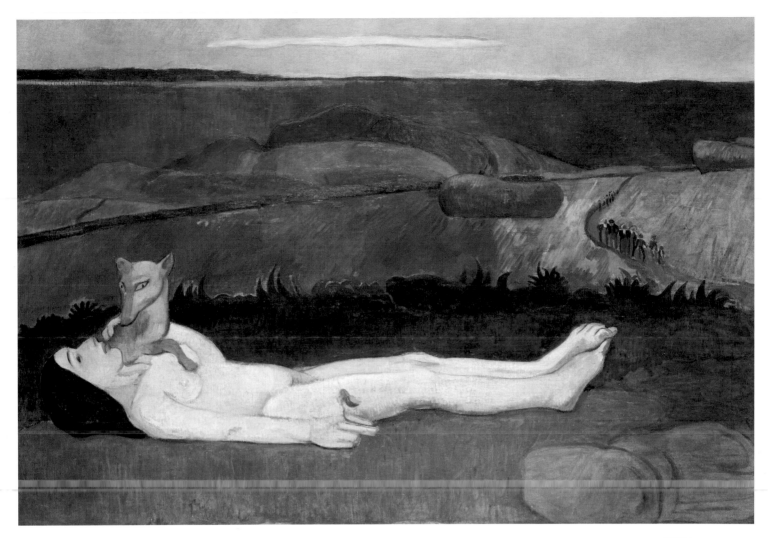

55
<u>*The Loss of Virginity (La Perte de pucelage)*</u> *1890–1*
Oil on canvas
90.2 x 130.2
Chrysler Museum of Art, Norfolk, VA.
Gift of Walter P. Chrysler, Jr

56
<u>*Study for The Loss of Virginity*</u> *1890*
Crayon, pastel, chalk and pencil on paper
31.6 x 33.2
Private Collection

57
Haystacks in Brittany 1890
Oil on canvas
74.3 x 93.6
National Gallery of Art, Washington. Gift
of the W. Averell Harriman Foundation in
memory of Marie N. Harriman

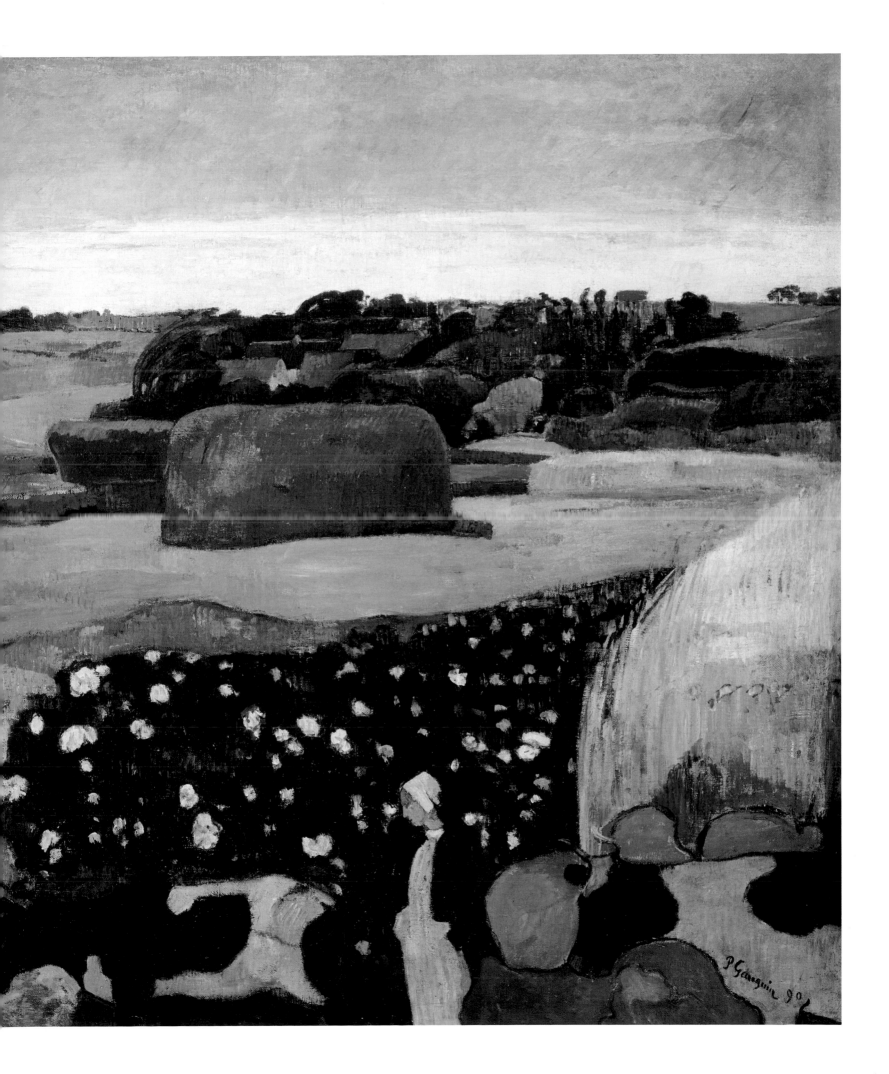

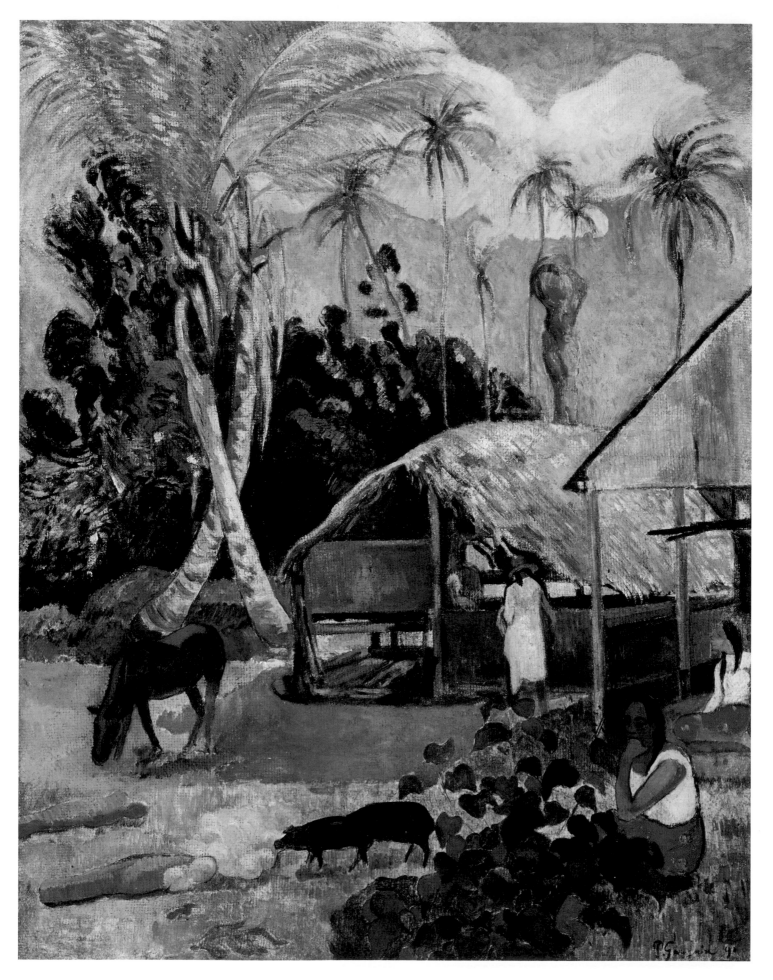

126

58
<u>Black Pigs</u> *1891*
Oil on canvas
91 x 72
Szépmuvészeti Múzeum, Budapest

59
<u>Tahitians</u> *c.1891*
Oil, crayon and charcoal on paper
mounted on millboard
85.4 x 101.9
Tate. Presented by the Contemporary
Art Society 1917

'You must think I speak too much about pigs: what's to be done you see them in every corner and they are part of the character of the country. I need to explain that in former times they were cannibals and the missionaries introduced the pig whose flesh tastes like that of a human being in order to break them of this bad habit. In a corner of the painting this inscription – E. haere maï ta maha – Come Eat'
Letter from Gauguin to his wife, spring 1892

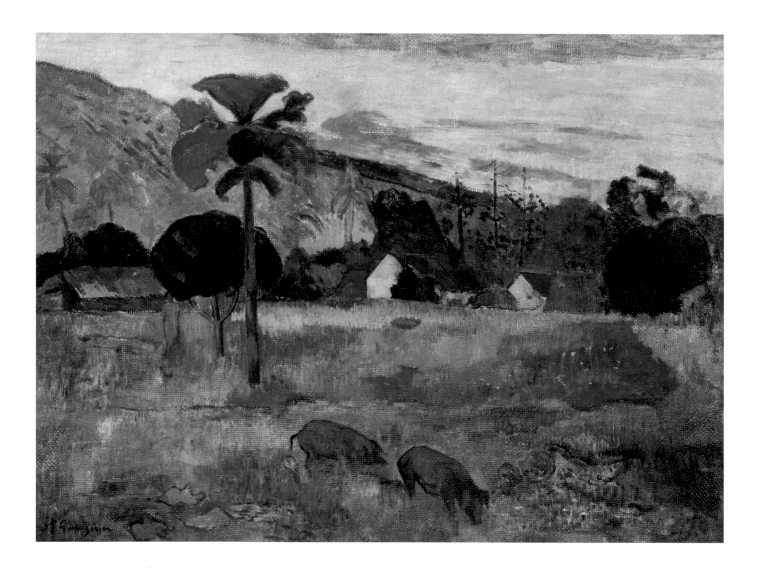

60

Haere Mai 1891
Oil on burlap
72.4 x 91.4
Solomon R. Guggenheim Museum,
New York, Thannhauser Collection.
Gift of Justin K. Thannhauser, 1978

61

Tahitian Landscape 1891
Oil on canvas
67.9 x 92.4
The Minneapolis Institute of Arts.
The Julius C. Eliel Memorial Fund

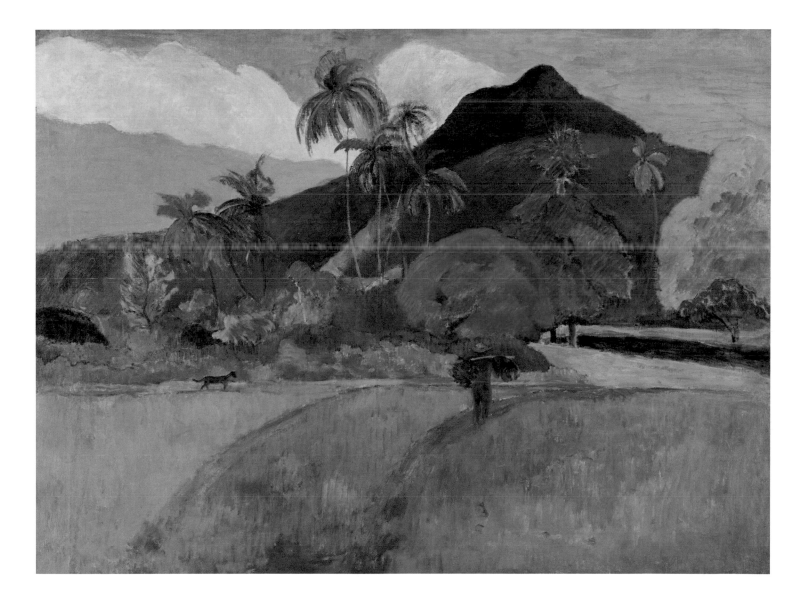

62
Te Poi Poi (Le Matin / Morning) 1892
Oil on canvas
68 x 92
Mr Joseph Lau Luen Hung

63
Mata Mua (Autrefois / In Olden
Times) *1892*
Oil on canvas
91 x 69
Carmen Thyssen-Bornemisza
Collection, on loan at the Thyssen-
Bornemisza Museum, Madrid

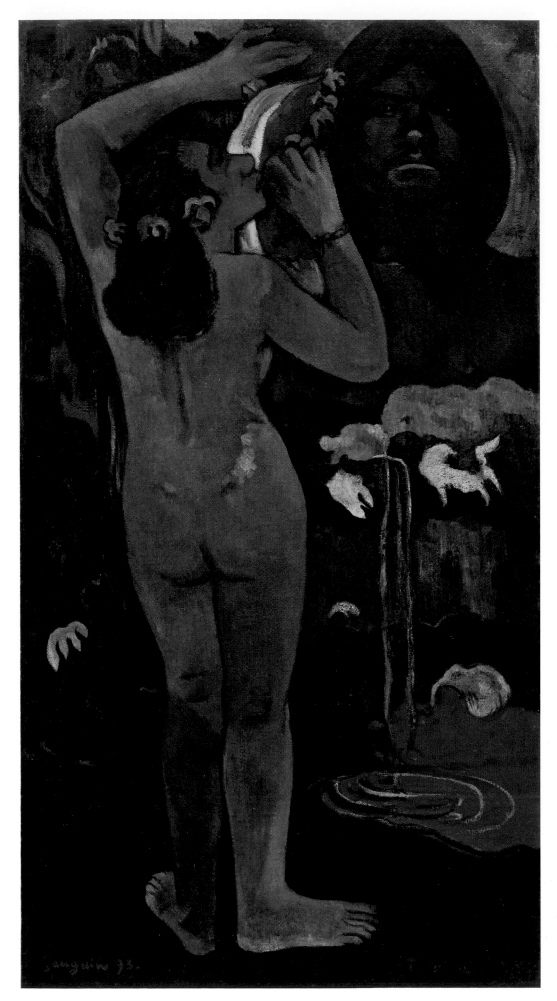

64
Hina Tefatou (La Lune et la Terre / The Moon and the Earth) 1893
Oil on burlap
114.3 x 62.2
The Museum of Modern Art, New York.
Lillie P. Bliss Collection, 1934

SACRED THEMES

If Gauguin was something of an immoralist, he was also something of a moralist. Perhaps this paradox accounts for the recurrence of sacred themes in his art. Religious stories and narratives, signs and symbols (no.72) pervade Gauguin's oeuvre. He engaged at an artistic and intellectual level with the belief systems of not just one religion but several, at first working his personal variants on their traditional iconography (fig. 61), later finding a syncretic commonality in the world's religious and mythological narratives. In his *Noa Noa* woodcuts Gauguin was bold enough to conjure imaginative evocations of grand universal themes: the eternal night, the realm of the gods, the creation, the great flood, heaven and hell.

Gauguin's outward behaviour and a number of his written statements suggest a total antipathy to the Christian Church and its teachings. Whilst living in Tahiti, between 1896 and 1898 he laboured over a tract, *L'Esprit moderne et le catholicisme*, wrestling, provocatively, with the many contradictions he saw inherent in the promulgation of religious dogma in a sceptical scientific age, contradictions of which he had become more acutely aware as he had moved from the sophisticated metropolis to the outposts of France's colonial empire.[1] Despite this, one infers from a number of his more emotive, unguarded statements, and from a study of his work as a whole, a profound respect for the example and teachings of Christ. A Catholic from birth, educated in a Jesuit seminary, Gauguin also had a surprisingly wide experience of Protestantism, through marriage to a Danish woman according to Lutheran rites and through rubbing shoulders with active Protestant missionaries in rural Polynesia. But he found Protestants, if anything, more judgemental than their Catholic rivals, and equally two-faced.[2] In view of these attitudes it would have been easy for Gauguin to denounce Christianity as a baleful influence and leave well alone. Instead he turned time and again for artistic inspiration to its themes and symbolic images, producing works of art that could stand comparison with the Old Masters. He even had a strong, if paradoxical, attraction toward the religious institutions of Christianity. To the incomprehension of his friends back in France, he built his last Marquesan studio and home right next to the Catholic bishop's house and adjoining the Protestant missionary school, seemingly relishing the contradiction and irritation he could thus cause. And despite the scandal Gauguin

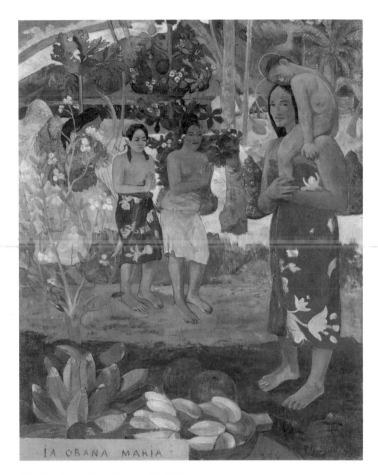

Fig.61 *Ia Orana Maria (Ave Maria)* 1891
Oil on canvas
113 x 87.7
The Metropolitan Museum of Art, New York.
Bequest of Sam A. Lewisohn, 1951

had allowed to build up around his name, he found in the Protestant pastor Paul Vernier a congenial and cultured companion during his last years.

Sacred themes first make an overt appearance in Gauguin's Breton work. Susceptible to the atmosphere of religiosity he found in Brittany, which set it apart from the rest of an increasingly secularised France and accounted for its picturesque value in the eyes of many contemporary painters, in 1888 Gauguin painted his own, highly personal and

experimental response, *Vision of the Sermon (Jacob Wrestling with the Angel)* (no.65). His most powerful picture to date, it was an attempt to depict the fervour of a faith grafted onto more ancient Celtic superstitions. The effort to conjure the idea of a vision resulted in a stark and decorative painting, the first in which Gauguin had achieved such expressive simplicity of form and allowed colour to depart so radically from observed reality. Pleased with the result, he sought to offer it to the church of Pont-Aven, then that of neighbouring Nizon.[3] Despite rejections by the local clergy, wary of his sincerity or baffled as to the work's meaning, Gauguin returned to the challenge the following year, transposing into two landscape compositions 'primitive' Breton carvings of the crucifixion and the descent from the cross, thereby dramatically heightening their emotional content (*Yellow Christ*, no.68; *Breton Calvary*, no.67). In finding creative inspiration in these rough-hewn, unpolished artefacts, which became filters for 'representing the "savage" consonance of artist and subject', he laid the pattern for his exploration of other more distant cultures.[4] But in the interim, he succumbed to a moment of intense self-pity, or perhaps self-regard, identifying his predicament – or, more generally, that of the modern misunderstood artist – with that of *Christ in the Garden of Olives* (no.9), as Gérard de Nerval had done before him in his harrowing poem *Le Christ aux Oliviers* (1844).

In the paintings and carvings Gauguin made between 1892 and 1895 or thereabouts, sacred themes adapted from Tahitian religion displace Christian themes. A key reason for Gauguin's travelling so far from his homeland had been to investigate this unfamiliar culture, its customs and religion. This was very much in the spirit of the times: in 1876 comparable objectives had motivated the artistic and ethnographic mission of Émile Guimet and Félix Régamey to Japan. Reports of the variety of 'types, religion, mysticism, symbolism' in Madagascar had initially led Gauguin to favour that island over more distant Tahiti. In Madagascar, he had learned, 'you find Indians from Calcutta, black Arab tribes, Hovas, Polynesian types'.[5] If the original stated purpose of Gauguin's artistic mission to Tahiti had been to 'fix the character and light', that project later enlarged to encompass 'studying the customs and landscapes of the country'.[6] Later still he would claim his mission had been to study the country and its ancient beliefs 'either as a painter,

or as a man of letters . . . ,' beliefs whose memory his art sought not just to preserve but to reawaken.[7]

Not until fellow colonist Auguste Goupil lent Gauguin what was then recognised as the most thorough study in French of Polynesian culture, Jacques-Antoine Moerenhout's *Voyages aux îles du grand océan* (1837), was the artist in a position to make good his commitment to studying Tahiti's former religion. The book's coverage ranged from geography, history, commerce and politics, to language, literature, religion and social customs. In focusing on the cosmogony, the specific gods, demigods and legends associated with Tahiti's ancient beliefs, Moerenhout, and Gauguin more acutely some fifty years later, clearly felt they were preserving the elements of a dying religion. After March 1892, Hina, the goddess of the moon, Tefatou, the god of the earth, Oro, the eldest son of the Creator, Taaroa, and his chosen earthly bride, the delightful Vairaumati, progenitrix of the Areoi (Tahiti's priestly elite), start to make an appearance in his art (nos.64, 73–82, 86). As Victor Segalen was quick to recognise, Gauguin's work sought to rehabilitate the dignity of the Areoi, who had been responsible for the oral transmission of Tahiti's ancient religious traditions. They had effectively been displaced and rendered impotent during the course of the island's conversion to Christianity and colonisation. Without openly celebrating their admittedly extreme practices – ranging from public displays of lewd dancing and copulation to infanticide and cannibalism – Gauguin alluded to some of them, visually and in written form, fascinated by precisely those aspects that had shocked, terrified and been forcibly suppressed by his colonial predecessors (no.87). René Huyghe, the first editor of Gauguin's *Ancien culte mahorie*, the notebook into which Gauguin copied selected extracts from Moerenhout, was struck by precisely this attraction toward the 'shock of the sacred' on Gauguin's part. 'The sacred for him is tied to a notion of obscure power, virginal and barbarous. The idol offers him what he no longer gets from God.'[8]

Coinciding with Gauguin's introduction to Moerenhout's text, and as a necessary preamble to his exploration of Tahitian myths in paint, went a phase of fashioning what he called 'bibelots'; the first of these was a 'tupapau (god), in ironwood with incrusted mother of pearl', as he described it to his wife Mette.[9] His sketch of this tiki, or idol-like figure, with its tattooed buttocks and schematic fork-like hands, reveals a familiarity

with certain characteristic features of Marquesan art that he could have observed and sketched in museums before leaving France (no.74).[10] It was around such invented but plausible sacred objects, the originals having long since been eradicated from the Tahitian landscape, that Gauguin proceeded to choreograph his paintings of ceremonial and religious rituals, in paintings like *Arii Matamoe* (*La Fin royale / The Royal End*) of 1892 (no.117) and *Mahana no Atua* (*Day of God*) of 1894 (no.81).

Yet many of Gauguin's Polynesian paintings continued to draw from the traditional narratives of Christianity – the Nativity, the Madonna and Child, Joseph and Potiphar's wife, the Last Supper, the Entombment, each of which is given a specifically Polynesian twist (figs.61, 62; nos.66, 70, 71, 83). Perhaps the imagery, directly drawn from Biblical stories, helped him establish some sort of dialogue with his neighbours, whose conversion to Christianity by British Protestant missions had begun over a century earlier. On Gauguin's arrival in Polynesia he found, to his dismay, that the legendary seductive vahines had adapted to missionary teachings, forsaking their native undress for demure cotton smocks and embracing the hymn-singing and intoning of prayers. The influence of the Protestant missionaries was only challenged in the late 1830s by rival Catholic missions from France.[11] Anglicisms were detectable in the language: *Ia Orana Maria*, for instance, the phrase of greeting Gauguin used as the title of his various images of the Madonna and Child, was a naturalisation of the deferential English salutation 'Your Honour'. French efforts to inculcate more secular values, in the spirit of the progressive anti-clericalism of the Third Republic, made little headway among this god-fearing people.

Gauguin is known to have admired and collected Japanese prints and Indian miniatures, and such sources undoubtedly influenced his decorative use of colour and detail in the Breton sacred works. For all its Christian theme, he achieved the suavity and hieraticism of his early Tahitian composition, *Ia Orana Maria* (*Ave Maria*) (fig.61), by incorporating poses and vegetal forms from Buddhist carvings at the Javanese temple of Borobudur – known only from photographs (fig.73). Certain of his other mythic figures, the Joan of Arc-like figure painted in the inn of Le Pouldu on the Brittany coast, for instance, or *Vairaumati tei oa* (*Her Name is Vairaumati*) 1892, acquired stylised or ponderous gestures from Javanese dances

or Egyptian wall paintings. Details copied from Maori carved objects are combined with a sombre, almost Poussin-like composition in *The Last Supper* (no.83). If, stylistically, Gauguin's approach to sacred themes was eclectic, his view of religion became increasingly syncretic, in response to his reading of and exposure to the comparative study of global religions.[12] Nevertheless, the sacred themes that pervade Gauguin's art continued to reinforce his most consistent, grandiose and irrefutable claim for his artistic practice, namely its quasi-divine creativity. In replying to an admiring letter from Émile Schuffenecker, with no false modesty Gauguin readily invoked a mysterious power that lifted his genius beyond the reach of mere mortals.[13] He repeatedly averred that his preferred narrative method, following the example of Christ, was the parable – a moral tale that could be apprehended by all, but would not be universally understood.

Fig.62 Te Tamar ino Atua (God's Child) 1896
Oil on canvas
96 x 128
Neue Pinakothek, Munich

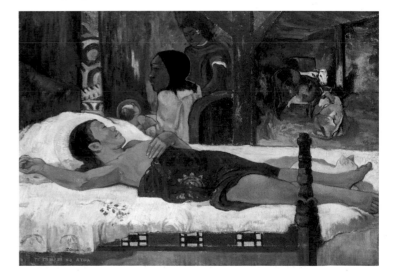

'I have just painted a religious picture, very badly done but it interested me and I like it. I wanted to give it to the church of Pont-Aven. Naturally they don't want it.
A group of Breton women are praying, their costumes very intense black. The coifs very luminous yellowy-white. The two coifs to the right are like monstrous helmets ...
I think I have achieved in the figures a great simplicity, rustic and superstitious. The whole thing very severe ...'
Letter to Vincent van Gogh, c.22 September 1888

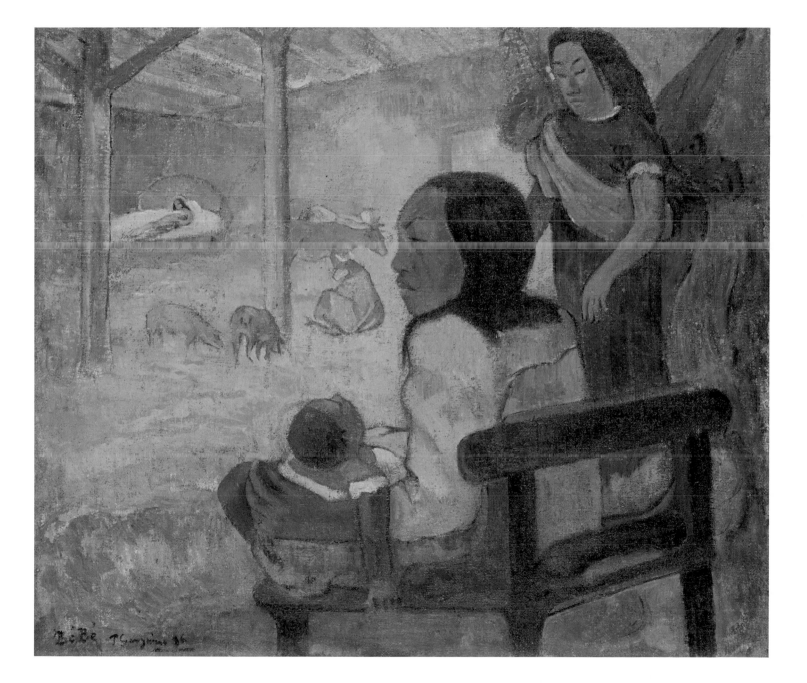

Breton Calvary (The Green Christ)
1889
Oil on canvas
92 x 73.5
Royal Museums of Fine Arts of
Belgium, Brussels

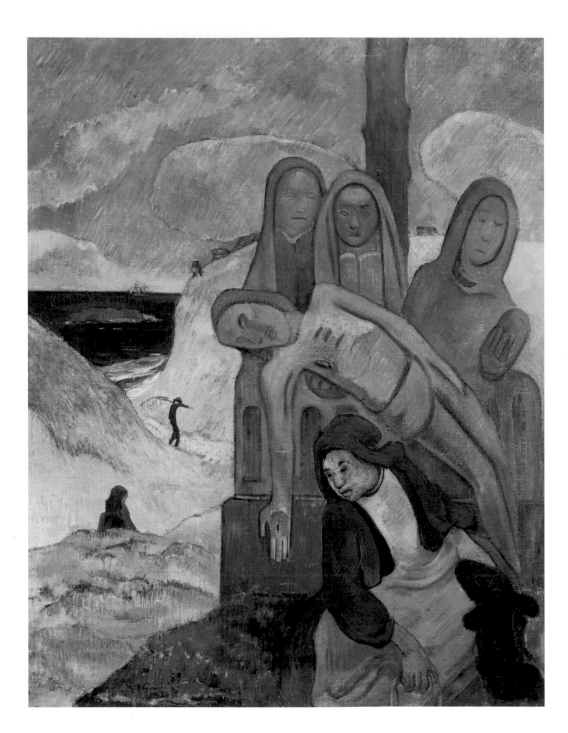

68
The Yellow Christ 1889
Oil on canvas
92.1 x 73.3
Albright-Knox Art Gallery Buffalo, NY.
General Purchase Funds, 1946

69
Sketch for 'The Yellow Christ' 1889
Pencil on paper
26.7 x 18.2
Carmen Thyssen-Bornemisza Collection,
on loan at the Thyssen-Bornemisza
Museum, Madrid

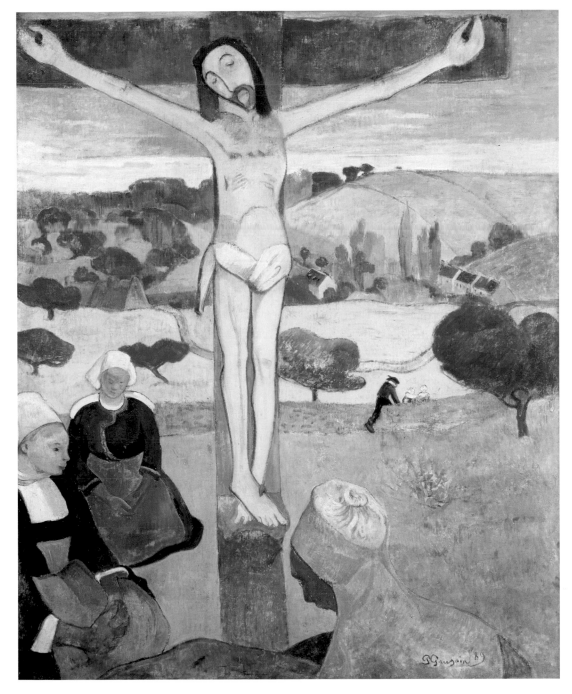

70
Ia Orana Maria (Ave Maria) c.1893–5
Charcoal, chalk and pastel on paper, on
millboard
59.7 x 37.5
The Metropolitan Museum of Art, New
York. Bequest of Loula D. Lasker, New
York City, 1961

71
Ia Orana Maria (Ave Maria) 1894–5
Lithograph on zinc printed on paper
25.8 x 20
The Trustees of the British Museum,
London

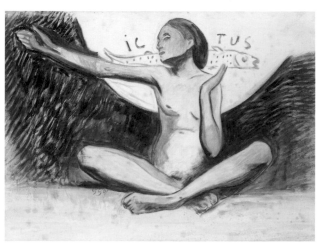

72
Ictus c.1889
Watercolour and touches of oil on paper
41.6 x 56
Collection Daniel Malingue

73
Hina and Fatu c.1892
Carved tamanu wood
32.7 x 14.2
*Art Gallery of Ontario, Toronto. Gift from
the Volunteer Committee Fund, 1980*

74
Letter to Mette Gauguin c.spring 1892
Ink on paper
21 x 13.5
Jean Bonna Collection, Geneva

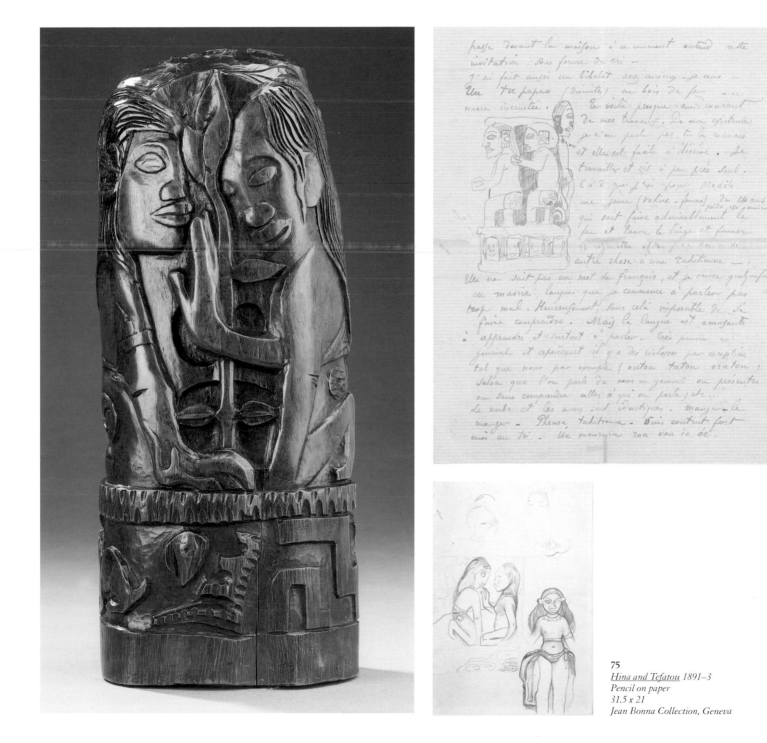

75
Hina and Tefatou 1891–3
Pencil on paper
31.5 x 21
Jean Bonna Collection, Geneva

76
Hina with Two Attendants 1892
Tamanu wood with painted gilt
37.1 x 13.4 x 10.8
Hirshhorn Museum and Sculpture Garden,
Smithsonian Institution, Washington.
Museum Purchase with Funds Provided
under the Smithsonian Institution
Collections Acquisition Program

77
*Hina Talking to Tefatou (Cylindrical
Vase in Burnt Clay with Figures of
Tahitian Gods)* 1893–5
Ceramic
h.33.7
The Danish Museum of Art & Design,
Copenhagen

78
Tahitian Woman and Idol 1893–4
Watercolour, pen, ink and wash on paper
34.9 x 24.8
Private Collection, Courtesy Galerie
Jean-François Cazeau, Paris

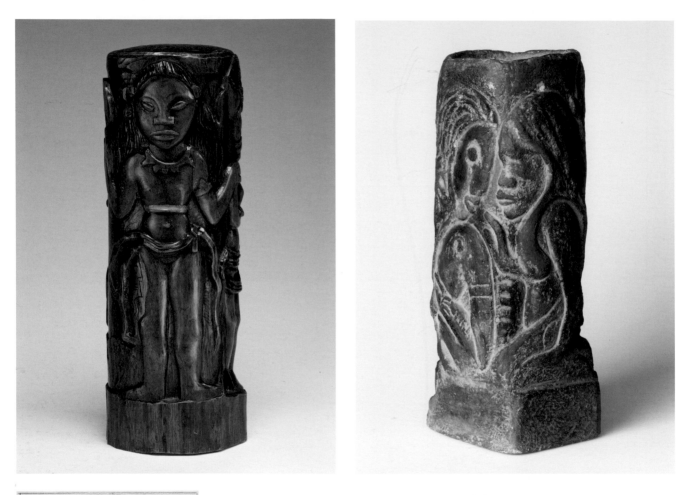

79
Arearea no Varua ino (Words of the Devil or
Reclining Tahitian Woman) 1894
Oil on canvas
60 x 98
Ny Carlsberg Glyptotek, Copenhagen

80
Arearea no Varua ino 1894
Watercolour monotype on paper
24.4 x 16.6
National Gallery of Art, Washington.
Rosenwald Collection

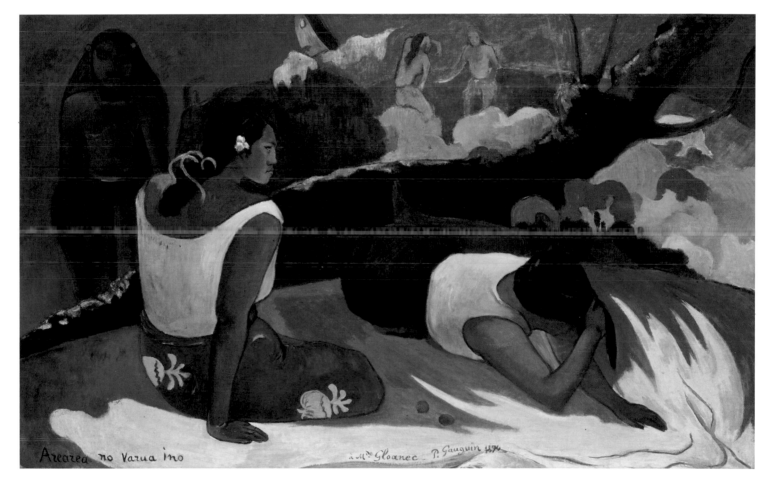

143

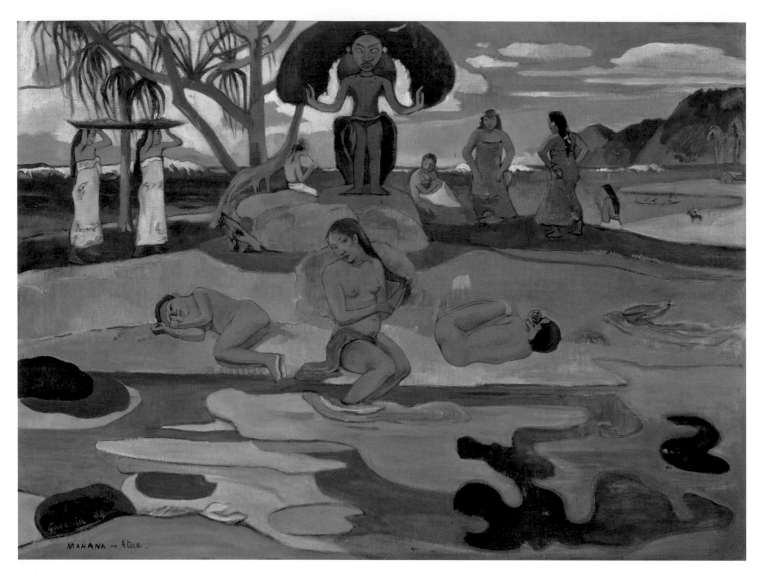

MAHANA no Atua.

81
Mahana no Atua (Day of God) 1894
Oil on canvas
68.3 x 91.5
The Art Institute of Chicago. Helen
Birch Bartlett Memorial Collection

82
*Design for a Fan Featuring a Landscape
and a Statue of the Goddess Hina* 1900–3
Gouache, watercolour, pastel and pencil
on paper
20.8 x 41.7
The Art Institute of Chicago. Gift of
Edward McCormick Blair, 2002

83
The Last Supper 1899
Oil on canvas
60 x 43.5
Collection Larock
Granoff, Paris

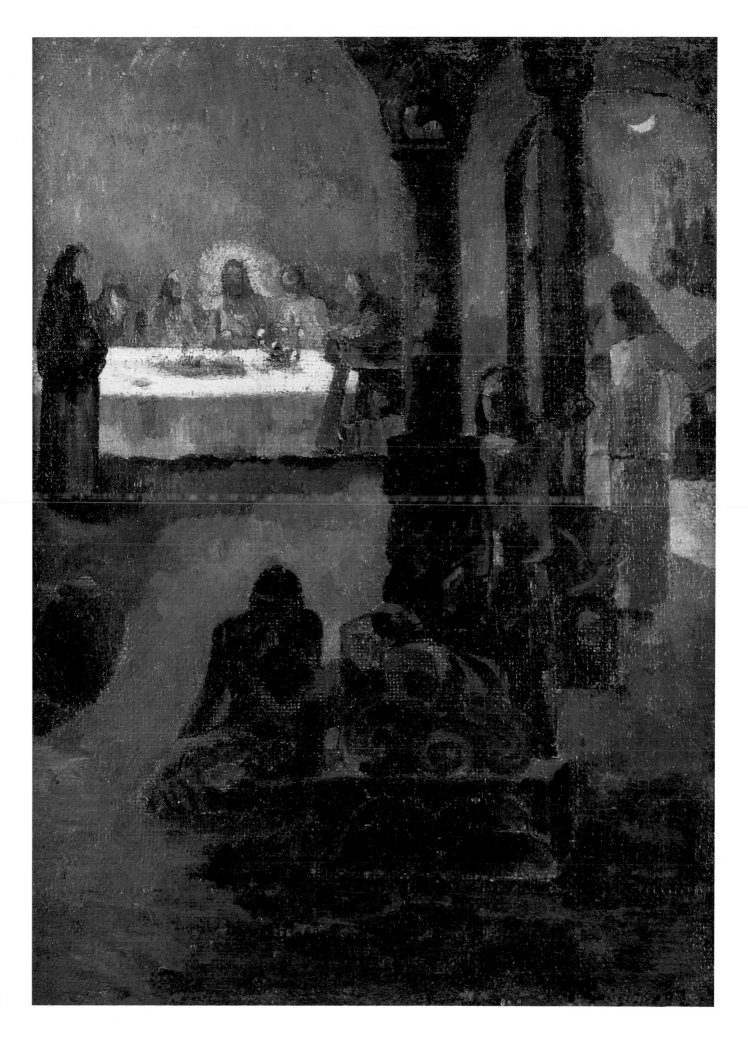

145

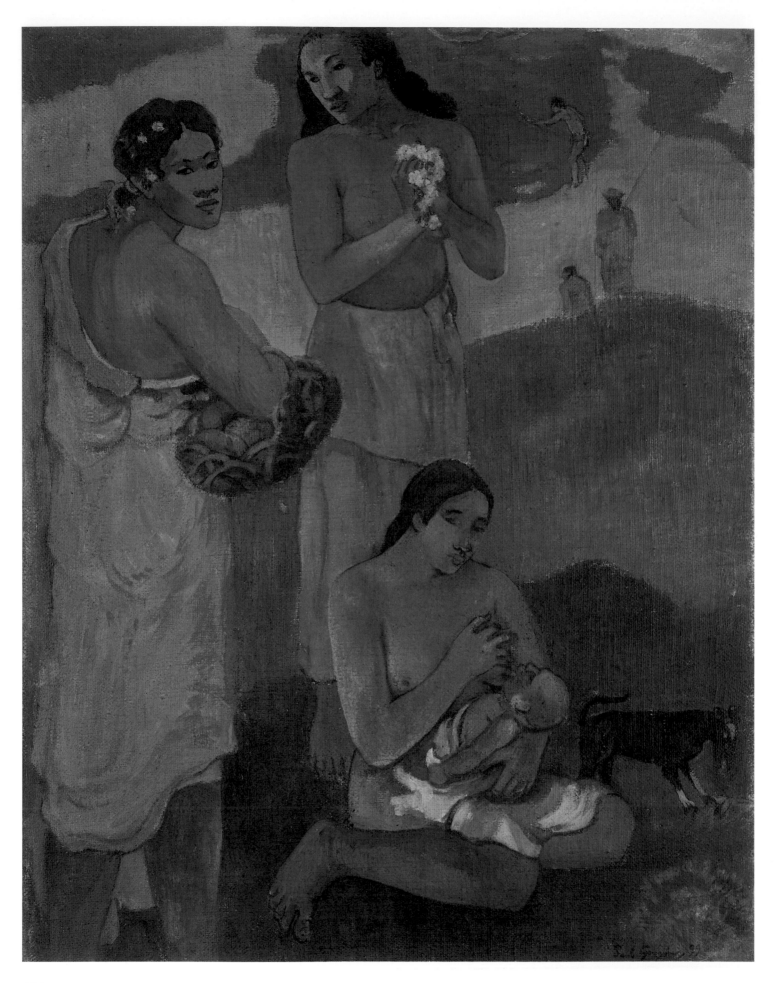

84
Maternity / Women by the Sea 1899
Oil on canvas
95.5 x 73.5
The State Hermitage Museum,
St Petersburg

<u>85</u>
The Bark (La Barque) 1896
Oil on canvas
50.5 x 37.5
Courtesy of Mr Giammarco Cappuzzo

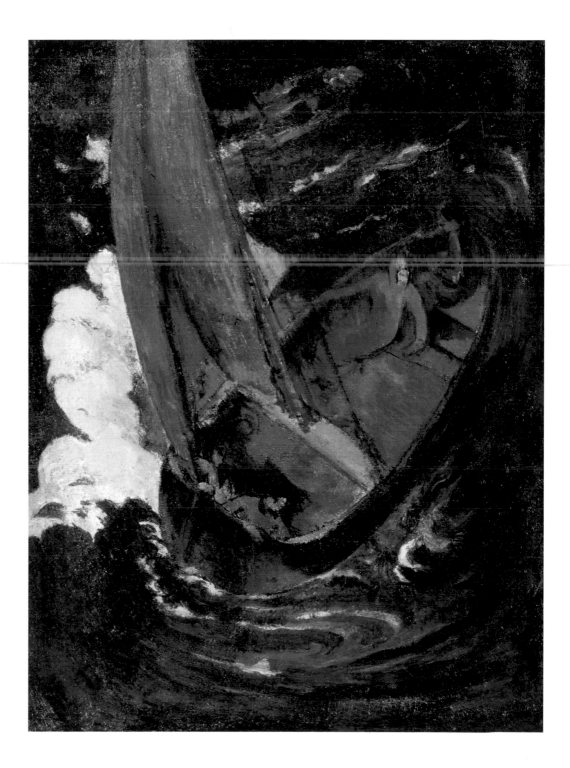

147

86
Te Pape Nave Nave
(Delectable Waters) 1898
Oil on canvas
74 x 95.3
National Gallery of Art,
Washington. Collection of
Mr and Mrs Paul Mellon

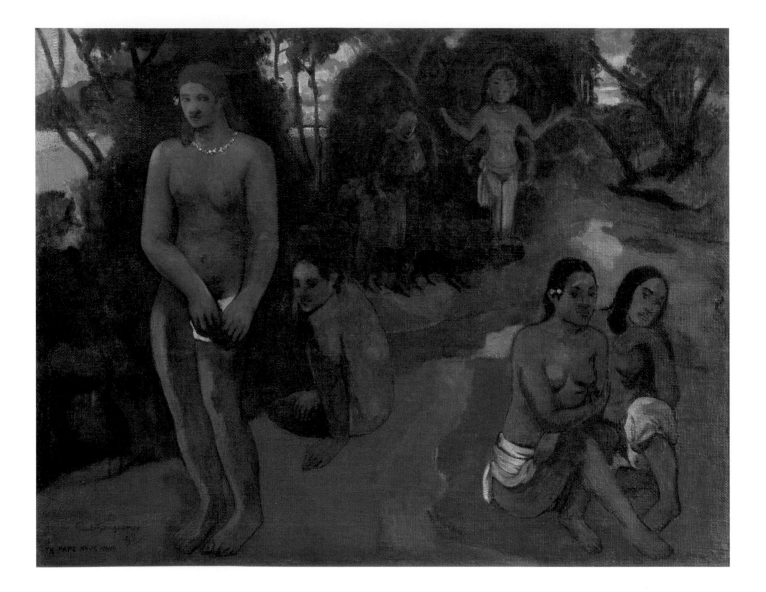

87
Parahi te Marae (Là réside le Temple / There Lies the Temple) 1892
Oil on canvas
66 x 88.9
Philadelphia Museum of Art. Gift of Mr and Mrs Rodolphe Meyer de Schauensee, 1980

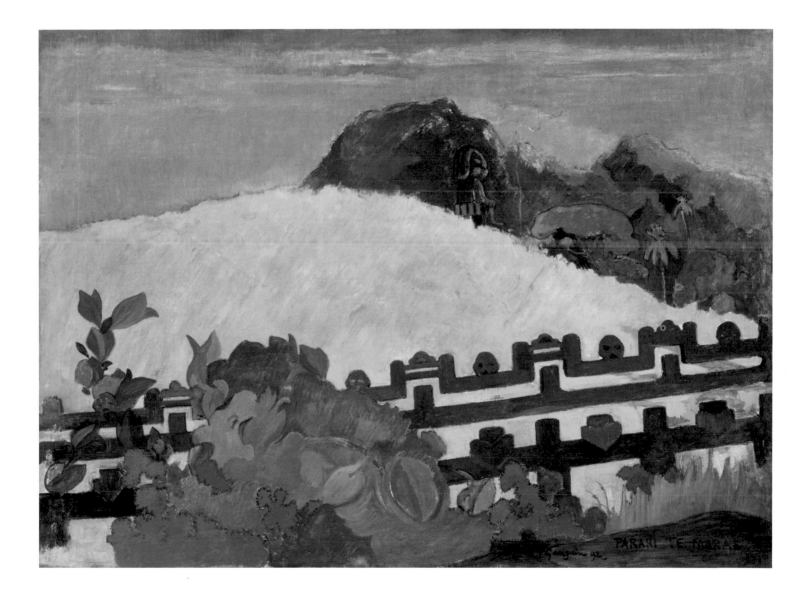

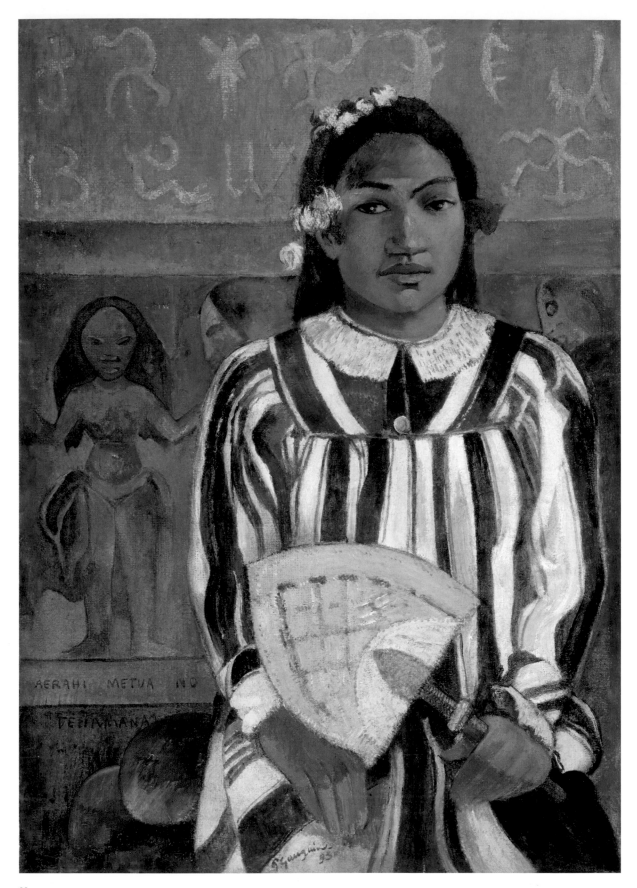

88
Merahi Metua no Tehamana (Les
Aïeux de Tehamana / The Ancestors
of Tehamana or Tehamana has Many
Parents) 1893
Oil on canvas
76.3 x 54.3
The Art Institute of Chicago. Gift of Mr
and Mrs Charles Deering McCormick

FICTIONS OF FEMININITY

Female subjects feature far more prominently than male ones throughout Gauguin's oeuvre, but in mid-career he started to use non-specific settings and to couch his image of woman in timeless myth. Of course, in itself, mythologising the female form was scarcely innovative. Gauguin's fictions of femininity can be linked to much broader currents of Western and non-Western culture, their stories deriving from folk literature, the Bible and classical mythology. But Gauguin avoided conventional allegories – peace, war, industry, or the like – preferring to represent a range of personal preoccupations: life, death, virginity, purity, abandonment, lewdness. He forged his own highly individual takes on the canonical themes of Western art with figural types that resist the idealising aesthetic of academic tradition. His Ondine moves with a deliberate awkwardness (no.92), he subjects his images of Eve to contradictory permutations (fig.67; nos.96, 99–105). If his recumbent nudes (nos.95, 132) have echoes of Manet or Lucas Cranach, his invented savage deity, Oviri, is almost unprecedented, gruesome and grotesque (nos.109–12).

The shift toward the mythic coincided with Gauguin's becoming an artist-tourist, working in increasingly remote environments in which it was still possible to imagine a pre-modern or primitive existence. Interestingly, on his travels he was just as keen to interrogate the 'essential' stereotypes he carried in his head as the specific realities of the place. In each locality, Brittany, Martinique, Arles, Tahiti and the Marquesas, he embraced, rather than shunned, the received ideas about the local people. He was even talking, at the end of his life, of returning to Europe and producing his own take on Spain and the clichéd image of the 'Spanish women, their hair plastered with lard', confident he would make of it something new.[1]

At a stylistic level the shift marked Gauguin's determination to free himself from naturalism and Impressionism. It brought him into alignment with other artists associated with Symbolism – Puvis de Chavannes (1824–1898) for instance, a reproduction of whose Hope he kept with him in Tahiti, or Odilon Redon (1840–1916) and Eugene Carrière (1849–1906), whose suggestive monochromatic imagery he admired. Nevertheless, Gauguin continued to regard the realist Édouard Manet (1832–1883) as a touchstone of quality, copying his Olympia in 1891 and keeping the image to hand. He quoted aspects of the

Fig.63 In the Heat (Pigs)
(En pleine chaleur (Cochons)) 1888
Oil on canvas
73 x 92
Private Collection

composition in his symbolically charged female nudes, *Manao tupapau* (*The Spirit of the Dead Keeps Watch*) of 1892 and *Nevermore O Tahiti* from 1897 (nos.121, 118), contriving to invigorate his largely imaginary portrayals of archetypal Tahitian women with that confrontational image of prostitution.

A moment of transition is revealed by two not unconnected pictures painted in Arles in 1888, *In the Heat* (fig.63) and *Misères humaines* (fig.64). In both, there is an allusion to an unspecified story concerning sexual transgression, and how this, in a closed rural community, could drag women into destitution; by the women's costumes Gauguin implied he still had Brittany, with its folk tales, gossip-mongers and religiosity in mind.[2] Perhaps his grandmother Flora Tristan's diatribes against the pervasive social evil of prostitution and its social causes, of which Gauguin had made a transcript, heightened his awareness of the 'abandoned woman' theme. Perhaps the allusion to animalistic rutting was prompted by reading Charles Morice's short story *La Truie bleue*, a current enthusiasm of Vincent van Gogh's.[3] Whatever Gauguin's prompts, this uncharacteristic flirtation

151

Fig.64 Misères humaines 1888
Oil on canvas
73 x 92
Ordrupgaard, Charlottenlund

with gritty naturalism seems to have tipped him toward a new, more symbolic conceptualisation of woman. In subsequent related images those central figures were transmogrified into the elemental figures of Ondine (no.92) and Eve (fig.67).

Gauguin's flirtation with this imagery makes him very much an artist of his time, a calculating opportunist to some degree; it also hints at the complex psychological issues around his own sexuality. The Symbolist movement, which took hold in literature and art from the mid-1880s onwards, battened onto Romanticism's earlier fascination with gender dichotomies, and that earlier myth, *L'Éternel féminin*, whereby woman was seen either as wicked temptress, *femme fatale*, or as saintly virgin, sister or mother. Gauguin borrowed from this popular trope when, in *Vision of the Sermon* (no.65), he vouchsafed the vision exclusively to women, or, in a similar fiction, imagined for his young Tahitian model, Tehamana, the role of repository of her people's lost culture, making her bear the weight of ancestral knowledge (*Merahi Metua no Tehamana*, no.88). Similarly in *Noa Noa*, glossing the true source of his Tahitian legends, he makes Tehura their mouthpiece: 'She knows the names of all the gods of the maori Olympus ... how they created the world, how they like to be venerated.'[4]

This reactionary retrenchment is often put down to fear of social change: if scientific and industrial progress were taking Western man ever further from his primitive origins, it was reassuring to imagine the female of the species as somehow innately closer to the rhythms of nature, or more attuned to the irrational and the spiritual. Paradoxically, as the grandson of a pioneering feminist, Flora Tristan, and husband of Mette, a resourceful, educated Dane, Gauguin's awareness of the discontents of real women's lives cannot be doubted. When facing up, in all honesty, to the predicament in which he had left his wife, struggling to support their large brood of children, he was capable of sympathising with her difficulties. But rather than allowing himself to become paralysed by a sense of personal responsibility, he preferred to echo his grandmother by ranting against the iniquities of bourgeois marriage, which he considered little better than a form of legalised prostitution. Gauguin felt his 'moral duty' was to nurture his talent for the sake of his children's future; only the iniquities of modern bourgeois society were preventing him from achieving that aim. If his Tahitian work propounds a number of carefree positive images of love, liberty and universal harmony, it more frequently communicates a sense of the burdensome nature of sexuality. His *Tahitiennes* frequently appear troubled, fearful, oppressed. In adopting this stance, Gauguin was implicitly accepting the meta-narrative of the 'fatal impact' whereby Polynesians were understood to have lost their *raison d'être*, as well as their health, in succumbing to foreigners with their adherence to materialism and ideas of Christian morality.[5]

Gauguin's moral credentials and the contradictions of his life have constantly come in for comment and censure. Following a period of cohabitation with Vincent van Gogh in Arles, the Dutch artist pinpointed the difficulty in a letter to his brother Theo: 'He's physically stronger than we are, so his passions must also be much stronger than ours. Then he's the father of children, then he has his wife and his children in Denmark, and at the same time he wants to go right to the other end of the globe to Martinique. It's horrifying, all the vice versa of incompatible desires and needs which that must cause him.'[6] Gauguin's tale-telling propensity has not helped. The cumulative impression of his boastful memoirs is of a sensual man who put up emotional barriers and was unable to sustain mutually respectful attachments. Yet he sounds sincere when regretting

the break-up of his family life. Never, as we have seen, the most reliable witness, one should be wary of accepting what Gauguin says in this most sensitive of areas.

Not surprisingly, Gauguin has been judged harshly by feminists who, in turn, were doubtless provoked by the way earlier male commentators had leapt to his defence.[7] Charles Morice, for instance, anticipating future moral indignation about Gauguin's native 'brides', stressed the equivalence in maturity of a Tahitian thirteen-year-old and a European eighteen- to twenty-year-old.[8] René Huyghe took up a similar position in 1951. He was one of many to paint an unflattering picture of Mette, maintaining that she was unsympathetic and mercenary: her ultimate abandonment of Gauguin, he argued, was first among the many factors driving the artist to attempt suicide in 1897–8.[9] The truth surely lies somewhere between these positions. Certainly Mette has emerged from recent scholarship as a broader-minded woman with a greater respect for her husband's wayward talent than might have been suspected.[10]

Ondine

One persistent fiction of femininity, explored by Gauguin over a lengthy period, concerned the bather, notably the woman in the waves. It began, prosaically enough, with an 1887 painting of two women taking a dip in a Breton river (fig.65): while one, seen from behind and cut off at the hips, holds up her hair, the other steps gingerly down the bank from upper right. Certainly Félix Fénéon read this painting as a naturalist work, fastening onto the differences in hair colour, skin tone and body shape to deduce that Gauguin had depicted an 'opulent bourgeoise' (the redhead) and a 'little servant girl with short straight hair'.[11] In a related finely painted work on paper, *The Bathing Place* (no.90), the two female bathers lose that class specificity. Here the redhead dominates the composition while her companion throws herself headlong into the waves. Oddly, though, Gauguin now gives greater prominence to the clogs on the right, which bear his abbreviated signature 'P Go' and the date '89' in gold paint.[12] The artist fused these two bather types to form his elemental and solitary redhaired *Ondine* in 1889 (no.92). In applying that title to his painting, albeit as an afterthought, Gauguin invoked the tragic Germanic folk tale of a water sprite who could only achieve a soul if she secured the love of a human mate.

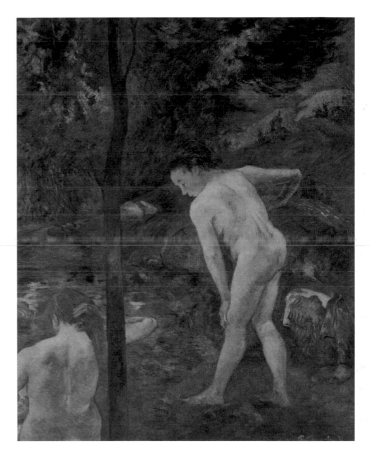

Fig.65 Two Bathers 1887
Oil on canvas
87.5 x 69.5
Museo de Bellas Artes,
Buenos Aires

Interpreted by poets, visual artists and musicians, the Ondine myth's fascination lasted well into the twentieth century.

This powerful image of the woman in the waves, her right arm thrust in an angular way upwards and partly under her face, recurs in paintings, fans and, most spectacularly, in the polychrome wood carving *Soyez mystérieuses* of 1890, where she is the focus of attention (no.94). In other works she is relegated to the background: among these one can include the cover image of the Volpini exhibition catalogue, the portrait of Meijer de Haan as *Nirvana* (fig.55), a watercolour juxtaposed with an unrelated line of Paul Verlaine's poetry, the lyrical painting entitled *Fatata*

Fig.66 *Peruvian mummy displayed in the Musée du Trocadéro, Paris*
Photograph
Musée du Trocadéro, Paris

Fig.67 *Breton Eve* 1889
Pastel and watercolour on paper
33.7 x 31.1
Collection of the McNay Art Museum.
Bequest of Marion Koogler McNay

te miti (no.113), finally a series of woodcuts (no.127).[13] But in a number of later Polynesian bather subjects the archetypal myth is dispensed with, and a greater conviviality is restored, as in *The Bathers* (no.114).

Eve

The original *femme fatale* of Judeo-Christian mythology, Eve was a source of renewed fascination for the artists of Gauguin's generation. Gauguin himself juggled two contrasting images of Eve, one in a closed, hunched, negative posture, the other standing proud, tall and unabashed.[14] He differentiated between these two on racial and ethnic grounds, the former being white (fig.67), the latter, designated an Exotic Eve or Tahitian Eve, starting out white but becoming progressively more black (no.102).

First seen in the compressed symbolic image of duality, *Life and Death* of 1889 (no.91), the hunched pose in Gauguin's watercolour drawing was clearly associated with Eve due to the presence of a writhing snake whose insinuations she attempts to block out (fig.67). He specified, when exhibiting this work at the Volpini café that year, that despite her pidgin French cry 'Pas écouter li li menteur', suggesting a Caribbean setting, she was a Breton Eve. The visual source for this pose was a Peruvian mummy Gauguin encountered in the Musée du Trocadéro in Paris, presumably in early 1889 (fig.66).

Gauguin's first incarnation of Exotic Eve, which predated, in all likelihood, his first stay in Tahiti, was formed of disparate readymade parts (fig.7): a photograph of the Javanese frieze of Borobudur for the swaying pose (fig.73), a photograph of his mother for the face, possibly an Indian miniature for the brilliant, jewel-like colour. Having established this archetypal female form, with her solemn, hieratic pose, between 1892 and 1893 Gauguin refined and reconfigured it through a dense sequence of images. A powerfully sculptural feminine presence, surely based on a study from life, comes into being in the velvety pastel (no.99). This first introduces the white cloth with which Eve attempts to hide her nudity, and leads on, through a traditional procedure of pricking and pouncing the design, to the Eve at the centre right of his haunting composition, *Parau na te Varua ino (Words of the Devil)* (no.101). The devil of the title is evoked in the crouching hooded figure to her left. In a pastel study of the head of a Tahitian woman (no.104) – doubtless a suitable candidate for

mythic transformation – we see Gauguin's curious variant on the traditional serpent of Genesis, one appropriate to a Tahitian vision of the Temptation. For snakes, as Pierre Loti had pointed out, were unknown in the island, so the Biblical tempter of Eve was described there as a black winged lizard. Eve and the lizard are the subject of a vibrant, delicately patterned watercolour (no.103) and a glowing oil, *Te Nave Nave Fenua* (no.105). In 1894, Eve reappears in the woodcuts *Noa Noa* and *Nave Nave Fenua* (no.127), and in 1898–9 in the *Standing Eve* from the Vollard suite (fig.35). Her final, most sumptuous and complex reincarnation is in the tenebrous monotype subtitled *The Nightmare* (no.100), where she is seen in combination with a snake and classical horse.

Pape Moe

The variants that Gauguin worked on the image of *Pape Moe* (*Mysterious Water*) are a further demonstration of his remarkable ability to mine the pictorial and poetic potential of certain telling figural poses. On this single theme he made an oil painting (fig.23), a watercolour, a gouache, a monotype and a remarkable carving (no.108).

The tentative bather, stepping toward the water, who featured in *Two Bathers* of 1887 (fig.65), became lodged in Gauguin's mind and he reworked it in at least two ceramics. Some time later, possibly at the Universal Exhibition of 1889, he acquired a recent photograph by Charles Spitz of a Polynesian of unclear gender, surrounded by tropical vegetation, leaning precariously over a gully to drink from a natural spring (fig.24). The two ideas became fused in the subject of *Pape Moe*, which he translated, in his 1893 exhibition catalogue, as 'Eau mystérieuse'. Gauguin retained the photograph's pose but summarised and gave imaginative colour to the monochrome, crisply outlined vegetation, and had the water splash into a pool instead of plunging into the void. This subject spawned several variants back in France and quickly acquired a literary dimension. Gauguin's watercolour monotype (no.106) reversed and radically simplified the composition and a gouache, possibly a counterproof of the former, introduced the heads of Hina and Tefatou into a roundel, and the proverb-like inscription: 'Qu'importe la source Si l'eau est délicieuse'. In *Noa Noa* Charles Morice incorporated a description of the artist stumbling upon the enchanted scene,

absolutely as though it had been actual experience and not a response to a photograph. In this account the gender of the native drinker – as ambiguous as an animal's – is only revealed as female when, detecting Gauguin's presence, the timid creature darts for cover. Gauguin's watercolour vignette was possibly intended to illustrate this retelling of the tale (no.107).[15]

No work shows the complexity of Gauguin's creative response to the Spitz photograph more tellingly than his bas-relief carving, which has made an exciting reappearance after many years (no.108). The fact that its gouged and stained design is worked into a panel of oak, a non-native species in the Pacific, points to it being carved in France and datable, like the gouache and monotype, to 1894. He also carved from oak three (or four) related panels, all of which were once in the same collection. The spring has turned into a major waterfall here, and the vegetation gives rise to mysterious faces such as the one seen in profile to upper right. Originally these motifs were linked and carried over into the adjacent panels. The curious way in which the segments of oak are slotted together here, incorporating a distinctive lozenge-shape hexagon, suggests the panel had a former life and could conceivably have formed part of a panelled interior. Certainly recycling a found, readymade panel would have appealed to Gauguin's resourcefulness, not least because the cost of bespoke limewood panels, as he knew from his experience with *Soyez amoureuses,* was considerable. Maybe its pre-existing lozenge shape offered a suggestive frame for the bulk of his drinker's body; he used its diagonals to reinforce the line of her shoulders and bent forearm. What is clear is that Gauguin incorporated the hexagonal lozenge in an exceptionally inventive way.

Oviri

Oviri, arguably the strangest of all Gauguin's sculptures, was the last in a sequence of three-dimensional female nudes that seem to evolve inexorably away from the conventional toward the grotesque. An image he refined and evolved in a variety of media (nos.109–11), the stoneware *Oviri* (no.112) created in December 1894 was surely intended as some sort of affront to classical canons of grace and beauty. Gauguin considered this work his masterpiece in the ceramic medium; it also served as a potent alter ego, a concretisation of his desire to become a savage.

Fig.68 *Diverses choses*, p.235
Pen and ink copies after Delacroix's
Arab Encampment and *Seneca*, and two
pasted prints: an unidentified Japanese
print and a Lucas van Leyden print of
Christ carrying the Cross
Musée du Louvre, Paris, Département
des arts graphiques

Gauguin made a number of carvings and ceramic sculptures featuring the nineteenth-century racial type, the 'négresse', in the wake of his 1887 trip to Martinique. The so-called *Black Venus* from 1889 (no.97) presents a robust female figure in kneeling pose over a male severed head – a possible John the Baptist, with features not unlike Gauguin's own. In around 1890 he conceived of the abandoned figure he called *La Luxure* (*Lewdness*), which was first modelled in clay and then carved in wood in a way that recorded the state of the damaged original clay model (no.98). Like *Oviri*, she is associated with an animal familiar, in this case a fox. It is perhaps no coincidence that Gauguin's 1890 standing statuette *Eve* is missing an arm (no.96); here he experimented with polychromy, then in vogue, the gold of the dramatic fall of hair jarring with the body's black patina. Finally, after returning from the South Seas Gauguin modelled the monstrous invention *Oviri*, setting the name in high-relief capitals in the statue's base. The word, meaning 'savage', was one he possibly first encountered when reading Pierre Loti; it became a musical refrain in Gauguin's writings, in a similar way to '*Noa Noa*'.

What could Gauguin have meant by this odd creature, this unnatural mother? The anatomy is wilfully distorted and disproportionate, a large dreaming mask-like head sunk into powerful shoulders atop a compact torso and puny legs flexed at the knee, scarcely capable of bearing weight. Beneath her feet is a blooded snarling she-wolf, whose whelp Oviri has snatched, her strong arms clasping the creature to her side in a gesture reminiscent of Eugène Delacroix's *Medea* (1838), taking away her sons to kill them. Indeed the whole of Gauguin's figure bears a strong resemblance to Delacroix's study for the *Dying Seneca*, c.1841, the Roman philosopher who brought on his own death by opening his veins, a deliquescent image from Gustave Arosa's art collection that Gauguin knew intimately and copied (see fig.68).

Although modelled in Paris, the origins of *Oviri* appear to go back to a bizarre literary idea that Gauguin conceived in Tahiti. The text in question, accompanied by a blot-like watercolour drawing – Oviri in embryonic form – became part of Gauguin's first template version of his satirical journal *Le Sourire*. Dedicated to M. Cardella, then Mayor of Papeete, the masthead is dated, curiously, August 1891, that is, only months after he first set foot in Tahiti. Production of *Le Sourire* was delayed until 1899, but

this particular sheet suggests the concept for the journal may have been much earlier. Under the heading 'L'Immorale', Gauguin penned a tongue-in-cheek review of a shocking, and surely imaginary, play performed by the 'Grand Théâtre National de Bora Bora'. The central character was Anna Demonio, whose practice of free love without emotional attachment ended with an act of incest resulting in a monstrous androgynous conception: 'And the monster strangling its creature fecundates spacious loins with its seed, thereby engendering Seraphitus Seraphita.' This gnomic phrase, which Gauguin repeated at the end of the review, was a reference to Honoré de Balzac's *Seraphita*, the curious mystical novel about androgyny in which, according to Morice, Gauguin contrived to find 'the whole of Balzac'. Although the text may explain the ambiguous gender of Gauguin's *Oviri*, there is nothing in Balzac to explain the sculpture's animalistic violence. This may allude, rather, to the former practice of infanticide among the Areoi, Tahiti's priestly elite, a practice that missionary workers in the region had by and large eradicated.[16]

Prior to modelling his stoneware sculpture, Gauguin first introduced his Oviri motif into a Tahitian genre painting from 1892, *E haere oe i hia* (*Where Are You Going?*) (no.115), producing a powerful, defamiliarising effect that is more disturbing than the near-identical composition *Eu haere ia oe* (*Where Are You Going?* or *Woman Holding a Fruit*) (no.122). Back in Paris, Gauguin made use of Ernest Chaplet's studio and kiln to model the statue. As June Hargrove and others have observed, the final realisation, at the formal and conceptual level, invites comparison with Auguste Rodin's statue of *Balzac*, a major project that was giving Rodin considerable trouble just at that date.[17] *Oviri*'s fluid forms, particularly when seen from the back, where the flow of hair divides into labial folds, are strangely similar to the voluminous cloak swathing the body of Balzac in Rodin's statue, and both works have a phallic dimension. Whether or not Gauguin could have had a clear idea of what Rodin's *Balzac* looked like, since it was not completed until 1898, Rodin's concurrent commission was on his mind: discussing with Morice how he would have set about sculpting Balzac, Gauguin stated that he would have shown the author holding in his palm his androgynous creatures, Seraphitus and Seraphita.

Gauguin's exhibition of his sculpture and ceramics at the 'Les XX' exhibition in Brussels in 1891 (including his *Eve* and two major wood carvings *Soyez amoureuses* and *Soyez mystérieuses*) provoked a critical storm in the city. When he submitted *Oviri* to the committee of the Salon de la Société Nationale des Beaux-Arts in Paris in 1895, it was refused admission, perhaps to pre-empt a repetition of the earlier furore. This rejection was surprising given the Salon's generally liberal attitudes toward decorative art objects: overtly erotic hybrid work like the sculpted furniture of Rupert Carabin was shown, for instance. The reason surely lay in *Oviri*'s incomprehensible ugliness. For Gauguin it was a crushing blow.

The Oviri idea would not rest. Gauguin revisited it in two watercolour monotypes (nos.109, 111) and he also reworked it in a woodcut, which he inserted into the text of *Noa Noa* (no.110). Although he left the stoneware sculpture behind in France, later he wrote to de Monfreid asking for it to be sent out to Polynesia so it could be placed on his tomb. This wish was ultimately realised, but with a bronze cast as the stoneware would not have survived the humid Marquesan climate. *Oviri* was manifestly some sort of alter ego, a female self – at once creative, mysterious and dreaming as well as destructive, monstrously cruel. Certainly Morice saw it that way and he was probably party to the artist's wishes: he described *Oviri* as a kind of Diana or Hina the huntress.[18] In the evolution of this hauntingly uncanny image we have an illuminating example of Gauguin's creative intelligence at work. *Oviri* was a project of many facets in which the artist engaged in a personal confrontation with his heroes and rivals in literature, painting and sculpture – Balzac, Delacroix and Rodin.

89
Study for 'In the Heat (Pigs) / En Pleine Chaleur (Cochons)' 1888
Pastel, watercolour and ink on paper
26.3 x 40.4
Van Gogh Museum, Amsterdam
(Vincent van Gogh Foundation)

90
The Bathing Place 1889
Gouache, watercolour, pastel and gold
paint on paper mounted on panel
34.5 x 45
Private Collection

91
Life and Death 1889
Oil on canvas
93 x 75
Musée Mahmoud Khalil, Giza

160

92
Ondine / In the Waves 1889
Oil on fabric
92.5 x 72.4
The Cleveland Museum of Art. Gift of
Mr and Mrs William Powell Jones

'I've been working for 2 months on a large (painted wood) carving and I'm bold enough to believe it's the best thing I've done up to now as far as strength and balance are concerned (although the literary side of it seems crazy to many people. A monster, who looks like me, is holding a naked woman by the hand – that's the main subject. The spaces are filled by smaller figures.) At the top there's a town, some sort of Babylon, and at the bottom the countryside with a few imaginary flowers (a desolate old woman) and a fox, the prophetic animal of perversity among the Indians ... despite the inscription, the people look sad, in contradiction to the title.'
Letter to Vincent van Gogh 10–13 November 1889

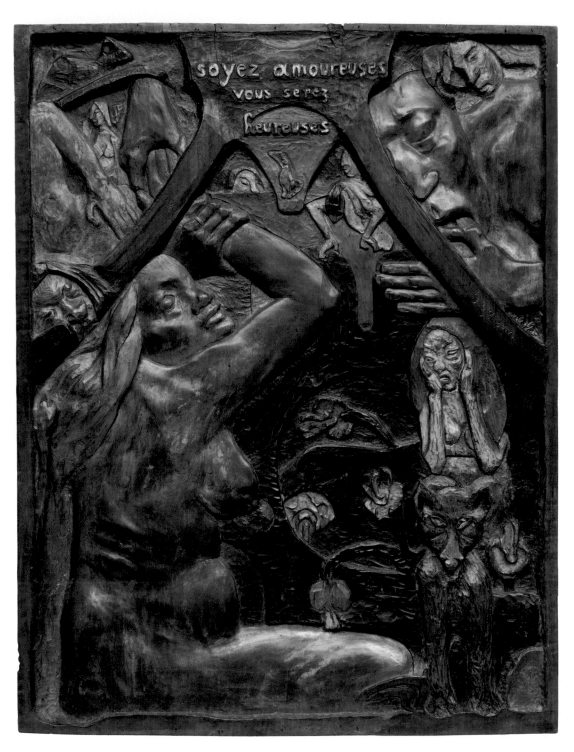

93
<u>Soyez amoureuses vous serez heureuses</u>
<u>(Be in Love and You Will be Happy)</u> 1889
Polychromed linden wood
97 x 75
Museum of Fine Arts, Boston. Arthur Tracy
Cabot Fund

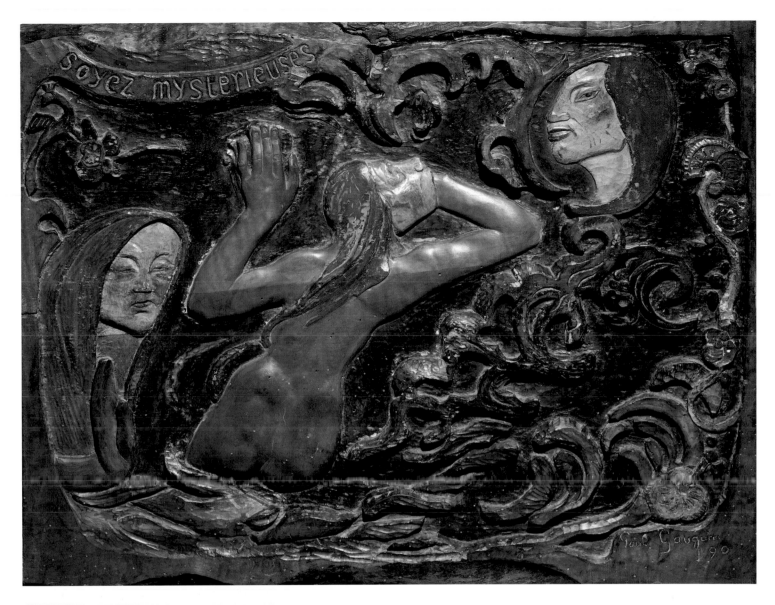

94
Soyez mystérieuses (Be Mysterious) 1890
Bas-relief in polychromed lime wood
73 x 95 x 5
Musée d'Orsay, Paris

95
Woman with Mango Fruits c.1889
Carved and painted oak
30 x 49
Ny Carlsberg Glyptotek, Copenhagen

163

96
Eve 1890
Glazed ceramic
60.6 x 27.9 x 27.3
National Gallery of Art, Washington.
Ailsa Mellon Bruce Fund

97
Black Venus 1889
Glazed stoneware
h.50
The Division of Museum Services,
Nassau County (NY) Department
of Parks, Recreation, and Museums

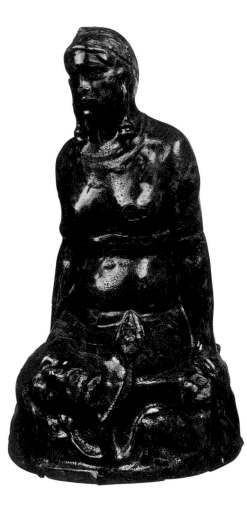

98
Lewdness (La Luxure) 1890
Guilded and polychromed oak and
pine, and metal
70.5 x 14.7 x 11.7
The J.F. Willumsen Museum,
Frederikssund, Denmark

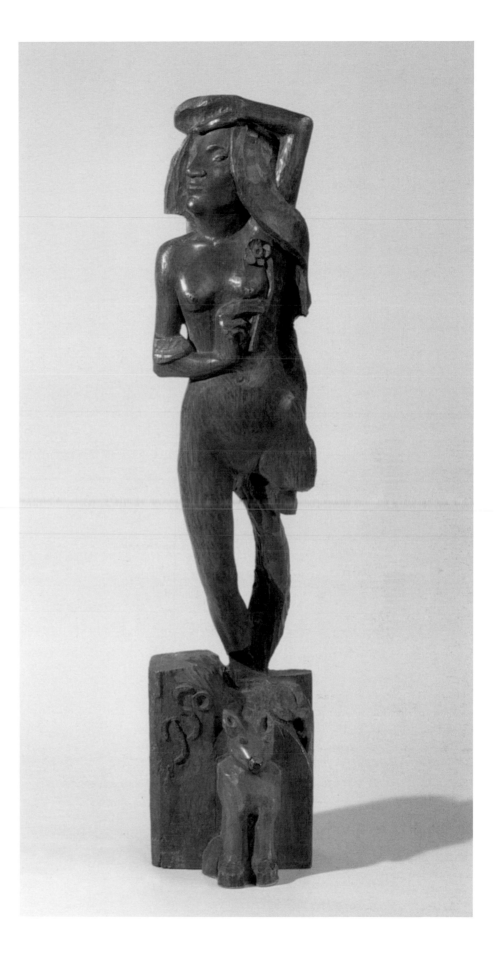

99
Study for Parau na te Varua ino (Words of the Devil) 1892
Pastel
76.5 x 34.5
Kunstmuseum Basel, Kupferstichcabinett

100
The Nightmare (Le Cauchemar) c.1900
Traced monotype
58.4 x 43
J. Paul Getty Museum, Los Angeles

101
Parau na te Varua ino (Paroles du Diable / Words of the Devil)
1892
Oil on canvas
91.7 x 68.5
National Gallery of Art, Washington. Gift of the W. Averell Harriman Foundation in memory of Marie N. Harriman

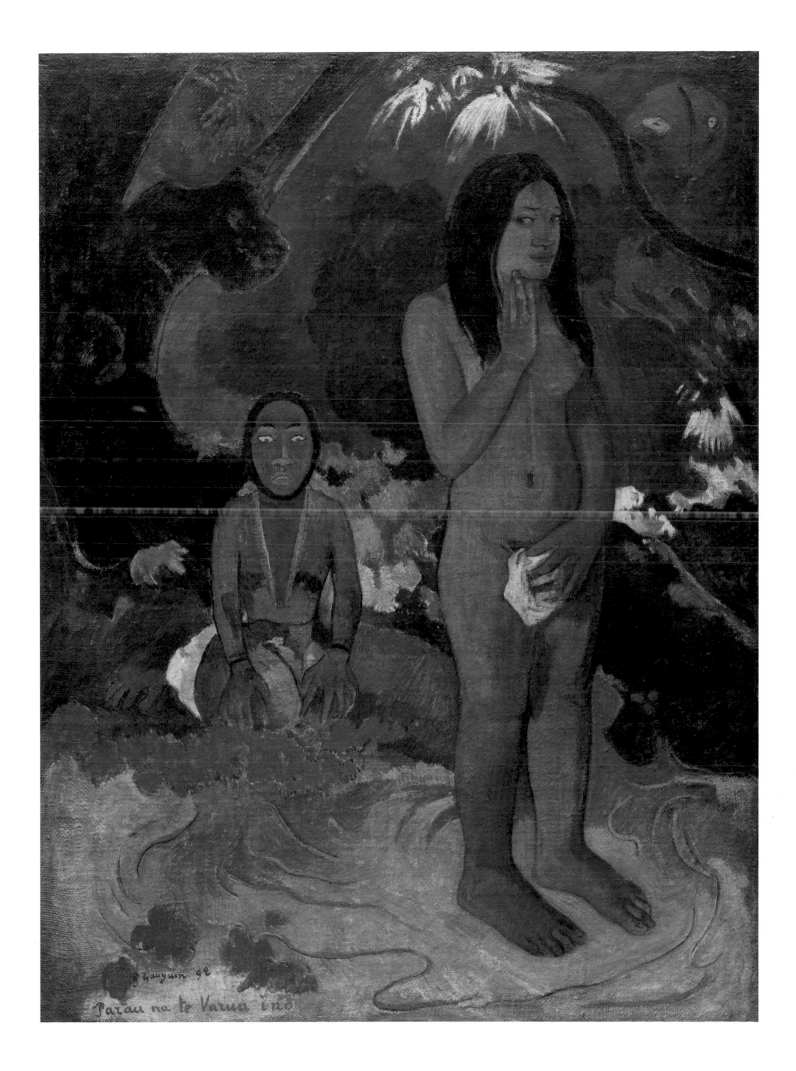

102
Nave nave fenua (Delightful Land)
1893–4
Gouache and Indian ink on paper
41.9 x 26
National Gallery of Art, Washington

103
Te Nave Nave Fenua _1892–3_
Watercolour, gouache, pen and ink on paper
40 x 32
Musée de Grenoble

104
Head of a Tahitienne _c.1892_
Crayon, pastel and gouache on paper
30.5 x 20.5
Private Collection, Courtesy of Jean-
Luc Baroni Ltd

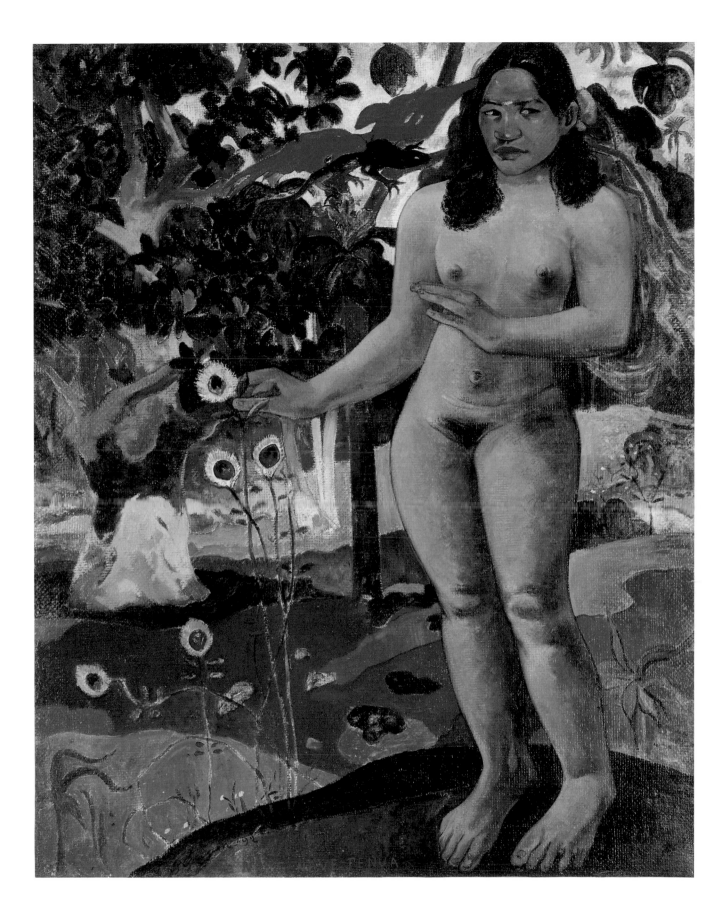

105

Te Nave Nave Fenua (The Delightful
Land) _1892_
Oil on canvas
92 x 73.5
Ohara Museum of Art, Okayama

106
Pape Moe 1894
Watercolour monotype on paper
27 x 15.5
Musée Marmottan, Paris

107
Pape Moe (Mysterious Water) 1893–4
Watercolour and ink on paper
35.2 x 25.5
The Art Institute of Chicago. Gift of
Emily Crane Chadbourne

108
Pape Moe 1894
Wood carving bas-relief on oak
73 x 55 x 5
Sandro and Marta Bosi Collection

109
Oviri 1894
Watercolour trace monotype on paper
29.3 x 20.7
Harvard Art Museum / Fogg Museum,
Cambridge, MA. Gift of the Woodner
Family Collection, Inc.

111
Oviri 1894
Watercolour monotype on paper
28.2 x 22.2
Private Collection

110
Oviri 1894–5
Colour woodcut
20.4 x 12.2
National Gallery of Art, Washington.
Rosenwald Collection, 1953

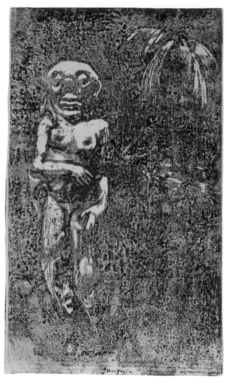

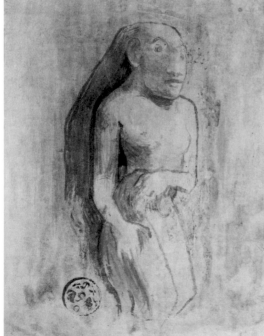

112
Oviri 1894
Stoneware
75 x 19 x 27
Musée d'Orsay, Paris

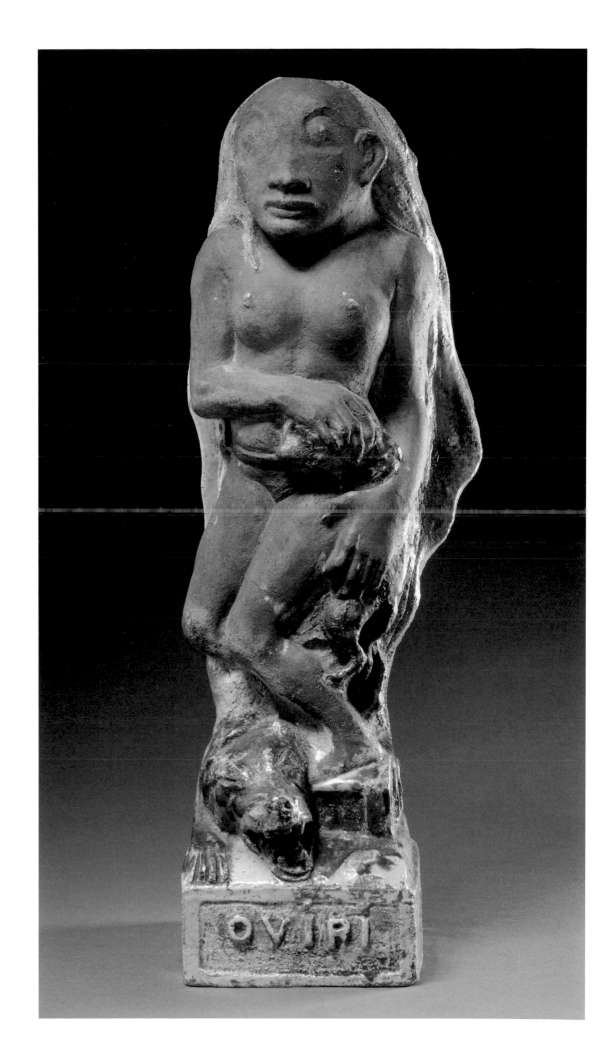

113
Fatata te Miti (Près de la Mer / By the Sea) 1892
Oil on canvas
92.4 x 114.9
National Gallery of Art, Washington.
Chester Dale Collection

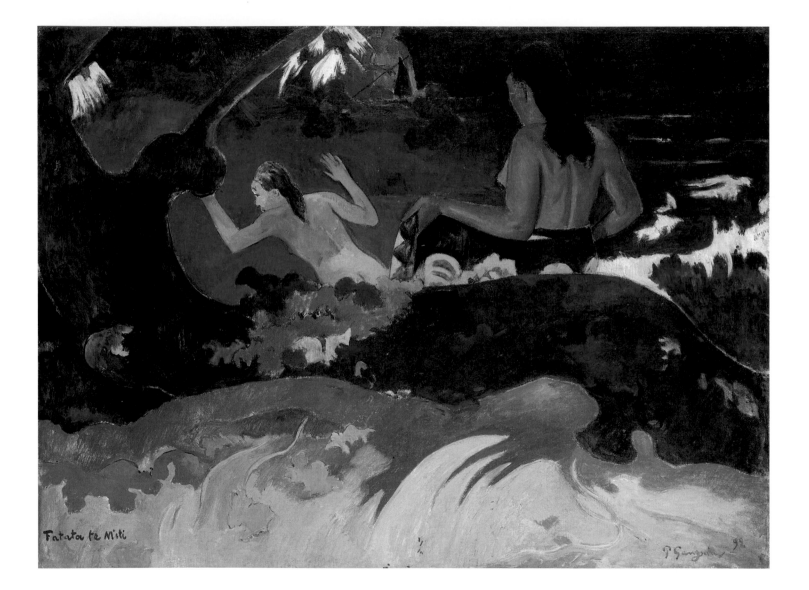

114
The Bathers 1897
Oil on canvas
60.4 x 93.4
National Gallery of Art, Washington.
Gift of Sam A. Lewisohn

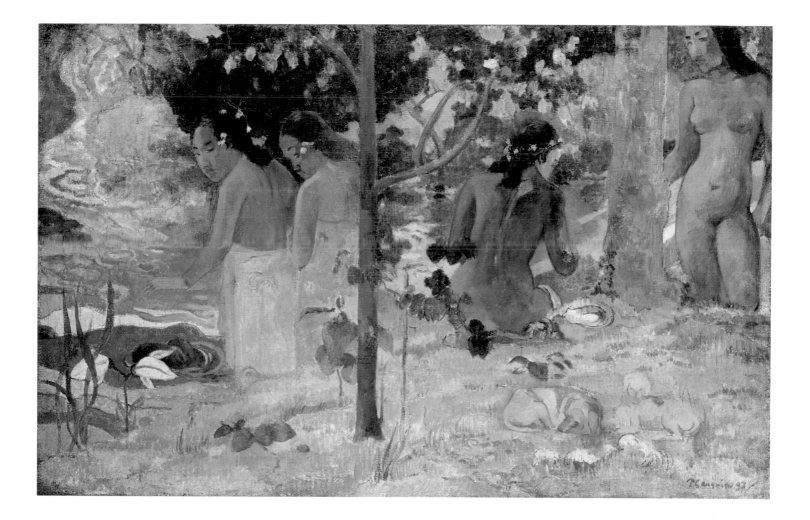

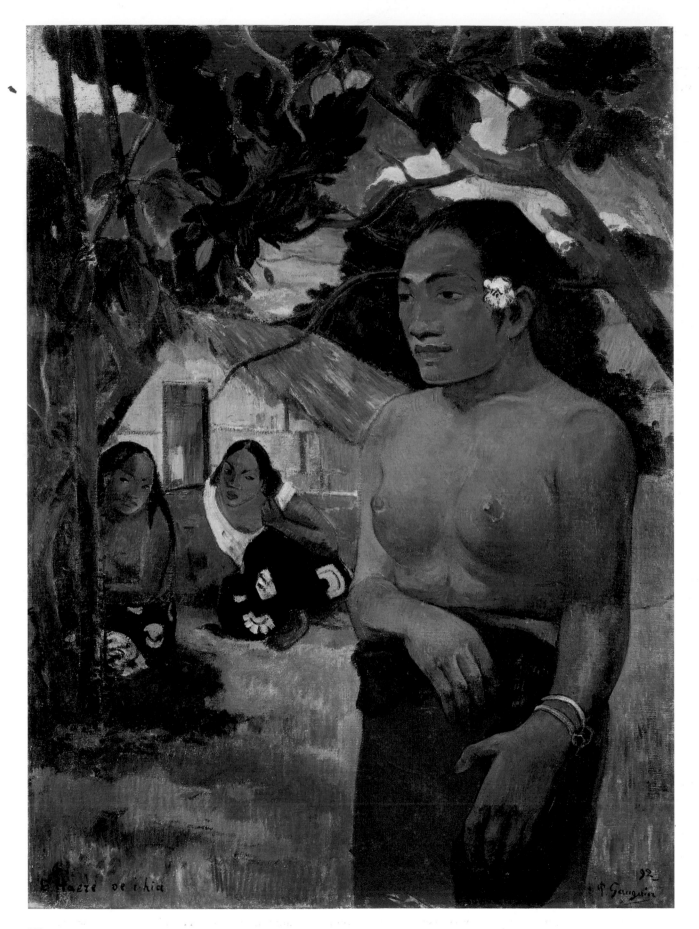

115
E haere oe i hia (Where Are You
Going?) *1892*
Oil on canvas
96 x 69
Staatsgalerie Stuttgart

ALLUSIVE AND ELUSIVE TITLES

Part and parcel of Gauguin's most potent images are their equally potent and engaging titles. Devising the title was not so much an afterthought as a final realisation and encapsulation of what he was seeking. His open-ended or questioning titles, often using Tahitian words, complicate the spectator's response, implying tantalising hidden narratives whilst at the same time resisting straightforward interpretation.

Whether chiselled into the wood or inscribed with brush or pen, Gauguin was fond of embedding words into the worked surfaces of his art. Sometimes they are overheard conversational phrases, like '*Haere Mai*' ('Come Eat'); indeed, Gauguin's paintings frequently depict conversations, intimacies, two conspiratorial figures exchanging words. Sometimes the inscribed titles assume a far more portentous resonance, functioning like the questions and aphorisms with which he peppered his writings. On important carvings, he gouged lapidary injunctions addressed to women in general, like '*Soyez amoureuses et vous serez heureuses*' and '*Soyez mystérieuses*', urging them to be 'loving', to be 'mysterious', These have the effect of removing the subject matter from the here and now, taking it onto the level of fable or myth. The questions on the paintings are more intimate and personal, and it is not always clear who is addressing whom: '*E haere oe i hia*' (*'Where Are You Going?'*), '*Aha oe feii?*' (*'What! Are You Jealous?'*), '*Nafea faa ipoipo*' (*'When Will You Marry?'*) (nos.115, 116; fig.69) If in the last case it is the women who challenge the artist – for Gauguin maintained in *Noa Noa* that this was a question the Tahitians routinely asked the visiting foreigner – elsewhere, as in *No te aha oe riri* (*Why Are You Angry?*) (no.123), the question would seem to be exchanged by figures in the composition, hinting at a small drama within the scene depicted.

Frequently, the titles or tags are written in the Tahitian tongue, as in *Te Nave Nave Mahana* or *Mahana no atua*, musical but impenetrable to the French or Anglo-Saxon ear. Gauguin's own grasp of the meaning of these phrases was far from perfect, as has been pointed out by various authors. Indeed, when he had to provide translations for the titles for an exhibition catalogue, he hesitated between different renderings. On the one hand he boasted to his wife Mette that the Tahitian language was easy and he was starting to master it, on the other he lamented the fact

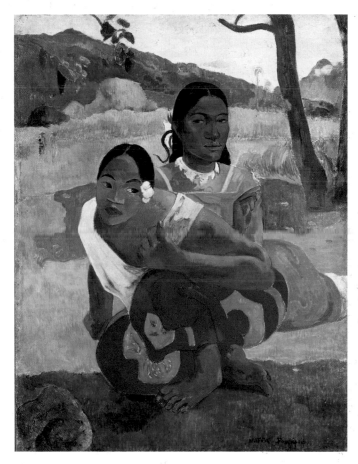

Fig.69 <u>Nafea faa ipoipo (When Will You Marry?)</u> 1892
Oil on canvas
101.5 x 77.5
Kunstmuseum Basel.
Collection Rudolf Staechelin

that he did not have her gift for languages. But it seems clear that the precise meaning mattered less to him than the musical sound and poetic effect of the words on the listener, a way of instantly transporting the Western viewer to a remote, exotic world. In a similar way, Pierre Loti had larded his book with Tahitian words, poems and phrases. 'Naturally many of the pictures will be incomprehensible and you will have plenty of fun,' he told Mette, who was to be the first to show them in Copenhagen.[1]

It is important to note that for Gauguin, and Loti before him, the distinctions between Oceanic, Tahitian and Maori were far from clear. Gauguin used these words more or less interchangeably. Whereas today the distinctness of the Maori identity is emphasised, and their history, culture and character are understood to have developed separately from their geographically and climatically distant Polynesian neighbours, Gauguin was imprecise in his use of terminology.[2] Thus when describing the language, religion and culture of the indigenous Tahitians which he was so keen to recapture in his art, it was often the word Maori he used.

Two figural types crop up insistently in Gauguin's paintings and prints, the sleeper or dreamer and the figure sunk in melancholia. Such recurrences give his *oeuvre* its powerful narrative continuity. By 1889 when he told Émile Schuffenecker that he was in essence a painter of sadness, Gauguin had already started to make a leitmotif of a specific pose and figural type who embodied that emotion, the guilt-ridden, transgressive female figure first seen in his *Misères humaines* of 1888 (fig.64).[3] Her slumped pose, head in hands, elbows on knees, was reminiscent of Albrecht Dürer's famous image of *Melancholia* (fig.70). Whether alone, as in *Te Faaturuma* (*Boudeuse / Brooding Woman*) (no.119), taking centre stage, as in *Te Rerioa* (*The Dream*) (no.120), or playing an important supporting role, as in *Arii Matamoe – La Fin royale* (*The Royal End*) (no.117) and *Where Do We Come From?* (fig.6), the occurrence of this figure never failed to introduce a note of anguish and melancholy.

Gauguin often gave his Tahitian women poses that reinforce this introspective mood, the models' ample bodies lending gravitas to their postures. In line with his earlier 'Hindu' aesthetic precepts, expressed under the guise of Wehli-Zunbul-Zadé, Gauguin's compositions studiously avoided 'poses involving movement'. They conveyed their discreet narratives and emotional states – jealousy, fear, suspicion, curiosity – through eye movements, cast down or glancing sidelong. This melancholic take conformed to a certain contemporary perception of the Polynesian: namely that under colonial rule this formerly joyful people had become indolent, langorous and morose.[4] Predisposed as the artist was to seeking the sad 'chord' in humanity, *Arii Matamoe* from 1892 is nevertheless an extraordinary variation on the genre of still life in an interior, the still life in question being a severed Polynesian head on a ceremonial stool. This macabre image was prompted initially, one supposes, by witnessing the funeral of King Pomare V soon after Gauguin arrived in Papeete in 1891, but this was a culturally loaded image if ever there was one.[5]

For the subject of his key painting of the first Tahitian voyage, *Manao tupapau* (*The Spirit of the Dead Keeps Watch*), which was inspired at some level by his admiration for Édouard Manet's *Olympia*, Gauguin took the theme of reverie to a hallucinatory level (no.121). Although the recumbent figure has her eyes open, we are to understand that the dark hooded figure, the ghostly spirit of the dead seated menacingly at the foot of her bed, is not really there but seen in her mind's eye. Once back in France, in 1894 Gauguin made a one-off lithograph of the motif (no.130), and a woodcut for the *Noa Noa* series in which the woman is curled into a foetal position, vainly trying to shield herself from the haunting presences her mind conjures (no.127).

As Gauguin explained, all Polynesians believed in ghosts, whom they called *tupapaus*, hated the dark, and were quick to take fright at the phosphorescent glimmerings of the tropical night. It is arguable whether this 'literary' meaning of *Manao tupapau* would have come down to us if the artist had not taken the trouble to convey it through strategically targeted intermediaries. He sent his Danish wife Mette a crib-sheet so she could be in the know when the canvas went on show in Copenhagen in 1893, and a more concise explanation to George-Daniel de Monfreid.[6] But he inserted the fullest of his various accounts of the painting's meaning, 'La Genèse d'un tableau', into the sketchbook of notes addressed to his teenage daughter Aline.[7] Through such narrative strategies, the artist effectively sought to control, or at least set limits to, his key paintings' interpretation. First he gave an aesthetic breakdown of the painting's motif, its lines and colours, the darks and lights supplied by purples and yellows, balanced by blue-gold complementaries in the patterned pareo. This was 'the musical part'. But having painted a nude lying on her stomach, he explained, it was necessary to find an appropriate story to block the image's potentially sexual innuendo. Hence his alighting upon the justificatory story, 'the literary part'. Once he had found his *tupapau*, he would not let it go and made it, so he claimed, the main subject of the painting, the nude becoming secondary.

Given that his wife and daughter were presumably the two people in the world least likely to wish to confront the indecent implications of this image, it is curious that Gauguin should so insistently have drawn attention to them. No such concern was expressed to de Monfreid.

Gauguin's exegesis closely parallels Edgar Allan Poe's essay 'Genèse d'un poème',[8] in which he explains exactly how he composed 'The Raven': establishing, first, the poem's overall length, tone, verse pattern, metre; searching for a word suitable to form a refrain and alighting upon 'Nevermore'; finally, in order to justify the word's repetitive utterance, deciding to have it spoken by a bird. And this bird, Poe reasoned, must not be a parrot: it had to be a raven. Gauguin's unmistakable wish was to identify his own creative decision-making process with that of the poet. In a later, somewhat similar, composition Gauguin once again presents us with a recumbent, morbidly melancholic Tahitian nude lying in a sumptuous decorative interior, under the portentous inscription 'NEVERMORE' (no.118). Discussing his painting's meaning, he said his desire was to suggest 'a certain barbarous luxury of former times', but denied the relevance of Poe.[9] The bird, to be sure, is not a raven – Gauguin specified it was a 'devil's bird' – but it was disingenuous of him to deny the reference to Poe's famous poem and we should surely disbelieve him.

If *Nevermore* reprised *Manao tupapau*, *Te Rerioa* can be seen as a more complicated reprise, in horizontal format, of *Te Faaturuma*, although this time the main figure confronts the spectator with a direct and searching gaze. Both images have spatial arrangements, particularly the emphatic diagonal, and central figures that call to mind Edgar Degas. Both have an opening in the far wall – although in *Te Rerioa* it could be a painted canvas – revealing a sunlit landscape and a horseman. The setting changes from austere to richly ornate, with murals in *Te Rerioa* featuring what look like Gauguin's own sculptures of Oceanic, Buddhist and Hindu deities and a frieze of animal motifs, including, as has been recently identified, a marsupial.[10] This antipodean theme continues in the foreground's ornately carved crib. Gauguin transcribed its design from a Maori carved bowl, of recent date, which he had seen and sketched in the Museum of Auckland on his journey out.[11] In his explanatory letter to de Monfreid, Gauguin remained non-committal as to his title's meaning: 'Everything is dream in this canvas; is it the dream of the child, the mother, the rider on the path or the artist!!!'[12] Certainly for the artist planning this oneiric painting, engaging in a knowing play of *déjà vu* can only have added to the work's layered narrative ambivalence.

Fig.70 Albrecht Dürer
Melancholia 1514
Engraving
31 x 26
Staatliche Museen zu Berlin.
Kupferstichkabinett

179

116
Aha oe feii? (Eh quoi! Tu es jalouse? /
What! Are You Jealous?) 1892
Oil on canvas
66 x 89
The State Pushkin Museum of Fine
Arts, Moscow

'I have just finished a severed kanak head nicely
arranged on a white cushion in a palace of my
invention and guarded by women also of my
invention. I believe that it is a pretty piece of painting.
It is not entirely mine since I stole it from a plank of
pine. Don't tell anyone but what do you want, one
does what one can, and when marble or wood
draws a head for you it's very tempting to steal.'
Letter to Daniel de Monfreid, June 1892

117
Arii Matamoe (La Fin royale / The Royal
End) 1892
Oil on coarse fabric
45 x 75
J. Paul Getty Museum, Los Angeles

'With a simple nude I intended to suggest a certain savage luxuriousness of a bygone age. The whole painting is bathed in deliberately sombre, sad colours; it is neither silk nor velvet, neither batiste nor gold that creates this luxury, but rather the paint surface enriched by the artist's hand. No fancifulness ... solely the imagination of a man has enriched this interior with his fantasy. The title is Nevermore; it is not Edgar Poe's raven keeping watch, but the Devil's bird ...'
Letter to Daniel de Monfreid, 14 February 1897

'Do you remember reproaching me for having put a title on that painting: don't you think that that title Nevermore lay behind this acquisition – Perhaps! Be that as it may, I am delighted that Delius should be its owner, given that it wasn't a speculative purchase for resale, but because he fell in love with it; then another time he will want to buy a second, especially if people who come to visit him compliment him on it, or all the more so enter into a discussion with him about it.'
Letter to Daniel de Monfreid, 12 January 1899

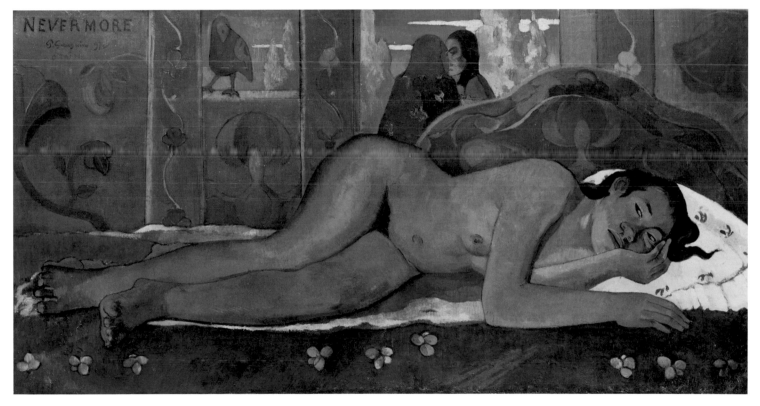

118
Nevermore O Tahiti 1897
Oil on canvas
60.5 x 116
The Samuel Courtauld Trust, The
Courtauld Gallery, London

183

'I work and live more or less alone. That's to say for a model I have a young girl (vahine – woman) aged 14 – weight about 150 [lbs] – who is very good at making a fire, doing the washing and smoking cigarettes. (It's pointless asking any more of a Tahitian woman.) She doesn't speak a word of French, and sometimes I chat in Maori, a language I am beginning to speak not too badly.
Letter to Mette, spring 1892

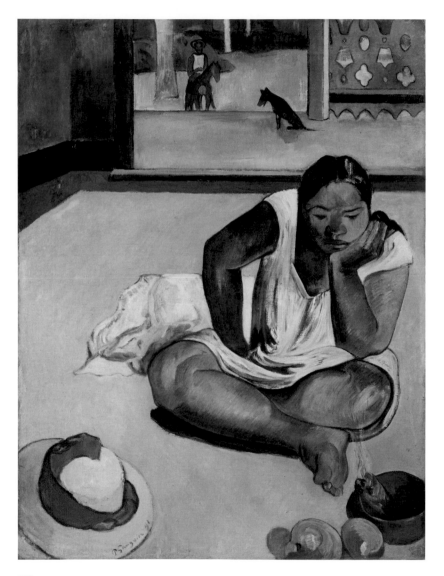

119
Te Faaturuma (Boudeuse / Brooding Woman) 1892
Oil on canvas
91.2 x 68.7
Worcester Art Museum, Worcester, MA

'I've taken advantage of the postponement of the naval vessel's departure for ten days to do another canvas that I think is even better than the previous ones, despite being executed in haste. Te Reroia (The Dream), that's the title. Everything is dream-like in this canvas; is it the child, is it the mother, is it the horseman on the path? Or is it the painter's dream! People will say all that is nothing to do with painting. Who knows. Perhaps not.'
Letter to Daniel de Monfreid, 12 March 1897

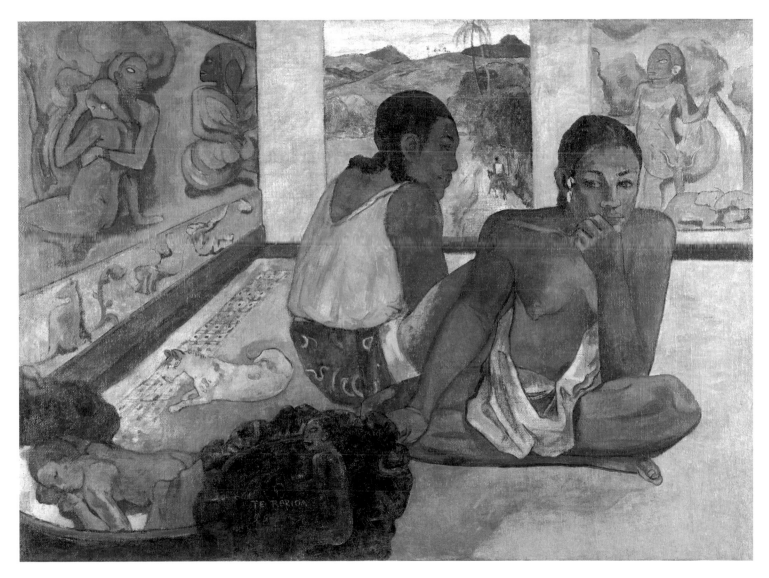

120
Te Rerioa (The Dream) 1897
Oil on canvas
95 x 132
The Samuel Courtauld Trust,
The Courtauld Gallery, London

121
Manao tupapau (L'Esprit veille / The
Spirit of the Dead Keeps Watch) 1892
Oil on burlap mounted on canvas
72.4 x 97.5
Albright-Knox Art Gallery Buffalo, NY.
A. Conger Goodyear Collection, 1965

122
Eu haere ia oe (Where Are You Going?
or Woman Holding a Fruit) 1893
Oil on canvas
92 x 73
The State Hermitage Museum, St
Petersburg

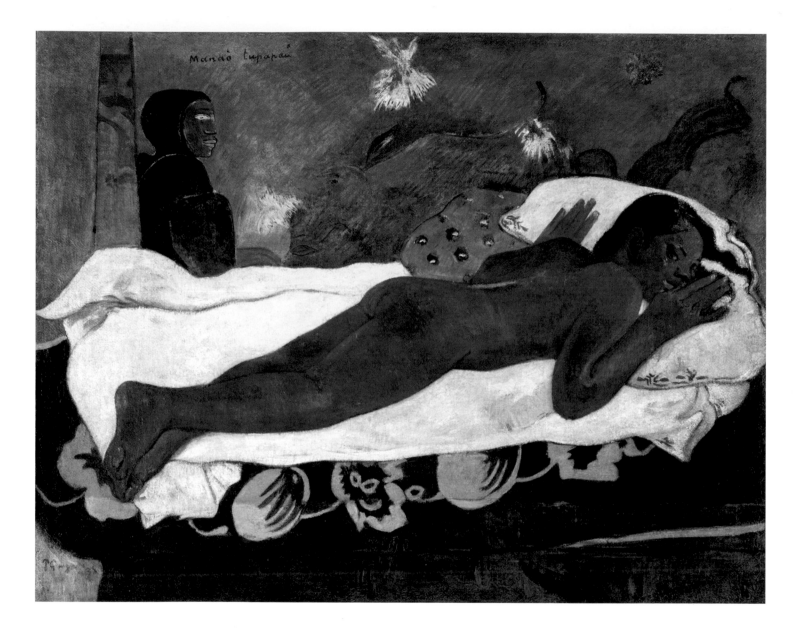

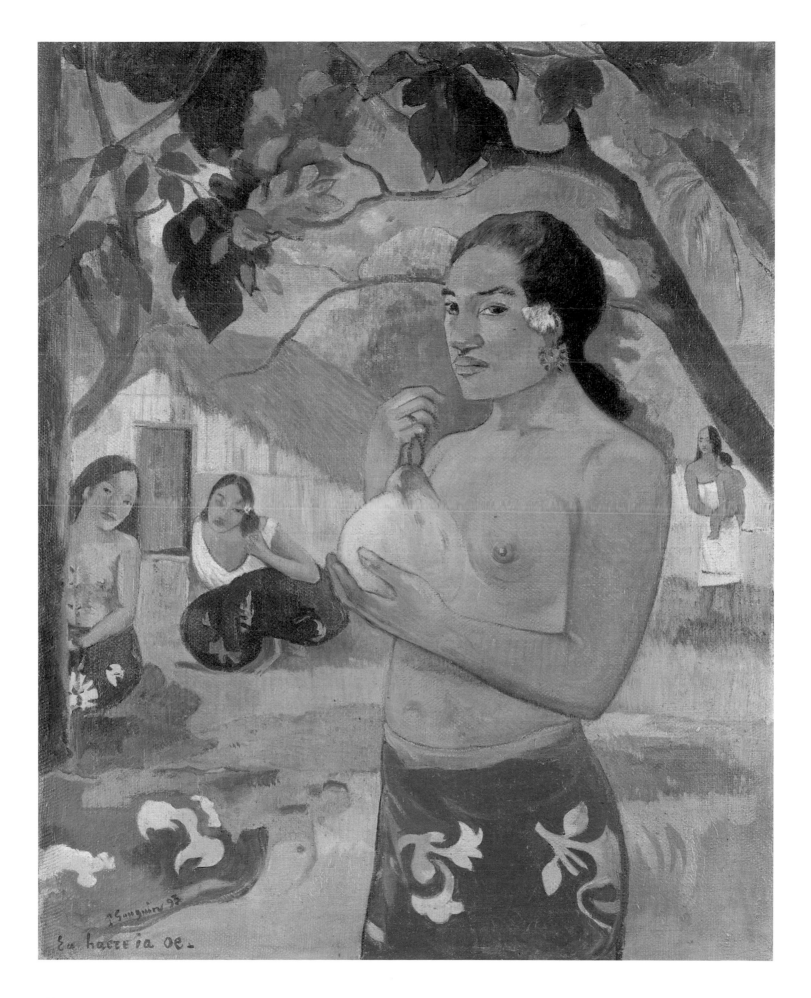

123
No te aha oe riri (Why Are You Angry?) 1896
Oil on canvas
95.3 x 130.5
The Art Institute of Chicago.
Mr and Mrs Martin A. Ryerson Collection

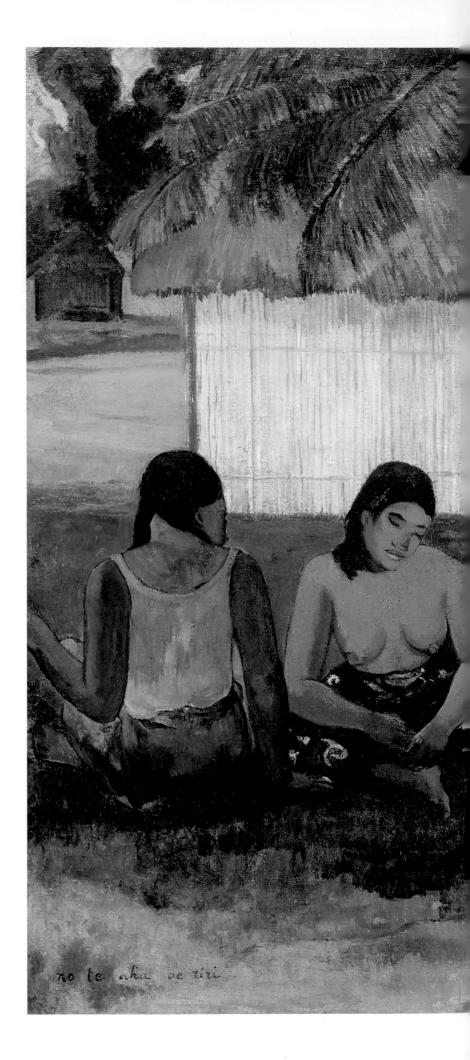

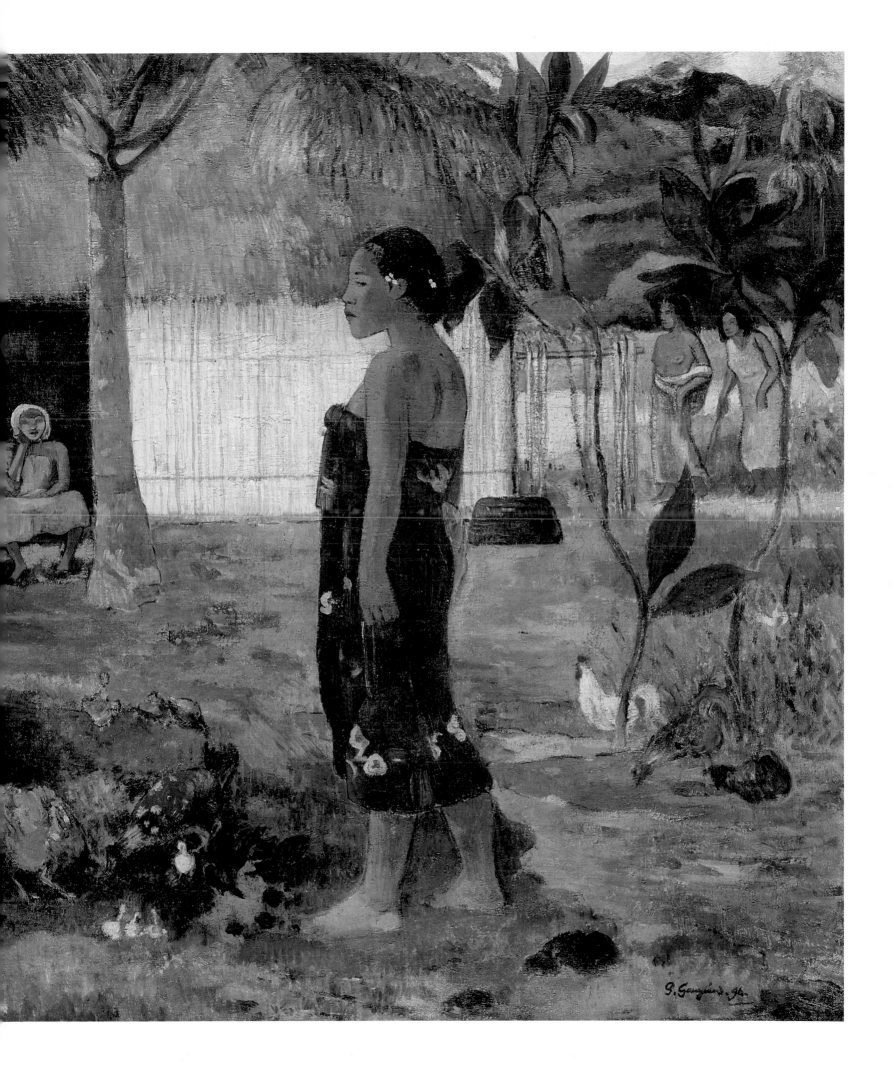

124
The Artist's Portfolio 1894
*Two inside covers decorated in watercolour,
gouache, charcoal and pencil on paper sewn
to leather, leather binding inscribed in pen
and ink with additions in watercolour; silk
ribbons stitched into binding*
42.5 x 26.4
*The Metropolitan Museum of Art, New
York. Promised Gift of Leon D. and Debra
R. Black, and Purchase, Joseph Pulitzer
and Florence B. Seldon Bequests, and 1999
Benefit Fund, 2000*

TELLER OF TALES

In Gauguin's book *Noa Noa* the arcane refrain 'Le Conteur parle' punctuates the text, introducing the sections penned by the artist – the 'I' of the narrative – as distinct from the insertions written in the third person by the 'poet', Charles Morice. The book closes with the words: 'Le Conteur achève son récit' ('The Teller of Tales concludes his narrative', see fig.41).[1] This arch stance as Teller of Tales is not without suggestive implications for the way Gauguin approached his art as a whole and, in particular, his work in the various graphic media.

For Gauguin *Noa Noa* realised a long-standing fascination with works that combine text and image. His appreciation in the mid-1880s of the contemporary artist-illustrators Randolph Caldecott and Boutet de Monvel informed his ceramic designs and also fed into the Volpini suite, his first serious undertaking as a maker of prints (no.125). Produced on the advice of his dealer Theo van Gogh, the album, comprising ten zincographs and a cover sheet, reprised subjects from his recent paintings; it was put on show with them at Monsieur Volpini's café at the 1889 Exposition Universelle in Paris. The prints are often captioned, and venture into new narrative territory.[2] A previously unsuspected excursion into the comic-strip genre recently came to light – a collaborative venture undertaken that same year in Brittany in which, together with Charles Laval and others, Gauguin compiled, for a child's amusement, an album of 'Istoyres' (fig.71).[3]

Gauguin had already produced a template, or sourcebook, for *Noa Noa* in the form of *Ancien Culte mahorie* (fig.72), whose text was wholly, if selectively, copied from J.-A. Moerenhout, sometimes verbatim, sometimes in summary form.[4] The transcribed legends informed a number of the paintings from the first Tahitian voyage, while the list of Tahitian words doubtless helped Gauguin devise his Tahitian titles. *Ancien Culte mahorie* also has beautiful embellishments in the form of vivid ink and watercolour illustrations, which occasionally borrow Marquesan decorative patterns (fig.31); they made their way, scarcely altered, into Gauguin's personal version of the *Noa Noa* text (now in the Louvre), on which he worked in Tahiti (no.128).

Gauguin's period of enforced immobility in Pont-Aven in 1894, following an ankle injury, was highly productive. This was possibly the moment when he started the scrapbook that became *Cahier pour Aline* (no.126). It remained a private production which, sadly, his daughter never received. Embellished with a haunting cover, it is partly a book of press cuttings relating to his

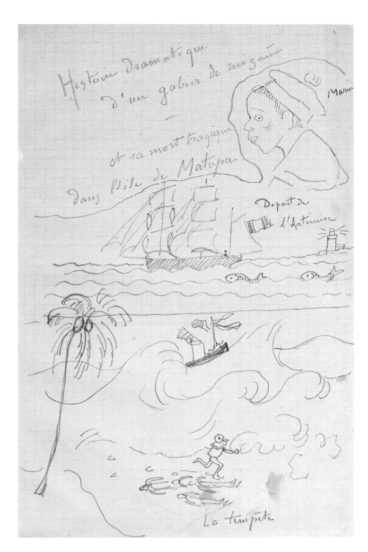

Fig.71 *From an album of drawings produced for the young Jacques Bousquet, Pont-Aven or Le Pouldu 1889–90 Cuite d'Istoyres illustré par Gauguin et de Laval et M. Jacques et Jourdan Pencil on paper Private Collection*

1893 exhibition, partly a series of philosophical and political reflections. Gauguin also embarked on a series of watercolour monotypes, some of his most inventive and delicate works in the graphic medium, mining and freely combining the rich seam of imagery offered by memories of his recent Tahitian paintings

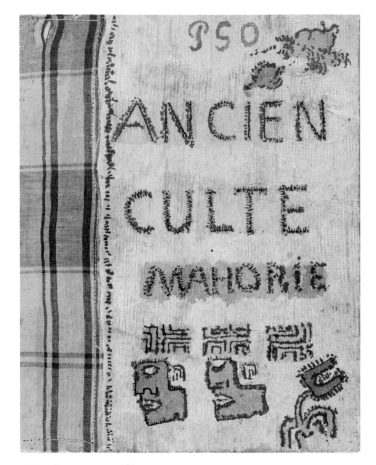

Fig.72 Cover from *Ancien Culte
mahorie* 1892
Decorated book
23.1 x 18 x 1
Musée du Louvre, Paris

(nos.80, 106, 109, 111). These were stored in a fascinating leather-bound portfolio from 1894, which Gauguin designated for the safe keeping of his and his friends' drawings, prints, poems and musical compositions (no.124). Dedicated, in mock-heroic style, to his landlady Marie-Jeanne Gloanec, the inside covers are decorated with Gauguin's playful and colourful Breton motifs.

Noa Noa, whose text was still a work-in-progress in 1894, weaves together disparate elements: Gauguin's personal experiences, traditional Oceanic folk tales garnered in the field,

and the professional writer Morice's commentary and poems. In a way its ambition invites comparison with the form of *The Arabian Nights* or the Finnish national epic, the *Kalevala*. But *Noa Noa* is both slighter and more visually rich than these prototypes, at once an adventurer's *récit de voyage*, one of the most popular literary forms in France at the time, and a sumptuous artist's book, replete with bespoke and collaged images (no.128).[5] What was not expected of the *récit de voyage*, whatever its claims to the contrary, was scrupulous truthfulness. This proviso applies to *Noa Noa*, which was written after Gauguin's return to France, embellished (or padded out as some have judged it) by the commentary and poems of Morice, and openly indebted to the earlier, authoritative research of J.-A. Moerenhout.[6]

Gauguin claimed the purpose of *Noa Noa* was to publicise the paintings he had brought back from Tahiti, and offer viewers some help with understanding them. And in Morice's opening essay, 'Songeries' ('Reveries'), the writer performs the role of stay-at-home observer, intrigued but perplexed by the artist's non-realistic, non-idealised approach to representing unfamiliar Oceanic subject matter. Whoever was responsible for the book's concept, it was clearly discussed in the autumn of 1893 when Morice was also asked to write the introduction to the Durand-Ruel exhibition catalogue.[7] In *Noa Noa* Gauguin strayed into territory strongly associated with the exoticism of Pierre Loti.[8] The nature and structure of the narrative show a similar awareness of, and willingness to play to, a particular public.[9] But Gauguin took steps to quash such parallels, in particular by constructing the fiction of his savage identity, insisting upon his much greater assimilation into island life.[10]

The ten *Noa Noa* woodcuts that Gauguin made during the winter of 1893–4 were intended to enrich the book visually. Each design was cut into a proprietory boxwood block comprising several separate pieces tightly locked together. Through this concerted effort of printmaking, Gauguin did much to revive a neglected archaic form. His printing methods were rudimentary, in keeping with the primitivism of the designs: for instance, lacking a press, he was witnessed resorting to using the weight of his bedstead to create impressions. Unsurprisingly, each impression turned out slightly differently from the last. Upon Gauguin's return to Paris at the end of 1894, a more consistent set of prints was pulled on a press with the collaboration of Louis

Roy, including a number of experimental coloured versions. Although the prints stand alone – indeed several are remarkable examples of the woodcut technique – their iconography relates closely to the Tahitian myths explored in the text (no.127). They range from the elegiac title-sheet to the darkly atmospheric *Mahna no varua ino*, whose dramatic firelight subject, reprising an earlier painting, *Upa Upa* (no.129), fully exploits the print's heavy black inking. Gauguin did not leave any clear indications of the sequence of this mythic origins-of-life narrative, but the order recently proposed by art historians Douglas W. Druick and Peter Kort Zegers makes coherent sense.[11] They divide the ten prints into a first, more positive, group evoking humanity's origins under the aegis of the gods, and a second darker group with humanity under the increasing sway of the Devil. Although specific Polynesian deities such as Hina and Tefatou feature, so does a Buddha-like figure in *Maruru*, and Gauguin's familiar Eve in *Nave Nave Fenua*. Thus the group references several belief systems and perhaps hints at more recent Darwinian thinking too. The print *Te Po* shows a kind of cosmic soup while *L'Univers est créé* has early life forms emerging from the water onto the land, mammals evolving from fish.

Noa Noa was the only book-length piece of writing Gauguin saw published during his lifetime, although he had a number of articles published, produced his own journals and was very keen to see his longer autobiographical texts in print.[12] And for all his impatience with Morice for slowing down the process, and overburdening the text with his own flowery interventions, it was thanks to the poet that *Noa Noa* got into print at all. Like almost every collaborative relationship Gauguin established, this one led to misunderstandings and acrimony. But in December 1897 he was not averse to discussing Morice's enthusiastic idea of staging a lyrical pantomine, or 'ballet doré', based on *Noa Noa*, even recommending suitable costumes – these should be severely classical, Gauguin insisted, not veering towards the comic as in *La Belle Hélène* – and scenery. For the proposed Salome scene, he suggested Morice ask Armand Seguin to come up with a suitable backdrop based on *Parahi te marae* (no.87).[13] This intriguing project seems never to have come to fruition.

Gauguin's more autobiographical self-justificatory essays were mostly composed in the Marquesas, where his isolation was more extreme and he was often too weak to paint.

In *Racontars de rapin*, written in 1902, Gauguin takes a series of swipes at the intervention of 'men of letters' into art criticism, an area in which they were ill-equipped to make judgements. His emphasis in this text on getting the plastic arts to speak, by 'constantly interrogating them and oneself', is thought-provoking. In *Avant et après*, completed in 1903, we find the elements of an autobiography, but loosely strung together, the desire to shock the *bien pensant* combined with salty wisecracks and moral maxims garnered from a life of adventure and travel, lived ardently in pursuit of a dream.

When Gauguin returned to making woodcuts in Polynesia, some were intended for local circulation – as headpieces for his satirical journal *Le Sourire* (nos.134–6) – others for the Parisian art dealer Ambroise Vollard, with whom he signed a contract in 1900 (nos.132–3). In the late monotypes Gauguin's unconventional and innovative method – although he boasted it was childishly simple – involved tracing his design onto a sheet of paper laid on a second, heavily inked, sheet of paper and varying the pressure of his hand or stylus to achieve a non-uniform surface. The mostly monochrome results, combining precise outline and richly atmospheric browny black shadows, are distillations of his by now well-practised Oceanic fables.[14] As with the Volpini prints, these transfer drawings recapitulate the subjects of Gauguin's key paintings (no.100). Several, particularly those prompted by his own change of residence from Tahiti to the Marquesas in 1901, have multiple figures and classical frieze-like compositions. Others feature two harmoniously balanced figures (nos.149, 151), suggestive of sisters, friends, or heterosexual lovers.

The combined impression of this remarkable outpouring of words and images commands immense interest and a wary respect, not sympathy but greater understanding, admiration for inventive craftsmanship and a restlessly curious and energetic intellect. Like Honoré de Balzac, whom he revered, Gauguin's tone in text and print veers in an extraordinary way from the sardonic and humorous to the solemn and mystificatory. As writer, draughtsman and teller of tales, he kept up an unstinting activity, one eye on his local audience, the other on posterity.

125
Volpini Suite 1889
Zincograph on paper
Each 50 x 65
Private Collection
Left to right, top to bottom:
Les drames de la mer / Dramas of the Sea
Les cigales et les fourmis / The Grasshoppers
and the Ants
Les drames de la mer: Bretagne / Dramas of
the Sea: Brittany
Misères humaines / Human Misery

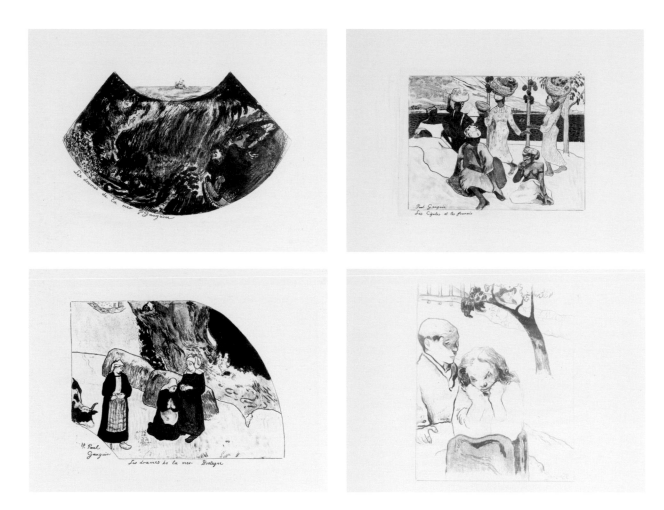

126
Cahier pour Aline 1893
Book of autograph notes and cuttings
Ink and watercolour on paper
22.2 x 17.2 x 0.5
Institut national d'histoire de l'art, Paris.
Bibliothèque, Collections Jacques Doucet
Left to right, top to bottom:
Cover embellished with Oceanic tiki motif
Inside front cover with pasted reproduction
of Corot's Italian Mandolin Player *and*
watercolour of tropical fish
Folios 8 verso, 9 recto with watercolour
memory sketch of Manao tupapau
Inside back cover with watercolour head
of a Tahitian, and pasted reproduction of
Delacroix's Arab Mounting a Horse
Both reproductions came from the Arosa
auction catalogue of 1878.

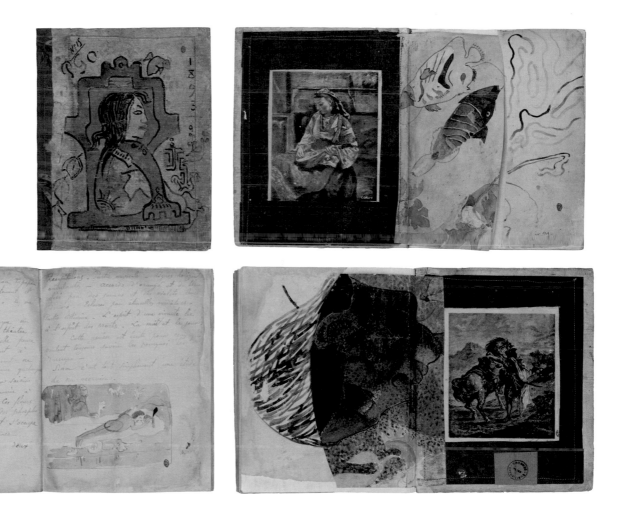

The sequence of the *Noa Noa* print series was not specified by Gauguin, but a plausible narrative would be as follows:

1 *Noa Noa* (*Fragrance*): stands outside, an image of contemporary Tahitian life, food gathering

2 *Te Po* (*The Night*): marks the beginnings of the stirrings of life

3 *Te Atua* (*The Gods*): the agency of the gods preparing the way

4 *L' Univers et crée* (*The Creation of the Universe*)

5 *Maruru:* (*Offerings of Thanks*): to the gods represented here by a single seated idol

6 *Nave Nave Fenua* (*Delightful Land*): an image of an Edenic paradise into which the devil intrudes, in lizard rather than serpent form, whispering evil thoughts to Eve

7&8 *Mahna no varua ino* (*The Devil Speaks*) and *Te Faruru* (*Here we Make Love*): the communal fire dance encourages the unleashing of the forces of human sexuality ...

9 *Auti te Pape* (*Women by the Shore*) ... which in turn leads to jealousy

10 *Manao tupapau* (*The spirit of the Dead is Watching*): fear of death and ghosts combined in a single figure whose foetal pose resumes birth, sleep and death

127
Noa Noa 1893–5
Woodcut
Various sizes
The Art Institute of Chicago (5)
The Trustees of the British Museum, London (1, 3, 9, 10)
Institut national d'histoire de l'art, Paris (4, 6)
National Gallery of Art Washington (2, 7, 8)

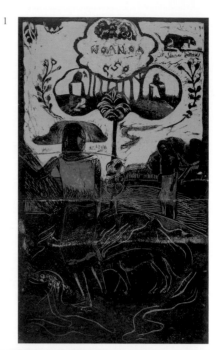

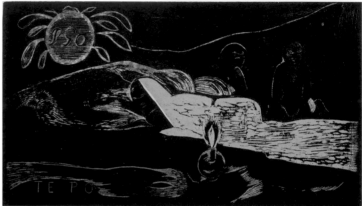

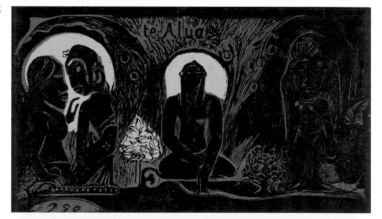

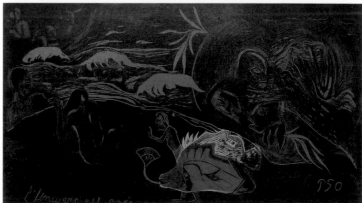

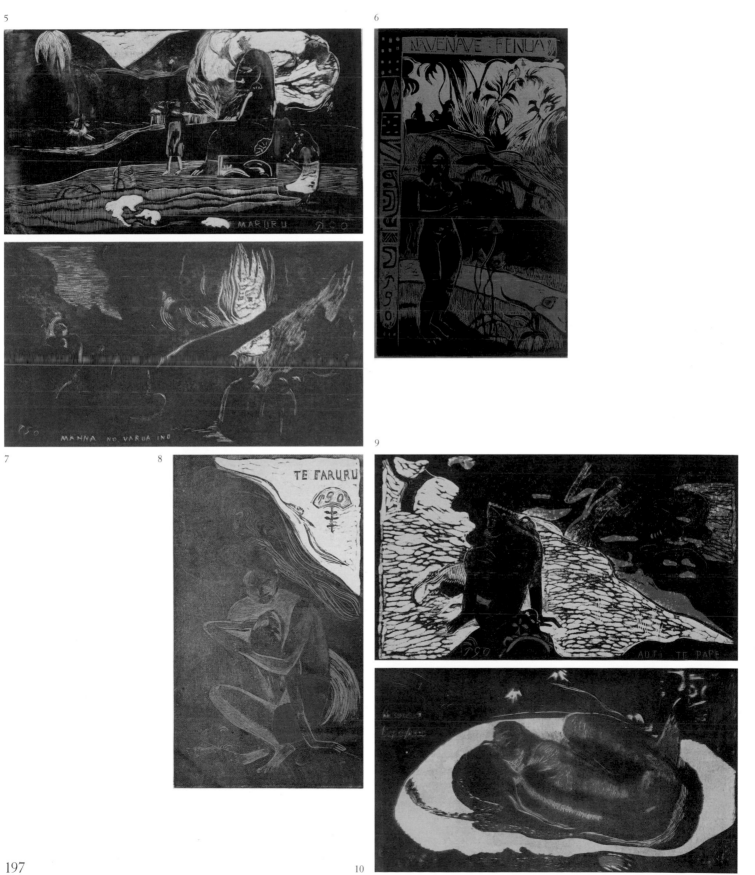

5

6

7 8

9

10

128
Noa-Noa 1893–7
Ink, pen, watercolour, print
31.5 x 23.2
Musée du Louvre, Département des arts
graphiques, Fonds Orsay
Left to right, top to bottom:
pp.56–7, folios 30 verso, 31 recto
p.59, folio 32 recto
p.63, folio 35 recto
p.73, folio 40 recto
p.75, folio 41 recto
pp.168–9, folios 87 verso, 88 recto

129
Upa Upa (Firedance) 1891
Oil on canvas
72.6 x 92.3
Israel Museum, Jerusalem

130
*Manao tupapau (The Spirit of
the Dead Keeps Watch)* 1894
Lithograph
18.2 x 27.3
*The Trustees of the British
Museum, London*

131
Te Atua (The Gods) 1898
Woodcut on paper
24.1 x 22.9
National Gallery of Art, Washington.
Rosenwald Collection

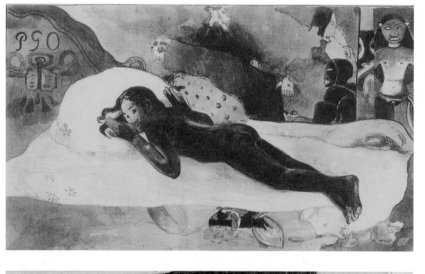

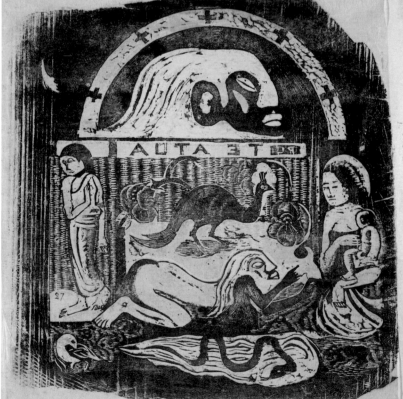

200

132
Te Arii Vahine – Opoi (Lady of Royal
Blood – Fatigue) 1898
Woodcut on paper
17.1 x 30.4
National Gallery of Art, Washington.
Rosenwald Collection, 1948

133
Soyez amoureuses, vous serez heureuses (Be
in Love and You Will be Happy) 1898
Woodcut on paper
16.2 x 27.6
National Gallery of Art, Washington.
Rosenwald Collection, 1950

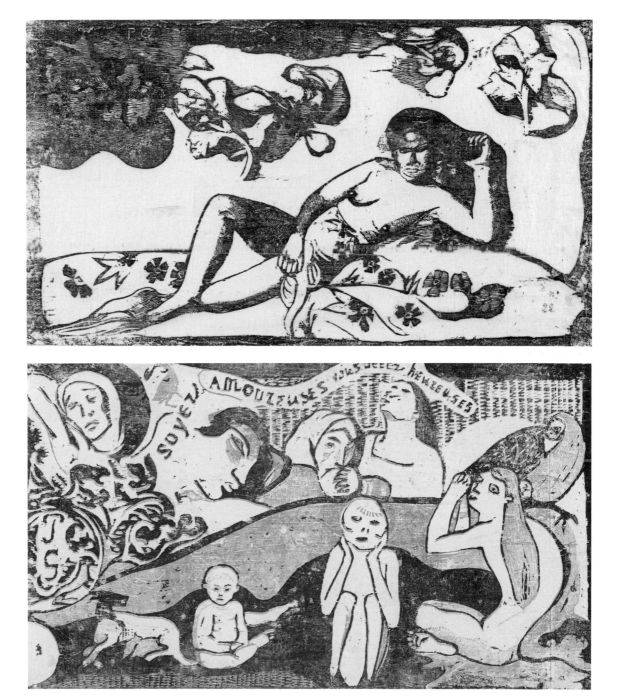

201

134
Le Sourire 1900
Title sheet
Woodcut inscribed in pen and ink
32 x 23.6
The Art Institute of Chicago.
Print sales Miscellaneous Fund

135
Le Sourire, Journal Sérieux
November 1899
Woodcut, monogram, hand-
written text and mimeograph
illustrations on paper
39.7 x 25.5
The Art Institute of Chicago.
Mr and Mrs Carter H.
Harrison Collection

Le Sourire

Writing and journalism ran in Gauguin's family, penned by his maternal grandmother Flora Tristan and his father Clovis. When jaded with what Tahiti had to offer as pictorial inspiration, Gauguin turned his attention to politics and satire. He wrote tracts attacking the institutions of the Catholic Church and marriage. As well as penning waspish journalism for *Les Guêpes*, an organ of the Catholic Party and owned by local politician François Cardella, Gauguin also worked solo on *Le Sourire*. Cyclostyled using a method devised by Thomas Edison, the journal – with a print run of about thirty copies – was probably modelled on such

polemical and satirical journals as Jean-Louis Forain's short-lived *Le Fifre*, which Gauguin enjoyed during the 1889 Exposition Universelle. *Le Sourire* – a sort of colonial *Private Eye* – is chiefly valued today for its inventive woodcut mastheads and illustrations; its highly localised articles deal with venality among local traders and administrators, Gauguin hiding his serious intent behind a jokey tone. The November 1899 issue (no.135) features appreciative references to other satirical works, Alfred Jarry's *Ubu Roi* (1896) and Diderot's *Supplément au Voyage de Bougainville* (1772).

136
Le Sourire, Journal Sérieux
19 September 1899
Woodcut, monogram, hand-written text and mimeograph illustrations on paper
34.9 x 26
The Art Institute of Chicago. Mr and Mrs Carter H. Harrison Collection

203

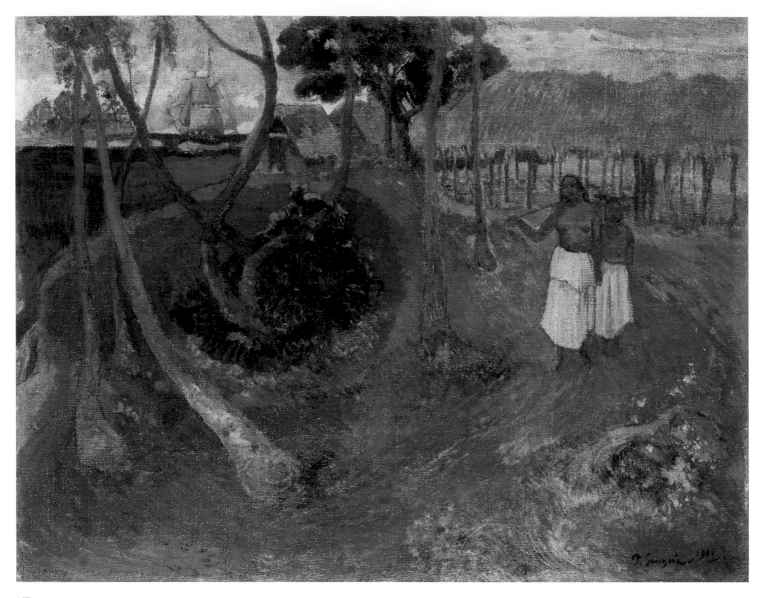

137
Idyll in Tahiti 1901
Oil on jute
74.5 x 94.5
Private Collection

204

EARTHLY PARADISE

Probably the most persistent myth surrounding Gauguin's Polynesian exile is that of his carefree paradisical existence. The myth of the artist who had dared to free himself from the humdrum cares of modern urban life in capitalist society, who had returned to a kind of tropical Eden where he could work at liberty, surrounded by the bounties of nature and seductive dusky maidens – that was the rhetoric he wished his audience to believe, and it was a fiction that Daniel de Monfreid advised him not to shatter by returning to Europe. The image, albeit somewhat tarnished, of Gauguin as lord of misrule was enshrined in the erotic epithet devised for him by Victor Segalen, who dubbed Gauguin 'le Maître-du-jouir' or 'Master of Pleasure'.

But as Edgar Degas shrewdly suspected, career strategies, financial concerns and the way his work was playing on the Paris art market were never far from Gauguin's mind in the South Seas.[1] Advising his intermediary about which pictures to send to an exhibition in Brussels in 1897, Gauguin argued for an all-Tahitian selection because Brittany had been 'digested'. He calculated that the significance and rarity value of *Where Do We Come From?* would be enhanced if he presented it to his potential buyers in France, truthfully or not, as a last testament.[2] And head as well as heart governed his decision to make a final move to the remote island group of the Marquesas, where he hoped to be free of Europeans: 'People are so stupid that when they are shown paintings containing new and terrifying elements, Tahiti will become comprehensible and charming. My Breton canvases have become milk-and-water stuff because of Tahiti, and my Tahitian work will seem tame compared with the things I plan to do in the Marquesas.'[3]

Gauguin himself was unquestionably captivated by an idyllic image of life in Oceania, to judge from the letters he wrote to friends before setting sail for Tahiti, and disappointed, initially, by what he found. As a Frenchman, it was impossible for his ideas about Tahiti not to start with the image of 'la Nouvelle Cythère', or 'l'isle heureuse' as Pierre Loti called it. This false, but now legendary, image had its origin in the open-armed welcome met by the crew of Louis de Bougainville's expedition, on their brief visit to Tahiti in 1767.[4] But as a much-travelled man of the world, Gauguin would also have had some knowledge of Tahiti's more recent and conflicted history and been aware of scientific, commercial and missionary activity in the Pacific. Tahiti's change of status in 1880, from protectorate to annexed territory of France, undoubtedly added to its viability as a destination in his eyes. It was only feasible to envisage maintaining a career at such a distance from his clientèle because of the efficiency of French colonial bureaucracy and the monthly postal service. Thus reality and myth mingled in his perceptions. As he ironised on his return to Tahiti in 1895 after an absence of two years, 'Papeete, the capital of this Eden, Tahiti, is now lit with electricity.'[5]

Nevertheless, whatever the shortcomings of the colonial reality he found, the age-old myth of the Earthly Paradise persisted in his imagination and informed his art, coming to the fore in some of the more complex, multifigured compositions that he painted in the later 1890s. In two compositions where Tahitians are presented in harmonious coexistence with nature, *Nave Nave Mahana* 1896 (no.142), and *Faa Iheihe* 1898 (no.143), Gauguin built on the observed reality of the figures he had repeatedly sketched to construct his paradisical dream. His artistic sources ranged from the sculptural friezes of Borobudur (fig.73) and Greece to the elegant decorative paintings of Sandro Botticelli and Pierre Puvis de Chavannes. For literary prompting he may have turned once again to John Milton or the book of Genesis. Countering his critics, Gauguin explained that the stately rhythms of these compositions, their rich colours and dense spatial arrangements, were necessary in order to evoke the open air yet intimate life of 'fabulous Tahiti . . . in the thickets and the shady streams, these women whispering in an immense palace decorated by nature itself'. For to achieve the grandeur, depth and mystery of Tahiti, the *trompe l'oeil* of conventional perspective would have been impotent.[6] To the lower left of *Nave Nave Mahana* he introduces the solitary figure of a child seated on the ground, tasting an apple, a suggestion perhaps of the future, the coming fall from grace. The pose of this seemingly inconsequential, but crucial, figure, prefigured in a charcoal sketch, may hark back further to a mysterious embryo-like pastel of uncertain date (nos.141, 140).

These larger-than-average paintings, together with *Te Pape Nave Nave* (no.86), anticipated and developed from the most ambitious of Gauguin's evocations of the Earthly Paradise, *Where Do We Come From?* (fig.6). These enigmatic and unanswerable

Fig.73 Anonymous
Relief on temple at Borobudur, Java
Top register: The Tathagat meets an
Ajiwaka monk on the Benares Road
Bottom register: Merchant Maitraknayake
greeted by Nymphs
Albumen photograph
24.5 x 30
Musée de Tahiti et des îles

questions, framed in the inclusive 'we' form, skilfully draw us, as spectators, into the composition but equally defy us to produce pat answers. They operate at a theological level, touching upon the eternal spiritual uncertainties facing all humankind about the purpose of life on Earth, probing the mysteries of death and the afterlife. They may also have referred to more immediate ethnographic debates about the origins of the Polynesian people and how they had come to settle these islands in the South Seas

(the perplexing question that Pierre Loti had his heroine Rarahu ponder).[7] Whatever their source – and many possibilities, from Thomas Carlyle to Charles Darwin, have been explored – they show Gauguin's willingness to deal in his art with the great mysteries of human existence.[8]

In other works, too, Gauguin hints that the Tahitian paradise has been endangered, if not yet lost or destroyed. In *Idyll in Tahiti*, for instance, one of his last paintings of the island before he left for the Marquesas, he seems to draw attention, in the form of the sailing ship on the horizon, to the coming of 'civilising' European interlopers (no.137). This view of the beach, that symbolic locus of cultural exchange, anticipates a group of late Marquesan paintings and related prints featuring horsemen and travellers in which a greater sense of space and movement is introduced. In *The Ford (The Flight)*, a hooded rider and his companion embark on a journey, hesitating before crossing a stream (no.148). The central figure is reminiscent of the hooded *tupapau* figure of earlier works, and is frequently likened to the symbolic figure of death in Albrecht Dürer's *Knight, Death and the Devil* (fig.74).

Victor Segalen took his epithet 'le Maître-du-Jouir' from the inscription Gauguin had carved in capitals into the door lintel above the entrance to his Marquesan home, '*Maison du Jouir*'. Indeed, it was Segalen who saved this important late carving for posterity by buying it at the posthumous auction of Gauguin's effects in Papeete and bringing it back to France. The provocative inscription was supplemented, on the lower horizontal beams, by two pseudo-religious injunctions familiar from earlier carvings, '*Soyez amoureuses vous serez heureuses*' and '*Soyez mystérieuses*'. Thus the studio on stilts in Atuona, which Gauguin probably realised would be his final resting place, advertised the artist's libertine philosophy and Symbolist, mystificatory aesthetic. But as much as an act of ultimate self-mythologisation, the strategy of labelling his home a house of ill repute was an act of deliberate provocation, intended to offend his neighbours and in particular the Catholic Bishop Martin. Ever since the late 1880s when he inscribed the Order of the Garter motto, '*Honi soit qui mal y pense*' ('Evil be who evil think') onto a print, Gauguin had delighted in playing up to the worst aspects of his reputation. Just as there had been a decade before

in his inscribed carving '*Soyez amoureuses*', there was a contradiction between the message and the imagery: if the two vertical panels flanking the entrance endorse the idea of sensual pleasure, with their opulent standing nudes surrounded by fruits and fauna, the horizontal friezes of hooded, wary, stern or secretive faces, recycled from earlier works, leave room for doubt.

Fig.74 Albrecht Dürer
Knight, Death and the Devil 1513
Copper etching and print
25 x 19
Staatliche Museen zu Berlin,
Kupferstichkabinett

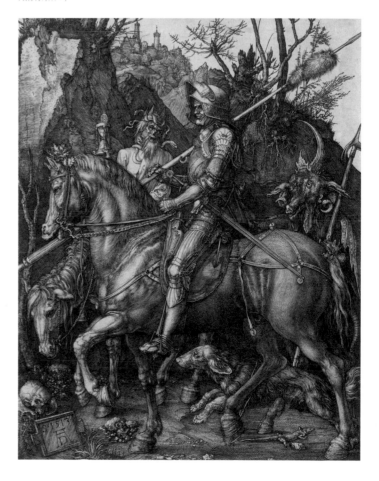

Gauguin gave this exotic tiki-like sculpture, inspired by the poetic idyll of the same name, to Stéphane Mallarmé soon after returning from his first Tahitian voyage, thereby sealing the mutual admiration between painter and poet. They were first introduced by Charles Morice in 1890. Mallarmé, whose dreams of distant voyages found expression in his poem *Brise marine*, took up Gauguin's cause, speaking eloquently, at a farewell banquet on 23 March 1891, of Gauguin's 'magnificent self-awareness that at the time of his talent's full flowering dares to take it into distant exile so as to regain vigour and get closer to himself'. In gratitude Gauguin etched his portrait, alluding, in the pointed ear, to the sensual faun of Mallarmé's earlier poem. Placing a large-beaked black bird behind the poet's head was another allusion, to the brush and ink illustrations Edouard Manet had made to accompany Mallarmé's translation of Edgar Allan Poe's poem *The Raven*, published in 1875. Although absent for the performed reading of Mallarmé's translation at the benefit concert staged in Paris on his and Verlaine's behalf in May 1891, the poem and its devilish bird haunted Gauguin's imagination and he never tired of citing Mallarmé's lapidary observation about his Tahitian paintings: 'It is extraordinary that one can put so much mystery into so much brilliance.'

138
Portrait of Stéphane Mallarmé 1891
Etching and drypoint on paper
13.6 x 12.7
Private Collection, Brussels, provenance
André Fontainas collection

139
L'Après-midi d'un faune (The Afternoon of a Faun) 1892
Carved and tinted tamanu wood
35.6 x 14.7 x 12.4
Prêt du Conseil général de Seine-et-Marne, collection du musée départemental Stéphane Mallarmé, Vulaines-sur-Seine

140
Seated Tahitian Youth 1890/1903
Watercolour, pencil and ink on paper
23.7 x 15.3
The Art Institute of Chicago. Gift of
Emily Crane Chadbourne

141
Two Panthers and Child Eating Apple
From sheet of studies, verso of Tahitian
Woman and an Entombment c.1896
Chalk and pencil on paper
26.8 x 17.8
Private Collection

142
Nave Nave Mahana (Jours Délicieux /
Delightful Days) 1896
Oil on canvas
95 x 130
Musée des Beaux-Arts, Lyon

'As I wanted to suggest a luxuriant and untamed type of nature, a tropical sun that sets aglow everything around it, I was obliged to give my figures a suitable setting.

It is indeed the out-of-door life – yet intimate at the same time, in the thickets and the shady streams, these women whispering in an immense palace decorated by nature itself, with all the riches that Tahiti has to offer. This is the reason behind all these fabulous colours, this subdued and silent glow.'
'But none of this exists!'
'Oh yes it does, as an equivalent of the grandeur, the depth, the mystery of Tahiti, when you have to express it on a canvas measuring only one metre square ...'
Diverses choses, 1896–8

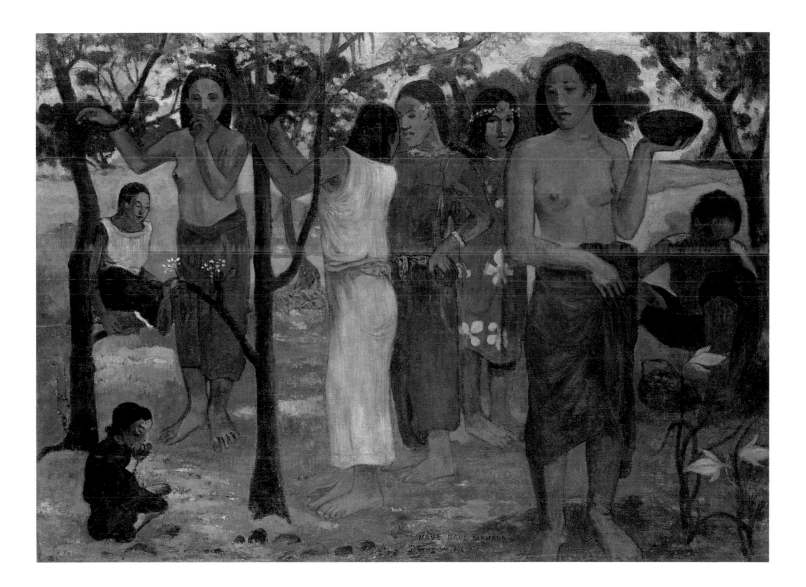

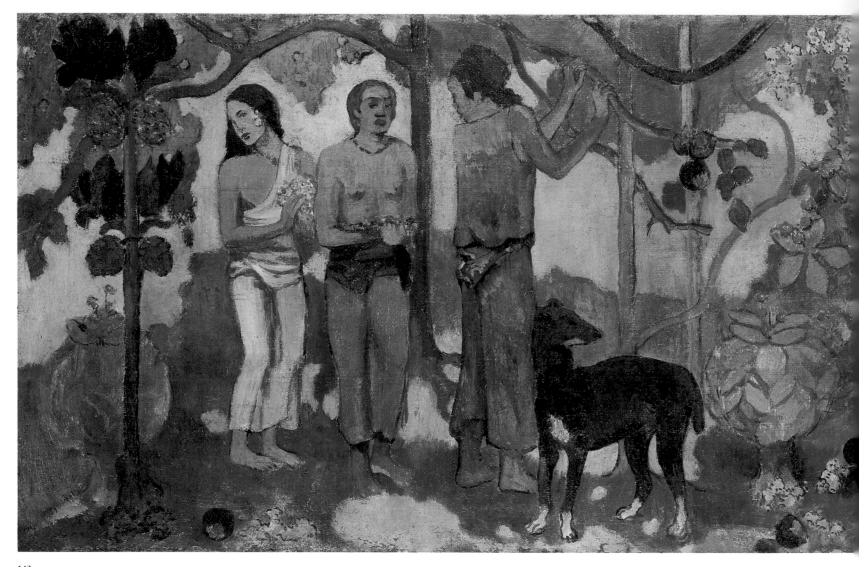

143
Faa Iheihe (Tahitian Pastoral) 1898
Oil on canvas
54 x 169.5
Tate. Presented by Lord Duveen 1919

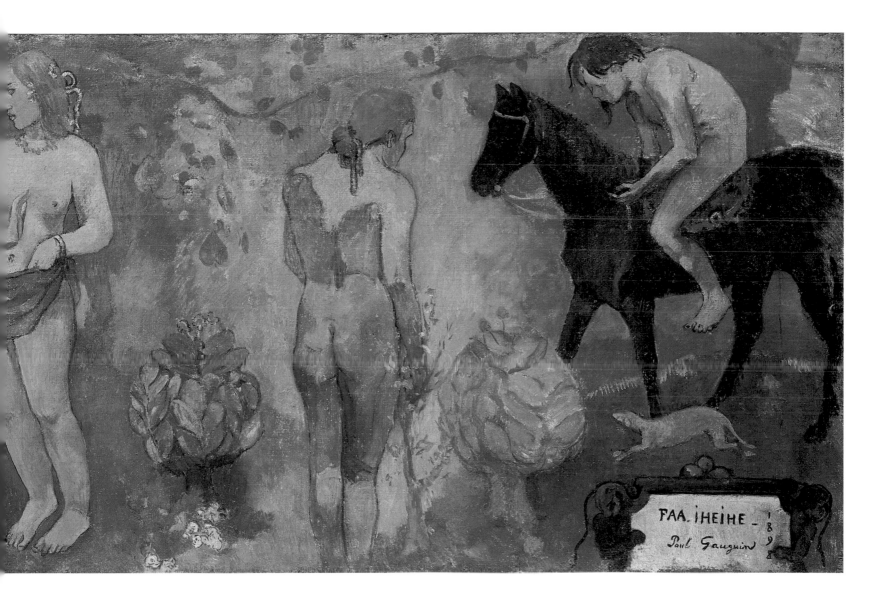

144
Tahitian Faces *c.1899*
Charcoal on paper
41 x 31.1
The Metropolitan Museum of Art,
New York. Purchase, The Annenberg
Foundation Gift, 1996

145
Two Tahitian Women *1899*
Oil on canvas
94 x 72.4
The Metropolitan Museum of Art,
New York. Gift of William Church
Osborn, 1949

150
The Escape 1902
Oil on canvas
73 x 93
Národní galerie v Praze / National
Gallery, Prague

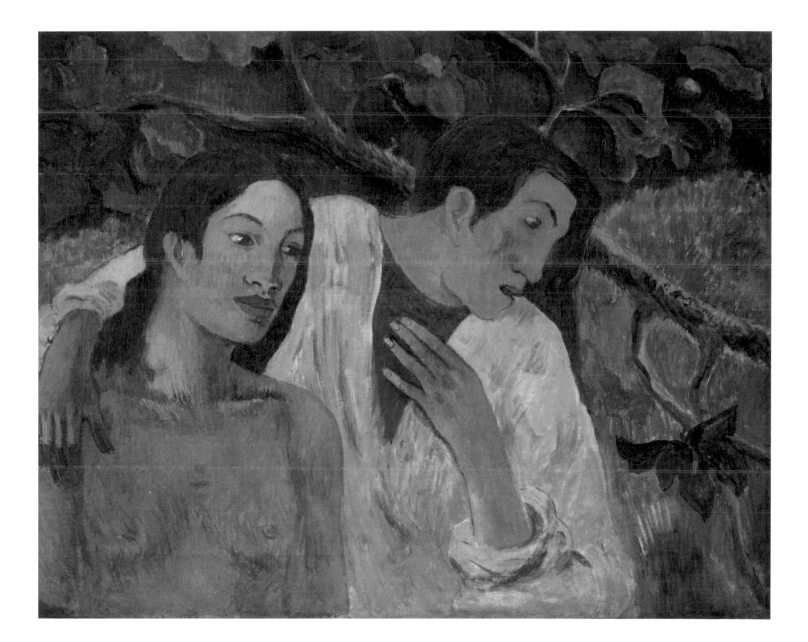

219
The Escape 1902
73 x 93

151
Two Marquesans c.1902
Traced monotype
45.8 x 34.5
National Gallery of Art, Washington.
Rosenwald Collection

152
Two Women (La Chevelure
Fleurie) 1902
Oil on canvas
74 x 64.5
Private Collection c/o
Portland Gallery, London

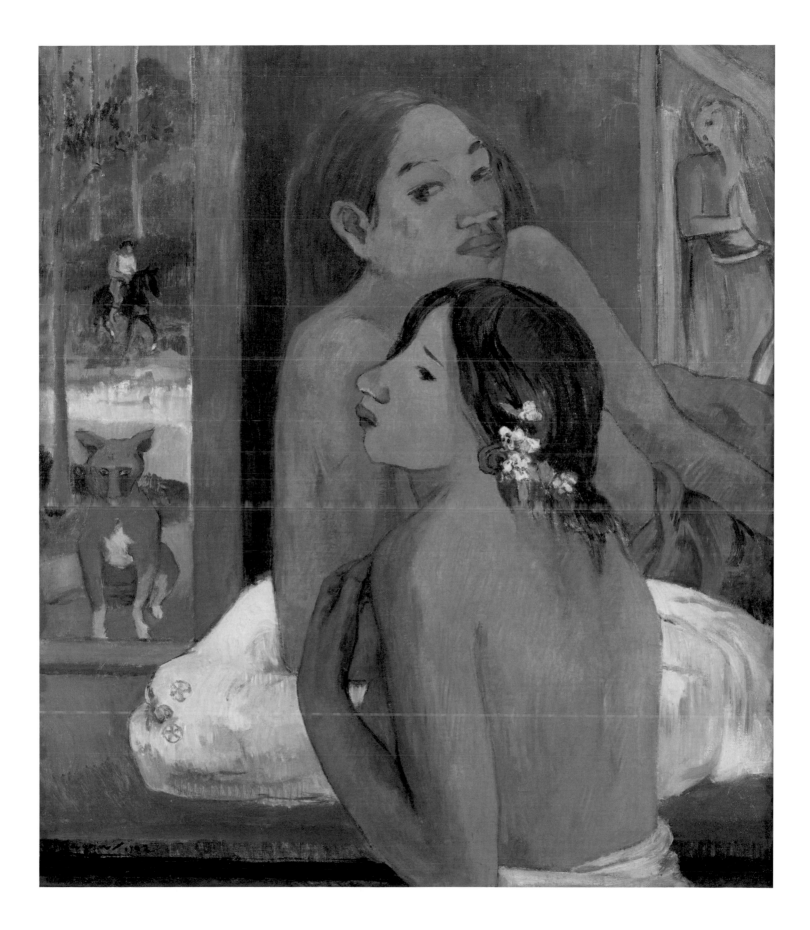

153
Study of a Nude *c.1902*
Pencil on paper
32 x 22
Private Collection, provenance
André Fontainas

154
Contes Barbares (Primitive Tales) *1902*
Oil on canvas
130 x 89
Folkwang Museum, Essen

155

Maison du jouir (House of Pleasure)
1901–2 Five carved door panels from
Gauguin's Atuona residence (Marquesas)
Polychromed sequoia wood
Musée d'Orsay, Paris

*Left to right: Soyez mystérieuses 32 x 153
x 3; Nude woman and small dog 200 x
39.8 x 2.5; Maison du Jouir 40 x 24.4 x 2.3;
Nude woman and tree with red fruits 159
x 40 x 2.5; Soyez amoureuses et vous serez
heureuses 45 x 204.5 x 2.2*

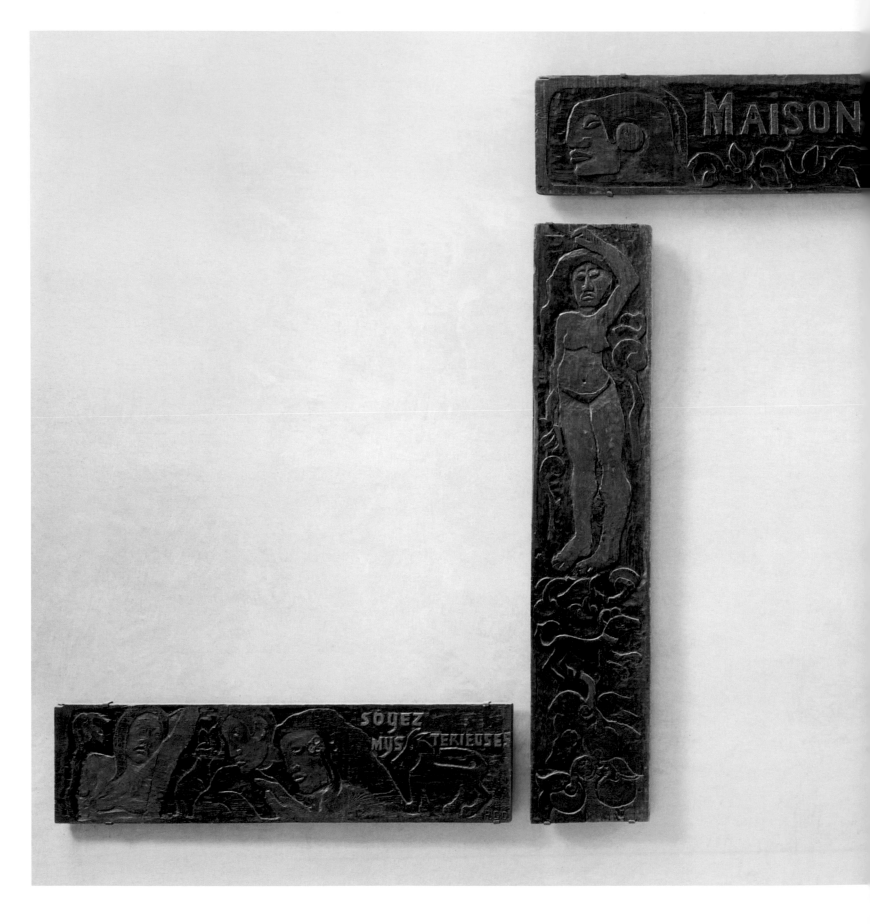

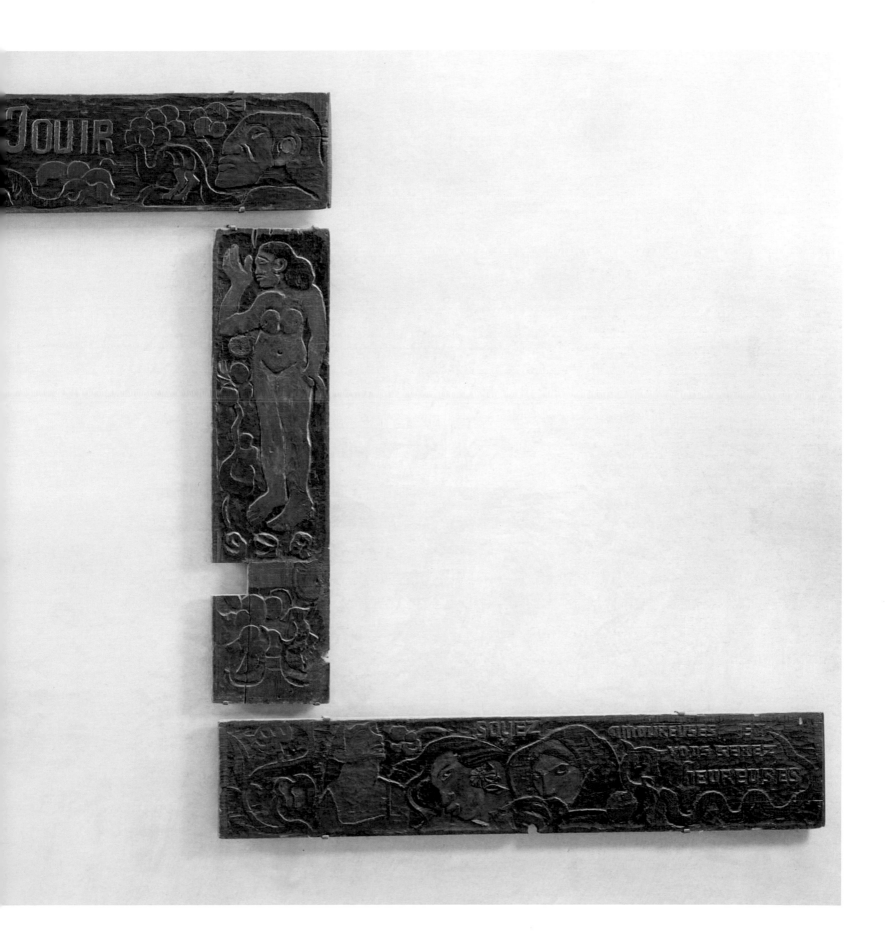

CHRONOLOGY

Amy Dickson

7 June 1848
Eugène Henri Paul Gauguin born in Paris, the second child of political journalist Pierre Guillaume Clovis Gauguin (1814–1849), an editor at the *National*, and Aline Marie Chazal (1825–1867), the daughter of writer and political activist Flora Tristan, a pioneer of modern feminism.

August 1849
Clovis and his family leave France for Peru and political exile in the aftermath of the 1848 Revolution. Clovis dies in transit from a sudden heart attack. Aline and the two children continue to Lima, taking up residence with an elderly uncle Don Pio di Tristan Moscoso. The young Gauguin spends the first five years of his life there and would later draw on this Peruvian heritage, casting himself as a 'savage' to explain both his artistic approach and his unconventional lifestyle. *'The Inca according to legend came straight from the sun and that's where I will return.'* Letter from Gauguin to Émile Schuffenecker, 22 December 1888.

End of 1854
The Gauguin family return to France, settling in the family residence at Orléans. Gauguin attends schools in Orléans and Paris.

Autumn 1859
Joins the Junior Seminary of the Saint Mesmin Chapel in Orléans, where he remains for three years.

December 1865
Enlists as an Officer's Candidate in the Merchant Marines. Spends much of the next six years at sea, in the Merchant Navy in the first instance and then performing military service in the French Navy from 1868 to 1871. *'As you can see, my life has always been very restless and uneven. In me, a great many mixtures. Coarse sailor. So be it. But there is also blue blood, or, to put it better, two kinds of blood, two races'.* From *Avant et Après*, Atuona 1903.

1867
Receives news whilst at sea of his mother Aline's death (7 July). By her will the wealthy financier and art collector Gustave Arosa becomes his guardian.

19 July 1870
France declares war on Prussia. Gauguin serves in French naval campaigns in the Mediterranean and North Sea.

23 April 1871
Released from military service. Returns to Paris and civilian life.

1872
Arosa helps him gain employment in Paris as a stockbroker with the firm P. Bertin and introduces Gauguin to a young Danish woman, Mette Gad. Meets Émile Schuffenecker.

By 1873
Gauguin had become a regular Sunday painter. Living in the *9ème arrondissement*, a hub of artistic activity.

22 November 1873
Marries Mette Gad in a ceremony at a Lutheran church, rue Chauchat, Paris.

31 August 1874
Birth of Gauguin's first son, Emil.

January 1875
Moves to rue de Chaillot, *16ème arrondissement*.

May 1876
The Paris Salon accepts Gauguin's submission of an unidentified landscape, demonstrating how quickly he has achieved a level of artistic competence.

June 1877
Moves to Parisian suburb of Vaugirard where his landlord is the sculptor Jules Bouillot.

24 December 1877
Birth of Gauguin's daughter Aline.

1878
Following a period of success on the Stock Exchange, Gauguin begins collecting contemporary art, including works by Camille Pissarro, his teacher, mentor and main connection to the Parisian artistic avant-garde. Gauguin is, by now, a regular visitor to the Impressionist café La Nouvelle Athènes. Sale in February of Arosa's significant art collection at Hôtel Drouot.

Spring 1879
Pissarro and Edgar Degas extend to Gauguin a last-minute invitation to exhibit his work in the Fourth Impressionist Exhibition. In spite of growing rivalries and tensions in the group, Gauguin continues to exhibit in the next three Impressionist exhibitions.

10 May 1879
Birth of second son Clovis.

Summer 1879
Begins working with Pissarro at Pontoise.

April 1880
Fifth Impressionist Exhibition – Gauguin exhibits eight works.

March 1881
Paul Durand-Ruel makes his first purchase from Gauguin, three paintings totalling 1,500 francs.

April 1881
Sixth Impressionist Exhibition – Gauguin exhibits eight paintings and two sculptures.
Birth of third son Jean-René (12 April).

January 1882
L'Union Générale declares bankruptcy and the stock market crashes, a critical moment for Gauguin, now at a crossroads between artistic and financial careers. In spite of his growing family, Gauguin decides to *'take the bull vigorously by the horns'* and abandon high finance to pursue painting.

March 1882
Participates in the Seventh Impressionist Exhibition.

6 December 1883
Birth of Gauguin's fifth child, Paul Rollon (Pola). Gauguin lists his profession on the birth certificate as 'artist-painter'.

January 1884
The impoverished Gauguin family move to Rouen where the cost of living was lower. With the conflicting pressures of family life, *'a wife incapable of living in poverty'*, and Gauguin's artistic ambitions, the cracks begin to show in his marriage.

Autumn 1884
Mette, distressed by their decline in fortunes, returns with the children to Denmark.

November 1884
Gauguin joins his family in Denmark and they take up residence with Mette's relatives in Copenhagen, where he works as a travelling salesman for a tarpaulin firm, Dillies & Cie.
'Here [in Copenhagen], I am more than ever tormented by art, and although I have to worry about money and look for business, nothing can deter me.' Letter to Émile Schuffenecker, Copenhagen, January 1885.

Winter 1884–5
Writes *Notes synthétiques* in Copenhagen.

June 1885
Fleeing Denmark and the Gads, Gauguin takes his second son Clovis and returns to Paris. Lodges Clovis with his sister, Marie.

Summer 1885
Spent in Dieppe with a three-week visit to London for reasons involving Spanish radical politics.

December 1885
With Clovis ill, begins working as a bill-poster for a French rail company.

1883–6
With the upheaval of the various moves and the distraction of the constant scramble for financial survival, Gauguin barely paints any more during this period than previously as a stockbroker and Sunday painter.

Spring 1886
Eighth Impressionist Exhibition – Gauguin exhibits nineteen paintings and one carved wood relief.

Summer 1886
Leaving Clovis in boarding school, Gauguin travels to the picturesque Breton village of Pont-Aven, lodging at the Pension Gloanec and living amongst a community of artists including the young painter Charles Laval, who becomes a close friend. Although initially attracted to Brittany for financial reasons, Gauguin is soon captivated by the picturesque Breton scenery and enduring folk traditions.
'I am respected as the best painter in Pont-Aven, although that does not put any more money in my pocket.' Letter to Mette, Pont-Aven, July 1886.

Autumn–Winter 1886

Returns to Paris and begins work with the ceramicist Ernest Chaplet at the Haviland Studio, producing fifty-five remarkable ceramic works.

'...what I want above all is to leave Paris, which is a wasteland for a poor man... I am going to Panama to live the life of a native. I know a little island called (Tabogas) a league off Panama; it is virtually uninhabited, free and very fertile. I shall take my paints and brushes and reinvigorate myself far from the company of men.' Letter to Mette, early April 1887.

April 1887

Sets sail for Panama with Laval. After a brief glimpse of Martinique, where their ship briefly lays anchor, they arrive in Colón on 30 April. Failing to secure financial assistance from Gauguin's brother-in-law, Gauguin and Laval work on the construction of the Panama Canal in order to raise enough money for their passage back to Martinique.

June–October 1887

Suffering from dysentery and malaria, Gauguin spends five months on Martinique, a period overshadowed by illness which produces comparatively few works. However, his Martinique works are often seen as his first step towards 'primitivism', and for Gauguin himself, the Martinique adventure was a defining moment in his transformation into artist-savage. *'you must remember that I have a dual nature, [that of] the Indian and [that of] the sensitive civilized man. The latter has disappeared [since my departure], which permits the former to take the lead... the sensitive man has disappeared, which permits the Indian to forge resolutely ahead.'* Letter to Mette, February 1888.

November 1887

Returns to Paris. Lives with Schuffenecker and paints in his studio. Exhibits Martinique works at the Montmartre premises of the colour merchant Portier, who acts informally as his dealer. On the strength of these remarkable works Theo van Gogh, working for the Goupil Gallery (Boussod et Valadon), agrees to take Gauguin on.

February 1888

Returns to Pont-Aven and the Pension Gloanec. *'I love Brittany: I find the wild and the primitive here. When my clogs resonate on this granite ground I hear the muffled and powerful thud that I'm looking for in painting.'* Letter to Émile Schuffenecker, Pont-Aven, February 1888.

May 1888

Vincent van Gogh writes to Gauguin suggesting that he join him in Arles and that together they establish a 'Studio of the South'.

June 1888

Theo van Gogh offers Gauguin a monthly allowance of 150 francs in exchange for one painting per month, contingent on him taking up Vincent's offer. Later that year (November), Theo shows paintings and ceramics by Gauguin in his mezzanine gallery and makes several sales.

August 1888

Begins a short, intense, collaborative working relationship with the young artist Émile Bernard. Friendship with Bernard's sister Madeleine, who is also in Pont-Aven at this time.

October 1888

Arrives at the Yellow House in Arles, beginning an intense and highly productive but fraught period of artistic exchange with Van Gogh. In December they visit the Musée Fabre in Montpellier. The experiment ends, after two months, in a drunken disagreement. Van Gogh threatens Gauguin, who flees, then Van Gogh severs his own ear. The next day Gauguin is arrested and released without charge, then returns to Paris where Schuffenecker lodges him.

'Vincent and I don't agree on much, and especially not on painting... He is romantic, whereas I, I am more inclined to a primitive state.' Letter to Émile Bernard, Arles, December 1888.

February 1889

Exhibits twelve paintings with *Les Vingt*, Brussels.

6 May–6 November 1889

The Universal Exhibition in Paris celebrates France's imperial expansion and showcases national achievements, exemplified by the newly constructed Eiffel Tower. Gauguin, Bernard and Schuffenecker organise an independent exhibition at the Café Volpini, inside the exhibition grounds. At the Colonial Exhibition, Gauguin sketches Javanese dancers. This reawakens his desire to travel in search of a tropical idyll.

'You missed something in not coming the other day. In the Javanese village there are Hindu dances. All the art of India can be seen in them, and they give you a literal transcription of the photographs I have from Cambodia.' Letter to Émile Bernard, Paris, end May 1889.

June 1889

Returns to Brittany before the opening of the Volpini show. Finding Pont-Aven crowded with tourists, retreats to the rugged coastal hamlet of Le Pouldu, where he decorates the dining room of Marie Henry's inn with Paul Sérusier and Jacob Meijer de Haan.

'Of course this exhibition sees the triumph of iron, not only with regard to machines but also with regard to architecture... It is up to the architect-engineers to come up with some sort of gothic lacework of iron. To some extent this is what we find in the Eiffel Tower...' From 'Notes on Art at the Universal Exhibition', *Le Moderniste*, July 1889.

'What I've been doing particularly this year is simple peasant children, walking unconcernedly by the sea with their cows. Only since I don't like the trompe-l'oeil of the open air, or of anything else, I try to put into these desolate figures the savageness I see in them and that is also in me.' Letter to Van Gogh, c.20 October 1889.

February 1890

Returns to Paris in order to pursue his bid to be appointed 'Vice-Resident' in Tonkin (now northern Vietnam).

Summer 1890

The tantalising experiences of the Universal Exhibition and correspondence with Van Gogh about founding a 'Studio of the Tropics' inspire various travel plans involving Bernard and de Haan in the ensuing months, with Gauguin considering Tonkin (now Vietnam), Madagascar, and finally settling on Tahiti.

Mid-June 1890

Returns to Le Pouldu.

Late July 1890

Receives the tragic news of Van Gogh's suicide.

October 1890

Theo van Gogh suffers a nervous breakdown, and dies January 1891. Gauguin thereby loses his most supportive dealer.

November 1890

Sells five canvases to a consortium of buyers organised by Eugène Boch, enabling him to return to Paris, where he becomes a regular during Symbolist gatherings at the Café Voltaire. Meets the poet Charles Morice for the first time at La Côte d'Or restaurant.

Late December 1890/early January 1891

Morice introduces Gauguin to the poet Stéphane Mallarmé.

January–February 1891

Launches a determined publicity campaign, recruiting Symbolist writers Octave Mirbeau and G. Albert Aurier to his cause, in preparation for a sale of his works to raise funds for his trip to Tahiti.

'I am leaving in order to have peace and quiet, to be rid of the influence of civilization... [and] to immerse myself in virgin nature, see no one but savages, live their life...' Interview, 'Paul Gauguin Discussing his Paintings' by Jules Huret, *L'Echo de Paris*, 1891.

23 February 1891

Auction of Gauguin's works at the Hôtel Drouot raises 9,985 francs. Exhibition of Gauguin's sculptures and ceramics at *Les Vingt* in Brussels provokes critics.

March 1891

Requests government sponsorship for his Tahiti trip. Endorsed by Georges Clemenceau, this request 'to study and ultimately paint the customs and landscapes of [Tahiti]' is granted on 26 March and he is able to purchase a reduced-rate ticket. Travels to Copenhagen to say goodbye to Mette and the children for what would turn out to be the last time.

1 April 1891

Gauguin travels to Marseilles, where he sets sail for Tahiti.

9 June 1891

Arriving in the Tahitian port of Papeete, his long hair earns him the nickname 'Taata-vahine', or 'man-woman'. Initially settles in Papeete and tries his hand at colonial life, cutting his hair and investing in a linen suit in the hope of making his living as a portrait painter for the colonial milieu.

'The Tahitian soil is becoming completely French and little by little the old order will disappear. Our missionaries had already introduced a good deal of protestant hypocrisy and wiped out some of the poetry, not to mention the pox which has attacked the whole race...'. Letter to Mette, Tahiti, late June 1891.

September 1891

Leaves the Tahitian capital for the remoter Mataiea, taking Titi, his Anglo-Tahitian mistress and guide with him but soon discarding her for being, in his view, too 'westernized'. Begins a two-year period of intense creativity.

'I am an artist and you are right, you're not mad, I am a great artist and I know it. It's because I know it that I have endured such sufferings. To have done otherwise I would consider myself a brigand – which is what many people think I am... What do husbands generally do, especially stockbrokers? On Sundays they either go to the races, or to the café, or with whores, for men need a few distractions, otherwise they cannot work and besides it's only human nature.' Letter to Mette, Tahiti, c.March 1892.

March 1892

Borrows a copy of J. A. Moerenhout's *Voyage aux îles du grand océan*, 1837, a detailed account of the forgotten culture, religious beliefs and customs of Tahiti, from the lawyer and coconut magnate Auguste Goupil. Gauguin begins carving tikis from local wood. Drawing on the texts of Pierre Loti and Moerenhout, he is able to invest his Tahitian paintings with the ancient, mythological aspects he longed for but that he found missing in contemporary colonial Tahiti.

'I am now living the life of a savage, walking around naked except for the essentials that women don't like to see (or so they say).' Letter to Daniel de Monfreid, Tahiti, 11 March 1892.

'What a religion the ancient Oceanian religion is. What a marvel!' Letter to Paul Sérusier, Papeete, 25 March 1892.

Spring/Summer 1892

Takes Teha'amana as his vahine.

12 June 1892

Ill and in desperate need of financial assistance, writes to the Director of Fine Arts in Paris, who is also Minister of Public Education, requesting repatriation. A chance meeting with a sea-captain acquaintance results in an unexpected loan and a potential portrait commission, which allow him to extend his stay.

December 1892

Sends consignment of pictures to de Monfreid for exhibition by his wife in Copenhagen.

'...I have known what absolute poverty means – being hungry, being cold – and everything that it implies... it is true that suffering sharpens genius. Yet too much suffering kills you.' Cahier pour Aline, Tahiti, 1892–3.

March–April 1893

An artists' society in Copenhagen, the Frie Udstilling, exhibits fifty works by Gauguin, including ten Tahitian paintings, and about thirty by Van Gogh.

May 1893
Moves to Papeete with Teha'amana. Requests repatriation once again.

August 1893
With just four francs in his pocket, but convinced of the novelty of his Tahitian works, Gauguin returns to Paris anticipating a hero's welcome.

November 1893
A modest inheritance from Uncle Isidore. Mounts an exhibition of his Tahitian works at the Durand-Ruel Gallery in Paris (forty-six items in catalogue, forty-one Tahitian paintings, three paintings from Brittany and two sculpture entries: cat.45 *La Femme noire*, cat.46 *Les Tiis*). Although the exhibition is commercially disappointing, an impressed Degas buys several works and helps to promote Gauguin in his circle. The critical reception is largely positive, encompassing enthusiastic reviews by such writers as Mirbeau, Fénéon, Natanson and Morice.

Early 1894
Takes a first-floor studio at 6 rue Vercingétorix, Paris, painting the walls a vibrant yellow and installing his Tahitian works alongside ethnographic artefacts. The studio becomes the eccentric backdrop for regular Thursday evening gatherings of artists, musicians and writers, presided over by an exotically attired Gauguin accompanied by his teenage mistress and model, Annah the Javanese. Gives tuition in the Académie Vitti, impasse du Maine. Works on *Noa Noa*, an illustrated narrative of his first Tahitian sojourn, with Charles Morice. Mette breaks off relations.

April 1894
Returns to Pont-Aven accompanied by Annah and her pet monkey. No longer living the pretence of being a respectable family man, he embraces his reputation as a rebel – drinking, fighting and bragging of his sexual exploits. A brawl with Breton sailors in Concarneau shatters his ankle, leaving him immobile for several months. He would never fully recover from this injury. On returning to Paris, discovers that Annah has ransacked his apartment.

14 November 1894
Returns to Paris.

22 November 1894
Morice, Roger Marx, Gustave Geffroy and Arsène Alexandre organise a banquet in Gauguin's honour at the Café des Variétés.

December 1894
Holds a small exhibition of recent work, combined with art historical reproductions, in his studio.

Early 1895
Diagnosed with syphilis.

February 1895
Hôtel Drouot sale of his work is poorly attended and Gauguin sells only nine of the forty-seven works, forcing him to delay his departure to the South Seas.

Spring 1895
Controversy surrounds his attempt to exhibit *Oviri* at the Société Nationale des Beaux-Arts.

June 1895
Departs for Tahiti. He would never return to France.

August 1895
Arrives in Auckland, New Zealand, where he studies Maori art at Auckland Museum.

9 September 1895
Arrives back in Tahiti at a moment of conflict between the colonising military and the defiant inhabitants of the neighbouring islands. This final period of exile in the South Seas is characterised by two disparate types of activity: writing, including political agitprop and satirical journalism, and a major body of late works. It is also punctuated by periods of financial crisis, ailing health and a possible suicide attempt. He is disappointed by the apparent modernisation of Tahiti. *'Papeete, the capital of this Eden, Tahiti, is now lit with electricity. A merry-go-round spoils the great lawn in front of the king's garden.'* Letter to William Molard, c. September 1895.

November 1895
Still plagued by his ankle injury and suffering from syphilitic symptoms, Gauguin settles in Punaauia, just three miles from Papeete.

January 1896
Lives with his vahine, Pau'ura.

July 1896
Hospitalised in Papeete.

November 1896
Ambroise Vollard holds exhibition of Gauguin's work at his gallery, 6 rue Laffitte, Paris.

December 1896
Pau'ura has a baby, which dies shortly after birth.

1897
A difficult year fraught with financial uncertainty and ill health.

February 1897
Six Tahitian paintings exhibited at the Salon de la Libre Esthétique, Brussels.

April 1897
Receives news from Mette of his daughter Aline's death from pneumonia.

Autumn 1897
Suffers a series of heart attacks.

October–November 1897
Noa Noa published in *La Revue blanche*.

December 1897
Rejects Morice's proposal that they share royalty payments but advises him on costumes and décors for his proposed *'ballet doré'* based on *Noa Noa*.

Winter 1897–8
After completing his largest painting, *Where do we come from? What are we? Where are we going?*, Gauguin may have attempted suicide by taking arsenic. *'I went to hide in the mountains, where my corpse would have been eaten up by ants. I didn't have a revolver but I did have arsenic that I had hoarded during the time that I had eczema.'* Letter to Daniel de Monfreid, Tahiti, February 1898.

1898–1901
Increasingly hampered by ill health, Gauguin produces comparatively few paintings. In need of funds, he takes a six-franc-a-day job as a clerk at the Office of Public Works and Surveys in Papeete in 1898. Increasingly disenchanted with the colonial administration, Gauguin turns to literary means of protest.

February 1898
At a small exhibition of Gauguin's works organised by Julien Leclercq at the Swedish Academy of Arts, *Manao tupapau* is removed on grounds of indecency.

August 1898
Hospitalised for three weeks.

17 November 1898
Exhibition of Gauguin's recent canvases, with *Where do we come from?* as centrepiece, opens at Vollard's gallery.

April 1899
Birth of son, Émile.

June 1899
Contributes acerbic articles to *Les Guêpes*, an organ of the Catholic faction in Papeete.

August 1899
Publishes first issue of his own monthly satirical journal, *Le Sourire*. In both of these foregoing journalistic ventures, Gauguin directs his own brand of biting satire to a variety of targets, encompassing the French colonial administration, Chinese immigrants, the Catholic Church and the Protestant missions.

September 1899
Plans to complete a dozen paintings to show at the Exposition Universelle of 1900 (wrongly addressed, they arrive too late).

February 1900
Becomes editor-in-chief of *Les Guêpes*.

March 1900
Agreement with Paris art dealer, Ambroise Vollard: Gauguin to send him a maximum of twenty-five canvases per year as well as drawings and prints in exchange for a regular monthly income of three hundred francs and the necessary materials. De Monfreid to continue acting as his intermediary.

April 1900
Le Sourire ceases publication.

May 1900
His son Clovis dies. Gauguin probably never finds out.

December 1900
Hospitalised in Papeete.

Spring 1901
Repeatedly hospitalised. In Béziers, several Gauguin works exhibited by a keen new collector, Gustave Fayet.

September 1901
Settles in Atuona on Hiva-Oa in the remote Marquesas Islands, a move that reinvigorates his art. Constructs *Maison-du-Jouir*. Resumes painting.

November 1901
Takes Marie-Rose Vaeoho as his vahine.

April 1902
Refuses to pay taxes and incites Marquesans to do likewise, resulting in criminal charges being brought against him.

September 1902
Birth of daughter, Tahiatikaomata, to Vaeoho, who has left Gauguin.

7 January 1903
Cyclone ravages the Marquesan islands, destroying homes and crops. Writes a series of legalistic letters to representative authorities, denouncing corruption and defending his own rights and those of indigenous Marquesans.

31 March 1903
Gauguin's intransigence and rabble-rousing toward the colonial administration results in a court summons and hefty fine.

April 1903
Prepares his defence. *'. . . I am down, but not yet defeated. Is the Indian who smiles under torture defeated? No doubt about it, the savage is certainly better than we are. You were mistaken one day when you said I was wrong to say that I am a savage. For it is true: I am a savage. And civilized people suspect this, for in my works there is nothing so suprising and baffling as this "savage in spite of myself" aspect. That is why it is inimitable . . .'.* Letter to Charles Morice, Atuona, Hiva-Oa, April 1903.

8 May 1903
Dies of syphilitic heart failure. Buried in the Catholic cemetery on Hiva-Oa.

23 August 1903
Daniel de Monfreid receives notice of Gauguin's death.

2–3 September 1903
Auction in Papeete of Gauguin's works and studio effects. Victor Segalen succeeds in buying the most important works.

November 1903
Eight paintings are shown in a commemorative room at the Salon d'Automne, Paris, and a small retrospective exhibition is organised by Ambroise Vollard.

6 October–15 November 1906
Major retrospective exhibition of 227 works at the Salon d'Automne.

NOTES

Paul Gauguin: Navigating the Myth
Belinda Thomson pp.10–23

1. For a philosophical investigation of the ethical challenge presented by Gauguin's career, see Williams 1981, pp.20–39.
2. René Huyghe credits him with determining in one fell swoop the three directions that modern art would take in order to escape 'la fatalité du réel': Cubism, Fauvism and Expressionism, and Surrealism. Huyghe 1960, p.238.
3. 'This terrible self which oppresses me'. Gauguin in a letter to Octave Mirbeau, 14 or 15 February 1891, in Michel and Nivet 2005, vol.II, p.346.
4. Letter to Theo van Gogh, 17 January 1889, no.736, vangoghletters.org.
5. 'Un désert pour l'homme peintre'. Letter from Gauguin to Mette of late March 1887, written prior to his departure for Martinique. He uses the image of Babylon, a common nineteenth-century topos for the burgeoning metropolis, when giving a guide to the complex meanings of his wood carving *Soyez amoureuses*, 1889. See letter from Gauguin to Vincent van Gogh, Le Pouldu, 10–13 November 1889, no.817, vangoghletters.org.
6. Gauguin described himself haughtily, but truthfully, in an altercation with Paul Signac, as a 'man of the world'. Letter from Gauguin to Signac, early July 1886, in Merlhès 1984, p.131.
7. Letter to Mette of c.22 January 1888, in Merlhès 1984, p.170.
8. 'Et il est évident que Gauguin qui est moitié Inca moitié Européen, superstitieux comme les premiers & avancé d'idées comme certains de ces derniers, ne peut pas travailler tous les jours de même.' Letter from Theo to Vincent van Gogh, 22 December 1889, no.830, vangoghletters.org.
9. *Racontars de rapin*, 1902. Despite Gauguin's efforts, this was not published in his lifetime. For a facsimile edition, illustrated and annotated, see Merlhès 1994.
10. *Avant et après*, 1903, first published in a limited edition facsimile, Leipzig 1918. Published with a preface by his eldest son Emil, as *Paul Gauguin's Intimate Journals*, New York 1921.
11. Joly-Segalen 1950; Somerset Maugham, *The Moon and Sixpence*, London 1919.

12. Paul Gauguin, in Malingue 1946; Cooper 1983; Merlhès 1984; Merlhès 1989; Merlhès 1995.
13. 'Car je suis un artiste et tu as raison, tu n'es pas folle je suis un grand artiste et je le sais. C'est parce que je le suis que j'ai tellement enduré de souffrances. Pour poursuivre ma voie sinon je me considérerai comme un brigand. Ce que je suis du reste pour beaucoup de personnes.' Letter from Gauguin to his wife Mette, March 1892, in Malingue 1946, pp.220–1.
14. See Wettlaufer 2007. Mario Vargas Llosa has devoted a dual fictionalised biography to the lives of grandmother and grandson, *The Way to Paradise*, London 2001.
15. In a letter to Mette of December 1887 he asks her what has become of his grandmother's London book, that is, *Promenades dans Londres*, Paris and London 1840; Letter to Mette of 6 December 1887, in Merlhès 1984, p.167.
16. The text was published in *L'Art moderne de Belgique* on 10 July 1887, p.219. At the time Gauguin was in Martinique. I am grateful to Florence Hespel of the Archives de l'art contemporain de Belgique for supplying me with a copy of this text.
17. Félix Fénéon, 'Textes', in *Bulletin*, no.4, 14 March 1914, reprinted in Halperin 1970, pp.280–2.
18. In the printed version this is somewhat truncated: 'Ne finissez pas trop: une impression est trop fugace pour que l'ultérieure recherche de l'infini détail ne nuise au premier jet. Vous en refroidiriez la lave, d'un sang bouillonnant feriez une pierre: fut-elle un rubis, – loin de vous.'
19. Linda Goddard suggests this reading in her essay, p.35.
20. Gustave Moreau, on taking over Gustave Boulanger's vacant chair at the Institut, larded the obligatory eulogy with pointed jibes at his predecessor's pronounced taste for characterful, picturesque, anecdotal subjects: 'Notice sur M. G. Boulanger par M. Gustave Moreau, membre de l'Académie, lue dans la séance du 22 novembre 1890', in *L'Assembleur de rêves: écrits complets de Gustave Moreau*, Fontfroide 1984, pp.235–44.
21. Thaulow, a Norwegian painter, married Ingeborg Gad in 1874; they divorced in 1883.
22. A comment in a letter to a fellow painter gives an insight into Gauguin's confrontational attitude

to the academic painters of his day: 'la contradiction J.-P. Laurens vous aura émoustillé ('the contradiction with J.-P. Laurens will have gingered you up'). Letter from Gauguin to Émile Schuffenecker, Martinique, second week of October 1887, in Merlhès 1984, p.162.
23. When his *Study of a Nude* or *Suzanne Sewing*, 1880 (fig.36), received glowing praise from the novelist J.-K. Huysmans at the Sixth Impressionist Exhibition of 1881, he dismissed the flattery on the basis that the critic was purely impressed by the 'literature' of the painting. Letter to Pissarro, 11 or 12 May 1883, Merlhès 1984, p.48.
24. Chaplet was a professional ceramicist working for the Haviland firm. Gauguin also received encouragement from Félix Braquemond, and both Chaplet and Braquemond bought pictures from him.
25. 'Comme la littérature l'art de la peinture raconte ce qu'il veut avec cet avantage que le lecteur connaît immédiatement le prelude [sic] la mise en scène et le dénouement.' Text in Hammer Sketchbook, National Gallery of Art, Washington DC, pp.2–3.
26. Letter from Gauguin to Vincent van Gogh, c.20 March 1890, no.859, vangoghletters.org.
27. This emerges from a letter from Mirbeau to Monet, 22 January 1891, in Michel and Nivet 2005, vol.II, pp.329–30. Although Monet's reply is unrecorded, it is clear that he was by no means as enthusiastic about Gauguin's recent art as Mirbeau had led Gauguin to believe.
28. 'J'ai toujours dit, (sinon dit) pensé que la poésie littéraire du peintre était spéciale et non l'illustration ou la traduction par des formes des écrits.' Letter to Daniel de Monfreid, August 1901, Joly-Segalen 1950, p.182.
29. In a letter to his dealer Theo van Gogh, Gauguin writes: 'Je cherche en même temps qu'à exprimer un état général plustôt qu'une pensée unique, faire ressentir à l'oeil d'un autre, une impression indefinie [sic] infinie. Suggérer une souffrance ne veut pas dire quel genre de souffrance; la pureté en général et non quel genre de pureté. La littérature est une, (la peinture aussi). En conséquence la pensée suggérée et non expliquée.' 20 or 21 November 1889, Cooper 1983, pp.159–61.

30. 'pour vous piloter dans l'ile son oeuvre serait un mauvais guide, si votre âme n'est parente du sien', Charles Morice, Preface to exh. cat., Galeries Durand-Ruel, *Exposition d'oeuvres récentes de Paul Gauguin*, 10–25 November 1893, p.11.
31. 'Examine them [my pictures] attentively at the same time as the wood carvings and the ceramics. You will see that it all holds together.' ('Examinez les [mes tableaux] attentivement en même temps que le bois que la céramique. Vous verrez que tout celà se tient ensemble.') Letter from Gauguin to Theo van Gogh, 20 or 21 November 1889, Cooper 1983, p.159.
32. Denis published his radical theory under a pseudonym, Pierre Louis; Définition du néo-traditionnisme', in *Art et Critique*, nos.65, 66, on 23 and 30 August, 1890, pp.540–2, 556–8. Reprinted in Maurice Denis, *Le Ciel et l'Arcadie*, in Bouillon 1993, pp.5–21.
33. *Manet and the Post-Impressionists*, Grafton Galleries, London, 8 November 1910 – 13 January 1911.
34. Fry 1918, p.85.
35. 'Je note qu'à de très rares exceptions près, les poètes marquèrent toujours, à la personne de Gauguin et à son art, une spontanée et profonde déférence, qui s'explique fort logiquement par la prépondérance que l'artiste attribuait, dans son oeuvre, à la pensée poétique, disons: à la pensée "littéraire".' 'Ses lectures ne sont pas très étendues; mais elles sont très approfondies.' Morice 1920, pp.27–8, 43.
36. 'Les arts plastiques ne se laissent pas deviner facilement, pour les faire parler il faut les interroger à toute heure en s'interrogeant soi-même. Arts complexes s'il en fut – Il y a de tout, de la littérature, de l'observation, du virtuose (je ne dis pas adresse), des dons de l'oeil, de la musique.' From *Racontars de rapin*, 1902, ed. Merlhès 1994, p.4.
37. Among the canonical French authors he cites at different times are La Fontaine, Fénelon, Diderot, Voltaire, Balzac, Baudelaire and Hugo.
38. Wildenstein 1958, pp.201–8.
39. It is likely the translation Gauguin represents of Milton's seventeenth-century text was the one by Chateaubriand, which appeared in 1836. Carlyle's *Sartor Resartus*, 1832, was not available in French at this

date; as Merlhès has shown, Meijer de Haan was probably reading the Dutch translation. Merlhès, 'LABOR, Painters at Play in Le Poulou', in *Gauguin's Nirvana*, exh. cat., Wadsworth Atheneum Museum of Art, 2001, pp.99–100.

40. Poe's *Extraordinary Tales* were available in French in the notable translation with commentary by Baudelaire. A reading of Mallarmé's translation of *The Raven* was given as part of the benefit performance for Gauguin and Verlaine in May 1891.

41. Daubigny decorated his daughter's bedroom at Auvers in the 1860s with a selection of nursery rhymes and La Fontaine fables. Moreau, commissioned to illustrate La Fontaine's fables by Antony Roux in 1879, exhibited the sixty-five resulting watercolours at Goupil's gallery in 1886. Boutet de Monvel's illustrations to the fables, designed in a spare *bande dessiné* style and first published in 1888, became instant children's favourites. As Boutet de Monvel's photograph of Gauguin reveals, the two artists clearly knew each other at a later date.

42. The fable of the Rats and the Weasels is a lesson on pride, the 'grands seigneurs' among the rats forfeiting their ability to give the enemy the slip because of their cumbersome appendages – horns, plumes or crests.

43. Gauguin called the fox, an animal widely associated with cunning in European folklore, 'the Indian symbol of perversity'.

44. Aurier 1891. Charles Morice was the author of a much talked-about recent publication, *La Littérature de toute à l'heure*, 1889, as well as of translations of Dostoievski and some provocative short stories.

45. In late 1889 Gauguin was confident that the Comtesse de Nimal, whom he met in Brittany, would talk up his work to her friend Maurice Rouvier, the minister of finance, clearly hoping for high-placed patronage that way.

46. Dorival 1951; Field 1960; Druick and Zegers 1991; Merlhès 2001, pp.81–101.

47. Letter from Gauguin to Vincent van Gogh, on or about Saturday, 8 September 1888, no.675, vangoghletters.org (Cooper 1983, 31, p.221).

48. 'Gauguin est surtout un peintre de sensations qui, toutes, émanent de souvenirs et d'assimilations littéraires ou qui, toutes, correspondent en notre esprit, à certaines réminiscences littéraires. C'est presque – et je ne trouve d'autre mot pour exprimer ma pensée – un peintre philosophe, tristement ironique, dont chaque toile synthétise un caractère mais d'une façon si cruelle que ce caractère nous surprend, vrai, et cependant jusqu'alors non compris ainsi. En ses arabesques décoratives, en sa rare science de composition, lui seul a compris la Bretagne, telle, certes non; cependant elle répond ainsi plus à l'idée préconçue qu'à la réelle vision et d'une telle vérité, qu'il semble que la réalité se soit faite rêve pour nos illusions. Bretagne que l'on désire,

qu'autrefois l'on a espérée – landes perdues, maisons tristes, solitude, mélancolie.' Seguin 1891.

49. Letter to Daniel de Monfreid, 12 October 1897, Joly-Segalen 1950, p.113.

50. Letter from Daniel de Monfreid to Gauguin, ibid., 11 December 1902, pp.233–4.

Gauguin and the Opacity of the Other: The Case of Martinique
Tamar Garb pp.24–31

1. For a detailed discussion of this work and Gauguin's stay in general, see Pope 1981. For a comprehensive discussion of the Martinique pictures, see Wildenstein 2001, pp.317–48.

2. Mirbeau, 'P.G.', *L'Echo de Paris*, 16 February 1891, p.1.

3. For a discussion of Gauguin's relationship to Cézanne's brushmark, see Shiff 2004, pp.65–8.

4. The adulation of Gauguin's primitivism is represented by scholars such as John Rewald, in Rewald 1956, and Robert Goldwater, in *Primitivism in Modern Art*, New York 1966. But these ideas have been the subject of much debate. See, for example, Pollock 1992; Eisenman 1999; Solomon-Godeau 1989, and 'Dreams of Happiness, Chimeras of Pleasure; Polynesia in the French Visual Imaginary', in S. Eisenman, ed., *Paul Gauguin: Artist of Myth and Dream*, exh.cat., Complesso del Vittoriano, Rome, 2007–8, pp.69–80.

5. Despite his oft-repeated assertion that he was a 'savage' and wished to live like one, Gauguin also referred to himself repeatedly in his correspondence as a 'white man' and a 'European'. See, for example, his letter to his wife Mette from Martinique, 20 June 1887, in Merlhès 1984, p.155. On his self-mythologising as a 'savage', see his letter to Mette of c.22 January 1888 in ibid., p.170.

6. In conversation with Charles Morice at the end of 1890, he said: 'I had a decisive experience in Martinique. It was only there that I felt like my real self, and one must look for me in the works I brought back from there rather than those from Brittany, if one wants to know who I am.' ('L'expérience que j'ai faite à la Martinique est décisive. Là seulement je me suis senti vraiment moi-même, et c'est dans ce que j'en ai rapporté qu'il faut me chercher, si l'on veut savoir qui je suis, plus encore que dans mes oeuvres de Bretagne.') Morice 1920, p.88. Brettell 1988, p.60.

7. For the standard account of Martinique's place in Gauguin's stylistic development, see Wildenstein 2001, p.319. For the earliest reading of the works in these terms, see O. Mirbeau, 'Paul Gauguin', *Le Figaro*, 18 February 1891, p.2.

8. See Gauguin's letter to his wife Mette of late March 1887 in which he explains his motivation to travel, in Merlhès 1984, pp.147–8.

9. Ibid., p.147.

10. See Gauguin's letter from Panama to his wife Mette, 1 May 1887, in Merlhès 1984, p.151; letter to Émile Schuffenecker, 12 May 1887, p.152; and letter to Mette, 12 May 1887, p.153.

11. Glissant sees Gauguin's sojourn in Tahiti and Hearn's adoption of Japan as a function of this search for the 'authentic'. Glissant 1999, pp.84–5.

12. Although Hearn's sojourn in the Lesser Antilles in mid-1887 coincided with Gauguin's, there is no evidence that they actually met. For Hearn's account see *Two Years in the French West Indies* (1889), Milton Keynes 2006.

13. The novel of this name by Pierre Loti, published in 1880 and set on the island of Tahiti. For a discussion of the sexual fantasy of the tropics, see Peter Brookes, 'Gauguin's Tahitian Body', *Yale Journal of Criticism*, 3.2, 1990, pp.51–89.

14. F. Fénéon, 'Calendrier de décembre 1887', *La Revue indépendante*, January 1888, in Halperin 1970, pp.90–1.

15. C. Baudelaire, 'Plans' in *Paris Spleen and La Fanfarlo* (1869), trans. Raymond N. Mackenzie, Indianapolis/Cambridge 2008, p.48.

16. For a discussion of the construction of the 'tropics' in the European imagination, see Nancy Leys Stepan, *Picturing Tropical Nature*, London 2001.

17. See Van Gogh's letter to his sister Willemeen, 31 July 1888, no.653 (657 W 5) in vangoghletters.org. The painting referred to is *Au bord de la rivière*, 1887, Wildenstein 2001, cat.252, Van Gogh Museum, Amsterdam.

18. Of course, this search was belated and doomed. Even in Tahiti, Gauguin was to be confronted with a modern colonial settlement, not an idyllic island paradise. On the persistent construction of the Pacific Islands as primitive, see Nicholas Thomas, *Oceanic Art*, London 1995.

19. Hearn (1889) 2006, p.19. For accounts of the history and persistence of racialised thinking in France, see Todorov 1993; Peabody and Stovall 2003.

20. This was the title that he gave to one of the Volpini prints.

21. Letter to his wife Mette, 20 June 1887, in Merlhès 1984, pp.154–5.

22. Hearn 1890, p.40.

23. See Gauguin's letter to Émile Schuffenecker, July 1887, in Merlhès 1984, p.156.

24. For Gauguin's account of the impression that the locals made on him, see the previously cited letter to Schuffenecker, ibid., pp.156–7.

25. For a lengthy and suggestive account of the available masculine types that populated the island, see Hearn 1890, pp.151–2.

26. See Gauguin's letter to Mette, 20 June 1887, in Merlhès 1984, p.155.

27. See Hearn (1889) 2006, p.20. See also *Costumes de femmes: traditions vestimentaires en Martinique de 1870 à 1940*, Bureau du Patrimoine, Fort de France, Martinique, 1990.

28. Lafcadio Hearn devotes a whole chapter of his 'Martinique Sketches' to the mountain and its reputation as a forbidding and impenetrable presence which dominated the island and was feared by settlers and colonisers. See Hearn (1889) 2006, pp.142–63.

29. A number of scholars have suggested Japanese influence in these views. See, for example, the entry for *By the Sea* in Brettell 1988, p.80.

30. See his letters to his wife Mette and to Émile Schuffenecker, in Merlhès 1984, pp.157–63.

31. See Hearn (1889) 2006 for a discussion of its place in the landscape and in local legend, pp.151–3, and Hearn 1890 for its place in a story of the bravery and courage of the slave girl who puts herself in danger in order to protect her ward from its venomous bite.

32. See Glissant 1999, pp.161–2.

'Following the Moon': Gauguin's Writing and the Myth of the 'Primitive' *Linda Goddard* pp.32–9

1. Paul Gauguin, *Avant et après*, 1903, in Gauguin 1923, p.1.

2. See Paul Gauguin, *Le Sourire*, in Bouge 1952. Diderot (1773) 1951. The narrator of Diderot's *Jacques le fataliste et son maître* (first French edition 1796) also frequently addresses a 'reader', with the reminder that 'this is not a novel', Diderot 1951, p.505.

3. Paul Gauguin, letter to George-Daniel de Monfreid, October 1902, in Joly-Segalen 1950, p.192.

4. Paul Gauguin, 'Notes synthétiques', 1884–5, in Gauguin 1910, p.52.

5. For a comprehensive list of Gauguin's writings, see the bibliography in *The Art of Paul Gauguin*, exh.cat., National Gallery of Art, Washington DC 1988. Guérin 1974, 1990, includes excerpts from all the major manuscripts, but they are substantially abridged and their original order is not always respected.

6. Scholars have tended to privilege Gauguin's 1893 Draft MS of *Noa Noa* (J. Paul Getty Museum, Los Angeles) over the co-authored Louvre MS (Musée du Louvre, 1893–7), despite evidence of his commitment to this collaborative project. On the history of *Noa Noa*, see Wadley 1985, and Goddard 2008, pp.277–93.

7. Paul Gauguin, letter to André Fontainas, February 1903, in Malingue 1946, p.308.

8. Exceptions include Belinda Thomson, 'Paul Gauguin: Interpreting the Words', in Thomson 1993; Hobbs 2002, pp.173–82; Childs 2003, pp.70–87, and 'Catholicism and the Modern Mind: The Painter as Writer in Late Career', in Childs 2004, pp.223–42. See also Isabelle Cahn, 'Gauguin the Writer', notes accompanying the CD-Rom of *Ancien Culte mahorie*, *Noa Noa* (Louvre MS), and *Diverses choses*, published by the Réunion des Musées Nationaux on the occasion of the 2004 exhibition 'Gauguin-Tahiti: Studio of the Tropics' (Galeries Nationales du Grand Palais, Paris, and Museum of Fine Arts, Boston). Cahn says that, for Gauguin, writing was 'more than just a form of release, a secondary complement to his art; it was a major means of expression in its own right'.

9. Wadley 1985, p.101.

10. Wayne Andersen, introduction to *Paul Gauguin: The Writings of a Savage*, ed. Guérin 1990, p.xviii.

11. Jean Loize, 'Post-script: The Real *Noa Noa* and the Illustrated Copy', in Paul Gauguin, *Noa Noa: Voyage to Tahiti*, Oxford 1961, p.69.

12. Dorra 2007, p.21. Richard R. Brettell, 'Foreword: Henri Dorra and Paul Gauguin', in ibid., p.xiii.

13. Paul Gauguin, *Racontars de rapin*, 1902, in Guérin 1974, p.250.

14. 'Notes synthétiques de Paul Gauguin', Gauguin 1910, p.52.

15. Gauguin 1902, in Guérin 1974, p.253.

16. Paul Gauguin, *Avant et après*, 1903 (Copenhagen 1920), p.16; Paul Gauguin, *Diverses choses*, 1896–8, Musée du Louvre, Paris, RF 7259, pp.205–6 (the reference to 'childish things' is on p.206). Excerpts from *Diverses choses* appear in Guérin 1990, but their original order is not respected. The manuscript is held by the Musée du Louvre (http://arts-graphiques.louvre.fr) and is available on CD-Rom published by the Réunion des Musées Nationaux (see note 8).

17. Van Gogh enclosed this sketch in a letter to Gauguin, c.25 July 1888, Druick and Zeghers 2001–2, p.126. Vincent wrote to his brother Theo on 29 July 1888 that 'a mousmé is a Japanese girl – provençale in this case – aged between twelve and fourteen' (vangoghletters.org, letter 650).

18. Gauguin 1903 (Copenhagen 1920), p.16; *Le Sourire*, August 1899, ed. L.J. Bouge, Paris 1952, p.1.

19. Gauguin 1903 (Copenhagen 1920), p.71.

20. Paul Gauguin, 'Les Peintres français à Berlin', *Le Soir*, 1 May 1895, p.2. In this article Gauguin elected himself to speak on behalf of those artists not selected by the French jury to take part in the 1895 International Exhibition in Berlin, and noted the conspicuous absence of 'avant-garde writers' from the debate. Roger Marx's review, 'L'Exposition Paul Gauguin', appeared in *La Revue encyclopédique*, vol.4, no.76, 1 February 1894, pp.33–4.

21. Marx notes that Baudelaire and Gauguin both embarked on their travels at a young age, and describes Baudelaire's prose poem as a 'faithful herald of Gauguin's obsessions'. Accordingly, the passage quoted from 'Les Projets' includes images familiar from Gauguin's paintings and texts, such as 'by the seashore, a fine wood cabin, surrounded by all those bizarre, gleaming trees', and ends with the anti-materialist statement: 'Yes, truly, *there* is the décor I've been seeking. Why did I bother with palaces?', from Baudelaire (1869) 2008, p.48.

22. Gauguin 1896–8, pp.208–9. Gauguin's *Manuscrit tiré du livre des métiers de Vehbi-Zumbul Zahdi* is held by the Bibliothèque Nationale de France (NAF 14903 ff.43–6). He included the text, with variations, in *Cahier pour Aline* and *Avant et après* as well as in *Diverses choses*.

23. Gauguin 1896–8, pp.253, 224, 206.

24. Edgar Allan Poe, quoted in Gauguin 1896–8, p.213.

25. Richard Wagner, quoted in ibid., p.215; Gauguin 1903 (Copenhagen 1920), p.16.

26. Leonardo da Vinci, *Treatise on Painting* (*Codex Urbinas Latinus 1270*), c.1550, trans. A. Philip McMahon, Princeton 1956, vol.1, p.27.

27. Eugène Delacroix, cited in Gauguin 1896–8, p.221. Gauguin's source was Eugène Piron, *Delacroix, sa vie et ses oeuvres*, Paris 1865, pp.409–10.

28. 'Notes synthétiques de Paul Gauguin', Gauguin 1910, p.51.

29. Gauguin 1896–8, p.266/3. Gauguin quotes this line from Achille Delaroche, 'D'un point de vue esthétique: à propos du peintre Paul Gauguin', *L'Ermitage*, January 1894, pp.35–9.

30. Ibid., p.266/4.

31. Paul Gauguin, *Cahier pour Aline*, 1893, ed. Suzanne Damiron, Paris 1962, pp.30–2.

32. Jirat-Wasiutynski 1978, p.206.

33. Gauguin *Noa Noa*, in Wadley 1985, p.20.

34. 'A green next to a red does not yield a reddish brown as would the mixture of the two, but gives two vibrant notes instead. Next to that red put a chrome yellow . . . Instead of the yellow put a blue, and you'll find three different tones all vibrating because of each other.' Gauguin, 'Notes synthétiques' (1884–5), in Guérin 1996, pp.9–10.

35. Gauguin *Noa Noa*, in Wadley 1985, p.20; Gauguin 1896–7, p.266/4.

36. 'Notes synthétiques de Paul Gauguin', 1910, p.51.

37. Gauguin *Noa Noa*, in Wadley 1985, p.20. This recalls Edgar Allan Poe's comment, as paraphrased by Gauguin 1896–7, p.212, that 'If I was asked to give a brief definition of the word "Art", I would define it as the reproduction of what our senses perceive in nature, through the veil of the soul.'

38. Gauguin 1896–8, p.206.

39. Gauguin 1893, ed. Wadley, trans. Griffin, 1985, pp.12–13.

40. Ibid., p.42.

41. Ibid., p.20.

42. Ibid., p.32.

43. Childs 2001, p.70 n.55.

44. Pierre Loti, *The Marriage of Loti*, 1880, trans. Clara Bell, London 2002, pp.21–2, 43–6.

45. Gray 1963, p.163.

46. Paul Gauguin, letter to Mette Gauguin, October 1893, in Malingue 1946, p.249.

47. Hobbs 2002, p.175, asks whether we are right to 'give artists' writings special status and authority in attempts at exegesis of visual works of art'.

48. Gauguin 1896–8, p.346.

Gauguin's Politics
Philippe Dagen pp.40–7

1. 'J'y veux oublier tout le mauvais du passé et mourir là bas ignoré d'ici libre de peindre sans gloire aucune pour les autres'; 'Une terrible époque se prépare en Europe pour la génération qui vient: le royaume de l'or. Tout est pourri, et les hommes et les arts. Il faut se déchirer sans cesse . . . Pendant qu'en Europe les hommes et les femmes n'obtiennent qu'après un labeur sans répit la satisfaction de leurs besoins, pendant qu'ils se débattent dans les convulsions du froid et de la faim, en proie à la misère, (les) Tahitiens au contraire, heureux habitants des paradis ignorés de l'Océanie, ne connaissent de la vie que les douceurs.' Paul Gauguin, 'A J.F. Willumsen', in Guérin 1974, pp.67–8. The much-abridged manuscript published by Daniel Guérin gives the source of these assertions: 'conference on Tahiti Van der Veene'. This is incorrect because, as Belinda Thomson has established, these thoughts on the island and its way of life derive in fact from a text by E. Raoul, *Tahiti*, published in 1889 as part of a series on the French colonies directed by Louis Henrique and published on the occasion of the Universal Exhibition, where the 'marvels' of these colonies were widely presented to the visitor. The text includes the following phrase: 'Whilst on the other side of the earth, men and women obtain only after relentless labour . . .'. Gauguin copies exactly the words that follow. I would like to thank Belinda Thomson for giving me this information. For an example of the refusal to read these lines politically, see Cachin, 1988. She prefers to find 'the mythical theme of Western decadence' (p.137).

2. 'L'Angélus n'existait plus. Il disparaissait avec l'or dont on venait de payer sa rançon . . . Il n'y avait plus d'art, il n'y avait plus de France, plus même d'Amérique. Il n'y avait plus que des tas d'or et autour de ces tas d'or des yeux luisants de convoitise ou des échines courbées de respect.' O. Mirbeau, 'L'Angelus', *L'Echo de Paris*, 9 July 1889; in Mirbeau 1993, vol.1, p.389.

3. 'payer une œuvre de peinture cinq cent mille francs, quelle que soit cette œuvre, est une chose monstrueuse . . . un défi barbare porté à la résignation du travail et de la misère, un outrage à la beauté de la mission de l'artiste . . .' (ibid., p.389).

4. 'Vous êtes seul à avoir compris que vouloir assigner un prix réel, en argent, à une œuvre d'art, fût-ce un demi million, c'est l'insulter' (ibid., p.389 n.12).

5. 'les prix très doux de cinq cents et quelques mille francs', 'Qui trompe-t-on ici ?', *Le Moderniste illustré*, 27 September 1889; Guérin 1974, p.54.

6. 'On ne peut suivre, en même temps, un rêve et le cours de la rente, s'émerveiller à d'idéales visions, pour retomber, aussitôt, de toute la hauteur d'un ciel, dans l'enfer des liquidations et des reports. M. Gauguin n'hésite plus. Il abandonne la Bourse, qui lui faisait facile la vie matérielle, et il se consacre tout entier à la peinture, malgré la menace des lendemains pénibles . . .' Octave Mirbeau, 'Paul Gauguin', *L'Echo de Paris*, 16 February 1891; Mirbeau 1993, vol.1, p.420.

7. 'nous sommes dans un temps où l'art pur ne rapporte que souffrances et déceptions à ceux qui en ont le culte; et la vie a des exigences immédiates, implacables'. Octave Mirbeau, 'Paul Gauguin', *Le Figaro*, 18 February 1891; Mirbeau 1993, vol.1, pp.425–6.

8. And this despite the friendship between Gauguin and Pissarro during this period and Pissarro's political convictions.

9. 'C'est une fille de nos jours, et une fille qui ne pose pas pour la galerie, qui n'est ni lascive, ni minaudière, qui s'occupe tout bonnement à repriser ses nippes.' Huysmans 1975, p.214.

10. See on this subject Delouche 1988.

11. 'deux pauvresses'. Letter to Emile Bernard, in Merlhès 1984, p.173. The term 'pauvresses' is also used by him for the titles of his paintings entrusted to Étienne Boussod (Gauguin, Réunion des Musées Nationaux, Paris 1989, p.172). See on this subject Dagen 1998, p.72.

12. 'A la prison coloniale, à l'hôpital colonial, toujours ces mots "combien?". Selon le poids de ton escarcelle, tu es classé soldat, sergent, officier . . . Puis la mort vous surprendra, vous prendra: selon le poids de votre escarcelle on vous donne un beau linceul blanc, un morceau de toile grise, une loque infecte . . .'. 'A la Martinique', *Le Sourire*, Septembre 1899; Guérin 1974, pp.233–4.

13. 'Les hordes civilisées arrivent et plantent leur drapeau: le sol fertile devient stérile, les rivières se dessèchent; non plus une fête perpétuelle, mais la lutte pour la vie, et le travail incessant.' 'Doux progrès', *Les Guêpes*, 12 January 1900; Guérin 1974, p.243.

14. This point is dealt with in depth in Dagen 1998, pp.79–92.

15. 'J'ai connu la misère extrême, c'est-à-dire avoir faim, avoir froid et tout ce qui s'ensuit . . . Mais ce qui est terrible dans la misère, c'est l'empêchement au travail, au développement des facultés intellectuelles. A Paris surtout, comme dans les grandes villes, la course à la monnaie vous prend les trois quarts de votre temps, la moitié de votre énergie.' Paul Gauguin, *Cahier pour Aline*, Paris 2009, p.28.

16. 'Il faudrait supprimer la bourse, tout l'agiotage, pour cette morale. Et cependant cette bourse et cet agiotage sont les pivots de notre existence financière. Sans eux, la société moderne ne pourrait marcher.' Ibid., pp.47–8.

17. 'Les démocrates, banquiers, ministres, critiques d'art prennent des airs protecteurs et ne protègent pas, marchandent comme des acheteurs de poisson dans la halle. Et vous voulez qu'un artiste soit républicain! . . . Si l'artiste ne peut vivre, donc la société est criminelle et mal organisée.' Ibid., pp.38–9.

18. 'Intuitivement, d'instinct, sans réflexion, j'aime la noblesse, la beauté, les goûts délicats et cette devise d'autrefois: "Noblesse oblige." J'aime les bonnes manières, la politesse même de Louis XIV. Je suis donc d'instinct et sans savoir pourquoi ARISTO.' 'Comme artiste. L'art n'est que pour la minorité, lui-

même doit être noble. Les grands seigneurs seuls ont protégé l'art, d'instinct, de devoir, par orgueil peut-être. N'importe, ils ont fait faire de grandes et belles choses. Les rois et les papes traitaient un artiste pour ainsi dire d'égal à égal.' Ibid.

19. 'Les grands monuments ont été faits sous le règne des potentats. Je crois que les grandes choses aussi ne seront faites qu'avec des potentats.' Ibid., p.32.

20. 'Il y avait un roi de moins et, avec lui, disparaissaient les derniers vestiges d'habitudes maories. C'était bien fini: rien que des civilisés. J'étais triste: venir de si loin pour . . .' Noa Noa; Guérin 1974, p.104.

21. 'Ainsi nous assistons à ce triste spectacle qui est l'extinction de la race en grande partie poitrinaire, les reins inféconds et les ovaires dévorés par le mercure. Voyant cela, je suis amené à penser, rêver plutôt, de ce moment où tout était absorbé, endormi, anéanti dans le sommeil du premier âge, en germes.' Paul Gauguin, Avant et après, new edition, Tahiti 1989, p.77. And further on: 'Bien des choses étranges et pittoresques ont existé autrefois mais aujourd'hui il n'y a plus de traces, tout a disparu. La race disparaît chaque jour disséminée par des maladies européennes . . .' ('Many strange and picturesque things existed in the past but today there no more traces, everything has disappeared . . .'). Ibid., p.163.

22. It is probable that this exploitation was less visible at the time in colonies such as Tahiti –which was far away and had minimal land or mining resources – than in the African or Asiatic colonies of the European states – Belgium, France and Great Britain mainly – which considered territories and populations as natural resources.

23. Avant et après, Gauguin 1989, p.119.

24. Ibid., p.121. His insistence on this point is clear from his descriptions of a childhood spent in a palace, with servants, horses and splendid relations. As early as the Cahier pour Aline he writes: 'Chez maman, la seule personne en habit quand on dînait, c'était le domestique et il ne comprenait pas ce qu'on disait; chez le gouverneur à Tahiti, la seule personne qui ne soit pas en habit, c'est le domestique et personne n'écoute les traits d'esprit du Taratata si ce n'est le domestique qui sourit. Comme tout change!' ('At my mother's, the only person dressed at dinner was the servant and he didn't understand what we were saying; at the governor of Tahiti's house, the only person not dressed for dinner was the servant and no one listens to Taratata's witticisms apart from the servant who smiles. How everything changes!') Taratata is a disparaging name for Governor Lacascade.

25. 'Ma cousine joueuse comme toutes les Péruviennes s'empressa d'aller jouer à la hausse sur l'emprunt péruvien dans la maison Dreyfus. Ce fut le contraire car quelques jours après, le Pérou était invendable. Elle but un bouillon de quelques millions.' ('My cousin, a gambler like all Peruvian women, hurried off to speculate on the Dreyfus Peruvian loan. The opposite happened because a few days later, Peru was un-saleable. She boiled a broth of a few millions.'). Ibid., p.124. Even more ironic, the Peruvian loan concerned the exploitation of guano, and was therefore a speculation on excrement.

26. 'Arriverai-je à retrouver une trace ce passé si lointain, si mystérieux? Et le présent ne me disait rien qui vaille. Retrouver l'ancien foyer, raviver le feu au milieu de toutes ces cendres. Et pour cela bien seul, sans aucun appui.' Noa Noa; Guérin 1974, p.104.

27. 'société moderne: . . . des êtres qui depuis la plus tendre enfance souffrent de la misère, du mépris des autres et à qui le prêtre offre pour tout dédommagement, toute consolation, l'absolution, le bonheur dans le paradis, tout cela garanti par l'Etat.' L'Esprit moderne et le catholicisme; Guérin 1974, p.211. Or again, 'Les missionnaires marchandaient volontiers . . . l'Evangile dans un main, le fusil de l'autre : l'Evangile pour leur Dieu, le fusil au nom de la civilisation d'Occident.' ('The missionaries willingly bargained . . . The Gospel in one hand, a gun in the other: The Gospel for their God, the gun in the name of Western civilisation.') Ibid., p.213.

28. 'à rebours de la vraie doctrine biblique et du Christ', L'Église catholique et les temps modernes, Guérin 1974, p.202.

29. 'dans une même répulsion le christianisme avec (l'Eglise) qui s'en disait l'identification, l'interprète traditionnel, privilégié, infaillible, alors qu'elle n'en était que contresens doctrinal et ne le pratiquait qu'à rebours', Guérin 1974, p.203.

30. 'je crois avoir atteint dans les figures une grande simplicité rustique et superstitieuse'. Letter from Gauguin to Vincent van Gogh, September–October 1888, in Merlhès 1984, p.232.

31. Letter from Gauguin to Émile Schuffenecker, 8 October 1888; ibid., p.248.

The Last Orientalist: Portrait of the Artist as Mohican
Vincent Gille pp.48–55

1. Letter from Gustave Flaubert to Louis Bouilhet, written from Egypt, 22 June [1850], in Steegmuller 1980, p.118.

2. Victor Hugo's preface to Les Orientales, Paris 2000, p.52. See Gille 2010.

3. 'Ce livre inutile de pure poésie'.

4. 'Dans le poème narratif, le romantisme, parce qu'il récuse les modèles anciens, parce qu'il en découvre de nouveaux dans ce qu'il appelle naïvement la "tradition populaire", pratique des recherches jusque là inimaginables et dans la construction de l'histoire et dans celle du récit.' Jean-Louis Backès, Le Poème narratif dans l'Europe romantique, Paris 2003, p.28.

5. Paul Gauguin, letter to Mette, February 1888, in Malingue 1946, no.LXI, p.126.

6. 'J'aime la Bretagne. J'y trouve le sauvage, le primitif. Quand mes sabots résonnent sur ce sol de granit, j'entends le ton sourd, mat, puissant que je cherche en peinture.' Paul Gauguin, letter to Émile Schuffenecker, February 1888, in Merlhès 1989, p.63.

7. 'Les mannequins d'hommes et de femmes qui ornent cet intérieur sont revêtus de costumes contemporains très complets, dont plusieurs, naguère très répandus, sont en voie de disparaître. A côté de cet ensemble, l'ethnographie est représentée par d'autres costumes, parmi lesquels une riche parure de mariée, ornée de paillettes; par des bonnets de baptême, très curieux, des coiffures, etc.' Paul Sébillot, quoted by Nelia Dias, Le Musée d'ethnographie du Trocadéro (1878–1908), Paris 1991, p.189.

8. 'un paradis perdu de la poésie, qui est le lieu de toute lumière et de toute simplicité.' Backès 2003, p.90.

9. 'Je crois avoir atteint dans les figures une grande simplicité rustique et superstitieuse.' Paul Gauguin, letter to Vincent van Gogh, 25–27 September 1888, in Correspondance, ed. Merlhès 1984, no.165, p.232.

10. From this journey, we also have a notebook that can be compared to the Noa Noa manuscript journal. See the reproductions and transcription of Carnet du Caire in Gérard de Nerval, Oeuvres complètes, eds. Claude Pichois and Jean Guillaume, vol.II, Paris 1984, pp.843–63.

11. Claude Pichois, notes on the Voyage en Orient in ibid., p.1,376.

12. There are two sources: on the one hand a ceremony described by Edward Lane in his book Account of the Manners and Customs of the Modern Egyptians, 1836, and on the other hand a plate from Voyage pittoresque de la Syrie, de la Phoenicie et de la Palestine by Louis-François Cassas: 'It was a wedding, there was no mistake. I saw in plates, in plates engraved by citizen Cassas, a complete picture of these ceremonies.' Gérard de Nerval, Oeuvres complètes, eds. Pichois and Guillaume, Paris 1984, p.264.

13. See, for example, the description of Manao Tupapau: L'Esprit des morts veille introduced in Noa Noa with these words: 'Et je vis sur le lit . . .' See Paul Gauguin, Noa Noa, Paris 1966, p.37.

14. Nerval, Voyage en Orient, vol.II, Paris 1984, p.515. We also note that these narrator's thoughts appear at a point in the journey where he has just fallen in love with a 'young Arab girl'. 'I have to unite myself with some simple girl from this sacred soil which is the first fatherland of us all, I have to soak myself in the vivifying sources of humanity from which flowed the poetry and beliefs of our fathers!', writes Nerval (p.506).

15. 'La vie de tous les jours – Tehamana se livre de plus en plus. Docile, aimante; le no noa tahitien embaume tout. Moi je n'ai plus conscience du jour et des heures, du Mal et du Bien.' Gauguin, Noa Noa, Paris 1966, p.36.

16. 'Adieu, sol hospitalier. Je partis avec deux années de plus – rajeuni de vingt ans, plus barbare et cependant plus instruit.' ibid., p.45.

17. 'Là à Tahiti je pourrai, au silence des belles nuits tropicales, écouter la douce musique murmurante des mouvements de mon cœur en harmonie amoureuse avec les êtres de mon entourage. Libre enfin, sans souci d'argent et je pourrai aimer, chanter et mourir.' Paul Gauguin, letter to Mette, February 1890, ed. Malingue 2003, letter C, p.207.

18. 'course vers le pays du soleil, vers le berceau de l'humanité, c'est-à-dire vers l'Orient, pour se baigner dans la source même des mystères de la création et de l'éternité, pour pouvoir renaître sous le signe du soleil'. Hasan Ananmur, 'L'Orientation solaire du Voyage en Orient de Gérard de Nerval', Orients littéraires: mélanges offerts à Jacques Huré, Paris 2004, p.19.

19. On this issue see Vincent Gille, 'Illusion of Sources – Sources of Illusion: Rousseau Through the Images of His Time' in Henri Rousseau: Jungles in Paris, ed. Frances Morris, exh.cat., Tate Modern, London 2005, pp.49–63.

20. 'C'est une féerie. Mais une féerie sans pareille. Toutes les couleurs, toutes les formes de monuments sont là pour vous charmer . . . Ce ne sont que dômes, clochetons, minarets, tours. Il règne sur cet ensemble une sorte de joie sans pareille. Les yeux ne savent pas où se fixer tant ils sont sollicités de toute part, et l'on est tenté de courir au plus brillant, sans plus savoir où il est. On marche dans un rêve.' Camille Debans, Les Coulisses de l'exposition pratique et anecdotique, Paris 1889, p.311.

21. Maybe this is where Gauguin found his taste for the unexpected associations that we sometimes find in his work.

22. 'Vous avez eu tort de ne pas venir. Dans le village de Java, il y a des Hindous. Tout l'art de l'Inde se trouvent là et les photographies que j'ai du Cambodge se retrouvent là textuellement.' Paul Gauguin, letter to Émile Bernard, undated [but datable to May 1889], ed. Malingue 1946, no.LXXXI, p.157.

23. 'Sous un ciel sans hiver, sur une terre d'une fécondité merveilleuse, le Tahitien n'a qu'à lever le bras pour cueillir sa nourriture – aussi ne travaille-t-il jamais . . . Pendant qu'en Europe les hommes et les femmes n'obtiennent qu'après un labeur sans répit la satisfaction de leurs besoins, pendant qu'ils se débattent dans les convulsions du froid et de la faim, en proie à la misère, tahitiens, au contraire, heureux habitants des paradis ignorés de l'Océanie, ne connaissent de la vie que les douceurs. Pour eux, vivre c'est chanter et aimer (conférence sur Tahiti de Van der Veene).' Paul Gauguin, letter to Jens-Ferdinand Willumsen, Summer 1890.

24. Edited by Louis Henrique, Les Colonies françaises, vol.IV, Colonies et protectorats de l'océan pacifique,

Paris 1889, p.25. The quotation follows extracts from a *Conférence sur Tahiti* by M. Théophile Van der Veene. The long quote was in fact taken from E. Raoul's book, *Tahiti*. Gauguin muddled the footnotes.

25. He only thinks of going to French territories or colonies: Martinique, Madagascar, Tahiti.

26. 'Puisse venir le jour (et peut-être bientôt), où j'irai m'enfuir dans les bois sur une île de l'Océanie, vivre là d'extase, de calme et d'art. Entouré d'une nouvelle famille, loin de cette lutte européenne après l'argent.' Paul Gauguin, letter to Mette, February 1890, ed. Malingue 1946, letter C, p.184.

27. Delacroix went to Morocco in 1832 as part of a diplomatic mission; Prosper Marilhat accompanied a scientific mission; Louis Garneray, Alexandre Decamps and Horace Vernet followed military expeditions. According to the official order from the French government, Gauguin's mission consisted in 'studying from the point of view of art and painting in order to understand the customs and landscape of this country'.

28. 'Quand je reviendrai, j'aurai de quoi fournir à la clientèle . . . Je sens que je commence à posséder le caractère océanien et je puis assurer que ce que je fais ici n'a été fait par personne et qu'on ne connaît pas en France cela.' Paul Gauguin, letter to Mette, June 1892, in Malingue 1946, no. CXXIX, p.227.

29. Je t'écris ce soir. Ce silence de la nuit à Tahiti est encore plus étrange que le reste. Il n'existe que là, sans un cri d'oiseau pour troubler le repos . . . Les indigènes circulent souvent la nuit, mais pieds nus et silencieux. Toujours ce silence. Je comprends pourquoi ces individus peuvent rester des heures, des journées assis sans dire un mot et regarder le ciel avec mélancolie. Je sens que tout cela va m'envahir.' Paul Gauguin, letter to Mette, July 1891, in Malingue 1946, no.CXXVI, p.218.

30. 'Au bord de la mer, une belle case en bois, enveloppée de tous ces arbres bizarres et luisants dont j'ai oublié les noms . . . dans l'atmosphère une odeur enivrante, indéfinissable . . . autour de nous, au-delà de la chambre éclairée d'une lumière rose tamisée par des stores, décorée de nattes fraîches et de fleurs capiteuses.' Charles Baudelaire, 'Les Projets', in *Le Spleen de Paris: oeuvres complètes*, Claude Pichois, ed., Bibliothèque de la Pleiade, vol.I, Paris 1975, pp.314–15. This quotation from Baudelaire's poem, an extract from a press cutting, was stuck by Gauguin into *Diverses choses*, see fig.20.

31. See *Zoos humains*, Nicolas Blancel, Pascal Blanchard, Gilles Boëtsch, Eric Deroo, Sandrine Lemaire, eds., Paris 2004.

32. 'Le sol Tahitien devient tout à fait français, et petit à petit tout cet ancien état de choses va disparaître.' Paul Gauguin, letter to Mette, July 1891, in Malingue 1946, no.CXXVI, p.219.

33. 'En somme, l'Orient n'approche pas de ce rêve éveillé que j'en avais fait il y a deux ans, ou bien c'est que cet Orient-là est encore plus loin ou plus haut, j'en ai assez de courir après la poésie; je crois qu'elle est à votre porte, et peut-être dans votre lit. Moi je suis encore l'homme qui court, mais je vais tâcher de m'arrêter et d'attendre.' Gérard de Nerval, letter to Jules Janin, written on his return from his journey to the Orient, 'on the boat, near Malta', ('en mer, près de Malte') 16 November 1843, in *Oeuvres complètes: voyage en Orient*, vol.II, Paris 1989, p.1,407.

34. 'Mon centre artistique est dans mon cerveau.' Paul Gauguin, letter to Mette, March 1892, ed. Malingue 1946, letter CXXVII, p.221.

35. 'L'expérience que j'ai faite à la Martinique est décisive. Là seulement je me suis senti vraiment *moi-même*, et c'est dans ce que j'en ai rapporté qu'il faut me chercher, si l'on veut savoir qui je suis, plus encore que dans mes œuvres de Bretagne.' Reported by Charles Morice, in *Gauguin*, Paris 1920, p.88.

36. 'ce que je désire, c'est un coin de moi-même encore inconnu', Paul Gauguin, letter to Émile Bernard, August 1889, ed. Malingue 1946, letter LXXXIV, p.163.

37. 'une des plus importantes richesses spirituelles que j'étais venu chercher à Tahiti', Paul Gauguin, *Noa Noa*, manuscript in the Louvre, Paris, fol.79 verso.

38. 'C'est que l'homme ne peut changer le fond de son cœur. Les objets extérieurs peuvent le distraire un moment, mais ce qui l'occupera sans cesse, ce qui se présentera sans cesse à lui, c'est son intérieur, ce sont les rêveries accoutumées de son âme. Après avoir été errant quelques moments hors de lui-même, il rentre pour ainsi dire dans son cœur.' François-René de Chateaubriand, 'Journal de Jérusalem', quoted by André Guyaux, 'Le Voyageur désabusé', in *Orients littéraires*, Paris 2004, pp.165–85.

39. 'J'apprends que M. Paul Gauguin va partir pour Tahiti. Son intention est de vivre là plusieurs années, seul, d'y construire sa hutte, d'y travailler à neuf des choses qui le hantent. Le cas d'un homme fuyant la civilisation, recherchant volontairement l'oubli et le silence pour mieux se sentir, pour mieux écouter les voix intérieures qui s'étouffent au bruit de nos passions et de nos disputes m'a paru curieux et troublant . . .'. Octave Mirbeau, 'Paul Gauguin', *Echo de Paris*, 16 February 1891.

40. 'la difficulté de gagner *régulièrement* ma vie malgré ma réputation, mon goût pour l'exotique aidant, m'ont fait prendre une détermination irrévocable . . . Je repars pour l'Océanie . . . Rien ne m'empêchera de partir et ce sera pour toujours. Quelle bête existence que l'européenne vie [sic].' Paul Gauguin, letter to William Molard, September 1894, ed. Malingue 1946, no.CLII, p.260.

41. 'depuis mon projet de m'enterrer aux îles du Pacifique', Paul Gauguin, letter to Maurice Denis, March 1895, ed. Malingue 1946, no.CLVII, p.267.

42. 'Je suis en train d'organiser ma vie pour me désintéresser de plus en plus de la peinture, me retirer, comme on dit, de la scène en faisant des travaux d'écriture à Tahiti soit avec un peu d'agriculture sur mon terrain.' Paul Gauguin, letter mistakenly described as being to Emmanuel Bibesco, May 1900, ed. Malingue 1946, no.CLXXIII, p.295. In fact the recipient was the dealer A. Vollard and the date Jan. 1900. See Rewald 1986, pp.189–92.

43. 'Je suis à terre aujourd'hui, vaincu par la misère et surtout la maladie d'une vieillesse tout à fait prématurée. Aurai-je quelque répit pour terminer mon œuvre, je n'ose l'espérer? En tout cas je fais un dernier effort en allant le mois prochain m'installer à Fatuiva, île des Marquises presqu'encore anthropophage. Je crois que là, cet élément tout à fait sauvage, cette solitude complète me donnera avant de mourir un dernier feu d'enthousiasme qui rajeunira mon imagination et fera la conclusion de mon talent.' Paul Gauguin, letter to Charles Morice, July 1901, ed. Malingue 1946, no.CLXXIV, p.300.

44. Note the difference that exists between, for example, certain photos of Tahitian men and women by Charles Spitz (e.g. fig.38), Henri Lemasson or Hoare, which the ethnologists classify under the title 'Types and costumes', and the works they inspired Gauguin to paint.

45. 'L'étoile route et le Désir d'Orient – l'Europe . . . – le rêve se réalise – Les mers – souvenirs débrouillés à travers . . . Les hommes m'ont fait souffrir – Climat où ma tête repose – Amours laissés dans un tombeau – Elle, je l'avais perdue – . . . – Vaisseau d'Orient'. Gérard de Nerval, *Carnet du Caire*, in *Oeuvres complètes*, eds. Pichois and Guillaume, vol.I, Paris 1984, p.853.

46. 'L'idole est là non comme une explication littéraire, mais comme une statue, moins statue peut-être que les figures animales; moins animale aussi, faisant corps dans mon rêve, devant ma case, avec la nature entière, régnant *en notre âme primitive*, consolation imaginaire de nos souffrances en ce qu'elles comportent de vague et d'incompris devant le mystère de notre origine et de notre avenir.' Paul Gauguin, letter to André Fontainas, March 1899, ed. Malingue 1946, no.CLXX, pp.288–9.

47. The critic of *L'Escarmouche* reproached him in 1893 for not being a real Tahitian painter: 'This travesty of a civilised man who masters his paintbrush so well makes us smile . . . we await the arrival in Paris of a real Tahitian painter who lives at the jardin d'acclimatation whilst his paintings are shown at Durand-Ruel's. A real Maori in fact!' ('Ce travesti d'un civilisé très maître de son pinceau nous fait sourire . . . nous attendons l'arrivée à Paris d'un vrai peintre tahitien qui, tandis que son œuvre sera chez Durand-Ruel ou ailleurs, logera au jardin d'acclimatation. Un vrai maorie. Quoi!'). *L'Escarmouche*, 19 November 1893. The article is pasted into Paul Gauguin's *Cahier pour Aline*.

48. 'Vous êtes actuellement cet artiste inouï, légendaire, qui du fond de l'Océanie envoie des oeuvres déconcertantes, inimitables, oeuvres définitives d'un grand homme pour ainsi dire disparu du monde . . . Bref, vous jouissez de l'immunité des grands morts, vous êtes passé dans l'Histoire de l'art.' Letter from George-Daniel de Monfreid to Paul Gauguin, 11 December 1902, in Joly-Segalen 1950, p.233.

49. 'Pas plus tard que cette nuit j'ai rêvé que j'étais mort et chose curieuse, c'était le moment vrai où je vivais heureux.' Paul Gauguin, *Avant et après*, reprinted in Guérin 1974, p.341.

Gauguin and Segalen: Exoticism, Myth and the 'Aesthetics of Diversity'
Charles Forsdick pp.56–63

1. For an introduction to Segalen, see Charles Forsdick, *Victor Segalen and the Aesthetics of Diversity: Journeys between Cultures*, Oxford 2000, and also Marie Dollé, *Victor Segalen: le voyageur incertain*, Croissy-Beaubourg 2008, and Gilles Manceron, *Segalen*, Paris 1992.

2. See James Clifford, 'A Poetics of Displacement: Victor Segalen', in *The Predicament of Culture: Twentieth-Century Ethnography, Literature and Art*, Cambridge, MA 1988, pp.152–63 (p.152).

3. Clifford 1988, p.152.

4. Victor Segalen, *Oeuvres complètes*, ed. Henry Bouillier, 2 vols, Paris 1995. These were published by Laffont and follow this pattern of cycles to structure Gauguin's works.

5. Gauguin inspired Segalen's first published literary work, the 1904 *Mercure de France* article entitled 'Gauguin dans son dernier décor', and he continued writing about the artist until his death in 1919. At the request of George-Daniel de Monfreid, he drafted an introduction to a new edition of *Noa Noa*, but this did not appear as a result of the First World War; Gauguin was also the subject of one of his final works, 'Hommage à Gauguin', published as the preface to a collection of letters from the artist to de Monfreid in 1918. (Segalen completed correction of the proofs of this work in January of that year, while he was still in China, recruiting Chinese workers to serve on the Western Front.)

6. David Sweetman, *Paul Gauguin: A Complete Life*, London 1995, p.539.

7. Victor Segalen, *Correspondance I, 1893–1912*, ed. Henry Bouillier, Paris 2004, p.527. Unless otherwise stated, all translations are my own.

8. On Gouzer, see Manceron 1992, pp.159–60, and Sweetman 1995, pp.443–4.

9. Victor Segalen, 'Hommage à Gauguin', *Oeuvres complètes*, Paris 1995, vol.I, pp.349–73.

10. Sweetman 1995, p.539.

11. For a discussion of these texts and their respective fates, see Manceron 1992, pp.162–4.

12. The original *Cahier* is now in the Bibliothèque de l'INHA (collections Jacques Doucet; mss.227). A facsimile was published in two volumes by the Société des amis de la Bibliothèque d'art et d'archéologie de l'Université de Paris in 1963. A copy is available online at: http://www.inha.fr/.

13. Victor Segalen, *Les Immémoriaux*, Paris 1907. For an English version, see *Lapse of Memory*, trans. Rosemary Arnoux, Brisbane 1995. Gilles Manceron recounts how Segalen heard the genealogical narrative with which the novel begins at Paul Vernier's house on Hiva-Oa. See Manceron 1992, pp.170–1.

14. Segalen's basic monthly salary was 243 francs and 90 centimes, of which his purchases at the auction amounted to 188 francs and 95 centimes.

15. Manceron 1992, p.185.

16. Segalen, 'Hommage à Gauguin', p.371. See also G. Wildenstein, 'Inventaire des biens' and 'Vente' in *Gauguin, sa vie, son oeuvre: documents inédits*, Paris 1958, pp.201–9.

17. These expressions are used in a letter (August 1903) to Louise Ponty, a friend of Segalen's from Bordeaux and cousin of philosopher Maurice Merleau-Ponty, Victor Segalen, *Correspondance I, 1893–1912*, pp.534–5.

18. Segalen purchased only four of these, with the fifth being acquired by an unknown bidder; it was only in 1990 that the set was reunited when the Musée d'Orsay acquired the fifth panel and was able to add it to those purchased by the French state from the Segalen family in 1952. For a detailed account of the auction, see Manceron 1992, pp.183–91. Details of the lots dispersed are included in H. Jacquier, 'Le Dossier de la succession Paul Gauguin', *Bulletin de la société des études océaniennes*, vol.120, 1959, pp.673–711.

19. Segalen, 'Hommage à Gauguin', p.373.

20. Victor Segalen, *Journal des îles*, in Bouillier 1995, pp.396–479 (p.429).

21. Sweetman 1995, p.539.

22. Arsène Alexandre was the first to suggest in 1930 that the picture had in fact not been painted in the Pacific but in Brittany, and subsequent scientific analyses of Gauguin's palette have proved that Segalen's hypothesis of a nostalgic artist longing for a snow-covered landscape was flawed; meteorological studies suggest that it seems most likely that the canvas was painted in 1889 or 1890. See Mauricette Berne, ed., *Victor Segalen: voyageur et visionnaire*, Paris 1999, p.50.

23. Victor Segalen, 'Gauguin dans son dernier décor', in *Oeuvres complètes*, ed. Bouillier 1995, vol.I (p.291).

24. Letter from Segalen to Jules de Gaultier, 18 October 1907, *Correspondance I, 1893–1912*, ed. Bouillier 2004, p.717.

25. Stephen F. Eisenman, *Gauguin's Skirt*, New York 1997, p.195.

26. Segalen 1995, vol.I, pp.361–2.

27. Letter from Segalen to George-Daniel de Monfreid, 12 April 1906, *Correspondance I, 1893–1912*, ed. Bouillier 2004, p.660.

Gauguin: A Very British Reception
Amy Dickson pp.64–9

1. Bullen Introduction, in J.B. Bullen, ed., *Post-Impressionists in England: The Critical Reception*, London 1988, p.14.

2. Fry's letter to his father, 24 November 1910, reproduced in Sutton Denys, *Letters of Roger Fry*, 1972, quoted in Anna Gruetzner Robins, *Modern Art in Britain 1910–1914*, London 1997, p.15.

3. Robert Ross, 'The Post-Impressionists at the Grafton: The Twilight of the Idols', *Morning Post*, 7 November 1910, three reviews reproduced in Bullen 1988, p.100.

4. Gruetzner Robins 1997.

5. Spencer Frederick Gore, 'Cezanne, Gauguin, Van Gogh &c., at the Grafton Galleries', in Bullen 1988, p.141.

6. *Manao tupapau* was listed in the 'Manet and the Post-Impressionists' catalogue as *L'Esprit Veille*.

7. 'Manet and the Post-Impressionists' catalogue, London 1910, and Gruetzner Robins 1997, p.28.

8. Unsigned review 'Paint Run Mad' in *Daily Express*, 9 November 1910 in Bullen 1988, pp.105–6.

9. J.B. Bullen, 'Great British Gauguin: His Reception in London in 1910–11', in *Apollo*, October 2003, p.4.

10. Gruetzner Robins 1997, p.29.

11. Gruetzner Robins makes this observation in Gruetzner Robins 1997, p.29.

12. C. Lewis Hind, *The Post-Impressionists*, London 1911, quoted in Gruetzner Robins 1997, p.29.

13. Laurence Binyon, 'Post Impressionists', *Saturday Review*, 12 November 1910, pp.609–10, in Bullen 1988, p.112.

14. Julius Meier-Graefe, *Modern Art: Being a Contribution to a New System of Aesthetics*, 1904 (trans. London 1908), p.63.

15. Joly-Segalen 1950, XLII, April 1898, pp.122–3, cited in Gloria Groom, 'Chronology: July 1895–November 1903', in *The Art of Paul Gauguin*, exh. cat., Chicago 1988, p.382.

16. Joly-Segalen 1950, pp.122–3.

17. M. Fayet se trouve en relations avec un écrivain qui va faire une étude sur vous (et sur d'autres artistes, je crois, tels que Degas, Renoir, etc. . .) Meier-Graef [sic], si je ne me trompe. Il va peut-être publier dans son livre votre manuscript primitivement destiné au "Mercure de France". Je verrai cela de près et vous tiendrai au courant, de toute façon.' Joly-Segalen 1950, p.241. The text to which he refers was probably *Racontars de rapin*, which Gauguin sent to Fontainas in September 1902.

18. Britt Salvesen, *Artists In Focus: Gauguin*, The Art Institute of Chicago, 2001, p.8.

19. Unsigned Review, 'An Art Victory: Triumphant Exit of the Post-Impressionists', *Daily Graphic*, 16 January 1911, p.15, in Bullen 1988, p.184.

20. J.B. M[anson], 'The Paintings of Cézanne and Gauguin' in *Outlook*, 2 December 1911, pp.785–6 in Bullen 1988, p.245.

21. Nicola Morby identified the figures in *Gauguin and Connoisseurs* in her catalogue entry no.2 in Robert Upstone (ed.), *Modern Painters : The Camden Town Group*, exh. cat. Tate, London 2008.

22. Sadler's notes from a conversation on 27 September 1911 with John Nevill, the new director of the Stafford Gallery, suggest that the 1911 exhibition was his son Michael's idea: 'I urged him [Nevill] (following up Michael's previous suggestion to him) to have next November a small carefully selected exhibition of fine pictures by Gauguin and Cézanne at his Gallery.' Conversation with Mr John Nevill, Stafford Gallery – Michael Sadler Archive/TGA 8221.5.23, as referred to by Frances Fowle in her essay, 'Following the Vision: From Brittany to Edinburgh', in Thomson 2005, p.108.

23. My thanks to Belinda Thomson for drawing my attention to these.

24. Bullen has argued that too much emphasis has been placed on the 1910 exhibition.

25. Susan Stein, 'From the Beginning: Collecting and Exhibiting Gauguin in New York', in *Lure of the Exotic: Gauguin in New York Collections*, Yale 2002.

26. *Exposition Paul Gauguin Galerie Ambroise Vollard*, exhibition catalogue, Paris 1903; also in Gloria Groom's chronology in the Chicago catalogue, p.387.

27. *The Times*, 9 October 1906, paraphrased in Bullen 1988, pp.6–7.

28. *The International Society of Sculptors, Painters and Gravers Art Congress. The Catalogue of The Eighth Exhibition*, London 1908. *Haere-Pape, Tahiti* is listed as hanging in the 'balcony' and is item 410 in the catalogue. Roger Fry's response to the Burlington editorial, published in the March 1908 issue of the same publication, refers to two further Gauguins, '*Femmes Maories*' and '*Te Arti Vahine*' [sic]. As these were not included in the 1908 show or illustrated in Meier-Graefe's *Modern Art*, it seems most likely that Fry had seen these in the 1906 Paris exhibition.

29. Unsigned review (probably by Roger Fry), 'Modern French Pictures at Brighton', in *The Times*, 11 July 1910, p.12, in Bullen 1988, pp.89–90.

30. Henry McBride, 'Gauguin's Rebirth', *The Dial*, vol.69, July–December 1920, pp.397–400, quoted in Stein 2002, p.161.

31. Maugham and O'Conor frequented the Chat Blanc in Montparnasse at this date, together with a large Anglophone group of artists – Gauguin was one of the artists they most admired.

32. W. Somerset Maugham, *Of Human Bondage*, in the Modern Library Paperback edition, 1999, chapter 44, p.370.

33. Frances Fowle, 'Following the Vision: From Brittany to Edinburgh', in Thomson 2005, p.108.

34. Edward Marsh, *The Collected Poems of Rupert Brooke: With a Memoir*, 1918, p.civ. Belinda Thomson drew my attention to this.

35. Richard Albert Cordell, *Somerset Maugham, A Writer for all Seasons*, London 1962.

36. Meier-Graefe 1908, p.63.

37. W. Somerset Maugham, *The Moon and Sixpence*, London 1919, reprinted 1999, p.1.

38. Letter to Mette, Tahiti, c. March 1892, in Malingue 1946, CXXVII, p.223.

39. J. David Macey Jr. makes the case for multiple narrators in his essay 'Fantasy as Necessity: The Role of the Biographer in *The Moon and Sixpence*', *Studies in the Novel*, vol.29, 1997, available online.

40. Unsigned review in *The Guardian*, 2 May 1919.

41. Screenplay for *The Moon and Sixpence*, 1943.

42. Robert Hughes, *Time*, 22 March 1971.

43. W. Somerset Maugham, *The Moon and Sixpence*, London 1919, reprinted 1999, p.3.

Plate Section Introductions

Identity and Self-Mythology pp.70–91

1. Contrary to the findings of the catalogue raisonné authors (Wildenstein 2001, cat.23), I agree with the curators of the Fogg Art Museum that this is a self-portrait.

2. Conventionally posed, this photograph, by a firm of Danish photographers possibly related to Mette and proud of their Paris accreditation, 'Julie Laurberg and Gad', shows Mette seated and Gauguin in debonair pose behind her, leaning on a couple of weighty tomes. Repr. Wildenstein 2001, p.596.

3. According to Druick and Zegers et al., exh.cat. *Van Gogh and Gauguin: The Studio of the South*, The Art Institute of Chicago and the Van Gogh Museum, Chicago, IL, 2001, pp.362–3.

4. See Druick and Zegers, idem, pp.257–68, and P. Dagen, 'Têtes coupées, Gauguin lecteur de Villiers de l'Isle-Adam', in *Gauguin, actes du colloque*, La Documentation française, Paris 1991, pp.213–25.

5. Letter from Gauguin to Émile Bernard, datable to November/December 1889, Malingue 1946, CVI, pp.192–4 (misdated June 1890).

6. The *Self-Portrait as Severed Head* appears as a receptacle for flowers in *Still Life with Japanese Print*, 1889, Teheran Museum of Art.

7. Letter 817 from Gauguin to Vincent van Gogh, 10–13 November 1889, vangoghletters.org.

8. 'Soyez amoureuses et vous serez heureuses' is difficult to render in English: 'Be in love and you will be happy' or just 'Love and be happy' perhaps.

9. Both Gauguin's Impressionist mentors, Pissarro and Degas, remarked upon his inveterate appropriation of exotic sources, Pissarro less sympathetically than Degas.

10. Meijer de Haan's large painting *Uriel Dacosta*, now lost, which he exhibited in 1888, dealt with the tragic story of a seventeenth-century Jewish convert to Catholicism who had reverted to Judaism, events that led to his excommunication and eventual suicide. See exh.cat. *Meijer de Haan: le maître caché*, Amsterdam and Paris 2010, pp.26–31.

11. De Haan, according to a later witness, had brought a collection of reproductions of Quattrocento Italian art to Pont-Aven. Cf. Caroline Boyle-Turner in op. cit., p.89.

12. June Hargrove, in her article 'Gauguin's Maverick Sage', explores these various questions in depth, *Van Gogh Studies* 3, pp.87–111.

13. I am grateful to Jodi Hauptmann for communicating Arnaud Toussaint's discovery of the origin of this text. The transcribed passage dealing with prostitution in London comes from chapter VIII, pp.111–12.

14. This fragile little painting was the focus of a whole exhibition, 'Gauguin's "Nirvana", Painters at Le Pouldu, 1889–1890', Wadsworth Atheneum, Hartford, CT, 2001, and continues to fascinate art historians.

15. The name Hardy (a possible misspelling of Henry) is the first to appear on the provenance of *Nirvana*, a work one would expect de Haan to have kept himself.

16. De Haan's letter, dated 13 December 1889, is cited in full in exh.cat. *Meijer de Haan*, Amsterdam and Paris 2010, pp.136–7. In Gauguin's letters to Émile Bernard of July and September 1890, de Haan is included in their plans to go to Tahiti. See Malingue 1946, letters CVII and CXII, pp.196, 202.

17. Letter to Mette datable to January or February 1893, CXXXV, Malingue 1946, p.240.

18. Wildenstein 1964, cat.594.

Making the Familiar Strange
pp.92–109

1. See Richard R. Brettell and Anne-Birgitte Fonsmark, exh.cat. *Gauguin and Impressionism*, Kimbell Art Museum, Fort Worth, TX, and Ordrupgaard, Copenhagen 2005, cat.43, pp.244–6. Fonsmark states that Gauguin carved the whole box from a block of wood from start to finish.

2. The importance of the ceramics for Gauguin's development of a synthetist style was conclusively shown by Merete Bodelsen's pioneering publications in the 1960s.

3. See Barbara Braun, 'Gauguin's Indian Identity: How Ancient Peruvian Pottery Inspired his Art', *Art History*, vol.9, no.1 (March 1986), pp.36–54.

4. Arosa's wide-ranging ceramic collection was featured in Auguste Demmin's authoritative *Guide de l'amateur des faïences et porcelaines*, Paris 1875, a work that ran into several editions. Among its pages were illustrations of a number of pre-Columbian examples.

5. Gauguin mischievously anticipates political conversations in the Köhlers' company in his letter to Émile Schuffenecker of 24 December 1888, in Merlhès 1989, p.243.

6. 'Il est extraordinaire qu'on puisse mettre tant de mystère dans tant d'éclat.' Mallarmé's phrase was reported by Gauguin (among other occasions) in a letter to André Fontainas, March 1899, in Malingue 1946, CLXX, p.288.

Landscape and Rural Narrative
pp.110–31

1. 'Vous êtes parisianiste. Et à moi la campagne. J'aime la Bretagne: j'y trouve le sauvage le primitif. Quand mes sabots résonnent sur ce sol de granit j'entends le ton sourd mat et puissant que je cherche en peinture. Tout cela est bien triste dirait le marsouin, mais à chaque peintre son caractère.' Letter of February 1888 from Gauguin to Émile Schuffenecker, in Merlhès 1989, p.63.

2. 'Je cherche à mettre dans ces figures désolées, le sauvage que j'y vois et qui est en moi aussi . . . Que diable, je veux aussi consulter la nature mais je ne veux pas en retirer ce que j'y vois et ce qui vient à ma pensée.' Letter 828 from Gauguin to Vincent van Gogh, on or about 13 December 1889, vangoghletters.org. Author's translation, which differs slightly from the version in the online publication of the letters.

3. See the detailed entry on this painting in Wildenstein 2001, cat.319, pp.524–9.

4. In his article 'Gauguin's Tahitian Titles', *The Burlington Magazine*, vol.109, no.769 (April 1967), pp.228–33, Bengt Danielsson revealed the limitations to Gauguin's understanding of Tahitian and the frequent non sequiturs in his resulting titles.

5. I am grateful to Richard Berrong for directing me to this highly pertinent 'missing chapter' from *Madame Chrysanthème*, published in *Le Figaro, Supplément littéraire*, on 7 April 1888. As well as the excursion into the mountains, Loti describes a similar swimming scene to the one found in *Noa Noa*.

Sacred Themes pp.132–49

1. This work, drafted in 1896–8, remained unpublished during Gauguin's lifetime. For Elizabeth Childs's lucid analysis, see exh.cat. *Gauguin in Tahiti*, Museum of Fine Arts, Boston 2004, pp.223–41.

2. Gauguin's Catholicism is central to Debora Silverman's study, *Van Gogh and Gauguin: The Search for Sacred Art*, New York 2000. But the contrast she establishes between the Dutch and French artists on the basis of their different religious heritages is questioned by Othon Printz, who explores the surprisingly frequent brushes Gauguin had with the reformed religion. Printz, *Gauguin et le protestantisme*, Liban 2008.

3. See Thomson 2005, pp.69–70.

4. This phrase is used by Douglas W. Druick and Peter Kort Zegers in *Paul Gauguin: Pages from the Pacific*, Auckland City Art Gallery, 1995, p.17.

5. Letter from Gauguin to Émile Bernard, summer 1890, in Malingue 1946, p.CIX.

6. Phrases taken from Gauguin's letters to the Directeur des Beaux Arts, dated 15 March 1891 and 12 June 1892 respectively, applying for and referring to his ongoing artistic mission. Archives Nationales, F21 2286, pièce 20, pièce 7.

7. This, interestingly, is how Gauguin retrospectively characterised his mission in a letter of 1903 to M. Pietri, judge in Papeete. See sale catalogue, Archives Joly-Segalen, Vente Drouot, 12 June 1992, cat. no.79. Gauguin was appealing against a punitive sentence (three months in prison and a fine of 1,000 francs) imposed for inciting his Marquesan neighbours to ignore the local gendarmerie's fines for possession of alcohol.

8. René Huyghe, ed., *Ancien culte mahorie*, 1951, repr. 2001, p.20.

9. Unpublished and incomplete letter to Mette Gauguin, datable to early 1892. Private Collection (see no.74).

10. In keeping with the vogue for literary exoticism and 'récits de voyage', a growing number of French ethnographic collections had Oceanic artefacts on display by the 1880s. One study carved Marquesan earplugs, oar handles, a royal stool formerly belonging to the Tahitian royal family, in public collections in Paris, Boulogne and Rouen.

11. The role of the Catholic Belgian-born Moerenhout in challenging the hegemony of Protestantism in Tahiti was key. Following the publication of his authoritative book he encouraged the introduction of Catholic missions, which in turn paved the way for France's establishing a protectorate over, and then annexing, Tahiti. In his journalism which served the Catholic cause, Gauguin was essentially following Moerenhout's lead.

12. Gauguin was clearly interested in the ideas of Gerald Massey, author of various publications on comparative religion, among them The Natural Genesis, London 1883, a partial French translation of which came into his hands in 1896. According to Elizabeth Childs, op. cit., p.231, 'Gauguin accepted Massey's basic idea that all religions share a common truth based on myth.'

13. Letter to Schuffenecker, 30 October 1890, in Victor Merlhès, De Bretagne en Polynésie: Paul Gauguin, pages inédites, Taravao 1995, p.57.

Fictions of Femininity pp.150–75

1. See his letter to George-Daniel de Monfreid, 25 August 1902, in Joly-Ségalen, 1950, p.190. 'Les Espagnoles aux cheveux plaqués de saindoux, ça a été fait, archi-fait: c'est drôle cependant que je me les figure autrement.'

2. See fig.60, *Pont-Aven, Village Drama*, variously dated 1888 and 1894, which appears to offer a fuller, but more awkward version of this assumed back story.

3. This intriguing and plausible suggestion is made by Martin Gayford in *The Yellow House*, London 2006, pp.130–3.

4. 'Elle sait par cœur les noms de tous les dieux de l'Olympe maorie . . . comment ils ont créé le monde, comment ils aiment à être honorés.' *Noa Noa*, ch.VIII, p.129 (folio 68 recto), Louvre manuscript. Cf. facsimile produced as CD Rom, *Gauguin: écrivain*, ed. Isabelle Cahn, Réunion des Musées Nationaux, Paris 2003.

5. See Alan Moorehead, *The Fatal Impact: An Account of the Invasion of the South Pacific 1767–1840*, Harmondsworth 1966.

6. Letter from Vincent van Gogh to Theo, no.736, 17 January 1889. 'Il est physiquement plus fort que nous, ses passions aussi doivent être bien plus fortes que les nôtres. Puis il est père d'enfants puis il a sa femme et ses enfants dans le Danemark et il veut simultanément aller tout à l'autre bout du globe à la Martinique. C'est effroyable tout le vice versa de désirs et de besoins incompatibles que cela doit lui occasionner.' vangoghletters.org.

7. See Abigail Solomon-Godeau, 'Going Native', *Art in America*, July 1989, pp.119–28/161; Griselda Pollock, *Avant-Garde Gambits: Gender and the Colour of Art History*, Walter Neurath Lecture, London 1992; Nancy Mowll Mathews, *Gauguin: An Erotic Life*, New Haven, CT, and London, 2001; Chantal Spitz, 'Où en sommes nous cent ans après la question posée par Gauguin . . . ?' in *Paul Gauguin: Héritage et confrontations*, Papeete 2003.

8. In a note added to the 1901 edition of *Noa Noa*.

9. *Ancien Culte mahorie*, 1951, reprint 2001, p.11.

10. Among those whose work has helped to correct this picture are Merete Bodelsen, Nancy Mowll Mathews and Anne-Birgitt Fonsmark. See also the remarkably frank, albeit racially patronising, nature of the 1892 letter from Gauguin to his wife (no.74).

11. Félix Fénéon, *La Revue indépendante*, February 1888, quoted in Wildenstein 2001, vol.II, p.314.

12. I am grateful to Joseph Baillio for sharing his research on this fascinating, previously unknown work.

13. For a recent, more extensive discussion of this theme, see Heather Lemonedes in exh.cat. *Paul Gauguin, Paris 1889*, pp.165–9.

14. The seminal article on this theme is Henri Dorra's 'The First Eves in Gauguin's Eden', *Gazette des Beaux-Arts*, March 1953, pp.189–202.

15. *Noa Noa*, Louvre Manuscript, fol.9 verso.

16. For a more complex reading of this statuette and text, see Henri Dorra, *The Symbolism of Paul Gauguin: Erotica, Exotica and the Great Dilemmas of Humanity*, Berkeley 2007, pp.228–36.

17. June Hargrove, 'Against the Grain: The sculpture of Paul Gauguin in the context of his contemporaries', *Van Gogh Studies*, I, 2007, pp.72–111, and on *Oviri*, pp.96–102.

18. Charles Morice, *Paul Gauguin (Les Hommes d'aujourd'hui)* 1896, and Paris 1920, p.171.

Allusive and Elusive Titles pp.176–89

1. See Gauguin's letter to his wife Mette, 8 December 1892, in Malingue 1946, cxxxiv, pp.235–8, where he also says 'Cette langue est bizarre et donne plusieurs sens.'
2. The Maori are understood to have migrated from the Cook islands to New Zealand in around 1300 AD, where their culture and language branched out in new ways as they adapted to the harsher climate.
3. In a letter to Schuffenecker dated 10 June 1889, Gauguin claimed that sadness was his special 'chord' in painting. Merlhès 1995, p.30.
4. Rod Edmond explores this argument in *Representing the South Pacific: Colonial Discourse from Cook to Gauguin*, Cambridge 1997.
5. See P. Dagen, 'Têtes coupées, Gauguin lecteur de Villiers de l'Isle-Adam' in *Gauguin: actes du colloque Gauguin*, Musée d'Orsay, Paris 1989, pp.213–25. See also Scott Allan's essay on this remarkable painting in A. Callen and Travers Newton, eds., *Paul Gauguin, Vincent van Gogh, Émile Bernard and their Circle: Essays in Memory of Vojtech Jirat-Wasiutynski*, London 2010.
6. Letter to his wife Mette, 8 December 1892, in Malingue 1946, cxxxiv, pp.235–8, and letter of same date to Daniel de Monfreid, Joly-Segalen 1950, viii, pp.61–2.
7. See *Cahier pour Aline*, INHA library, Paris, Ms 227, online resource, http://www.inha.fr/spip.php?article302&id_document=346. For an English translation, see *Gauguin: A Retrospective*, eds. Marla Prather and Charles F. Stuckey, New York 1987, p.199.
8. E.A.Poe's *La Genèse d'un poème*, translated, together with the rest of Poe's oeuvre, by Baudelaire, was published as part of the latter's *Oeuvres complètes*, 1868–70. Gauguin made a passing reference to Poe's decision to choose a raven not a parrot in a letter to Bernard of November 1888, Malingue 1946, no.lxxv, p.150. See also Gamboni 2003.
9. Letter of 14 February 1897 to Daniel de Monfreid, in Joly-Segalen 1950, no.xxix, p.101.
10. For Gauguin's paintings within paintings, see I. Cahn in *Gauguin: actes du colloque Gauguin*, Musée d'Orsay, Paris 1989, pp.173–85. Douglas W. Druick and Peter Kort Zegers, exh.cat. *Pages from the Pacific*, Auckland 1995, p.15, illustrate a sketch that Gauguin based on a Khmer carving from Angkor-Wat seen in plaster cast form at the 1889 Universal Exhibition.
11. See exh.cat. *Gauguin and Maori Art*, Auckland 1995, pp.64–5.
12. Letter of 12 March 1897 to Daniel de Monfreid, in Joly-Segalen 1950, no.xxx, p.102.

Teller of Tales pp.190–203

1. The *conteur* only makes his appearance in the published version of *Noa Noa*, which first appeared in two instalments in *La Revue blanche* in October/November 1897, and in Gauguin's illustrated and expanded version of the text (Département des arts graphiques, Musée du Louvre), not in the so-called 'draft manuscript' (Getty Special Collections).
2. For a detailed examination of this print suite and its 1889 context, see exh.cat. *Gauguin: Paris, 1889*, Cleveland, OH, and Amsterdam 2009–10.
3. See Sale 5443, 23 May 2006, Christie's Paris, lot 50. The album has stories of derring-do, piracy and cannibalism, with Gauguin leaning heavily on such prototypes as *The Arabian Nights*.
4. J.-A Moerenhout, *Voyage aux îles du grand océan*, Paris 1837.
5. Linda Goddard discusses the importance of travel literature in her article 'Gauguin's Guidebooks: *Noa Noa* in the Context of Nineteenth-Century Travel Writing', in *Strange Sisters: Literature and Aesthetics in the Nineteenth Century*, eds. J.B. Bullen and F. Orestano, Oxford 2008, pp.233–59.
6. I am indebted for some of these insights to a talk given at the Institut français d'Ecosse by Dr Culpin of St Andrew's University.
7. Gauguin mentions it and the work it will involve in a letter to his wife datable to October 1893, in Malingue 1946, cxliii, p.249. See Linda Goddard's essay 'Following the Moon' for a more extended discussion of the evolution of this manuscript and the tricky relations between Gauguin and Morice.
8. Pierre Loti's bestselling book, *Rarahu* or *Le Mariage de Loti*, 1880, which Gauguin had read, makes many overt references to the conventions of the *récit de voyage*.
9. Vincent van Gogh, a great fan of Loti's writing, saw *Rarahu* as an open invitation to a painter of the tropics such as Gauguin. The latter certainly assimilated aspects of Loti's take on Tahiti, but publicly preferred to distance himself from this over-popular author. Morice, in the preface to the Durand-Ruel exhibition catalogue, makes the comparison, but all in Gauguin's favour.
10. As revealed by René Huyghe, who published the first scholarly edition of *Ancien Culte mahorie* in 1951.
11. See exh.cat. *Pages from the Pacific*, Auckland 1995, pp.23–4.
12. See his articles in *Le Moderniste* and *Les Essais d'art libre* and his own journalistic venture, *Le Sourire* (nos.134–6).
13. These ideas are outlined in largely unpublished letter from Gauguin to Morice dated 10 December 1897, Bibliothèque du Louvre, Ms 310.
14. For a detailed analysis of Gauguin's various monotype techniques, see Richard S. Field, exh.cat. *Paul Gauguin: Monotypes*, Philadelphia Museum of Art, 1973.

Earthly Paradise pp.204–25

1. Degas is reported as remarking to Vollard, 'Poor Gauguin! On his island, all that distance away, he must constantly be thinking about rue Laffitte.' Ambroise Vollard, *Degas*, Paris 1924, p.45.
2. Gauguin claimed in letters to de Monfreid and Morice that he had painted this work prior to making a failed attempt to commit suicide with an overdose of arsenic. This may have been the case, although there were no witnesses. In the unpublished letter written to Morice in December 1897 (Bibliothèque du Louvre) and discussing future plans, his state of mind appears relatively buoyant.
3. 'Le monde est si bête que lorsqu'on lui fera voir des toiles contenant des éléments nouveaux et terribles, Tahiti deviendra compréhensible et charmant. Mes toiles de Bretagne sont devenues de l'eau de rose à cause de Tahiti; Tahiti deviendra de l'eau de Cologne à cause des Marquises.' Letter to de Monfreid, June 1901, in Joly-Segalen 1950, no.lxxv, p.177.
4. By this learned classical allusion to the legendary Greek island dedicated to the cult of Venus, Louis-Antoine de Bougainville (1729–1811) sought to normalise for the readers of his *Voyage* the Tahitian practice of uninhibited lovemaking. The accounts of Wallis's and Cook's voyages make clear that there was also a political agenda behind the Tahitians' welcoming strategy, and practical objectives such as iron nails and weaponry.
5. Letter to William Molard, in Malingue 1946, clx, p.270, where dated July (in fact September) 1895.
6. From Paul Gauguin, *Diverses choses*, Paris 1896–8, p.256.
7. See for example J.-A. Moerenhout, vol.ii, ch.iv, 'Recherches sur l'antiquité des peuples de la Polynésie: État des Polynésiens à l'époque de la découverte. – État présumé des Polynésiens antérieurement à la découverte – Époque présumée de l'antique civilisation des Polynésiens'; ch.v, 'Recherches sur l'origine des peuples de la Polynésie'.
8. See George Shackelford, exh.cat. *Gauguin in Tahiti*, Museum of Fine Arts, Boston 2003, pp.181–2, and Jane Monro, *Endless Forms: Charles Darwin, Natural Science and the Visual Arts*, New Haven, CT, 2009, pp.273–6.

BIBLIOGRAPHY

Amishai-Maisels, Ziva, *Gauguin's Religious Themes*, The Hebrew University, PhD, 1969, New York 1985.

Ananmur, Hasan, 'L'Orientation solaire du Voyage en Orient de Gérard de Nerval', *Orients littéraires: mélanges offerts à Jacques Huré*, Paris 2004.

Aurier, Albert, 'Le Symbolisme en peinture – Paul Gauguin', *Mercure de France*, March 1891.

Backès, Jean-Louis, *Le Poème narratif dans l'Europe romantique*, Paris 2003.

Baudelaire, Charles, 'Les Projets', in *Le Spleen de Paris: oeuvres complètes*, ed. Claude Pichois, Bibliothèque de la Pleiade, vol.i, Paris 1975, pp.314–15.

Baudelaire, Charles, *Paris Spleen and La Fanfarlo*, trans. Raymond N. Mackenzie, Indianapolis 2008.

Becker, Christoph, et al. *Paul Gauguin, Tahiti*, Staatsgalerie, Stuttgart 1998.

Berne, Mauricette, ed., *Victor Segalen: voyageur et visionnaire*, Paris 1999.

Berson, Ruth, ed., *The New Painting: Impressionism 1874–1886, Documentation*, vol.1, Reviews, vol. 2, Exhibited Works, San Francisco 1996.

Binyon, Laurence, 'Post Impressionists', *Saturday Review*, 12 November 1910, pp.609–10, in Bullen 1988, p.112.

Blancel, N., P. Blanchard, G. Boëtsch, E. Deroo, and S. Lemaire, eds., *Zoos humains*, Paris 2004.

Bodelsen, Merete, *Gauguin's Ceramics: A Study in the Development of his Art*, London 1964.

Bodelson, Merete, 'Gauguin the Collector', *Burlington Magazine*, September 1970, pp.590–613.

Bodelsen, Merete, *Gauguin and Van Gogh in Copenhagen in 1893*, exh.cat., Ordrupgaard, Copenhagen 1984.

Bouge, L-J. ed., *Le Sourire de Paul Gauguin, Collection complète en fac-simile*, Paris 1952.

Braun, Barbara, 'Gauguin's Indian Identity: How Ancient Peruvian Pottery Inspired his Art', *Art History*, vol.9, no.1 (March 1986), pp.36–54.

Brettell, Richard R., and Anne-Birgitte Fonsmark, *Gauguin and Impressionism*, exh.cat., Ordrupgaard, Copenhagen, and Kimbell Art Museum, Fort Worth, TX, 2005.

Brettell, Richard et al., *The Art of Paul Gauguin*, exh.cat., National Gallery of Art, Washington 1988, p.60.

Bullen, J.B., 'Great British Gauguin: His Reception in London in 1910–11', in *Apollo*, October 2003, p.4.

Bullen, J.B., ed., *Post-Impressionists in England: The Critical Reception*, London 1988.

Cachin, Françoise, *Gauguin*, Paris 1988.

Cachin, Françoise, et al., *The Art of Paul Gauguin*, exh.cat. (National Gallery of Art, Washington; Art Institute of Chicago; Galeries nationales du Grand Palais, Paris), Washington 1988, Paris 1989.

Cachin, Françoise, et al., *Gauguin: actes du colloque Gauguin, Musée d'Orsay, Paris 1989*, Paris 1991.

Cahn, I., 'Gauguin the Writer', notes accompanying the CD-Rom of *Ancien Culte mahorie, Noa Noa* (Louvre MS), 2003.

Callen, A., and H. Travers Newton, eds., *Paul Gauguin, Vincent van Gogh, Émile Bernard and their Circle: Essays in Memory of Vojtech Jirat-Wasiutynski*, London 2010.

Cariou, André, *L'Aventure de Pont-Aven et Gauguin*, exh.cat., Musée du Luxembourg, Paris 2003.

Cariou, André, *Les Peintres de Pont-Aven*, Rennes 1999.

Chassé, Charles, *Gauguin et le Groupe de Pont-Aven*, Paris 1921.

Chassé, Charles, *Gauguin et son temps*, Paris 1955.

Childs, Elizabeth, '"Catholicism and the Modern Mind": The Painter as Writer in Late Career', in *Gauguin Tahiti*, exh.cat., Museum of Fine Arts, Boston 2004, pp.222–41.

Childs, Elizabeth, 'Gauguin as Author: Writing the Studio of the Tropics', *Van Gogh Museum Journal*, 2003, pp.70–87.

Childs, Elizabeth, 'The Colonial Lens: Gauguin, Primitivism and Photography in the fin-de-siècle', in Lynda Jessup, *Antimodernism and Artistic Experience: Policing the Boundaries of Modernity*, Toronto 2001, pp.50–70.

Clifford, James, 'A Poetics of Displacement: Victor Segalen', in *The Predicament of Culture: Twentieth-Century Ethnography, Literature and Art*, Cambridge, MA 1988, pp.152–63 (p.152).

Cooper, Douglas, ed., *Paul Gauguin: 45 Lettres à Vincent, Théo et Jo van Gogh*, Lausanne 1983.

Coppel, Stephen, 'The Other Half', *British Museum Magazine*, no.51, Spring 2005, pp.36–7.

Cordell, Richard Albert, *Somerset Maugham, A Writer for all Seasons*, London 1962.

Cusinberche, Jean-Marie, *Gauguin et ses amis peintres en Bretagne, Pont-Aven et Le Pouldu*, Valle d'Aosta Cultura, Milan 1993.

Da Vinci, Leonardo, *Treatise on Painting (Codex Urbinas Latinus 1270)*, c.1550, trans. A. Philip McMahon, Princeton 1956, vol.1.

Dagen, Philippe, *Le Peintre, le poète, le sauvage*, Paris 1998.

Dagen, Philippe, 'Têtes coupées, Gauguin lecteur de Villiers de l'Isle-Adam', in *Gauguin, actes du colloque*, Musée d'Orsay, Paris 1989/La Documentation française, Paris 1991, pp.213–25.

Danielsson, Bengt, *Gauguin in the South Seas*, London 1965.

Danielsson, Bengt, 'Gauguin's Tahitian Titles', *The Burlington Magazine*, vol.109, no.760 (April 1967), pp.228–33.

Debans, Camille, *Les Coulisses de l'exposition pratique et anecdotique*, Paris 1889.

Delouche, Denise, *Gauguin et la Bretagne*, Rennes 1996.

Delouche, Denise, *Les Peintres et le paysan breton*, Baillé/URSA, Le Chasse Marées 1988.

Denis, Maurice [Louis, Pierre]: 'Définition du néo-traditionnisme', *Art et Critique*, nos.65 and 66 on 23 and 30 August 1890, pp.540–2, 556–8. Reprinted in Maurice Denis, *Le Ciel à l'Arcadie*, ed. Jean-Paul Bouillon, Paris 1993, pp.5–21.

Diderot, Denis, *Ceci n'est pas un conte* (first published in *Correspondance littéraire*, April 1773) in *Oeuvres*, ed. André Billy, Paris 1951.

Dollé, Marie, *Victor Segalen: le voyageur incertain*, Croissy-Beaubourg 2008.

Donald, Diana, and Jane Monro, ed., *Endless Forms: Charles Darwin, Natural Science and the Visual Arts*, New Haven, CT, 2009.

Dorival, Bernard, 'Sources of the Art of Gauguin from Java, Egypt and Ancient Greece', *Burlington Magazine*, April 1951, vol.xciii, pp.118–22.

Dorra, Henri, 'Gauguin and Emile Bernard', *Gazette des Beaux-Arts*, 6e période, vol.xiv, April 1955, pp.227–46, 259–60.

Dorra, Henri, 'The First Eves in Gauguin's Eden', *Gazette des Beaux-Arts*, March 1953, pp.189–202.

Dorra, Henri, *The Symbolism of Paul Gauguin: Erotica, Exotica and the Great Dilemmas of Humanity*, Berkeley and Los Angeles 2007.

Druick, Douglas W., 'Vollard and Gauguin: Fictions and Facts', in *Cézanne to Gauguin: Ambroise Vollard, Patron of the Avant-Garde*, exh.cat., The Metropolitan Museum of Art, New York, 2006, pp.60–81.

Druick, Douglas W., and Peter Kort Zegers, 'Le Kampong et le pagode', in *Gauguin: actes du colloque*, Musée d'Orsay 1991, pp.101–42.

Druick, Douglas W., and Peter Kort Zegers, *Paul Gauguin: Pages from the Pacific*, exh.cat., Auckland Art Gallery 1995.

Druick, Douglas W., and Peter Kort Zegers, *Van Gogh and Gauguin: The Studio of the South*, exh.cat., The Art Institute of Chicago and the Van Gogh Museum, Amsterdam 2001–2002.

Dumont, Françoise, et.al., *Gauguin: Les XX et la Libre Esthétique*, exh.cat., Musée d'Art moderne et d'Art contemporain de la ville de Liège 1994.

Eckermann, Elise, 'Gauguin's Critical Reception in Belgium in 1889 and 1891', *Van Gogh Studies*, 3, 2010, pp.67–86.

Eckermann, Elise, 'Out of Sight, Out of Mind? Paul Gauguin's Struggle for Recognition after his Departure for the South Seas in 1895', *Van Gogh Studies*, 1, 2007, pp.169–88.

Edmond, Rod, *Representing the South Pacific: Colonial Discourse from Cook to Gauguin*, Cambridge and New York, 1997.

Eisenman, Stephen F., *Gauguin's Skirt*, London 1999.

Field, Richard, 'Gauguin plagiaire ou créateur', in *Gauguin: génies et réalités*, Paris 1960, pp.139–69.

Field, Richard, *Gauguin: The Paintings of the First Voyage to Tahiti*, New York 1977.

Field, Richard, *Paul Gauguin: Monotypes*, exh.cat., Philadelphia Museum of Art 1976.

Forsdick, Charles, *Victor Segalen and the Aesthetics of Diversity: Journeys between Cultures*, Oxford 2000.

Fowle, Frances, 'Following the Vision: From Brittany to Edinburgh', in Thomson 2005, p.108.

Fry, Roger, 'On a Composition by Gauguin', *The Burlington Magazine*, no.180, vol.xxxii, March 1918, p.85.

Gamboni, Dario, 'Paul Gauguin's *Genesis of a Picture*: A Painter's Manifesto and Self-Analysis', *Nineteenth-Century Art Worldwide* vol.2, Issue 3, Autumn 2003.

Gamboni, Dario, 'The Vision of a Vision: Perception, Hallucination and Potential Images in Gauguin's *Vision of the Sermon*, Van Gogh Studies, 3, 2010, pp.11–30.

Gauguin, Paul: see also 'Articles and Texts by Paul Gauguin' in the Documentary Material section (p.245).

Gauguin, Paul, *Paul Gauguin's Intimate Journals*, a translation of *Avant et Après* with preface by Emil Gauguin, New York 1921.

Gauguin, Paul, 'A.J.F. Willumsen', in Guérin, *Oviri, écrits d'un sauvage*, Paris 1974, pp.67–8.

Gauguin, Paul, 'A la Martinique', *Le Sourire*, September 1899, pp.233–4.

Gauguin, Paul, *Ancien culte mahorie*, facsimile edited and commentated by René Huyghe, Paris 1951, 2001.

Gauguin, Paul, *Ancien culte mahorie, Noa Noa* and *Diverses choses* available on the website of the Musée du Louvre, Département des arts graphiques, http://arts-graphiques.louvre.fr/fo/visite?srv=mtrn under inventory numbers RF 10755, 1-61; RF 7259, 1-200; RF 7259, 201-353. Also available on DVD as *Gauguin écrivain/Gauguin the Writer*, with introduction and notes by Isabelle Cahn, Réunion des musées nationaux, Paris 2003.

Gauguin, Paul, *Avant et après*, 1903, translated as *The Intimate Journals of Paul Gauguin*, Van Wyck Brooks, London 1923, p.1; Paris 1989; 2003 facsimile edition Copenhagen 1920.

Gauguin, Paul, *Cahier pour Aline*, 1893, ed. Suzanne Damiron, Paris 1962; facsimile edition, Victor Merlhès, ed., Bordeaux 1989; pocket edition with preface by Philippe Dagen, Paris 2009. Also available on the website of the Institut national de l'histoire de l'art, Paris: http://www.inha.fr/spip.php?rubrique87

Gauguin, Paul, *Diverses choses*, 1896–8, Musée du Louvre, Paris.

Gauguin, Paul, 'Doux progrès', *Les Guêpes*, 12 January 1900.

Gauguin, Paul, *Le Sourire*, no.4, November 1899, ed. L.J. Bouge, Paris 1952.

Gauguin, Paul, 'Les Peintres français à Berlin', *Le Soir*, 1 May 1895, p.2.

Gauguin, Paul, *Manuscrit tiré du livre des métiers de Vehbi-Zumbul Zahdi*, Bibliothèque Nationale de France, Paris, undated. First published in *L'Art Moderne*, 10 July 1887.

Gauguin, Paul, *Noa Noa* (draft MS 1893), J. Paul Getty Museum, Los Angeles; co-authored Louvre MS 1893–7 (Musée du Louvre).

Gauguin, Paul, 'Notes synthétiques', 1884–5, first published as 'Notes synthétiques de Paul Gauguin', in *Vers et prose*, vol.22, 1910, p.52.

Gauguin, Paul, *Racontars de rapin*, 1902, extracts in Guérin 1974, p.250. See Merlhès 1994.

Gayford, Martin, *The Yellow House*, London 2006.

Gille, Vincent, 'Illusion of Sources – Sources of Illusion: Rousseau Through the Images of His Time' in *Henri Rousseau: Jungles in Paris*, ed. Frances Morris, exh.cat., Tate Modern, London 2005, pp.49–63.

Gille, Vincent, 'L'Air du temps, sources et contexte des *Orientales*', *Les Orientales*, exh.cat., Maison de Victor Hugo, Paris 2010.

Glissant, E., *Faulkner, Mississippi*, 1996, trans. Barbara B. Lewis and Thomas C. Spear, Chicago 1999.

Goddard, Linda, 'Gauguin's Guidebooks: *Noa Noa* in the Context of Nineteenth-Century Travel Writing', in Francesca Orestano and Francesca Frigerio, eds., *Strange Sisters: Literature and Aesthetics in the Nineteenth Century*, Bern 2009, pp.233–59.

Goddard, Linda, 'The Writings of a Savage? Literary Devices in Gauguin's *Noa Noa*', *Journal of the Warburg and Courtauld Institutes*, vol.LXXI, 2008, pp.277–93.

Goldwater, Robert, *Primitivism in Modern Art*, New York 1966.

Gore, Spencer Frederick, 'Cezanne, Gauguin, Van Gogh &c., at the Grafton Galleries', in Bullen 1988, p.141.

Gray, Christopher, *Sculpture and Ceramics of Paul Gauguin*, Baltimore 1963/New York 1980.

Gruetzner Robins, Anna, *Modern Art in Britain 1910-1914*, exh.cat., Barbican Art Gallery, London 1997.

Guérin, Daniel, ed., *Oviri: écrits d'un sauvage*, Paris 1974 (English trans., *Paul Gauguin: The Writings of a Savage*, ed. Daniel Guérin, New York 1990).

Halperin, Joan, ed., *Félix Fénéon, Oeuvres plus que complètes*, vol.I, Paris 1970, pp.280–2.

Hargrove, June, 'Against the Grain: The Sculpture of Paul Gauguin in the Context of his Contemporaries', *Van Gogh Studies*, 1, 2007, pp.73–112.

Hargrove, June, 'Gauguin's Maverick Sage: Meijer de Haan', *Van Gogh Studies*, 3, 2010, pp.87–111.

Hearn, Lafcadio, *Two Years in the French West Indies* (1889), Milton Keynes 2006.

Hearn, Lafcadio, *Youma: The Story of a West Indian Slave*, New York 1890.

Henrique, Louis, ed., *Les Colonies françaises, Notices illustrées, Tahiti, Iles Sous-le-Vent*, Paris 1889.

Hind, C. Lewis, *The Post-Impressionists*, London 1911.

Hobbs, Richard, 'Reading Artists' Words', in *A Companion to Art Theory*, eds. Paul Smith and Carolyn Wilde, Oxford 2002, pp.173–82.

Hughes, Robert, 'Unforgettable Self-Delusion', in *Time*, 22 March 1971.

Huyghe, René, 'Gauguin, initiateur des temps nouveaux', in *Gauguin, Génies et réalités*, Paris 1960, p.238.

Huyghe, René, ed., *Ancien culte mahorie*, Paris 1951, reprint Paris 2001.

Huyghe, René, ed. *Le Carnet de Paul Gauguin*, Paris 1952 (facsimile of a sketchbook used between 1888 and 1890, Jerusalem Museum).

Huysmans, Joris Karl, 'L'Exposition des Indépendants en 1881', *L'Art moderne*, UGE, Paris 1975, p.214.

Jacquier, H., 'Le Dossier de la succession Paul Gauguin', *Bulletin de la société des études océaniennes*, vol.120, 1959, pp.673–711.

Jaworska, Wladislawa, *Gauguin and the Pont-Aven School*, Greenwich, CT, 1972.

Jirat-Wasiutynski, Voytech, *Paul Gauguin in the Context of Symbolism*, New York and London 1978.

Jirat-Wasiutynski, Voytech, 'Paul Gauguin's Self-Portraits and the Oviri: The Image of the Artist, Eve and the Fatal Woman', *The Art Quarterly* 2, no.2 (Spring 1979), pp.172–90.

Jirat-Wasiutyenski, Voytech, and H. Travers Newton Jr., *Technique and Meaning in the Paintings of Paul Gauguin*, Cambridge 2000.

Joly-Segalen, Mme (Annie), *Lettres de Paul Gauguin à Georges-Daniel de Monfreid, précédées d'un hommage par Victor Segalen*. Rev. ed. with additional letters, Paris 1950.

Kosinski, Dorothy, *The Artist and the Camera: Degas to Picasso*, with the essay 'Paradise Redux: Gauguin, Photography and Fin-de-Siècle Tahiti' by Elizabeth Childs, Dallas Museum of Art 2000.

Loize, Jean, 'Post-script: The Real *Noa Noa* and the Illustrated Copy', in Paul Gauguin, *Noa Noa: Voyage to Tahiti*, Oxford 1961.

Loti, Pierre, *Rarahu, or The Marriage of Loti*, 1880, trans. Clara Bell, London 2002.

Macey, J. David Jr., 'Fantasy as Necessity: The Role of the Biographer in *The Moon and Sixpence*', *Studies in the Novel*, vol.29, 1997.

Malingue, Maurice, *La Vie prodigieuse de Gauguin*, Paris 1987.

Malingue, Maurice, ed., *Paul Gauguin, Lettres à sa femme et à ses amis*, Paris 1946, 1992, 2003.

Manceron, Gilles, *Segalen*, Paris 1992.

Marsh, Edward, *The Collected Poems of Rupert Brooke: With a Memoir*, London 1918.

Marx, Roger, 'L'Exposition Paul Gauguin', in *La Revue encyclopédique*, vol.4, no.76, 1 February 1894, pp.33–4.

Meier-Graefe, Julius, *Modern Art: Being a Contribution to a New System of Aesthetics*, 1904 (trans. London 1908).

Merlhès, Victor, ed., *Correspondance de Paul Gauguin 1873–1888*, Paris 1984.

Merlhès, Victor, ed., Gauguin, *De Bretagne en Polynésie: Paul Gauguin, pages inédites*, Papeete 1995.

Merlhès, Victor ed., *Paul Gauguin et Vincent van Gogh, 1887–1888, Lettres retrouvées, sources ignorées*, Taravao 1989.

Merlhès, Victor, ed., *Racontars de rapin* [1902], Taravao 1994.

Michel, Pierre, and J.-F. Nivet, eds., *Octave Mirbeau: Correspondance générale*, vol.II, Lausanne 2005.

Mirbeau, Octave, *Combats esthétiques*, Paris 1993.

Mirbeau, Octave, 'L'Angelus', *L'Echo de Paris*, 9 July 1889.

Mirbeau, Octave, 'Paul Gauguin', *L'Echo de Paris*, 16 February 1891.

Mirbeau, Octave, 'Paul Gauguin', *Le Figaro*, 18 February 1891.

Moerenhout, J.-A, *Voyage aux îles du grand océan*, Paris 1837.

Mongan, E., E. Kornfeld, and Harold Joachim, *Paul Gauguin: Catalogue Raisonné of his Prints*, Bern 1988.

Moorehead, Alan, *The Fatal Impact: An Account of the Invasion of the South Pacific 1767–1840*, Harmondsworth 1966.

Morice, Charles, 'Paul Gauguin' *Les Hommes d'aujourd'hui*, 9, 1896.

Morice, Charles, *Paul Gauguin*, Paris 1919; 2nd ed. 1920.

Mowll Mathews, Nancy, *Gauguin: An Erotic Life*, New Haven, CT, and London, 2001.

Musée d'Orsay/École du Louvre, *Gauguin, Actes du colloque Gauguin, Musée d'Orsay, 11–13 janvier 1989*, Paris 1991.

Nerval, Gérard de, *Oeuvres complètes*, eds. Claude Pichois and Jean Guillaume, Paris 1984.

Nerval, Gérard de, *Oeuvres complètes: Voyage en Orient*, eds. Claude Pichois and Jean Guillaume, Paris 1989.

Nicholson, Bronwen, et al., *Gauguin and Maori Art*, Auckland 1995.

O'Reilly, Patrick, and Raoul Teissier, *Tahitiens. Répertoire bio-bibliographique de la Polynésie française*, publication of the Société des Océanistes, no.10, Paris 1962.

Peabody, S., and Tyler Stovall, *The Colour of Liberty: Histories of Race in France*, Durham, NC, and London 2003.

Pickvance, Ronald, *Gauguin Drawings*, London 1969.

Pickvance, Ronald, *Gauguin*, exh.cat., Fondation Pierre Gianadda, Martigny 1998.

Piron, Eugène, *Delacroix, sa vie et ses oeuvres*, Paris 1865, pp.409–10.

Pollock, Griselda, *Avant Garde Gambits 1888–1893: Gender and the Colour of Art History*, London 1992.

Pope, K., *Gauguin and Martinique*, PhD Dissertation, The University of Texas at Austin 1981, pp.122–5.

Prather, Marla, and Charles F. Stuckey, eds., *Gauguin: A Retrospective*, New York 1987. (This volume contains translations of many of the original reviews of Gauguin's work and of some of his own writings.)

Printz, Othon, *Gauguin et le protestantisme*, Colmar 2008.

Rewald, John, *Gauguin Drawings*, New York 1958.

Rewald, John, *Post-Impressionism: From Van Gogh to Gauguin*, Museum of Modern Art, New York 1956; London 1978.

Rewald, John, *Studies in Post-Impressionism*, London 1986.

Roskill, Mark, *Van Gogh, Gauguin and the Impressionist Circle*, London 1970.

Ross, Robert, 'The Post-Impressionists at the Grafton: The Twilight of the Idols', *Morning Post*, 7 November 1910, three reviews reproduced in Bullen 1988, p.100.

Rotonchamp, Jean de, *Paul Gauguin, 1848–1903* (first edn. 1906), Paris 1925.

Salvesen, Britt, *Artists In Focus: Gauguin*, The Art Institute of Chicago, 2001.

Segalen, Victor, *Correspondance I, 1893–1912*, ed. Henry Bouillier, Paris 2004.

Segalen, Victor, 'Hommage à Gauguin', *Oeuvres complètes*, Paris 1995, vol.I, pp.349–73.

Segalen, Victor, *Les Immémoriaux*, Paris 1907.

Segalen, Victor, ed., *Lettres de Paul Gauguin à Georges-Daniel de Monfreid, précédées d'un hommage par Victor Segalen*, Paris 1918

Segalen, Victor, *Oeuvres complètes*, ed. Henry Bouillier, 2 vols., Paris 1995.

Seguin, Armand, *L'Union agricole et maritime*, 11 October 1891, quoted in *Armand Seguin*, exh.cat., Musée de Pont-Aven 1989, p.61.

Shackelford, George, and Claire Frèches-Thory, *Gauguin Tahiti*, exh. cat., Galeries nationales du Grand Palais, Paris 2003, and Museum of Fine Arts, Boston 2004.

Shiff, R., 'The Primitive of Everyone Else's Way', in *Gauguin and the Origins of Symbolism*, exh.cat., Museo Thyssen-Bornemisza, Madrid 2004, pp.65–8.

Silverman, Debora, *Van Gogh and Gauguin: The Search for Sacred Art*, New York 2000.

Simpson, Juliet, 'The Décor of Dreams: Gauguin, Aurier and the Symbolists' vision,' *Van Gogh Studies*, 3, 2010, pp.31–46.

Solana, Guillermo, *Gauguin and the Origins of Symbolism*, exh.cat., Museo Thyssen-Bornemisza, Madrid 2004–5.

Solomon-Godeau, Abigail, 'Going Native: Paul Gauguin and the Invention of Primitivist Modernism', *Art in America*, 77, July 1989, pp.119–28, 161.

Solomon-Godeau, Abigail, 'Dreams of Happiness, Chimeras of Pleasure: Polynesia in the French Visual Imaginary', in S. Eisenman, ed., *Paul Gauguin: Artist of Myth and Dream*, exh.cat., Complesso del Vittoriano, Rome, 2007 1, pp.69–80

Somerset Maugham, W., *Of Human Bondage*, Modern Library Paperback edition 1999.

Somerset Maugham, W., *The Moon and Sixpence*, London 1919, 1999.

Spitz, Chantal, *Island of Shattered Dreams* (the first Māʻohi novel, published as *L'Île aux rêves écrasés*, 1991), Wellington 2007.

Spitz, Chantal, 'Où en sommes nous cent ans après la question posée par Gauguin . . . ?' in *Paul Gauguin: Héritage et confrontations*, Papeete 2003.

Steegmuller, Francis, ed. and trans., *The Letters of Gustave Flaubert, 1830–1857*, The Belknap Press, Cambridge, MA, and London, 1980.

Stein, Susan, 'From the Beginning: Collecting and Exhibiting Gauguin in New York', in *Lure of the Exotic: Gauguin in New York Collections*, Yale 2002.

Stolwijk, Chris, ed., 'Current Issues in 19th-Century Art', *Van Gogh Studies*, 1, Amsterdam 2007, with articles on Gauguin by June Hargrove, Elise Eckermann, and Caroline Boyle-Turner.

Stolwijk, Chris, ed., 'Visions: Gauguin and his Time', *Van Gogh Studies*, 3, Amsterdam 2010, with articles on Gauguin by Dario Gamboni, Juliet Simpson, Rodolphe Rapetti, Elise Eckermann, June Hargrove, and Richard Thomson.

Sweetman, David, *Paul Gauguin: A Complete Life*, London 1995.

Teilhet-Fisk, Jehanne, *Paradise Reviewed: An Interpretation of Gauguin's Polynesian Symbolism*, Ann Arbor 1983.

Thomson, Belinda, *Gauguin*, London 1987, 2000.

Thomson, Belinda, 'Paul Gauguin and Robert Louis Stevenson: A Frenchman and a Scot in the South Seas', *Van Gogh Museum Journal*, 2003, pp.56–69.

Thomson, Belinda ed., *Gauguin by Himself*, Boston, MA, and London 1993, 1998, 2000.

Thomson, Belinda, ed., *Gauguin's Vision*, exh.cat., National Gallery of Scotland, Edinburgh 2005.

Thomson, Richard, 'Seeing Visions, Painting Visions: On Psychology and Representation under the Early Third Republic', *Van Gogh Studies*, 3, 2010, pp.135–62.

Todorov, Tzvetan, *On Human Diversity, Nationalism, Racism and Exoticism in French Thought*, Harvard University Press, Cambridge, MA, and London 1993.

Tréhin, Jean-Yves, *Tahiti. L'Eden à l'épreuve de la photographie*, Papeete, Tahiti 2003.

Tristan, Flora, *Pérégrinations d'une paria*, Paris 1838.

Tristan, Flora, *Promenades dans Londres*, Paris and London 1840.

Van Gogh, Vincent, Complete Letters, New York and London 1958. http://www.vangoghletters.org/vg/letters.html. The web edition of the Van Gogh letters, 2009.

Vargas Llosa, Mario, *The Way to Paradise*, London 2001.

Vollard, Ambroise, *Degas*, Paris 1924.

Wadley, Nicholas, ed., *Noa Noa: Gauguin's Tahiti*, Oxford 1985.

Wettlaufer, Alexandra, 'She is Me: Tristan, Gauguin and the Dialectics of Colonial Identity', *The Romanic Review*, 1 January 2007.

Wildenstein, Daniel, ed., *Gauguin: Premier itinéraire d'un sauvage: Catalogue de l'oeuvre peint (1873–1888)*, text and research by Sylvie Crussard, documentation and chronology by Martine Heudron, 2 vols., Paris and Milan 2001 (English language edition 2002).

Wildenstein, Georges, ed., 'Inventaire des biens de Gauguin, 27 mai 1903', in *Gauguin, sa vie, son œuvre: documents inédits*, Paris 1958, pp.201–8.

Wildenstein, Georges, and Raymond Cogniat, *Gauguin: I, Catalogue*, Paris 1964.

Williams, Bernard, 'Moral Luck', *Philosophical Papers 1973–1980*, Cambridge 1981, pp.20–39.

Zafran, Eric, ed., *Gauguin's Nirvana*, exh.cat., Wadsworth Atheneum Museum of Art, Hartford, CT, 2001.

A Select Chronology of Exhibition Catalogues

Exposition d'oeuvres récentes de Paul Gauguin (Galeries Durand-Ruel, Paris), 10–25 November 1893.

Exposition Paul Gauguin (Galerie Ambroise Vollard, Paris), November 1903.

Salon d'Automne 4me Exposition (Grand Palais des Champs-Elysées, Paris) 1906.

Manet and the Post-Impressionists (Grafton Galleries, London), 8 November 1910–13 January 1911.

Gauguin: Exposition du Centenaire (Orangerie des Tuileries, Paris), Summer 1949.

Gauguin: An Exhibition of Paintings, Engravings, and Sculpture (Organised with the Edinburgh Festival Society by The Arts Council of Great Britain; Royal Scottish Academy, Edinburgh; Tate Gallery, London), 1955.

Gauguin and the Pont-Aven Group (Tate Gallery, London), 1966.

Paul Gauguin: Monotypes (Philadelphia Museum of Art), 1973.

Post-Impressionism: Cross Currents in European Painting (Royal Academy of Arts, London), 1979–80.

Gauguin and Van Gogh in Copenhagen in 1893 (Ordrupgaard, Copenhagen), 1984–5.

Primitivism in Modern Art (with essay by Kirk Varnedoe, 'Gauguin'; Museum of Modern Art, New York), 1984.

Le Chemin de Gauguin: genèse et rayonnement (Musée du Prieuré, Saint-Germain-en-Laye), 1985.

The Art of Paul Gauguin (National Gallery of Art, Washington; Art Institute of Chicago; Galeries nationales du Grand Palais, Paris), Washington 1988, Chicago 1988, Paris 1989.

Gauguin and the School of Pont-Aven, Prints and Paintings (Royal Academy of Arts, London), 1989.

Gauguin: Les XX et la Libre Esthétique (Musée d'Art moderne et d'Art contemporain de la ville de Liège), 1994.

Paul Gauguin: Pages from the Pacific (Auckland Art Gallery), 1995.

Modern Art in Britain 1910-1914 (Barbican Art Gallery, London), 1997.

Gauguin (Fondation Pierre Gianadda, Martigny), 1998.

Paul Gauguin, Tahiti (Staatsgalerie, Stuttgart), 1998.

Paul Gauguin: Von der Bretagne nach Tahiti, Ein Aufbruch zur Moderne (Landesmuseum Joanneum, Graz), 2000.

The Artist and the Camera: Degas to Picasso, with essay 'Paradise Redux: Gauguin, Photography and Fin-de-Siècle Tahiti' by Elizabeth Childs (Dallas Museum of Art), 2000.

Gauguin's 'Nirvana', Painters at Le Pouldu, 1889–1890 (Wadsworth Atheneum Museum of Art, Hartford, CT), 2001.

Van Gogh and Gauguin: The Studio of the South (The Art Institute of Chicago and the Van Gogh Museum, Amsterdam), 2001–2.

Kannibals et vahinés. Imagerie des mers du Sud (Musée national des Arts d'Afrique et d'Océanie, Paris), 2002.

The Lure of the Exotic: Gauguin in New York Collections (The Metropolitan Museum of Art, New York), 2002.

L'Aventure de Pont-Aven et Gauguin (Musée du Luxembourg, Paris), 2003.

Gauguin Tahiti (Galeries nationales du Grand Palais, Paris, and Museum of Fine Arts, Boston), Paris 2003, Boston 2004.

Gauguin and the Origins of Symbolism (Museo Thyssen-Bornemisza, Madrid), 2004–5.

Gauguin and Impressionism (Ordrupgaard, Copenhagen, and Kimbell Art Museum, Fort Worth, TX), 2005.

Gauguin's Vision (National Gallery of Scotland, Edinburgh), 2005.

Pacific Encounters: Art and Divinity in Polynesia 1760–1860 (Sainsbury Centre, University of East Anglia, London), 2006.

Cézanne to Picasso: Ambroise Vollard, Patron of the Avant-Garde, The Metropolitan Museum of Art, New York, 2006–7, Art Institute of Chicago, 2007; Musée d'Orsay, Paris 2007.

L'aristocrate et ses cannibales. Le voyage en océanie du comte Festetics de Tolna, 1893–1896 (Musée du quai Branly, Paris), 2007.

Paul Gauguin: Artist of Myth and Dream (Complesso del Vittoriano, Rome), 2007.

Gauguin: Paris, 1889 (Cleveland Museum of Art and Van Gogh Museum, Amsterdam), 2009–10.

Meijer de Haan: le maître caché (Jewish Historical Museum, Amsterdam, and Musée d'Orsay, Paris), 2010.

Gauguin's Paradise Remembered. The Noa Noa Prints (Princeton University Art Museum), 2010–11.

EXHIBITED WORKS

Plate numbers are given at the end of the entry.

Self-Portrait c.1876
Oil on canvas 46.7 x 38.4
Harvard Art Museum / Fogg Museum.
Gift of Helen W. Ellsworth in memory
of Duncan S. Ellsworth '22, nephew of
Archibald A. Hutchinson, benefactor
of the Hutchinson Wing
2

Inside the Painter's House, rue Carcel 1881
Oil on canvas 103.5 x 162.5
Nasjonalmuseet for kunst, arkitektur
og design, Oslo
London only
26

*The Little One is Dreaming, Study /
La petite rêve, étude* 1881
Oil on canvas 59.5 x 74.5
Ordrupgaard, Copenhagen
London only
25

Embellished Frame or *Frame with
Two Interlaced 'G's* 1881–3
Carved walnut containing photograph
of the artist c.1885 18.9 x 33.6 x 1
Musée d'Orsay, Paris. Gift of Corinne
Peterson, in memory of Fredrick
Peterson and Lucy Peterson, 2003
4

Clovis Asleep 1884
Oil on canvas 46 x 55.5
Private Collection
24

Still Life with Peonies 1884
Oil on canvas 59.7 x 73
National Gallery of Art, Washington.
Collection of Mr and Mrs Paul Mellon
London only
27

Circles and Numbers: Self-Portrait
[recto] 1884–6
Crayon and pencil on paper 16.9 x 21.8
National Gallery of Art, Washington.
The Armand Hammer Collection 1991
London only

Profile of a Boy and Self-Portrait
[recto] 1884–6
Pen and ink on paper 16.9 x 11.6
National Gallery of Art, Washington.
The Armand Hammer Collection 1991
London only

Self-Portrait 1885
Oil on canvas 65.2 x 54.3
Kimbell Art Museum, Fort Worth,
Texas
1

The Breton Shepherdess 1886
Oil on canvas 61 x 74
Laing Art Gallery, Newcastle upon Tyne
(Tyne & Wear Archives and Museums)
London only
43

Still Life with Profile of Laval 1886
Oil on canvas 46 x 38.1
Indianapolis Museum of Art. Samuel
Josefowitz Collection of the School of
Pont-Aven, through the generosity of
Lilly Endowment Inc., the Josefowitz
Family, Mr and Mrs James M. Cornelius,
Mr and Mrs Leonard J. Bentley, Lori
and Dan Efroymson, and other Friends
of the Museum
London only
31

French Peasant [recto] c.1886
*Study of Heads, possibly relating to
ceramics* [verso]
Watercolour, red solid and pencil
27.2 x 17.6
The Trustees of the British
Museum, London
London only

Geese; Girls in Bonnets, Geese [recto] 1886
Pencil on paper 16.9 x 22.6
National Gallery of Art, Washington.
The Armand Hammer Collection 1991
London only

Monkey and Cottage: Little Breton Boy
[recto] 1886
Pencil and crayon on paper 16.9 x 22.6
National Gallery of Art, Washington.
The Armand Hammer Collection 1991
London only

*Three Studies of a Pig: Breton Boy
Walking with a Jug* [recto] 1886
Crayon and pencil on paper
16.9 x 22.6
National Gallery of Art, Washington.
The Armand Hammer Collection 1991
London only

Double Vase 1886–7
Unglazed stoneware 14 x 24
The Danish Museum of Art & Design,
Copenhagen
London only
37

Comings and Goings, Martinique 1887
Oil on canvas 72.5 x 92
Carmen Thyssen-Bornemisza Collection,
on loan at the Thyssen-Bornemisza
Museum, Madrid
London only
45

Landscape in Martinique (Fan) 1887
Watercolour and gouache on paper 20 x 42
The Fan Museum, Greenwich, London
London only

Still Life with Sketch by Delacroix 1887
Oil on canvas 45 x 30
Musée d'Art moderne et contemporain
de Strasbourg
London only
29

Study of Martiniquaises 1887
Pastel and charcoal on paper 41.9 x 53.6
Private Collection, Moscow
London only
46

Women in a Mango Grove, Martinique 1887
Oil on canvas 92.4 x 72
Private Collection
Washington only
42

Double Vessel with Mask of Woman 1887–8
Glazed and unglazed stoneware with
touches of gold h.19.5
Ny Carlsberg Glypotek, Copenhagen
London only
30

Breton Girls Dancing, Pont-Aven 1888
Oil on canvas 73 x 92.7
National Gallery of Art, Washington.
Collection of Mr and Mrs Paul Mellon
1983.1.19
London only
48

Still Life with Fan 1888
Oil on canvas 50 x 61
Musée d'Orsay, Paris RF 1959–7
Washington only
35

Still Life with Fruit 1888
Oil on canvas 43 x 58
The State Pushkin Museum of Fine
Arts, Moscow
33

Still Life with Three Puppies 1888
Oil on wood 91.8 x 62.6
The Museum of Modern Art, New York.
Mrs Simon Guggenheim Fund, 1952
34

*Study for 'In the Heat (Pigs) / En Pleine
Chaleur (Cochons)'* 1888
Pastel watercolour and ink on paper
26.3 x 40.4
Van Gogh Museum, Amsterdam
(Vincent van Gogh Foundation)
London only
89

*Vision of the Sermon (Jacob Wrestling
with the Angel)* 1888
Oil on canvas 73 x 92
National Gallery of Scotland, Edinburgh
65

Self-Portrait Dedicated to Carrière
1888 or 1889
Oil on canvas 46.5 x 38.6
National Gallery of Art, Washington.
Collection of Mr and Mrs Paul. Mellon
1985.64.20
6

Carved Cane c.1888–90
Boxwood, mother-of-pearl and iron h.93.9
The Metropolitan Museum of Art, New
York. Bequest of Adelaide Milton de
Groot (1876–1967), 1967 (67.187.45a,b)
49

*Letter to Vincent van Gogh with sketches
of Soyez Amoureuses and Self-Portrait as
Christ* November 1889
Pen, ink and watercolour on paper 42 x 27
Van Gogh Museum, Amsterdam
(Vincent van Gogh Foundation)
London only
8

The Bathing Place (La Baignade) 1889
Gouache, watercolour, pastel and gold
paint on paper mounted on panel
34.5 x 45
Private Collection
London only
90

Black Venus 1889
Glazed stoneware h.50
The Division of Museum Services,
Nassau County (NY) Department of
Parks, Recreation, and Museums
97

Bonjour Monsieur Gauguin 1889
Oil on canvas glued onto wood
74.9 x 54.8 x 1.9
Hammer Museum, Los Angeles. The
Armand Hammer Collection, Gift of
the Armand Hammer Foundation
7

Breton Calvary (The Green Christ) 1889
Oil on canvas 92 x 73.5
Musées Royaux des Beaux-Arts de
Belgique, Brussels; inv.4416
67

Breton Eve 1889
Pastel and watercolour on paper
33.7 x 31.1
McNay Art Museum, San Antonio.
Bequest of Marion Koogler McNay

Breton Girl Spinning 1889
Oil on plaster 116 x 58
Van Gogh Museum, Amsterdam
53

Christ in the Garden of Olives 1889
Oil on canvas 72.4 x 91.4
Norton Museum of Art, West Palm
Beach, Florida. Gift of Elizabeth C.
Norton, 46.5
9

En Bretagne (In Brittany) 1889
Gouache and watercolour on card
37.9 x 27
The Whitworth Art Gallery,
University of Manchester
London only
52

The Ham 1889
Oil on canvas 50.2 x 57.8
The Phillips Collection, Washington, DC
London only
41

Ondine / In the Waves 1889
Oil on fabric 92.5 x 72.4
Cleveland Museum of Art. Gift of Mr
and Mrs William Powell Jones
92

Portrait of Jacob Meijer de Haan [recto]
Text transcribed from Flora Tristan's
'Promenades dans Londres' [verso] 1889
Watercolour and pencil on paper
16.2 x 11.4
The Museum of Modern Art, New York.
Gift of Arthur G. Altschul, 1976
Washington only
13

*Portrait of Meijer de Haan by
Lamplight* 1889
Oil on wood 79.6 x 51.7
Fractional Gift to The Museum
of Modern Art, New York, from a
Private Collector.
10

Self-Portrait 1889
Oil on wood 79.2 x 51.3
National Gallery of Art, Washington.
Chester Dale Collection
Washington only
11

*Self-Portrait as Christ with Two Profile
Portraits* 1889
Pen and ink with pencil on paper
18 x 12.8
Collection of Waldemar Januszczak
London only

Self-Portrait Drawing [recto]
*Drawing of a Man with a Beard, possibly
Schuffenecker, who owned the sheet*
[verso] 1889
Charcoal on paper 31 x 19.9
Musée d'Art modern et contemporain
de Strasbourg
London only
21

*Self-Portrait Vase in the Form of a
Severed Head* 1889
Stoneware h.19.5
The Danish Museum of Art & Design,
Copenhagen
5

Sketch for 'The Yellow Christ' 1889
Pencil on paper 26.7 x 18.2
Carmen Thyssen-Bornemisza Collection,
on loan at the Thyssen-Bornemisza
Museum, Madrid
London only
69

*Soyez amoureuses vous serez heureuses
(Be in Love and You Will be Happy)* 1889
Polychromed linden wood 97 x 75
Museum of Fine Arts, Boston. Arthur
Tracy Cabot Fund
Washington only
93

*Still Life with Apples, a Pear and a
Ceramic Portrait Jug* 1889
Oil on cradled panel 28.6 x 36.2
Harvard Art Museum / Fogg Museum,
Cambridge, MA. Gift of Walter E. Sachs
38

Volpini Suite 1889
Zincograph on paper
Each 50 x 65, except where otherwise
stated
Private Collection
Martinique Pastorals (Pastorales Martinique)
*The Grasshoppers and the Ants (Les cigales
et les fourmis)*
*Old Women of Arles (Les vieilles filles
[Arles])*
The Laundresses (Les laveuses)
*Dramas of the Sea: Brittany (Les drames
de la mer: Bretagne)*
*Breton Women by a Gate (Bretonnes
à la barrière)*
Joys of Brittany (Joies de Bretagne)
57.8 x 73.7
Breton Bathers (Baigneuses bretonnes)
57.8 x 72.7
Human Misery (Misères humaines)
Dramas of the Sea (Les drames de la mer)
125

The Yellow Christ 1889
Oil on canvas 92.1 x 73.3
Albright-Knox Art Gallery Buffalo, NY.
General Purchase Funds, 1946
68

Two Children c.1889
Oil on canvas 46 x 60
Ny Carlsberg Glyptotek, Copenhagen
32

Woman with Mango Fruits c.1889
Carved and painted oak 30 x 49
Ny Carlsberg Glyptotek, Copenhagen
95

Gauguin's Wooden Shoes (Sabots) 1889–90
Polychromed oak, leather and iron nails
Each 12.9 x 32.7 x 11.3
National Gallery of Art, Washington.
Chester Dale Collection 1963
50

Portrait Bust of Meijer de Haan 1889–90
Carved and painted oak
58.4 x 29.8 x 22.8
National Gallery of Canada, Ottawa.
Purchased 1968
Washington only
15

Eve 1890
Glazed ceramic 60.6 x 27.9 x 27.3
National Gallery of Art, Washington.
Ailsa Mellon Bruce Fund
Washington only
96

Harvest: Le Pouldu 1890
Oil on canvas 73 x 92.1
Tate. Accepted by HM Government
in lieu of tax and allocated to the
Tate Gallery 1966
54

Haystacks in Brittany 1890
Oil on canvas 74.3 x 93.6
National Gallery of Art, Washington.
Gift of the W. Averell Harriman
Foundation in memory of Marie N.
Harriman 1972.9.11
57

Lewdness (La Luxure) 1890
Gilded and polychromed oak and
pine, and metal 70.5 x 14.7 x 11.7
The J.F. Willumsen Museum,
Frederikssund, Denmark
98

*Self-Portrait with Portraits of Roderic
O'Connor and Jacob Meijer de Haan* 1890
Crayon on paper 28.8 x 45
The J.F. Willumsen Museum,
Frederikssund, Denmark
London only
18

Soyez mystérieuses (Be Mysterious) 1890
Bas-relief in polychromed lime wood
73 x 95 x 5
Musée d'Orsay, Paris RF 3405
London only
94

*Studies of Different Faces and a Javanese
Dancer in Full Figure* [recto]
Peasant Women Returning with Their Herds
[verso] 1890
Pencil and crayon on paper 27.4 x 23
The J.F. Willumsen Museum,
Frederikssund, Denmark
London only

*The Loss of Virginity (La Perte de
pucelage)* 1890–1
Oil on canvas 90.2 x 130.2
Chrysler Museum of Art, Norfolk, VA.
Gift of Walter P. Chrysler, Jr
55

Seated Tahitian Youth 1890/1903
Watercolour, pencil and ink on paper
23.7 x 15.3
The Art Institute of Chicago. Gift
of Emily Crane Chadbourne
London only
140

Black Pigs 1891
Oil on canvas 91 x 72
Szépmúvészeti Múzeum, Budapest
58

Haere Mai 1891
Oil on burlap 72.4 x 91.4
Solomon R. Guggenheim Museum,
New York, Thannhauser Collection.
Gift of Justin K. Thannhauser, 1978
London only
60

Tahitian Landscape 1891
Oil on canvas 67.9 x 92.4
The Minneapolis Institute of Arts.
The Julius C. Eliel Memorial Fund
61

Tahitians c.1891
Oil, crayon and charcoal on paper
mounted on millboard 85.4 x 101.9
Tate. Presented by the Contemporary
Art Society 1917
London only
59

Hina and Tefatu [recto]
Te Atua [verso] 1891–3
Pencil [recto]; pencil, pen and ink
[verso] 31.5 x 21
Jean Bonna Collection, Geneva
London only
75

*Aha oe feii? (Eh quoi! Tu es jalouse? /
What! Are you Jealous?)* 1892
Oil on canvas 66 x 89
The State Pushkin Museum of Fine
Arts, Moscow
116

*L'après-midi d'un faune (The Afternoon
of a Faun)* 1892
Carved and tinted tamanu wood
35.6 x 14.7 x 12.4
Conseil général de Seine-et-Marne,
collection du musée départemental
Stéphane Mallarmé, Vulaines-sur-Seine
139

*Arii Matamoe (La Fin royale /
The Royal End)* 1892
Oil on coarse fabric 45 x 75
J. Paul Getty Museum, Los Angeles
Washington only
117

*E haere oe i hia / Where Are You
Going?* 1892
Oil on canvas 96 x 69
Staatsgalerie Stuttgart
London only
115

*Fatata te Miti (Près de la Mer /
By the Sea)* 1892
Oil on canvas 92.4 x 114.9
National Gallery of Art, Washington.
Chester Dale Collection
Washington only
113

Hina with Two Attendants 1892
Tamanu wood with painted gilt
37.1 x 13.4 x 10.8
Hirshhorn Museum and Sculpture
Garden, Smithsonian Institution,
Washington. Museum Purchase with
Funds Provided under the Smithsonian
Institution Collections Acquisition
Program
Washington only
76

*Manao tupapau (L'Esprit veille / The
Spirit of the Dead Keeps Watch)* 1892
Oil on burlap mounted on canvas
72.4 x 97.5
Albright-Knox Art Gallery Buffalo, NY.
A. Conger Goodyear Collection, 1965
121

Mata Mua (Autrefois / In Olden Times)
1892
Oil on canvas 91 x 69
Carmen Thyssen-Bornemisza Collection,
on loan at the Thyssen-Bornemisza
Museum, Madrid
Washington only
63

241

*Parahi te Marae (Là réside le Temple /
The Sacred Mountain)* 1892
Oil on canvas 66 x 88.9
Philadelphia Museum of Art. Gift
of Mr and Mrs Rodolphe Meyer de
Schauensee, 1980
87

*Parau na te Varua ino (Paroles du
Diable / Words of the Devil)* 1892
Oil on canvas 91.7 x 68.5
National Gallery of Art, Washington.
Gift of the W. Averell Harriman
Foundation in memory of Marie N.
Harriman
101

Still Life with Flowers and Idol 1892
Oil on canvas 40.5 x 32
Kunsthaus Zurich. Gift of Walter
Haefner
23

*Study for Parau na te Varua ino
(Words of the Devil)* 1892
Pastel 76.5 x 34.5
Kunstmuseum Basel,
Kupferstichcabinett
Washington only
99

*Te Faaturuma (Boudeuse / Brooding
Woman* 1892
Oil on canvas 91.2 x 68.7
Worcester Art Museum, MA
119

*Te Nave Nave Fenua (The Delightful
Land)* 1892
Oil on canvas 92 x 73.5
Ohara Museum of Art, Okayama
Washington only
105

Te Poi Poi (Le Matin / Morning) 1892
Oil on canvas 68 x 92
Mr Joseph Lau Luen Hung
London only
62

Head of a Tahitienne c.1892
Crayon, pastel and gouache on paper
30.5 x 20.5
Private Collection, Courtesy of
Jean-Luc Baroni Ltd
London only
104

Hina and Fatu c.1892
Carved tamanu wood 32.7 x 14.2
Art Gallery of Ontario, Toronto. Gift from
the Volunteer Committee Fund, 1980
73

Cahier pour Aline 1893
Book of autograph notes and cuttings
Ink and watercolour on paper
22.2 x 17.2 x 0.5
Institut national d'histoire de l'art, Paris.
Bibliothèque, Collections Jacques Doucet.
London only
126

Eu haere ia oe / Where are you Going?
or *Woman Holding a Fruit* 1893
Oil on canvas 92 x 73
The State Hermitage Museum,
St Petersburg
122

*Hina Tefatou (La Lune et la Terre /
The Moon and the Earth* 1893
Oil on burlap 114.3 x 62.2
The Museum of Modern Art, New York.
Lillie P. Bliss Collection, 1934
64

*Merahi Metua no Tehamana (Les Aïeux de
Tehamana / The Ancestors of Tehamana* or
Tehamana has many Parents) 1893
Oil on canvas 76.3 x 54.3
The Art Institute of Chicago. Gift of Mr
and Mrs Charles Deering McCormick
88

Musique Barbare (Barbaric Music) 1893
Pencil with ink and watercolour on
canvas 12 x 21.3
Kunstmuseum Basel,
Kupferstichcabinett. Bequest of Richard
Doetsch-Benziger

Portrait of the Artist with Idol c.1893
Oil on canvas 43 x 32
McNay Art Museum, San Antonio.
Bequest of Marion Koogler McNay
16

Pape Moe (Mysterious Water) 1893–4
Pen and ink and watercolour on paper
35.2 x 25.5
The Art Institute of Chicago. Gift of
Emily Crane Chadbourne
London only
107

Noa Noa Suite

› *Noa Noa: Noa Noa* 1893–4
Colour woodcut on paper printed by
Louis Roy 35.3 x 20.4
The Trustees of the British Museum,
London
London only

› *Noa Noa: Te Po (Eternal Night)* c.1894
Colour woodcut on paper printed by
Louis Roy 20.5 x 36
Institut national d'histoire de l'art,
Paris. Bibliothèque, Collections
Jacques Doucet
London only

› *Noa Noa: Te Atua (The Gods)* c.1894
Colour woodcut on paper printed by
Louis Roy 20.5 x 35.5
Institut national d'histoire de l'art,
Paris. Bibliothèque, Collections
Jacques Doucet
London only

› *Noa Noa: Te Atua: Frieze Composition
with Tahitian Deities* 1894
Colour woodcut on paper printed by
Louis Roy 20.5 x 35.5
The Trustees of the British Museum,
London
London only

› *Noa Noa: L'Univers est crée* 1893–4
Colour woodcut on paper printed by
Louis Roy 20.5 x 39.9
Institut national d'histoire de l'art,
Paris. Bibliothèque, Collections
Jacques Doucet
London only

› *Noa Noa: Maruru (Thank You)* 1893–4,
printed by Pola Gauguin, 1921
Woodcut on paper 26.5 x 42.6
National Gallery of Art, Washington.
Rosenwald Collection 1944
London only

› *Noa Noa: Nave Nave Fenua
(Delightful Land)* 1893–4
Colour woodcut on paper printed by
Louis Roy 35.7 x 20.5
Institut national d'histoire de l'art,
Paris. Bibliothèque, Collections
Jacques Doucet
127

› *Noa Noa: Nave Nave Fenua
(Delightful Land)* 1893–4
Colour woodcut on paper printed
by Louis Roy
National Gallery of Art, Washington.
Rosenwald Collection
Washington only

› *Noa Noa: Mahna no Varua ino
(The Devil Speaks)* 1893–4
Colour woodcut on paper printed
by Louis Roy 20.7 x 35.7
Institut national d'histoire de l'art,
Paris. Bibliothèque, Collections
Jacques Doucet
London only

› *Noa Noa: Te Faruru (Here We
Make Love)* 1893–4
Colour woodcut on paper printed
by Louis Roy 35.7 x 20.4
Institut national d'histoire de l'art,
Paris. Bibliothèque, Collections
Jacques Doucet

› *Noa Noa: Auti Te Pape (Women by
the Shore)* 1893–4
Colour woodcut on paper printed
by Louis Roy 20.4 x 35.5
The Trustees of the British Museum,
London
London only
127

› *Noa Noa: Auti Te Pape (Women by
the Shore)* 1894
Woodcut printed by the artist in black
and hand coloured in yellow and blue
grey 20.4 x 35.5
The Trustees of the British Museum,
London
London only

› *Noa Noa: Manao tupapau* 1893–4
Colour woodcut on paper printed
by Louis Roy 20.4 x 35.5
The Trustees of the British Museum,
London
London only
127

Self-Portrait with Manao tupapau 1893–4
Oil on canvas 46 x 38
Musée d'Orsay, Paris RF 1966–7
17

Tahitian Woman and Idol 1893–4
Watercolour, pen, ink and wash on paper
34.9 x 24.8
Private Collection, Courtesy Galerie
Jean-François Cazeau, Paris
London only
78

*Hina Talking to Tetatou (Cylindrical
Vase in Burnt Clay with Figures of
Tahitian Gods)* 1893–5
Ceramic h.33.7
The Danish Museum of Art & Design,
Copenhagen
London only
77

Ia Orana Maria (Ave Maria) c.1893–5
Charcoal, chalk and pastel on paper,
mounted on millboard 59.7 x 37.5
The Metropolitan Museum of Art,
Bequest of Loula D. Lasker, New York
City, 1961, 61.145.2
70

*Arearea no Varua ino (Words of the Devil
or Reclining Tahitian Women)* 1894
Oil on canvas 60 x 98
Ny Carlsberg Glyptotek, Copenhagen
79

The Artist's Portfolio 1894
Two inside covers decorated in
watercolour, gouache, charcoal and
pencil on paper sewn to leather; leather
binding inscribed in pen and ink with
additions in watercolour; silk ribbons
stitched into binding
42.5 x 26.4
The Metropolitan Museum of Art, New
York. Promised Gift of Leon D. and
Debra R. Black, and Purchase, Joseph
Pulitzer and Florence B. Selden Bequests,
and 1999 Benefit Fund, 2000, 2000.255
London only
124

Mahana no Atua (Day of God) 1894
Oil on canvas 68.3 x 91.5
The Art Institute of Chicago. Helen
Birch Bartlett Memorial Collection
Washington only
81

*Manao tupapau (The Spirit of the Dead
Keeps Watch)* 1894
Lithograph on paper 18.2 x 27.3
The Trustees of the British Museum,
London
London only
130

Oviri 1894
Watercolour trace monotype on paper
29.3 x 20.7
Harvard Art Museum / Fogg Museum,
Cambridge, MA. Gift of the Woodner
Family Collection, Inc.
109

Oviri 1894
Stoneware 75 x 19 x 27
Musée d'Orsay, Paris OAO 1114
112

Pape Moe 1894
Bas-relief on oak 73 x 55 x 5
Sandro and Marta Bosi Collection
108

*Tahitians: Sheet of Studies with Six Heads;
Five Tahitians, One of the Artist, with
Half-Length Tahitian Woman* 1894
Colour monotype printed on paper
24 x 20
The Trustees of the British Museum,
London
London only
19

Ia Orana Maria (Ave Maria) 1894–5
Lithograph (on zinc) printed on paper
25.8 x 20
The Trustees of the British Museum,
London
London only
71

Oviri (The Savage) [Recto] 1894–5
Mahna no Varua Ino (The Demon
Speaks the Truth) [verso]
*Cut fragment of Mahna no Varua Ino
printed by Louis Roy [verso]*
Colour woodcut 20.4 x 12.2
National Gallery of Art, Washington.
Rosenwald Collection 1953
London only
110

Head with Horns c.1895–7
Wood with traces of polychromy 20 x 25
x 17.5 (overall dimensions 39.5 x 25 x 17.5)
J. Paul Getty Museum, Los Angeles

The Bark (La Barque) 1896
Oil on canvas 50.5 x 37.5
Courtesy of Mr Giammarco Cappuzzo
London only
85

*Nave nave mahana (Jours Délicieux /
Delightful Days)* 1896
Oil on canvas 95 x 130
Musée des Beaux-Arts, Lyon
London only
142

*No te aha oe riri? (Why Are You
Angry?)* 1896
Oil on canvas 95.3 x 130.5
The Art Institute of Chicago. Mr and
Mrs Martin A. Ryerson Collection
Washington only
123

Nativity (Bébé) c.1896
Oil on canvas 67 x 76.5
The State Hermitage Museum,
St Petersburg
66

Memory of Meijer de Haan 1896–7
Woodcut on tissue laid down on paper
10.6 x 8.1
The Art Institute of Chicago. Gift of
the Print and Drawing Club
12

The Bathers 1897
Oil on canvas 60.4 x 93.4
National Gallery of Art, Washington.
Gift of Sam A. Lewisohn
114

Nevermore O Tahiti 1897
Oil on canvas 60.5 x 116
The Samuel Courtauld Trust,
The Courtauld Gallery, London
London only
118

Te Rerioa (The Dream) 1897
Oil on canvas 95 x 132
The Samuel Courtauld Trust,
The Courtauld Gallery, London
Washington only
120

Faa Iheihe (Tahitian Pastoral) 1898
Oil on canvas 54 x 169.5
Tate. Presented by Lord Duveen 1919
143

Te Pape Nave Nave (Delectable Water) 1898
Oil on canvas 74 x 95.3
National Gallery of Art, Washington.
Collection of Mr and Mrs Paul Mellon
1973.68.2
86

Vollard Suite

› *Vollard Suite: Soyez amoureuses, vous
serez heureuses (Be in Love and You
Will be Happy)* 1898
Woodcut on paper 16.2 x 27.6
National Gallery of Art, Washington.
Rosenwald Collection 1950
133

› *Vollard Suite: Eve* 1898–9
Woodcut on paper 40.5 x 24.2
National Gallery of Art, Washington.
Rosenwald Collection, 1948

› *Vollard Suite: Te Arii Vahine – Opoi
(Lady of Royal Blood – Fatigue)* 1898
Woodcut on paper 17.1 x 30.4
National Gallery of Art, Washington.
Rosenwald Collection, 1948

› *Vollard Suite: Char à boeufs
(The Ox Cart)* 1898–9
Woodcut on paper 15.1 x 27.8
National Gallery of Art, Washington.
Rosenwald Collection 1950

› *Vollard Suite: Misères humaines
(Human Sorrow)* 1898–9
Woodcut on paper 19.3 x 29.1
National Gallery of Art, Washington.
Rosenwald Collection 1943

› *Vollard Suite: Le Calvaire Breton
(Wayside Shrine in Brittany)* 1898–9
Woodcut on paper 16.1 x 25
National Gallery of Art, Washington.
Rosenwald Collection 1943

› *Vollard Suite: Bouddha (Buddha)*
1898–9
Woodcut on paper 29.5 x 22.2
National Gallery of Art, Washington.
Rosenwald Collection, 1950

› *Vollard Suite: L'Enlèvement d'Europe
(The Rape of Europa)* 1898–9
Woodcut on paper 23.7 x 21.2
National Gallery of Art, Washington.
Rosenwald Collection, 1950

The Last Supper 1899
Oil on canvas 60 x 43.5
Collection Larock Granoff, Paris
Washington only
83

Maternity / Women by the Sea 1899
Oil on canvas 95.5 x 73.5
The State Hermitage Museum,
St Petersburg
84

Two Tahitian Women 1899
Oil on canvas 94 x 72.4
The Metropolitan Museum of Art,
New York. Gift of William Church
Osborn, 1949
145

*Tahitian Faces (Frontal View and
Profiles)* c.1899
Charcoal on paper 41 x 31.1
The Metropolitan Museum of Art,
New York. Purchase, The Annenberg
Foundation Gift, 1996, 1996.418
144

*Two Tahitians Gathering Fruit
[recto]* 1899–1900
Traced monotype on paper 62.8 x 51.5
National Gallery of Art, Washington.
Collection of Mr and Mrs Paul Mellon
1995
London only

The Nightmare (Le Cauchemar) c.1900
Traced monotype on paper 58.4 x 43
J. Paul Getty Museum, Los Angeles
Washington only
100

*Design for a Fan Featuring a Landscape
and a Statue of the Goddess Hina* 1900–3
Gouache, watercolour, pastel and pencil
on paper 20.8 x 41.7
The Art Institute of Chicago. Gift of
Edward McCormick Blair, 2002
Washington only
82

The Ford The Flight 1901
Oil on canvas 76 x 95
The State Pushkin Museum of Fine
Arts, Moscow
148

Contes Barbares (Primitive Tales) 1902
Oil on canvas 130 x 89
Folkwang Museum, Essen
Washington only
154

The Escape 1902
Oil on canvas 73 x 93
Národní galerie v Praze / National
Gallery, Prague
London only
150

Maison du Jouir (House of Pleasure)
1901–2
5 carved wood door panels from
Gauguin's Atuona residence
Soyez mystérieuses (left plinth) 32 x 153 x 3
Nude woman and little dog (left upright)
200 x 39.8 x 2.5
Maison du jouir (lintel) 40 x 24.4 x 2.3
Nude woman with tree and red fruits
(right upright) 159.2 x 40 x 2.5
Soyez amoureuses et vous serez heureuses
(right plinth) 45 x 204.5 x 2.2
Musée d'Orsay, Paris
155

Two Women (La Chevelure fleurie) 1902
Oil on canvas 74 x 64.5
Private Collection c/o Portland Gallery,
London
London only
152

Heads of Two Marquesans [recto]
Pencil drawing used to make the tracing
[verso] c.1902
Traced monotype 32.1 x 51
The Trustees of the British Museum,
London
London only
149

Study of a Nude c.1902
Pencil on paper 32 x 22
Private Collection, provenance André
Fontainas
London only
153

The Invocation 1903
Oil on canvas 65.5 x 75.6
National Gallery of Art, Washington.
Gift from the Collection of John and
Louise Booth in memory of their
daughter Winkie
London only

Self-Portrait with Glasses 1903
Oil on canvas 41.5 x 24
Kunstmuseum Basel. Gift of
Dr Karl Hoffmann
22

Le Sourire

› *Title pages for 'Le Sourire': Three People,
a Mask, a Fox and a Bird* 1899 or after
Woodcut on paper 10 x 18.3
National Gallery of Art, Washington.
Rosenwald Collection 1943
London only

› *Title Page for 'Le Sourire': Fox, Busts of
Two Women and a Rabbit* 1899–1900
Woodcut on paper 10.2 x 18.3
National Gallery of Art, Washington.
Rosenwald Collection 1943
London only

› *Title Page of 'Le Sourire': Bust of Nude
Tahitian Woman and Breton Woman in
Profile* 1899 or after
Woodcut on paper 10.3 x 18.5
National Gallery of Art, Washington.
Rosenwald Collection 1952
London only

› *Title Page for 'Le Sourire': A Horse and
Birds* 1899 or after
Woodcut on paper 13.8 x 21.9
National Gallery of Art, Washington.
Rosenwald Collection 1950
London only

› *Headpiece for 'Le Sourire'* 1899–1900
Woodcut printed on paper and drawing
in watercolour, pen and ink and crayon;
sheet laid down on board 29.6 x 20.4
Art Institute of Chicago. Gift of
Walter S. Brewster
London only
20

› *Title Sheet for 'Le Sourire':
Composition with a Turkey* 1900
Woodcut inscribed in pen and ink
32 x 23.6
The Art Institute of Chicago. Print
sales Miscellaneous Fund
London only
134

Norwegian Rootwood Tankard ?1740
Wood 22.9
Ronald Cohen, Trafalgar Galleries,
London
London only

Gauguin's Paintbox late nineteenth
century
Wood 36 x 46 x 11.8
Ny Carlsberg Glypotek, Copenhagen

Documentary Material
Curated by Vincent Gille
London only

Manuscripts and correspondence

Note: Unless otherwise specified the artist/author is Paul Gauguin

Mette Gauguin (1850–1920)
Letter to Daniel de Monfreid (1856–1929)
16 February 1893
Facsimile 18 x 22.6
Research Library, The Getty Research Institute, Los Angeles

Notes synthétiques, and *list of addresses*
1884–5, 1886
Manuscript, two sheets from a notebook used in Copenhagen 16.9 x 21.7
National Gallery of Art, Washington.
The Armand Hammer Collection

Visiting card, with notes describing the colour and emotional impact of 'Christ in the Garden of Olives' c.1889–90
6.1 x 10.2
Van Gogh Museum, Amsterdam (Vincent van Gogh Foundation)

Letter to Octave Maus (1856–1919) 1889
Manuscript, two sheets, each one has been cut in the middle (4 pieces)
17.3 x 22.4
Musées Royaux des Beaux-Arts de Belgique, Archives de l'Art Contemporain en Belgique

Letter to Jens Ferdinand Willumsen (1863–1958) (including a sketch after Rembrandt's 'Raising of Lazarus') 1890
Manuscript, three sheets, six pages
17.4 x 22
The J.F. Willumsen Museum, Denmark

Letter to Jens Ferdinand Willumsen 1891
Manuscript, one sheet, one page,
17.8 x 11.4
The J.F. Willumsen Museum, Denmark

Letter to Octave Maus 1891
Manuscript, one sheet, one page
17.7 x 22.5
Musées Royaux des Beaux-Arts de Belgique, Archives de l'Art contemporain en Belgique

Émile Bernard (1868–1941)
Letter to Paul Gauguin undated
[datable to June 1890]
Manuscript, one sheet 22.5 x 28
Musée de Pont-Aven

Letter to the Minister of Fine Arts
15 March 1891
Manuscript, one sheet, one page 20 x 15
Archives Nationales, Paris

Letter to the Director of Fine Arts
12 June 1892
Manuscript, one sheet, two pages 30 x 20
Archives Nationales, Paris

Letter to his wife Mette undated
[datable to Spring 1892]
Manuscript, two sheets, four sides, incomplete, each sheet 21 x 13.5
Jean Bonna Collection, Geneva

Letter to Jens Ferdinand Willumsen 1893
Manuscript, three sheets, six pages
17.4 x 22
The J.F. Willumsen Museum, Denmark

Letter to William Molard (1862–1936)
undated [datable to summer 1894]
Manuscript, one sheet, two pages
17.5 x 22.5
Musée de Pont-Aven

Letter to Octave Maus undated
[datable to c. January 1894]
Manuscript, one sheet, one page
21.2 x 27.1
Musées Royaux des Beaux-Arts de Belgique, Archives de l'Art contemporain en Belgique

Letter to Ambroise Vollard (1866–1939),
May 1900
Facsimile 26.6 x 20.3
Research Library, The Getty Research Institute, Los Angeles

Letter to André Fontainas (1865–1949)
February 1903
Manuscript, 1 sheet, 4 pages 24.5 x 19
Private Collection, Brussels, provenance André Fontainas Collection

Daniel de Monfreid (1856–1929)
Letter to Mette Gauguin
20 September 1905
Manuscript, one sheet, two pages 21 x 27
Musée de Pont-Aven

Victor Segalen (1878–1919)
Letter to Daniel de Monfreid
12 April 1906
Manuscript, two sheets, three pages
17 x 12
Bibliothèque nationale de France, Paris

Paul Sérusier (1864–1927)
Letter to Charles Chassé (1893–1965) c.1920
Manuscript, two sheets, four pages 20 x 25
Musée de Pont-Aven

Ministère de l'Instruction Publique
Rough draft of the official endorsement of Paul Gauguin's mission 26 March 1891
Manuscript 29 x 21
Archives Nationales, Paris

Portraits

Gauguin and his Family
Photographs
Anon
Portrait of Gustave Arosa
Photograph (contretype)
Musée Maurice Denis, Saint-Germain-en-Laye

Etienne Carjat (1828–1906)
Portrait of Paul Gauguin 1873
Photograph (contretype)
Musée Maurice Denis, Saint-Germain-en-Laye

Etienne Carjat (1828–1906)
Portrait of Mette Gad 1873
Photograph (contretype)
Musée Maurice Denis, Saint-Germain-en-Laye

Julie Laurberg & Gad (Photographer)
Paul and Mette Gauguin in Copenhagen
1885
Photograph (contretype)
Musée Maurice Denis, Saint-Germain-en-Laye

Anon
Paul Gauguin c.1886
Photograph (contretype)
Musée de Pont-Aven

K.L. Hof (Photographer, Copenhagen)
Mette Gauguin and her five children 1888–9
Photograph (contretype)
Musée de Pont-Aven

Anon
Paul Gauguin c.1891
Photograph (contretype)
Musée de Pont-Aven

Maurice Boutet de Monvel (1851–1913)
Portrait of Gauguin in Breton costume
February 1891
Photograph mounted on card; on verso, menu of the banquet held in Gauguin's honour at the café Voltaire, 23 March 1891
Musée de Pont-Aven

Anon
Emil, Paul and Aline Gauguin March 1891
Photograph (contretype)
Musée Maurice Denis, Saint-Germain-en-Laye

Anon
In Gauguin's studio c.1894
From left to right, front: unknown, Fritz Schneklud, Larrivel
Behind: Paul Sérusier, Annah la Javanaise and Georges Lacombe
Photograph (contretype)
Musée de Pont-Aven

Anon
Aline Gauguin c.1895
Photograph (contretype)
Musée Maurice Denis, Saint-Germain-en-Laye

Prints
André Chazal (1796–1860)
Portrait of Flora Tristan (1803–1844)
Lithograph 19 x 12
Musée Carnavalet, Paris

Portraits of Friends

Photographs
Anon
Group of painters on the bridge at Pont-Aven c.1886
Photograph (contretype)
Musée de Pont-Aven

Anon
Group of painters in front of the Pension Gloanec
Photograph (contretype)
Musée de Pont-Aven

Anon
Group Portrait at the Villa St Joseph, Le Pouldu
Photograph (contretype)
Musée de Pont-Aven

Anon
Portrait of Émile Bernard in Brittany
Photograph (contretype)
Musée Maurice Denis, Saint-Germain-en-Laye

Anon
Portrait of Émile Schuffenecker (1851–1934)
Photograph pasted into an album formerly owned by Paul Gauguin, modern print
Musée du Louvre, Département des Arts Graphiques, Paris

Anon
Portrait of Daniel de Monfreid (1856–1929) 1905
Photograph, modern print
Musée de Narbonne, Narbonne
© Jean Lepage

Jules Dornac
Portrait of Pierre Loti (1850-1923) c.1890
Photograph
Musée Carnavalet, Paris

L. Talbot studio, Noumea
Portrait of Victor Segalen 1904
Original photograph mounted on board
Private Collection, Paris

Roger-Viollet
Camille Pissarro (1830–1903) and Paul Cézanne (1839–1906)
Photograph, modern print
Paris © Roger-Viollet

Prints
Portrait of Stéphane Mallarmé (1842–1898) 1891 with original envelope postmarked 8 Mars 1899, Papeete
Etching and drypoint on paper
13.6 x 12.7
Private Collection, Brussels, provenance André Fontainas collection

'Soyez symboliste', portrait of Jean Moréas (Ioánnis A. Papadiamantópoulos, known as 1856–1910)
Drawing reproduced in *La Plume*
1 January 1891
Private Collection, Paris

Books

Max-Anély [Victor Segalen]
Les Immémoriaux
Société du Mercure de France, Paris 1907
Binding by Yvonne Segalen based on a design by Victor Segalen
Private Collection, Paris

Honoré de Balzac (1799–1850)
Louis Lambert, Séraphita
Michel Lévy, Paris 1875
Private Collection, Paris

Jules Barbey d'Aurevilly (1808–1889)
Les Diaboliques
Alphonse Lemerre, Paris 1883
Private Collection, Paris

Charles Baudelaire (1821–1867)
'Les Projets' in *Le Spleen de Paris*
Œuvres complètes, t. II.
Alphonse Lemerre, Paris 1888
Bibliothèque Historique de la Ville de Paris

Thomas Carlyle (1795–1881)
Sartor Resartus
Chapman and Hall, London 1888
Private Collection, Paris

Alphonse Daudet (1840–1897)
Tartarin de Tarascon
C. Marpon et E. Flammarion, Paris 1889
Private Collection, Paris

André Fontainas
L'ornement de la solitude
Mercure de France, Paris 1899
Private Collection, Brussels, provenance
André Fontainas collection

Jean de La Fontaine (1621–1695)
Fables illustrated by Maurice Boutet
de Monvel (1851–1913)
E. Plon, Nourrit et Cie, Paris 1888
Private Collection, Paris

Victor Hugo (1802–1885)
Les Misérables, with 200 illustrations
by Gustave Brion
Hetzel, Paris 1865
Private Collection, Paris

Stéphane Mallarmé (1842–1898)
L'Après-midi d'un Faune, illustrations
by Edouard Manet
A. Derenne, 1876
Prêt du Conseil Général de Seine-et-
Marne, Collection du Musée
départemental Stéphane Mallarmé,
Vulaines-sur-Seine

Somerset Maugham (1874–1965)
The Moon and Sixpence
William Heinemann, London 1919
Tate Library and Archive

John Milton (1608–1674)
Le Paradis perdu, translation by
Chateaubriand
Bernardin-Béchet libraire, Paris 1859
Private Collection, Paris

Charles Morice (1860–1919)
La Littérature de tout à l'heure
Perrin, Paris 1889
Bibliothèque Historique de la
Ville de Paris

Jehan Rictus (1867–1933)
«L'Hiver» in *Le Soliloque du pauvre*
Mercure de France, Paris 1897
Private Collection, Paris

Flora Tristan
Mémoires et pérégrinations d'une paria
Ladvocat, Paris 1838, Vol.1
Bibliothèque Historique de la
Ville de Paris

Flora Tristan
Promenades dans Londres
Delloye, Paris 1840
Bibliothèque Marguerite Durand,
Ville de Paris

Paul Verlaine (1844–1896)
Romances sans paroles
Léon Vanier, Paris 1891
Private Collection, Paris

Catalogues

*Catalogue for the auction of modern
pictures belonging to M. Gustave Arosa*
Hôtel Drouot, 25 February 1878
National Gallery of Art Library,
Washington, DC. David K.E. Bruce Fund

*Catalogue of the 7th Exhibition of
Independent Artists* 1882
Manuscript copy
Typo-Morris père et fils, rue Amelot,
Paris 1882–1884
Bibliothèque nationale de France, Paris

Catalogue de l'Exposition des XX 1889,
Vve Monnom, Bruxelles, 1889
Bibliothèque des Musées Royaux des
Beaux-Arts, Brussels

*Catalogue of the Exhibition of the
'Groupe impressionniste et synthétiste'
Café Volpini* 1889
Plates shown: 'Aux Roches noires' et '
Les Faneuses' by Paul Gauguin, 'Rêverie'
by Émile Bernard and an untitled plate
by Ludovic Nemo, pseudonym of
Émile Bernard
Watelet, Paris 1889
Institut national d'histoire de l'art, Paris

*Catalogue of the Paul Gauguin
Exhibition with frontispiece etching,
'Parau Hina Tefatou'*
Galeries Durand-Ruel, November 1893
Archives Durand-Ruel © Durand-
Ruel & Cie

*Catalogue of an auction sale of the
works of Paul Gauguin*
Hôtel Drouot, 18 February 1895,
with preface by August Strindberg
Institut national d'histoire de l'art, Paris

Catalogue of the 'Salon d'automne' 1906
Bibliothèque du Musée d'Orsay, Paris

Articles and Texts by Paul Gauguin

'Notes sur l'art à l'Exposition
Universelle'
Le Moderniste illustré, 4 and 13 July 1889
Bibliothèque Historique de la Ville
de Paris

'Natures mortes'
Essais d'art libre, January 1894, facsimile

'Sous deux latitudes'
Essais d'art libre, May 1894
Private Collection, Paris

'Armand Seguin'
Le Mercure de France, February 1895
Musée Maurice Denis, Saint-
Germain-en-Laye

Paul Gauguin and Charles Morice
Noa Noa
La Revue blanche, 15 October and
1 November 1897
Bibliothèque du Musée d'Orsay, Paris

Critical Reviews

Octave Maus
'Sur l'exposition des XX'
La Cravache parisienne, 16 February–
2 March 1889
Musées Royaux des Beaux-Arts de
Belgique, Brussels. Archives de l'Art
contemporain en Belgique

Félix Fénéon (1861–1944)
'Autre groupe impressionniste'
La Cravache parisienne, 6 July 1889,
facsimile

Octave Mirbeau (1848-1917)
'Paul Gauguin'
Le Figaro, 18 February 1891, facsimile

Albert Aurier (1865–1892)
'Le Symbolisme en peinture –
Paul Gauguin'
Le Mercure de France, March 1891
Musée Maurice Denis, Saint-
Germain-en-Laye

Henri Foulquier
'L'Avenir symboliste'
Le Figaro, 24 May 1891, facsimile

Armand Seguin (1869-1904)
'Paul Gauguin'
Union Agricole et Maritime, 11 October
1891, facsimile

Albert Aurier (1865–1892)
'Le Symbolisme'
Revue Encyclopédique, 1 April 1892
Private Collection, Paris

Gustave Geffroy (1855–1926)
'Paul Gauguin'
La Justice, 12 November 1893, facsimile

Octave Mirbeau
'Retour de Tahiti'
Echo de Paris, 14 November 1893,
facsimile

Olivier Merson
'Chronique des Beaux-Arts'
Le Monde illustré, 16 December, 1893
Private Collection, Paris

Armand Dayot
'La Vie artistique, revue des expositions'
Le Figaro illustré, January 1894
Private Collection, Paris

Achille Delaroche
['From an aesthetic point of view,
concerning the painter Paul Gauguin']
'D'un point de vue esthétique, à propos
du peintre Paul Gauguin'
L'Ermitage, January 1894
Bibliothèque littéraire Jacques
Doucet, Paris

Interview with E. Tardieu
Echo de Paris, 13 May 1895, facsimile

Charles Morice
'Paul Gauguin' with portrait, illustration
by Émile Schuffenecker
Les Hommes d'aujourd'hui no.440, 1896
Private Collection

André Fontainas
'Paul Gauguin'
Le Mercure de France, January 1899
Musée Maurice Denis, Saint
Germain-en-Laye

Victor Segalen
['Paul Gauguin in his final setting']
'Paul Gauguin dans son dernier décor'
Le Mercure de France, June 1904
Musée Maurice Denis, Saint-
Germain-en-Laye

Charles Morice
Paul Gauguin
Floury, Paris 1920
Bibliothèque du Musée d'Orsay, Paris

Miscellaneous Documents

*Invitation to the opening of the Exposition
des Artistes Impressionnistes et Synthétistes*
Café Volpini, June 16, 1889
Musée Maurice Denis, Saint-
Germain-en-Laye

*Advertisement for Le Grand Café,
boulevard des Capucines, managed
by M. Volpini*
La Revue de l'Exposition, 1889
Musée Maurice Denis, Saint-
Germain-en-Laye

Paris-Salon 1889
Paris, Hachette, 1889
Paris, Private Collection

Moorish Bath
Charles-Louis Courtry after a
painting by J.L.Gérôme 1874,
Etching 23.0 x 16.7
Musée Goupil, Bordeaux

For sale
Photograph of a painting by J.L.
Gérôme by Goupil & Co, 1873
Albumen silver print 34.3 x 26
Musée Goupil, Bordeaux

Posters

Anon
Agrandissement du *Petit Journal*,
25ème année, le mieux informé de tous
les journaux 1888
Poster, colour lithograph 187 x 132
Bibliothèque Forney, Ville de Paris

Anon
La Science illustrée, journal
hebdomadaire, 1890
Poster, colour lithograph, 52 x 36
Bibliothèque Forney, Ville de Paris

Hugo d'Alesi (1849–1906)
Chemins de fer PLM Algérie
Poster, colour lithograph 107 x 76
Bibliothèque Forney, Ville de Paris

Gustave Fraipont (1849–1923)
*Chemins de fer de l'Ouest, Normandie-
Bretagne* c.1895
Poster, colour lithograph 106 x 75
Bibliothèque Forney, Ville de Paris

Louis Bombled (1862–1927)
Journal des Voyages, lisez 'Fiancée Mexicaine', grand roman d'aventure par Louis Boussenard
Poster, colour lithograph 150 x 106
Bibliothèque Forney, Ville de Paris

Hugo d'Alési (1849–1906)
Exposition Universelle de 1900. Le Maréorama 1900
Poster, colour lithograph 198 x 130
Bibliothèque Forney, Ville de Paris

Georges Meunier (1869–1934)
Chemin de fer d'Orléans, Pont-Aven 1914
Poster, colour lithograph 103 x 74
Bibliothèque Forney, Ville de Paris

Henri Audoux
Compagnie des Messageries Maritimes, Grèce, Turquie, Mer noire… Australie, Nouvelle –Calédonie, Nouvelles-Hébrides 1889
Poster, colour lithograph 73 x 105.5
Collection of the French-Lines Association, Le Havre

David Dellepiane (1866–1932)
Cie des Messageries Maritimes, Paquebots Poste français, Australie, Indo-Chine, Océan Indien, Méditerranée, Brésil et Plata 1910
Poster, colour lithograph 104 x 74
Collection of the French-Lines Association, Le Havre

Photographs in Brittany and Martinique

Brittany
Anon
Pont-Aven, watermills and houses
Digital print from a glass negative
Musée des Civilisations de l'Europe et de la Méditerranée, Paris

Anon
Young girl in traditional costume
Digital print from a glass negative
Musée des Civilisations de l'Europe et de la Méditerranée, Paris

Anon
Young women in traditional costume
Digital print from a glass negative
Musée des Civilisations de l'Europe et de la Méditerranée, Paris

Anon
Elderly Breton couple c.1880
Photograph, albumen paper 10.5 x 6.4
Gérard Levy Collection, Paris

Anon
Local costumes from the Quimperlé region c.1880
Photograph, albumen paper 10.8 x 6.5
Gérard Levy Collection, Paris

Anon
'Quimper', young Breton couple c.1880
Photograph, albumen paper 10.3 x 6.5
Gérard Levy Collection, Paris

Noël le Boyer (1863–1967)
Pont-Aven, view of the town
Digital print from a glass negative
Médiathèque de l'Architecture et du Patrimoine, Paris

Noël le Boyer
Pont-Aven, Le bois d'amour
Digital print from a glass negative
Médiathèque de l'Architecture et du Patrimoine, Paris

Société d'excursions des amateurs de photographies
'Brittany' diorama from the French room in the Trocadéro ethnographic museum c.1895
Printed on baryta coated paper, 11.9 x 17.6
Musée du Quai Branly, Paris

Martinique
Gaston Fabre (1827– after 1900)
La Baie de St Pierre c.1875
Photograph, albumen print 20.8 x 28
Serge Kakou Collection, Paris

Gaston Fabre
[Female coal heaver], Charbonnière, Fort de France c.1875
Photograph, albumen print 26.3 x 19.4
Serge Kakou Collection, Paris

Gaston Fabre
Martinique vegetation
Digital print from a glass positive
Bibliothèque nationale de France, fonds de la société de Géographie, Paris

Firmin André Salles (1860–1929)
On the road near Fort-de-France 1899
Digital print from a glass positive
Bibliothèque nationale de France, fonds de la société de Géographie, Paris

Firmin André Salles
Washerwomen, Saint-Pierre 1899
Digital print from a glass positive, reproduced by Radiguet et Massiot
Bibliothèque nationale de France, fonds de la société de Géographie, Paris

Prints
The Calvary of Sainte-Anne d'Auray in Brittany 1852
Handblocked wood engraving
49.3 x 37.5
Musée départemental breton, Quimper

Notre-Dame de Rumengol, Patron saint of Brittany 1858
Handbocked wood engraving
35.5 x 24
Musée départemental breton, Quimper

Frédéric Sorrieu (1807–?)
Souvenir of Lower Brittany
Album of 15 engravings c.1860
Musée départemental breton, Quimper

Books
Henry Blackburn (1830–1897) and Randolph Caldecott (1846–1886)
Breton Folk: An Artistic Tour in Brittany
Sampson Low, Marston, Searle & Rivington, London, 1883
Private Collection, Paris

Alfred de Courcy
'Le Breton' from the series *Les Français peints par eux-mêmes*
J. Philippart, Paris 1876
Private Collection, Paris

Gustave Flaubert (1821–1880)
Par les champs et par les grèves, voyage en Bretagne
G. Charpentier et Cie, Paris 1886
Private Collection, Paris

Alphonse Joanne (1813–1881)
Guide du Finistère
Hachette, Paris, 1900
Private Collection, Paris

Pierre Loti
Mon frère Yves
Calmann Lévy, Paris 1892
Private Collection, Paris

André Petitcolin (1865–1920)
Arvor
E. Plon, Nourrit et Cie, Paris 1898
Private Collection, Paris

Magazines
['All Saints' Day in Brittany, morning service] 'La Toussaint en Bretagne, l'Office du matin'
L'Illustration, 3November 1892
Private Collection, Paris

'A girl of Pont-Aven'
The London Illustrated News,
Saturday, 30 December 1876
Private Collection, Paris

Caumery (Maurice Languereau, known as, 1867–1941) and Joseph Pinchon (1871–1953)
[The childhood of Bécassine: 'Bécassine does some cooking', 'Bécassine starts school'] L'Enfance de Bécassine: 'Bécassine fait la cuisine', 'Bécassine commence ses études'.
La semaine de Suzette, no.13 and 17, 1 and 29 May 1913
Private Collection, Paris

Postcards
Pont-Aven, general view
Pont-Aven, the old road to Concarneau
Pont-Aven, the bridge and the road to Concarneau
Pont-Aven, boulders in the stream of the Aven
Pont-Aven, little girl going to market
Le Pouldu, Hôtel des Grands sables
Musée de Pont-Aven

Pont-Aven, view of the harbour looking downstream
Pont-Aven, entrance to the Bois d'amour
Pont-Aven, the Trémalo chapeLe Pouldu, Porz-Guen
Le Pouldu, general view of the Grands sables
Environs of Pont-Aven, the Nizon calvary
Private Collection, Paris

The Universal Exhibition of 1889

Photographs
Anon
Palais des Machines, façade
Photograph (contretype)
Bibliothèque Historique de la Ville de Paris / Roger-Viollet

Anon
Palais des Machines and École Militaire
Photograph (contretype)
Bibliothèque Historique de la Ville de Paris / Roger-Viollet

Anon
['General history of domestic architecture'] *'Histoire générale de l'Habitation, view of a street'*
Photograph (contretype)
Bibliothèque Historique de la Ville de Paris / Roger-Viollet

Anon
[Centennial exhibition of the Fine Arts] *Exposition centennale des Beaux-Arts*
Photograph (contretype)
Bibliothèque Historique de la Ville de Paris / Roger-Viollet

Anon
Palais des colonies
Photograph (contretype)
Bibliothèque Historique de la Ville de Paris / Roger-Viollet

Anon
Javanese Dancers
Photograph mounted on card 19.6 x 24.5
Gérard Levy Collection, Paris

Neurdein Frères – Neurdein, Etienne (1832–1918), Neurdein, Louis Antonin (1846–after 1915)
View of the Javanese village and Angkor Pagoda at the Esplanade des Invalides
Photograph mounted on card, from the album 'Exposition Universelle, 1889'
13 x 18
Gérard Levy Collection, Paris

Magazines
'Etat actuel de la Tour Eiffel'
Le Monde illustré, 10 November 1888
Private Collection, Paris

'Palais des Beaux-Arts'
Le Monde illustré, 3 March 1889
Private Collection, Paris

'Petites danseuses javanaises'
Journal illustré, 23 June 1889
Private Collection, Paris

['Life in the American wild west, equestrian exercises performed by Buffalo Bill's troop'] 'La vie sauvage dans l'ouest américain, exercices équestres de la troupe de Buffalo Bill'
Journal des Voyages, 2 October 1889
Private Collection, Paris

['Official award ceremony'] 'Distribution solennelle des récompenses'
Le Monde illustré, 6 October 1889
Private Collection, Paris

['The central gallery of the Palais des Machines, on the evening of the Exhibition's closure'] 'La Galerie centrale du Palais des Machines le soir de la clôture de l'Exposition'
Le Monde illustré, 10 November 1889
Private Collection, Paris

Ethnographic Museums

Photographs

Société d'excursions des amateurs
de photographie
*Paris Ethnographic Museum, the
American room* c.1895
Photograph mounted on card 17 x 12
Musée du Quai Branly, Paris

Société d'excursions des amateurs
de photographie
*Paris Ethnographic Museum, Oceanian
objects and casts of Indochinese carvings*
c.1895
Photograph mounted on card 17.6 x 24
Musée du Quai Branly, Paris

Société d'excursions des amateurs
de photographie
*Paris Ethnographic Museum,
Oceanian objects and casts of Indochinese
carvings* c.1895
Photograph mounted on card 11.5 x 16
Musée du Quai Branly, Paris

Anon
Paris Ethnographic Museum c.1890–9
*Life-size models of indigenous people
from the Solomon Islands – San Cristolval,
Hawaii – Samoan woman printing
bark cloth*
Photographs mounted on card
8.9 x 8.9, 8.5 x 8.9, 9 x 8,9
Musée du Quai Branly, Paris

Anon
*The Auckland Museum in Princes
Street* c.1890
Digital print from a glass plate negative
Auckland Museum, Auckland

Magazines

'The Ethnographic Museum at
the Trocadéro'
La Nature, 1892
Private Collection, Paris

'Kanak Chief at the Ethnographic
Exhibition'
Le Monde illustré, 14 décembre 1878
Private Collection, Paris

Oceania

Photographs

Jules Agostini (1859–1930)
*Gauguin's house and studio in Punaauia,
Tahiti* 1897
Digital print from a glass negative
Musée du Quai Branly, Paris

Susan Hoare
Group of Tahitian women c.1885
Photograph, albumen print 19.8 x 15.8
Serge Kakou Collection, Paris

Susan Hoare
*Evite, Atupa and Naehu, Tahitian
dancers* c.1880–9
Photograph, albumen paper 12.9 x 9.8
Musée du Quai Branly, Paris

Attributed to Frank Holmes
*House of the Governor, Papeete,
Tahiti* c.1900
Photograph, aristotype print 11.7 x 16.8
Serge Kakou Collection, Paris

Henri Lemasson (1870–1956)
*'Where do we Come From? What are
we? Where are we Going?' in Gauguin's
studio* 2 June 1898
Photograph, albumen print 13 x 18
Centre des Archives d'Outre-Mer,
Aix-en-Provence

Attributed to Henri Lemasson
Tahitian woman 1897
Photograph, silver print 16.9 x 11.9
Serge Kakou Collection, Paris

Henri Lemasson
The road at Punaauia, Tahiti c.1896
Digital print from a glass negative
Centre des Archives d'Outre-Mer,
Aix-en-Provence

Henri Lemasson
View of Atuona, Marquesas Islands c.1896
Digital print from a glass negative
Centre des Archives d'Outre-Mer,
Aix-en-Provence

Henri Lemasson
*The Church in Atuona, Marquesas
Islands* c.1896
Digital print from a glass negative
Centre des Archives d'Outre-Mer,
Aix-en-Provence

Henri Lemasson
Atiheu Bay, Marquesas Islands c.1897
Photograph, gelatin-silver print
13.2 x 17.9
Serge Kakou Collection, Paris

Charles Georges Spitz (1857–1894)
*Street in the 'Petite Pologne' quarter
of Papeete, Tahiti* c.1890
Photograph, aristotype print by
Frank Holmes 17.4 x 23
Serge Kakou Collection, Paris

Charles Georges Spitz
Fishing scene near Afaahiti, Tahiti c.1890
Photograph, aristotype print by Frank
Holmes 16.5 x 21.7
Serge Kakou Collection, Paris

Charles Georges Spitz
Tahitian village c.1890
Photograph, aristotype print by Frank
Holmes 18.4 x 22.7
Serge Kakou Collection, Paris

Charles Georges Spitz
Fruit pickers c.1890
Photograph, aristotype print by Frank
Holmes 21.7 x 16.5
Serge Kakou Collection, Paris

Charles Georges Spitz
Fountain in the rock, Samoan Islands
c.1888
Photograph, aristotype print by Frank
Holmes 22.9 x 17
Serge Kakou Collection, Paris

George D. Valentine
The Wharf, Papeete, Tahiti 1887
Photograph, albumen print 18.9 x 29.1
Serge Kakou Collection, Paris

Documents

**Photographs and reproductions
of artworks**

Anon
Photo of a Tahura Tablette
Photograph, print on silver paper
from a glass negative 8.6 x 12.6
Private Collection, Paris

Gustave Arosa Studio
*Plate from the Parthenon Frieze,
Man with a horse* 1868
Collotype 19.5 x 23.5
Jean-Yves Tréhin Collection, Paris

Gustave Arosa Studio
Plate from the Parthenon Frieze,
Group of horsemen 1868
Collotype 23.5 x 31.5
Jean-Yves Tréhin Collection, Paris

Gustave Arosa Studio
*Plate from the Panathenean Frieze,
Four standing figures* 1868
Collotype 23.5 x 22.5
Jean-Yves Tréhin Collection, Paris

Photographs

Anon
Erotic photograph, Port-Saïd c.1890
Albumen print 27.1 x 20.3
Gérard Lévy Collection, Paris

Anon
Erotic photograph, Port-Saïd c.1890
Albumen print 26.3 x 20
Gérard Lévy Collection, Paris

Le Sourire

Le Sourire
Number 1, August 1899, hand-tinted
with watercolour by Gauguin
Musée des Beaux-Arts, Chartres

Le Sourire
Number 2, September 1899
Musée des Beaux-Arts, Chartres

'La vie d'un géomètre', 'Gallet-
Rousselle est bon enfant'
Songs by Paul Gauguin
Papeete, 1900
Musée des Beaux-Arts, Chartres

Magazines

'Les Anthropophages'
Journal des Voyages, 2 June 1878
Private Collection, Paris

A. Pailhès
'Souvenirs du Pacifique, Archipel
de Tahiti'
Le Tour du Monde, 1876
Private Collection, Paris

Annexion de Tahiti à la France
L'illustration, 18 September 1880
Private Collection, Paris

Pierre Loti
'Un chapitre inédit de *Madame
Chrisanthème*'
Le Figaro supplément littéraire,
7 April 1888
Private Collection, Paris

Pierre de Myrica
'Tahiti'
Le Tour du Monde, 1902
Private Collection, Paris

Books

Louis Henrique (1848–1906)
*Les colonies françaises, vol.IV, Colonies
et protectorats de l'Océan pacifique*
Maison Quantin, Paris 1889
Private Collection, Paris

Pierre Loti
Rarahu: Le mariage de Loti
Calmann Lévy, Paris 1888
Private Collection, Paris

Jacques Antoine Moerenhout
(1796–1879)
Voyages aux Iles du grand Océan,
two volumes
Arthur Bertrand, Paris 1837
Bibliothèque Historique de la Ville
de Paris

*Te Faufaa Api, a to tatou fatu e te ora a
iesu Mesia ra: iritihia ei parau Tahiti; ...*
The New Testament, translated into
Tahitian by Henry Nott, London 1853
Edinburgh University Library

*Exposé des faits qui ont accompagné
l'agression des français contre l'Ile de
Tahiti ...*
[Brief statement of the aggression of
the French on the Island of Tahiti ...]
translated into French by the London
Missionary Society
L.–R. Delay, Paris 1843
Edinburgh University, New College
Library

Postcards

*Marseille, Embarcation of the Messageries
maritimes
The Australien
The Armand Béhic
View of Moorea
Papenoo valley
Papeete
Papeete, quai du commerce
Moorea, house of a publicworker
Tahitian woman
Tattooed Marquesan
Tepairu
Old woman reading the Bible*
Private collection, Paris

LENDERS AND CREDITS

Lenders

Albright-Knox Art Gallery, Buffalo, NY
Archives Durand-Ruel © Durand-
 Ruel & Cie
Archives Nationales, Paris
The Hammer Museum, Los Angeles
Art Gallery of Ontario, Toronto
The Art Institute of Chicago
Bibliothèque Forney, Ville de Paris
Bibliothèque du Musée d'Orsay, Paris
Bibliothèque Historique de la Ville
 de Paris
Bibliothèque littéraire Jacques Doucet,
 Paris
Bibliothèque Marguerite Durand,
 Ville de Paris
Bibliothèque Nationale de France, Paris
Jean Bonna Collection, Geneva
Carmen Thyssen Bornemisza Collection,
 Madrid
Centre des Archives d'Outre-Mer,
 Aix-en-Provence
Chrysler Museum of Art, Norfolk, VA
The Cleveland Museum of Art
Collection of the French-Lines
 Association, Le Havre
Galerie Larock Granoff, Paris
Waldemar Januszczak
Conseil général de Seine-et-Marne,
 Collection du musée départmental
 Stéphane Mallarmé
The Samuel Courtauld Trust, The
 Courtauld Gallery of London
The Danish Museum of Art & Design,
 Copenhagen
The Division of Museum Services,
 Nassau County (NY) Department of
 Parks, Recreation and Museums
Edinburgh University Library
The Fan Museum, Greenwich, London
Folkwang Museum, Essen
Harvard Art Museum/Fogg Museum,
 Cambridge, MA
Indianapolis Museum of Art
The J. F. Willumsen Museum,
 Frederikssund, Denmark
Gérard Levy Collection, Paris
J. Paul Getty Museum, Los Angeles
Hirshhorn Museum and Sculpture
 Garden, Smithsonian Institution,
 Washington, DC
Institut National d'Histoire de l'Art, Paris
Serge Kakou Collection, Paris
Kimbell Art Museum, Fort Worth, Texas
Kunsthaus, Zurich
Kunstmusem, Basel
Kunstmusem, Basel, Kupferstichkabinett
Laing Art Gallery, Newcastle-upon-Tyne
Mr Joseph Lau Luen Hung
McNay Art Museum, San Antonio
Médiathèque de l'Architecture et du
 Patrimoine, Paris

The Metropolitan Museum of Art,
 New York
The Minneapolis Institute of Arts
Musée du Quai Branly, Paris
Musée des Beaux-Arts, Chartres
Musée des Civilisations de l'Europe et
 de la Méditerranée, Paris
Musée d'Art moderne et contemporain
 de Strasbourg
Musée Carnavalet, Paris
Musée départemental breton, Quimper
Musée Goupil, Bordeaux
Musée du Louvre, Département des
 Arts Graphiques, Paris
Musée de Narbonne, Narbonne
 © Jean Lepage
Musée d'Orsay, Paris
Musée de Pont-Aven
Musée des Beaux-Arts, Lyon
Musée Maurice Denis, Saint-Germain-
 en-Laye
Musées Royaux des Beaux-Arts de
 Belgique
Museum of Fine Arts, Boston
The Museum of Modern Art, New York
Národni galerie v Praze/National
 Gallery, Prague
Nasjonalmuseet for kunst, arkitektur
 og design, Oslo
National Gallery of Art, Washington, DC
National Gallery of Art Library,
 Washington, DC
National Gallery of Canada, Ottawa
National Gallery of Scotland, Edinburgh
Norton Museum of Art, West Palm Beach
Ny Carlsberg Glypototek, Copenhagen
Ohara Museum of Art, Okayama
Ordrupgaard, Copenhagen
Philadelphia Museum of Art
The Phillips Collection, Washington, DC
Private Collection Courtesy of Mr
 Giammarco Cappuzzo
Private Collection, Courtesy Galerie
 Jean-François Cazeau, Paris
Private Collection, Courtesy of Jean-
 Luc Baroni Ltd
Private Collection, Moscow
Private Collection, Paris
Private Collection, Courtesy of
 Portland Gallery, London
Private Collection, Brussels, former
 André Fontainas Collection
Ronald Cohen, Trafalgar Galleries,
 London
Sandro and Marta Bosi
Solomon R. Guggenheim Museum,
 New York
Staatsgalerie Stuttgart
The State Hermitage Museum,
 St Petersburg
The State Pushkin Museum of Fine
 Arts, Moscow

Szépmuvészeti Múzeum, Budapest
Tate
The British Museum, London
Jean-Yves Tréhin Collection, Paris
Van Gogh Museum, Amsterdam
Vincent van Gogh Foundation
The Whitworth Art Gallery, University
 of Manchester
Worcester Art Museum, MA
*And our lenders who wish to
remain anonymous*

Photo credits

Unless stated otherwise, copyright in the
photograph is as given in the caption to
each illustration.
© 2010 AGO no.73
© akg-images nos.3, 62
© akg-images / André Held fig.63
© akg-images / Erich Lessing nos.33, 91,
 148; fig.23
© 2010. Albright Knox Art Gallery/ Art
 Resource, NY/ Scala, Florence nos.68,
 121
© Les Arts Décoratifs/Jean Tholance.
 All rights reserved no.51
© The Art Institute of Chicago / photo
 by Karin Patzke no.127
© Dean Beasom nos.110, 127 (2, 8), 131
© Yvan Bourhis – DAPMD/CG77 no.139
© BPK, Berlin, Dist. RMN/ Image
 BStGS fig.4
© Christie's Images/ The Bridgeman Art
 Library fig.71
© Christie's Images / SuperStock fig.18
© The Danish Museum of Art & Design,
 photo: Pernille Klemp nos.5, 25, 37,
 77; fig.58
© Foundation E.G. Buhrle Collection,
 Zurich no.137
© Patrick Goetelen, Geneva nos.74, 75
© Illustrated London News Ltd/Mary
 Evans fig.48
© The Israel Museum by Avshalom
 Avital no.129
© Jan Krugier and Marie-Anne Krugier-
 Poniatowski Collection fig.16
© Kimbell Art Museum, Fort Worth,
 Texas /Art Resource, NY/Scala,
 Florence no.1
Image Courtesy Kunsthandel Ivo
 Bouwman. Photo by Ed Brandon no.14
© 2009 KUNSTHAUS ZURICH. ALL
 RIGHTS RESERVED no.23
© Kunstmuseum Basel, Martin P. Bühler
 nos.22, 99; fig.69
© Lyon MBA / Alain Basset no.142
© The Metropolitan Museum of Art/
 Art Resource/ Scala, Florence nos.49,
 64, 70, 124, 127 (7),144, 145; fig.61
© Ex colección Di Tella MNBA fig.65
© João Musa fig.44

© Musée d'Orsay, Dist. RMN / Patrice
 Schmidt fig.25
© Musee Marmottan, Paris, France/
 Giraudon/ The Bridgeman Art
 Library no.106
© Musées de la Ville de Strasbourg,
 A. Plisson 21, 29
© 2010 Musee du quai Branly/ Scala,
 Florence figs.34, 38, 66
© The Museum of Fine Arts Budapest/
 Scala, Florence no.58
© 2010 The Museum of Modern Art,
 New York / Scala, Florence nos.10,
 34, 80
© 2010 The Norton Simon Foundation
 fig.57
© Ny Carlsberge Glyptotek,
 Copenhagen, Ole Haupt nos.30, 32,
 79, 95; figs.22, 26
© President and Fellows of Harvard
 College, Photo by Katya Kallsen
 nos.2, 38, 100
© Pushkin Museum, Moscow, Russia/
 The Bridgeman Art Library fig.2
© RMN/ Jean-Gilles Berizzi fig.33
© RMN / Agence Bulloz no.40
© RMN (Musée d'Orsay) / Michèle
 Bellot fig.45
© RMN (Musée d'Orsay)/ Herve
 Lewandowski nos.17, 35, 112, 128;
 figs.20, 30, 31, 35, 41, 43, 53, 68, 72
© RMN (Musée d'Orsay) / René-Gabriel
 Ojéda nos.4, 155; fig.54
© RMN (Musée d'Orsay) / Jean
 Schormans no.94
Used by permission of The Random
 House Group Ltd. fig.52
© Scala, Florence fig.51
© Scala, Florence/BPK, Bildagentur fuer
 Kunst, Kultur und Geschichte, Berlin.
 Joerg P. Anders figs.62, 70, 74
© 2010 Scala, Florence /Museum
 Associates/LACMA/Art Resource
 NY fig.27
© Luc Schrobiltgen nos.138, 153
Courtesy of Sotheby's, Inc fig.9
© Speltdoorn no.67
© Lee Stalsworth no.76
© The State Hermitage Museum. Photo
 by: Vladimir Terebenin, Leonard
 Kheifets, Yuri Molodkovets nos.66,
 84, 122
© Tate Photography, 2010 nos.54, 59, 143
© Thaw Collection, The Pierpont
 Morgan Library, New York. EVT
 213. Photography: Joseph Zehavi,
 2007 no.47
© 2010 Wadsworth Atheneum Museum
 of Art /Art Resource, NY/Scala,
 Florence fig.55
© 2010. White Images / Scala, Florence
 nos.28, 116
© Worcester Art Museum, MA 119

INDEX

SUPPORTING TATE

Tate relies on a large number of supporters – individuals, foundations, companies and public sector sources – to enable it to deliver its programme of activities, both on and off its gallery sites. This support is essential in order for Tate to acquire works of art for the Collection, run education, outreach and exhibition programmes, care for the Collection in storage and enable art to be displayed, both digitally and physically, inside and outside Tate. Your donation will make a real difference and enable others to enjoy Tate and its Collection both now and in the future. There are a variety of ways in which you can help support Tate and also benefit as a UK or US taxpayer. Please contact us at:

Development Office
Tate
Millbank
London SW1P 4RG

Tel: 020 7887 4900
Fax: 020 7887 8098

American Patrons of Tate
520 West 27 Street Unit 404
New York, NY 10001
USA

Tel: 001 212 643 2818
Fax: 001 212 643 1001

Donations, of whatever size, are gratefully received, either to support particular areas of interest, or to contribute to general activity costs.

Gifts of Shares
We can accept gifts of quoted share and securities. All gifts of shares to Tate are exempt from capital gains tax, and higher rate taxpayers enjoy additional tax efficiencies. For further information please contact the Development Office.

Gift Aid
Through Gift Aid you can increase the value of your donation to Tate as we are able to reclaim the tax on your gift. Gift Aid applies to gifts of any size, whether regular or a one-off gift. Higher rate taxpayers are also able to claim additional personal tax relief. Contact us for further information and to make a Gift Aid Declaration.

Legacies
A legacy to Tate may take the form of a residual share of an estate, a specific cash sum or item of property such as a work of art. Legacies to Tate are free of inheritance tax, and help to secure a strong future for the Collection and galleries. For further information please contact the Development Office.

Offers in lieu of tax
Inheritance Tax can be satisfied by transferring to the Government a work of art of outstanding importance. In this case the amount of tax is reduced, and it can be made a condition of the offer that the work of art is allocated to Tate. Please contact us for details.

Tate Members
Tate Members enjoy unlimited free admission throughout the year to all exhibitions at Tate, as well as a number of other benefits such as exclusive use of our Members' Rooms and a free annual subscription to Tate Etc. Whilst enjoying the exclusive privileges of membership, you are also helping secure Tate's position at the very heart of British and modern art. Your support actively contributes to new purchases of important art, ensuring that the Tate's Collection continues to be relevant and comprehensive, as well as funding projects in London, Liverpool and St Ives that increase access and understanding for everyone.

Tate Patrons
Tate Patrons share a strong enthusiasm for art and are committed to giving significant financial support to Tate on an annual basis. The Patrons support the acquisition of works across Tate's broad collecting remit, as well as other areas of Tate activity such as conservation, education and research. The scheme provides a forum for Patrons to share their interest in art and to exchange knowledge and information in an enjoyable environment. United States taxpayers who wish to receive full tax exempt status from the IRS under Section 501 (c) (3) are able to support the Patrons through the American Patrons of Tate. For more information on the scheme please contact the Patrons office.

Corporate Membership
Corporate Membership at Tate Modern, Tate Britain and Tate Liverpool offers companies opportunities for corporate entertaining and the chance for a wide variety of employee benefits. These include special private views, special access to paying exhibitions, out-of-hours visits and tours, invitations to VIP events and talks at members' offices.

Corporate Investment
Tate has developed a range of imaginative partnerships with the corporate sector, ranging from international interpretation and exhibition programmes to local outreach and staff development programmes. We are particularly known for high-profile business to business marketing initiatives and employee benefit packages. Please contact the Corporate Fundraising team for further details.

Charity Details
The Tate Gallery is an exempt charity; the Museums & Galleries Act 1992 added the Tate Gallery to the list of exempt charities defined in the 1960 Charities Act. Tate Members is a registered charity (number 313021). Tate Foundation is a registered charity (number 1085314).

American Patrons of Tate
American Patrons of Tate is an independent charity based in New York that supports the work of Tate in the United Kingdom. It receives full tax exempt status from the IRS under section 501(c)(3) allowing United States taxpayers to receive tax deductions on gifts towards annual membership programmes, exhibitions, scholarship and capital projects. For more information contact the American Patrons of Tate office.

Tate Trustees
Helen Alexander, CBE
Tom Bloxham
Lord Browne of Madingley,
 FRS, FREng (Chair)
Sir Howard Davies
Jeremy Deller
Prof David Ekserdjian
Mala Gaonkar
Patricia Lankester
Elisabeth Murdoch
Franck Petitgas

Monisha Shah
Bob and Roberta Smith
Gareth Thomas
Wolfgang Tillmans

Tate Foundation Trustees
John Botts, CBE
Carol Galley
Noam Gottesman
Scott Mead
Franck Petitgas (Chair)
Anthony Salz
Sir Nicholas Serota
Lord Stevenson of Coddenham, CBE

Tate Foundation
Non-Executive Trustees
Victoria Barnsley, OBE
Mrs James Brice
Lord Browne of Madingley,
 FRS, FREng
Susan Burns
Melanie Clore
Sir Harry Djanogly, CBE
Dame Vivien Duffield
Lady Lynn Forester de Rothschild
The Hon Mrs Rita McAulay
Ronald McAulay
Mandy Moross
Paul Myners, CBE
Sir John Ritblat
Lady Ritblat
The Rt Hon Lord Sainsbury of
 Preston Candover
Lady Sainsbury of Preston Candover
The Rt Hon Sir Timothy Sainsbury
Peter Simon
Jon Snow
John J Studzinski, CBE
The Hon Mrs Janet Wolfson
 de Botton, CBE
Anita Zabludowicz

Tate Members Council
Elkan Abrahamson
David Adjaye
Caroline Blyth
Hannah Collins
Shami Chakrabarti
Brendan Finucane, QC
Ryan Gander
Linda Genower
Dominic Harris
Robert McCracken
Miranda Sawyer
Steven Sharp
Francine Stock (Chair)
Cathy Watkins
Simon Wilson

American Patrons of Tate Trustees
Frances Bowes
James Chanos
Henry Christensen III
Ella Fontanals-Cisneros
Jeanne Donovan Fisher
Lady Forester de Rothschild (Chair)
Marguerite Hoffman
Sandra M. Niles
John J. Studzinski, CBE
Juan Carlos Verme

Tate Modern Donors to the Founding Capital Campaign
29th May 1961 Charitable Trust
AMP
The Annenberg Foundation
The Arts Council England
The Asprey Family Charitable
 Foundation
Lord and Lady Attenborough
The Baring Foundation
Ron Beller and Jennifer Moses
Alex and Angela Bernstein
David and Janice Blackburn
Mr and Mrs Anthony Bloom
BNP Paribas
Mr and Mrs Pontus Bonnier
Lauren and Mark Booth
Mr and Mrs John Botts
Frances and John Bowes
Ivor Braka
Mr and Mrs James Brice
The British Land Company plc
Donald L Bryant Jr Family
Melva Bucksbaum
Cazenove & Co
The Clore Duffield Foundation
CGU plc
Clifford Chance
Edwin C Cohen
The John S. Cohen Foundation
Ronald and Sharon Cohen
Sadie Coles
Carole and Neville Conrad
Giles and Sonia Coode-Adams
Douglas Cramer
Alan Cristea Gallery
Thomas Dane
Michel and Hélène David-Weill
Julia W Dayton
Gilbert de Botton
Pauline Denyer-Smith and
 Paul Smith
Sir Harry and Lady Djanogly
The Drapers' Company
Energis Communications
English Heritage
English Partnerships
The Eranda Foundation
Esmée Fairbairn Charitable Trust
Donald and Doris Fisher
Richard B. and Jeanne
 Donovan Fisher
The Fishmongers' Company
Freshfields Bruckhaus Deringer
Friends of the Tate Gallery
Bob and Kate Gavron
Giancarlo Giammetti
Alan Gibbs
Mr and Mrs Edward Gilhuly
GKR
GLG Partners
Helyn and Ralph Goldenberg
Goldman Sachs
The Horace W Goldsmith
 Foundation
The Worshipful Company
 of Goldsmiths
Lydia and Manfred Gorvy
Noam and Geraldine Gottesman

Pehr and Christina Gyllenhammar
Mimi and Peter Haas
The Worshipful Company
 of Haberdashers
Hanover Acceptances Limited
The Headley Trust
Mr and Mrs André Hoffmann
Anthony and Evelyn Jacobs
Jay Jopling
Mr and Mrs Karpidas
Howard and Lynda Karshan
Peter and Maria Kellner
Madeleine Kleinwort
Brian and Lesley Knox
Pamela and C Richard Kramlich
Mr and Mrs Henry R Kravis
Irene and Hyman Kreitman
The Kresge Foundation
Catherine and Pierre Lagrange
The Lauder Foundation – Leonard
 and Evelyn Lauder Fund
Lazard Brothers & Co., Limited
Leathersellers' Company
 Charitable Fund
Edward and Agnès Lee
Lex Service Plc
Lehman Brothers
Ruth and Stuart Lipton
Anders and Ulla Ljungh
The Frank Lloyd Family Trusts
London & Cambridge
 Properties Limited
London Electricity plc, EDF Group
Mr and Mrs George Loudon
Mayer, Brown, Rowe & Maw
Viviane and James Mayor
Ronald and Rita McAulay
The Mercers' Company
The Meyer Foundation
The Millennium Commission
Anthony and Deirdre Montagu
The Monument Trust
Mori Building, Ltd
Mr and Mrs M D Moross
Guy and Marion Naggar
Peter and Eileen Norton, The Peter
 Norton Family Foundation
Maja Oeri and Hans Bodenmann
Sir Peter and Lady Osborne
William A Palmer
Mr Frederik Paulsen
Pearson plc
The Pet Shop Boys
The Nyda and Oliver Prenn
 Foundation
Prudential plc
Railtrack plc
The Rayne Foundation
Reuters
Sir John and Lady Ritblat
Rolls-Royce plc
Barrie and Emmanuel Roman
Lord and Lady Rothschild
The Dr Mortimer and Theresa
 Sackler Foundation
J. Sainsbury plc
Ruth and Stephan Schmidheiny
Schroders
Mr and Mrs Charles Schwab
David and Sophie Shalit
Belle Shenkman Estate
William Sieghart
Peter Simon
Mr and Mrs Sven Skarendahl
London Borough of Southwark
The Foundation for Sports
 and the Arts
Mr and Mrs Nicholas Stanley
The Starr Foundation
The Jack Steinberg Charitable Trust
Charlotte Stevenson

Hugh and Catherine Stevenson
John J. Studzinski, CBE
David and Linda Supino
The Government of Switzerland
Carter and Mary Thacher
Insinger Townsley
UBS
UBS Warburg
David and Emma Verey
Dinah Verey
The Vintners' Company
Clodagh and Leslie Waddington
Robert and Felicity Waley-Cohen
Wasserstein, Perella & Co., Inc.
Gordon D Watson
The Weston Family
Mr and Mrs Stephen Wilberding
Michael S Wilson
Poju and Anita Zabludowicz
*and those donors who wish to
remain anonymous*

Donors to Transforming Tate Modern
Lauren and Mark Booth
The Deborah Loeb Brice Foundation
James Chanos
Paul Cooke
Tiqui Atencio Demirdjian and
 Ago Demirdjian
Anthony d'Offay
Lydia and Manfred Gorvy
Noam Gottesman
Maja Hoffmann
Peter and Maria Kellner
Alison and Howard Lutnick
Anthony and Deirdre Montagu
Alison and Paul Myners
Daniel and Elizabeth Peltz
The Dr Mortimer and
 Theresa Sackler Foundation
John J. Studzinski, CBE
Tate Members
The Thistle Trust
Nina and Graham Williams
*and those donors who wish to
remain anonymous*

**Tate Modern Benefactors
and Major Donors**
We would like to acknowledge and
thank the following benefactors who
have supported Tate Modern prior to
28 February 2010.

29th May 1961 Charitable Trust
Alexander and Bonin Publishing, Inc
Klaus Anschel
The Art Fund
Art Mentor Foundation Lucerne
The Arts and Humanities
 Research Council
Charles Asprey
The Estate of Frith Banbury
The Estate of Peter and Caroline
 Barker-Mill
Beecroft Charitable Trust
The Benlian Trust
Luis Benshimol
Big Lottery Fund
Billstone Foundation
The Charlotte Bonham-Carter
 Charitable Trust
Mr Pontus Bonnier
Louise Bourgeois
Frances Bowes
British Council
Melva Bucksbaum and Ray Learsy
James Chanos
Charities Advisory Trust
Henry Christensen III
The Clothworkers' Foundation

Michael Craig-Martin
The Peter Cruddas Foundation
DG Education and Culture
The Danish Arts Agency
Dedalus Foundation
Department for Business,
 Innovation And Skills
Department for Children,
 Schools and Families
Department for Culture,
 Media and Sport
Christian Dinesen
Anthony d'Offay
The D'Oyly Carte Charitable Trust
Jytte Dresing
Carla Emil and Richard Silverstein
Fares and Tania Fares
The Estate of Maurice Farquharson
Marilyn and Larry Fields
Doris and Donald G Fisher
Jeanne Donovan Fisher
Marc Fitch Fund
Mildred and Martin Friedman
Kathy Fuld
Larry Gagosian
Henrietta Garnett
The Getty Foundation
The Horace W. Goldsmith Foundation
Nicholas and Judith Goodison
Marian Goodman
The Goss-Michael Foundation
Arthur and Helen Grogan
Calouste Gulbenkian Foundation
The Armenian Communities
 Department, Calouste Gulbenkian
 Foundation
Mimi and Peter Haas Fund
Christine and Andrew Hall
Viscount and Viscountess Hampden
 and Family
Damien Hirst
David Hockney
Cristina Iglesias
Stanley Thomas Johnson Foundation
Jack Kirkland
Leon Kossoff
Kirby Laing Foundation
LCACE (London Centre for Arts and
 Cultural Exchange)
David Leathers
The Leverhulme Trust
Mark and Liza Loveday
Vatche and Tamar Manoukian
 Foundation
Becky and Jimmy Mayer
Paul Mellon Centre For Studies
 In British Art
Marisa Merz
Sir Geoffroy Millais
Victoria Miro and Glen Scott Wright
The Henry Moore Foundation
National Heritage Memorial Fund
New Art Trust
PF Charitable Trust
Parx Casino and Racetrack, Philadelphia
Catherine Petitgas
The PHG Cadbury Charitable Trust
The Pilgrim Trust
Mrs Miuccia Prada and
 Mr Patrizio Bertelli
Pro Helvetia, Swiss Arts Council
The Radcliffe Trust
Liz Gerring Radke and Kirk Radke
Robert Rennie and Carey Fouks
Rootstein Hopkins Foundation
Embassy of the Kingdom
 of the Netherlands
The Estate of Simon Sainsbury
Saint Sarkis Charity Trust
The Estate of August Sander
Armen and Nouneh Sarkissian

Julião Sarmento
Jeffrey Steele
Norah and Norman Stone
Tate Members
Terra Foundation for American Art
The Estate of Mr Nicholas Themans
Jannick Thiroux
The Sir Jules Thorn Charitable Trust
The Vandervell Foundation
Michael Werner Gallery
Paulo A W Vieira
The Estate of Lyn Williams
*and those who wish to
remain anonymous*

Platinum Patrons

Ghazwa Mayassi Abu-Suud
Mr Shane Akeroyd
Mr and Mrs Edward Atkin
Beecroft Charitable Trust
Rory and Elizabeth Brooks
Lord Browne of Madingley, FRS,
 FREng
Mr Dónall Curtin
Ms Sophie Diedrichs-Cox
Pieter and Olga Dreesmann
Mrs Wendy Fisher
Mr David Fitzsimons
The Flow Foundation
Hugh Gibson
The Goss-Michael Foundation
The Hayden Family Foundation
Vicky Hughes (Chair)
Mr and Mrs Yan Huo
Mrs Gabrielle Jungels-Winkler
Mr Phillip Keir
Maria and Peter Kellner
Mr and Mrs Eskandar Maleki
Panos and Sandra Marinopoulos
Nonna Materkova
Mr and Mrs Scott Mead
Mrs Megha Mittal
Mr Mario Palencia
Mr and Mrs Paul Phillips
Ramzy and Maya Rasamny
Simon and Virginia Robertson
Mr and Mrs Richard Rose
Sally and Anthony Salz
Mr and Mrs J Shafran
Mrs Andrée Shore
Mr and Mrs Malek Sukkar
Mr and Mrs Stanley S. Tollman
Poju and Anita Zabludowicz
*and those who wish to
remain anonymous*

Gold Patrons

Ryan Allen and Caleb Kramer
Ms Thoraya Bartawi
Elena Bowes
Pierre Brahm
Broeksmit Family Foundation
Beth and Michele Colocci
Alastair Cookson
Haro Cumbusyan
Ms Carolyn Dailey
Maria de Madariaga
Flora Fraser and Peter Soros
Mr and Mrs A Ramy Goldstein
Mrs Maryam Eisler
Mr Michael Hoppen
Mrs Petra Horvat
Anne-Marie and Geoffrey Isaac
Mrs Heather Kerzner
Mr Eugenio Lopez
Fiona Mactaggart
Mrs Bona Montagu
Mr Francis Outred
Simon and Midge Palley
Catherine and Franck Petitgas
Mathew Prichard

Mr David Roberts
Mr Charles Roxburgh
Mrs Rosario Saxe-Coburg
Carol Sellars
Mrs Celia Forner Venturi
Michael and Jane Wilson
Manuela and Iwan Wirth
Barbara Yerolemou
*and those who wish to
remain anonymous*

Silver Patrons

Agnew's
Mr Abdullah Al Turki
Helen Alexander, CBE
HRH Princess Alia Al-Senussi
Harriet Anstruther
Toby and Kate Anstruther
Mr and Mrs Zeev Aram
Mr Giorgio Armani
Sigurdur Arngrimsson
Kiran Arora
Kirtland Ash
Edgar Astaire
Daphne Warburg Astor
Ms Myrna Ayad
Mrs Jane Barker
Mr Edward Barlow
Victoria Barnsley, OBE
Jim Bartos
Mrs Nada Bayoud
Mr and Mrs Paul Bell
Mr Harold Berg
Ms Anne Berthoud
Madeleine Bessborough
Janice Blackburn
Mr and Mrs Anthony Blee
Mr Andrew Bourne
Mrs Lena Boyle
Mr Daniel Bradman
Ivor Braka
Viscountess Bridgeman
The Broere Charitable Foundation
Mr and Mrs Charles Brown
Ben and Louisa Brown
Michael Burrell
Mrs Marlene Burston
Timothy and Elizabeth Capon
Laurent and Michaela Caraffa
Matt Carey-Williams and
 Donnie Roark
Mr Francis Carnwath and Ms
 Caroline Wiseman
Lord and Lady Charles Cecil
Frank Cohen
Dr Judith Collins
Terrence Collis
Mr and Mrs Oliver Colman
Mrs Laura Comfort
Carole and Neville Conrad
Giles and Sonia Coode-Adams
Cynthia Corbett
Mark and Cathy Corbett
Thamara Corm
Tommaso Corvi-Mora
Mr and Mrs Bertrand Coste
Kathleen Crook and James Penturn
The Cowley Foundation
James Curtis
Loraine da Costa
Mrs Isobel Dalziel
Sir Howard Davies
Ms Isabelle De La Bruyère
Mr Giles de la Mare
The de Laszlo Foundation
Mr Jan De Smedt
Anne Chantal Defay Sheridan
Marco di Cesaria
Simon C Dickinson Ltd
Mr Alan Djanogly
Ms Michelle D'Souza

Joan Edlis
Lord and Lady Egremont
John Erle-Drax
Stuart and Margaret Evans
Eykyn Maclean LLC
Gerard Faggionato
Dana Farouki
Mrs Heather Farrar
Mrs Margy Fenwick
Mr Bryan Ferry
The Sylvie Fleming Collection
Mrs Rosamund Fokschaner
Jane and Richard Found
Joscelyn Fox
Eric and Louise Franck
Elizabeth Freeman
Michael Freund
Stephen Friedman
Julia Fuller
Carol Galley
Gapper Charitable Trust
Mrs Daniela Gareh
Mrs Joanna Gemes
Mr David Gibbons
The Swan Trust
Mr Mark Glatman
Mr and Mrs Paul Goswell
Penelope Govett
Gavin Graham
Mrs Sandra Graham
Martyn Gregory
Sir Ronald Grierson
Mrs Kate Grimond
Richard and Odile Grogan
Miss Julie Grossman
Mr Nick Hackworth
Alex Haidas
Mr Benji Hall
Louise Hallett
Dr Lamees Hamdan
Mrs Sue Hammerson, CBE
Jane Hay
Richard Hazlewood
Michael and Morven Heller
Mrs Alison Henry-Davies
Mr Nigel Mark Hobden
Mr Frank Hodgson
Robert Holden
James Holland-Hibbert
Lady Hollick
Mrs Susanna Hong Rodzynek
John Huntingford
Miss Eloise Isaac
Mr Haydn John
Mr Michael Johnson
Mr Chester Jones
Jay Jopling
Mrs Brenda Josephs
Tracey Josephs
Ms Melek Huma Kabakci
Andrew Kalman
Mr Efe Kapanci
Dr Martin Kenig
Mr David Ker
Mr and Mrs Simon Keswick
Richard and Helen Keys
Ali Khadra
David Killick
Mr and Mrs Paolo Kind
Mr and Mrs James Kirkman
Brian and Lesley Knox
Helena Christina Knudsen
Ms Marijana Kolak
Mrs Caroline Koomen
Kowitz Trust
Mr Jimmy Lahoud
Steven Larcombe
Simon Lee
Zachary R Leonard
Mr Gerald Levin
Leonard Lewis

Anders and Ulla Ljungh
Mr Gilbert Lloyd
George Loudon
Mrs Siobhan Loughran Mareuse
Mark and Liza Loveday
Charlotte Lucas
Daniella Luxembourg Art
The Mactaggart Third Fund
Mr M J Margulies
Mr and Mrs Jonathan Marks
Marsh Christian Trust
Mr Martin Mellish
Mrs R W P Mellish
Dr Rob Melville
Mr Michael Meynell
Mr Alfred Mignano
Victoria Miro
Jan Mol
Mr Fernando Moncho Lobo
Mrs Valerie Gladwin Montgomery
Mrs Roberta Moore Hobbis
Houston Morris
Erin Morris
Mrs William Morrison
Mr Stamatis Moskey
Paul and Alison Myners
Mr David Nader
Mr and The Hon Mrs Guy Naggar
Richard Nagy
Mrs Gwen Neumann
Mrs Annette Nygren
Jacqueline O'Leary
Alberto and Andrea Olimon
Julian Opie
Pilar Ordovás
Mr O'Sullivan
Desmond Page
Maureen Paley
Dominic Palfreyman
Michael Palin
Cornelia Pallavicini
Mrs Kathrine Palmer
Phyllis Papadavid
Stephen and Clare Pardy
Ms Camilla Paul
Mr Mauro Perucchetti
Eve Pilkington
Ms Michina Ponzone-Pope
Lauren Prakke
Susan Prevezer QC
Mrs Barbara Prideaux
Mr and Mrs Ryan Prince
Valerie Rademacher
Miss Sunny Rahbar
Mrs Phyllis Rapp
Mr and Mrs James Reed
Mr and Mrs Philip Renaud
The Reuben Foundation
Sir Tim Rice
Lady Ritblat
Tim Ritchie
Mr Bruce Ritchie and Mrs Shadi Ritchie
Rupert and Alexandra Robson
Kimberley and Michael Robson-Ortiz
David Rocklin
Frankie Rossi
Mr James Roundell
Mr Lyon Roussel
Mr and Mrs Paul Ruddock
Mr Alex Sainsbury and Ms Elinor Jansz
Mrs Sherine Sawiris
Cherrill and Ian Scheer
Sylvia Scheuer
The Schneer Foundation
Andrew and Belinda Scott
Ms Joy Victoria Seppala-Florence
Mr Roopak Shah
Amir Shariat
Neville Shulman, CBE
Andreas B Siegfried
Andrew Silewicz

Ms Julia Simmonds
Tammy Smulders
Mrs Cindy Sofer
Louise Spence
Ms Brigitta Spinocchia
Digby Squires, Esq.
Mr and Mrs Nicholas Stanley
Miss Malgosia Stepnik
Charlotte Stevenson
Mrs Tanya Steyn
Mrs Patricia Swannell
Mr James Swartz
The Lady Juliet Tadgell
Sir Anthony and Lady Tennant
Christopher and Sally Tennant
Soren S K Tholstrup
Britt Tidelius
Emily Tsingou and Henry Bond
Melissa Ulfane
Mr and Mrs Petri Vainio
Mrs Dita Vankova
Mr Mehmet Erdinc Varlibas
Rachel Verghis
Mrs Cecilia Versteegh
Gisela von Sanden
Audrey Wallrock
Stephen and Linda Waterhouse
Offer Waterman
Terry Watkins
Mr and Mrs Mark Weiss
Jack Wendler
Miss Cheyenne Westphal
Mr Benedict Wilkinson
Mr Douglas Woolf
Mr Josh Wyatt
Mr Fabrizio Zappaterra
*and those who wish to
remain anonymous*

North American
Acquisitions Committee
Beth Rudin De Woody
Dr Kira Flanzraich
Glenn Fuhrman (Chair)
Marc Glimcher
Margot and George Greig
Monica Kalpakian
Massimo Marcucci
Lillian Mauer
Stavros Merjos
Gregory R. Miller
Elisa Nuyten and David Dime
Amy and John Phelan
Liz Gerring Radke and Kirk Radke
Laura Rapp and Jay Smith
Robert Rennie and Carey Fouks
Michael Sacks
Randy W Slifka
Christen and Derek Wilson
*and those who wish to
remain anonymous*

Latin American
Acquisitions Committee
Monica and Robert Aguirre
Luis Benshimol
Estrellita and Daniel Brodsky
Carmen Buqueras
Rita Rovelli Caltagirone
Trudy and Paul Cejas
Patricia Phelps de Cisneros
Gerard Cohen
HSH the Prince Pierre d'Arenberg
Tiqui Atencio Demirdjian (Chair)
Tania Fares
Angelica Fuentes de Vergara
Yolanda Garza Santos
William A. Haseltine
Mauro Herlitzka
Rocio and Boris Hirmas
Anne Marie and Geoffrey Isaac

Nicole Junkermann
Jack Kirkland
Fatima and Eskander Maleki
Becky and Jimmy Mayer
Solita and Steven Mishaan
Victoria and Isaac Oberfeld
Catherine and Michel Pastor
Catherine Petitgas
Isabella Prata and Idel Arcuschin
Estefania and Philip Renaud
Frances Reynolds
Erica Roberts
Alin Ryan von Buch
Lilly Scarpetta and Roberto Pumarejo
Catherine Shriro
Norma Smith
Susana and Ricardo Steinbruch
Beatriz Quintella and Luiz Augusto
 Teixeira de Freitas
Paula Traboulsi
Juan Carlos Verme
Tania and Arnoldo Wald
Juan Yarur
*and those who wish to
remain anonymous*

Asia-Pacific
Acquisitions Committee
Bonnie and R Derek Bandeen
Mr and Mrs John Carrafiell
Mrs Christina Chandris
Richard Chang
Pierre T M Chen, Yageo
 Foundation, Taiwan
Ms Mareva Grabowski
Elizabeth Griffith
Cees Hendrikse
Mr Yongsoo Huh
Ms Yung Hee Kim
Mr and Mrs Sylvain Levy
Ms Kai-Yin Lo
Mr Nicholas Loup
Mrs Yana Peel
The Red Mansion Foundation
Mr Paul Serfaty
Mr Robert Shum
Sir David Tang (Chair)
Katie de Tilly
*and those who wish to
remain anonymous*

Middle East and North Africa
Acquisitions Committee
Mehves Ariburnu
Sule Arinc
Marwan Assaf
Ms Isabelle de la Bruyère
Füsun Eczacıbaşı
Shirley Elghanian
Defina Entrecanales
Noor Fares
Serra Grantay Avcioglu
Maryam Homayoun Eisler
Ali Yussef Khadra
Maha and Kasim Kutay
Lina Lazaar
Mr and Mrs Eskandar Maleki
Fayeeza Naqvi
Basil and Raghida Al-Rahim
Ramzy and Maya Rasamny (Chair)
HRH Sheikha Lulu Al-Sabah
Dania Sakka
Mrs Sherine Sawiris
HRH Princess Alia Al-Senussi
Mr and Mrs Malek Sukkar
Berna Tuglular
Abdullah Al Turki
*and those who wish to
remain anonymous*

International Council Members
Doris Ammann
Mr Plácido Arango
Mrs Miel de Botton Aynsley
Gabrielle Bacon
Anne H Bass
Nicolas Berggruen
Mr Pontus Bonnier
Mrs Frances Bowes
Ivor Braka
The Deborah Loeb Brice Foundation
The Broad Art Foundation
Bettina and Donald L Bryant Jr
Melva Bucksbaum and
 Raymond Learsy
Foundation Cartier pour l'art
 contemporain
Mrs Christina Chandris
Pierre TM Chen, Yageo
 Foundation, Taiwan
Mr and Mrs Borja Coca
Mr and Mrs Attilio Codognato
David and Michelle Coe
Sir Ronald Cohen and Lady
 Sharon Harel-Cohen
Mr Alfonso Cortina de Alcocer
Mr Douglas S Cramer and Mr
 Hubert S Bush III
Mr Dimitris Daskalopoulos
Mr and Mrs Michel David-Weill
Julia W Dayton
Tiqui Atencio Demirdjian
 and Ago Demirdjian
Joseph and Marie Donnelly
Mrs Jytte Dresing
Stefan Edlis and Gael Neeson
Carla Emil and Rich Silverstein
Harald Falckenberg
Fares and Tania Fares
Mrs Doris Fisher
Mrs Wendy Fisher
Dr Corinne M Flick
Mr Albert Fuss
Candida and Zak Gertler
Alan Gibbs
Lydia and Manfred Gorvy
Mr Laurence Graff
Ms Esther Grether
Mr Xavier Guerrand-Hermès
Mimi and Peter Haas Fund
Mr Joseph Hackmey
Margrit and Paul Hahnloser
Andy and Christine Hall
Mr Toshio Hara
André and Rosalie Hoffmann
Ms Maja Hoffmann (Chair)
ITYS, Athens
Dakis and Lietta Joannou
Sir Elton John and Mr David Furnish
HRH Princess Firyal of Jordan
Mr Per and Mrs Lena Josefsson
C Richard and Pamela Kramlich
Pierre and Catherine Lagrange
Baron and Baroness Philippe Lambert
Agnès and Edward Lee
Jacqueline and Marc Leland
Panos and Sandra Marinopoulos
Mr and Mrs Donald B Marron
Mr Ronald and The Hon Mrs McAulay
Mr and Mrs Minoru Mori
Mr Guy and The Hon Mrs Naggar
Mr and Mrs Takeo Obayashi
Young-Ju Park
Yana and Stephen Peel
Daniel and Elizabeth Peltz
Catherine and Franck Petitgas
Sydney Picasso
Mr and Mrs Jürgen Pierburg
Jean Pigozzi
Ms Miuccia Prada and Mr
 Patrizio Bertelli

Patrizia Sandretto Re Rebaudengo
 and Agostino Re Rebaudengo
Mr John Richardson
Michael Ringier
Lady Ritblat
Barrie and Emmanuel Roman
Ms Güler Sabancı
Mrs Mortimer Sackler
Mrs Lily Safra
Muriel and Freddy Salem
Dasha Shenkman
Uli and Rita Sigg
Norah and Norman Stone
John J Studzinski, CBE
David Teiger
Mr Robert Tomei
The Hon Robert H Tuttle and
 Mrs Maria Hummer-Tuttle
Mr and Mrs Guy Ullens
Paulo A W Vieira
Mr Robert and The Hon
 Mrs Waley-Cohen
Pierre de Weck
Angela Westwater and
 David Meitus
Diana Widmaier Picasso
Mrs Sylvie Winckler
The Hon Mrs Janet Wolfson
 de Botton, CBE
Anita and Poju Zabludowicz
Michael Zilkha
*and those who wish to
remain anonymous*

Tate Modern Corporate Supporters
Access Industries
Aviva plc
AXA Art Insurance Ltd
Bloomberg
BT
Derwent London
Fujitsu
Guaranty Trust Bank
Land Securities
Nissan Qashqai
Rolex
Savills
UBS
Unilever
*and those who wish to
remain anonymous*

Tate Modern Corporate Members
Accenture
Alstom Ltd
Centrica
Deutsche Bank
EDF Energy
Freshfields Bruckhaus Deringer
Hanjin Shipping
HSBC Holdings plc
IPC Media Ltd
Linklaters
Mace Group Ltd
Morgan Stanley
Native Land and Grosvenor
Nomura
Pearson
Sotheby's
Thames & Hudson
*and those who wish to
remain anonymous*

255